DATE DUE

~~DE 19 04~~			
~~NO 29 04~~			
~~NO 28 05~~			
~~MR 31 '09~~			

DEMCO 38-296

THE GREAT BOOK OF

Post-Impressionism

THE GREAT BOOK OF

Post-Impressionism

DIANE KELDER

ABBEVILLE PRESS · PUBLISHERS · NEW YORK

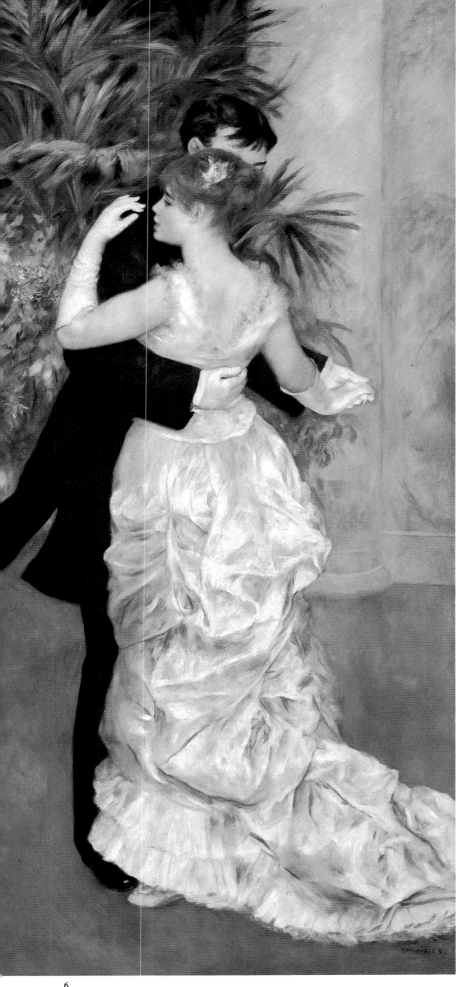

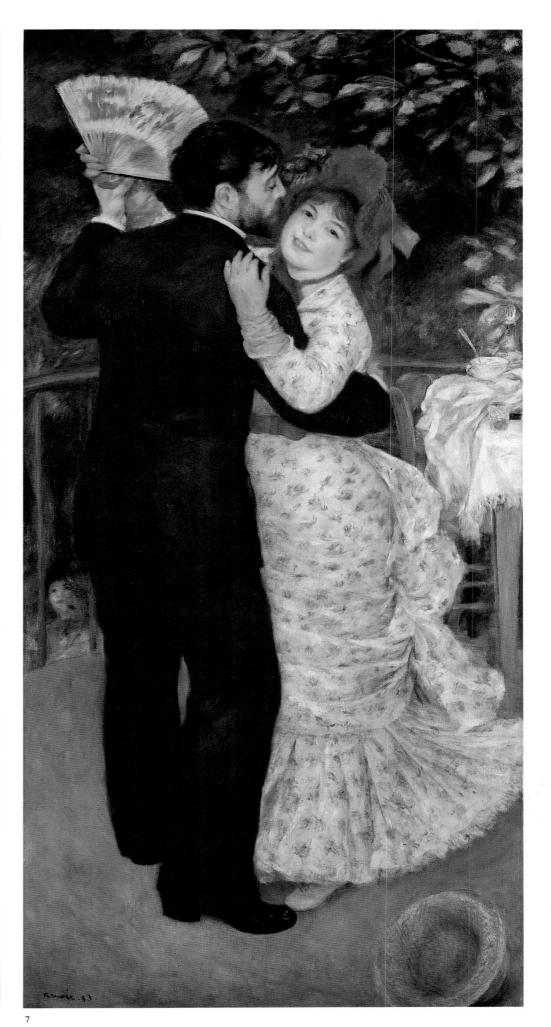

6

7

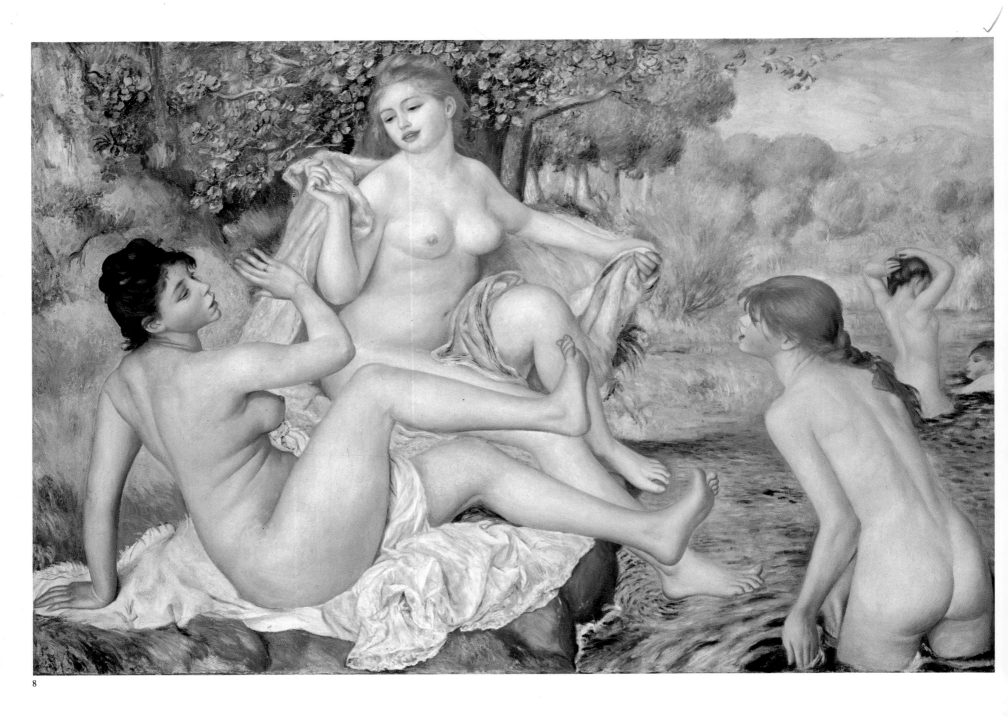

8

Doubts and Divergences

In the early 1880s Pissarro, Renoir, and Monet began to question the very foundations of Impressionist vision, echoing—either consciously or unconsciously—the objections to its apparent superficiality and absence of finish that critics had voiced repeatedly since the first exhibition. Pissarro was "much disturbed by [his own] unpolished and rough execution" and longed for "a smoother technique." [3] He made an effort to imbue his landscapes with greater formal clarity, but he would not achieve a significant breakthrough until 1885, when his friendship with two remarkable younger painters directed him to a thorough reevaluation of color (see chapter 2).

Renoir's journey to Italy in 1881 had opened his eyes to classical art and inspired a profound admiration for Raphael. Years later he recalled that this newfound enthusiasm for the art of the past had led to the recognition that

I had wrung Impressionism dry; and I finally came to the conclusion that I knew neither

8. Pierre Auguste Renoir (1841–1919). *Bathers*, 1887. Oil on canvas, 46⅜ x 67¼ in. Philadelphia Museum of Art; Gift of Jacques Laroche.

9. François Girardon (1628–1715). *The Bath of the Nymphs*, 1675 (detail). Lead, originally gilded, 7 ft. 4½ in. x 20 ft. 2 in. Park of Versailles.

10. Pierre Auguste Renoir (1841–1919). *Three Bathers*, 1883–85. Pencil on paper, 24½ x 42½ in. Musée du Louvre, Cabinet des Dessins, Paris; Gift of Jacques Laroche.

van Eogh pg 174
Sunflowers

When Renoir exhibited this monumental canvas in 1887 its critical reception was mixed. Yet within three years even critics dedicated to Symbolism, such as Teodor de Wyzewa, had been won over to the pleasing harmonies of Renoir's new style. Recalling the impact of the Bathers, *Wyzewa wrote in 1890: "I cannot forget the extraordinary emotion that this painting aroused in me, so gentle and yet so strong, a delightful blend of precise vision and dreamlike music. The effort of so many years culminated in triumph. . . . M. Renoir is a classical painter and one of the most French; this is what endears him to us most deeply. He concerns himself with formal perfection [and] . . . proceeds farther and farther toward an art of discreet and simple harmony. In that respect he is linked to Poussin and Watteau, who, along with Rubens, are his real masters."*

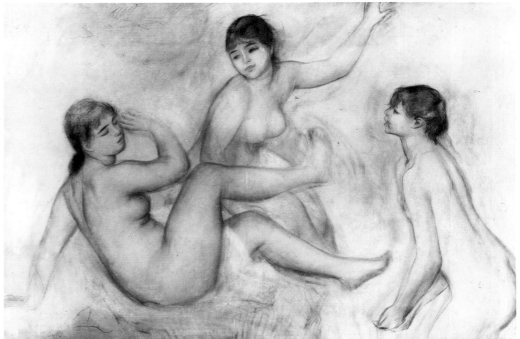

10

pg. 224
Matisse

pg. 151
last 3 impressionist
Bernard
Monet
Van Gogh

pg. 161 — Bernard stylized
more to Degas.

how to paint nor draw. In a word, Impressionism was a blind alley. . . . Out of doors there is a greater variety of light than in the studio, where, to all intents and purposes, it is constant but, for just that reason, light plays too great a part. . . . If a painter works directly from Nature, he ultimately looks for nothing but momentary effects; he does not try to compose, and soon he gets monotonous.[4]

Following his Italian trip, Renoir made a determined effort to master the academic technique that he felt his work lacked. At the same time, he displayed a willingness to accommodate the bourgeois taste of his time, a concession that would become increasingly evident in his choice of subjects. His efforts to simplify forms by emphasizing strong contours and modifying the role of color are evident in the pendant pictures *Dance in the City* and *Dance in the Country* of 1883 (plates 6, 7), which retain a somewhat cosmeticized Impressionist theme but offer a more immediately legible surface design than his work of the previous decade.

In 1884 Renoir abandoned contemporaneity for a classical subject in his *Bathers* (plate 8). This monumental canvas, which he finished three years later, was academic in conception and execution. Its composition was adapted from a bas-relief by the seventeenth-century French sculptor François Girardon (plate 9), but it also combined elements from works by other artists Renoir greatly admired: François Boucher's *Bath of Diana* and Raphael's *Galatea*. The numerous preparatory studies for this painting (plate 10) document Renoir's determination to reconcile the Impressionist palette with the rigorous drawing and timeless subject matter that he had discovered in the works of the Renaissance masters. Yet the insistent contours and arid colors of this ambitious composition underscore his capitulation to the art of the past. Renoir described his work as "an attempt at decorative painting" and claimed that he wanted it to look like a "fresco in oil,"[5] thus indicating his desire for the work to be seen within the context of the great decorative cycles of the past. When the painting was exhibited in 1887, its popular reception was encouraging. Renoir's attempted marriage of the traditional and the modern was doubtless greeted with favor by viewers and critics who had long

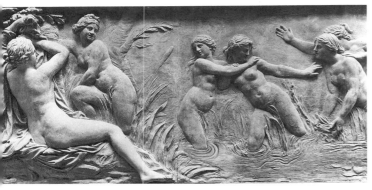

9

awaited some formal and thematic concessions by the Impressionists.

Like Renoir, Monet began to find fault with his painting. In December 1883 he wrote to Durand-Ruel: "I have more and more trouble in satisfying myself . . . the fact is simply that I have more difficulty now in doing what I formerly did with ease."[6] Earlier that year Monet and his large household had moved to Giverny, where he would remain until the end of his life, painting the Oise River, its tributaries, the surrounding fields, and the ever-expanding gardens that he had begun to plant. A brief trip with Renoir to the Côte d'Azur opened Monet's eyes to the intense light and lush vegetation of the Mediterranean, and he resolved to return there the next year.

When Monet revisited the south he was alone, as he now preferred isolation to the camaraderie that he and Renoir had enjoyed at La Grenouillère and Argenteuil during the early years of Impressionism. The colors and physical energy of the subtropical landscape challenged him to create new chromatic harmonies and a more emphatic and

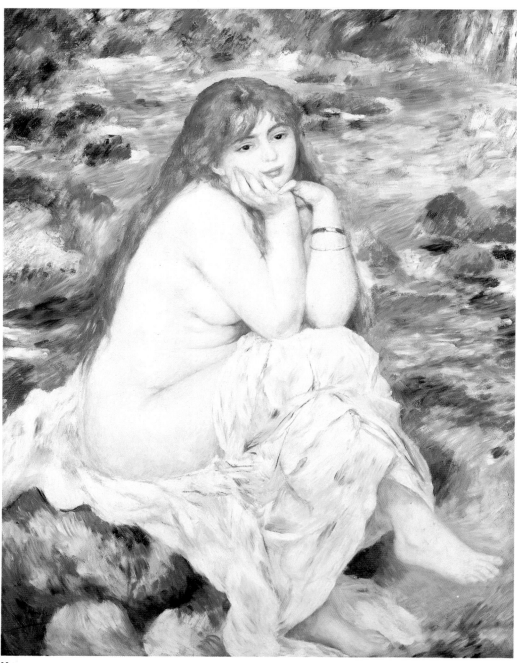

11

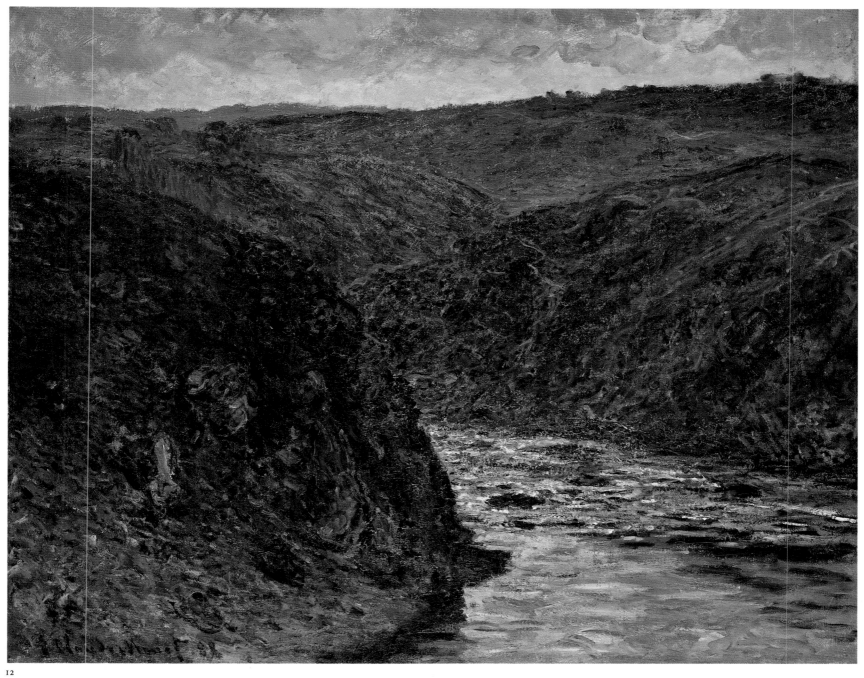

12

11. Pierre Auguste Renoir (1841–1919). *Seated Bather*, 1885. Oil on canvas, 47 x 36½ in. Fogg Art Museum, Harvard University; Bequest Collection of Maurice Wertheim, Class of 1906.

12. Claude Monet (1840–1926). *Ravine of the Creuse II*, 1889. Oil on canvas, 25½ x 31 in. Museum of Fine Arts, Boston; Ross Collection; Gift of Denman W. Ross.

regular brushwork. Over the next four years Monet expanded his range of color from delicately modulated pastels to the dramatically paired complementaries employed in *Ravine of the Creuse II* (plate 12).

During the 1880s Monet's approach to painting underwent a major transformation. If his earlier work can be described as responsive to the appearance of a particular site, his later development is characterized by more active intervention and interpretation, as he consciously sought to adjust nature's forms to the intrinsic dictates of structure and color harmony. Increasingly, the experience of painting *en plein air* was followed by prolonged examination and alteration in his studio.

Monet's move to Giverny, like Cézanne's to Aix-en-Provence, was indicative of the painter's desire to distance himself from Paris and his Impressionist colleagues. With Pissarro in the remote village of Eragny and Sisley settled in Moret near the Forest of

Fontainebleau, only Renoir, Degas, and Morisot remained in the city. For a time, the original Impressionists made an effort to overcome the geographic distances that separated them by gathering informally for dinner. But the individual crises of style that had manifested themselves in the early 1880s were indicative of a more fundamental artistic crisis that would surface when only three of the original Impressionists participated in their last group show in 1886.

Durand-Ruel and the Art Market

The economic boom that had accompanied Emperor Napoleon III's consolidation of power in the 1860s had produced a new wealthy class, largely inexperienced in the tradition of art patronage. In the decades that followed, these industrialists and entrepreneurs were the primary clients for an expanding nucleus of Paris-based dealers such as Paul Durand-Ruel. Able and eager to advise both artists and their potential patrons, the dealers worked ceaselessly to overcome the public prejudice against Impressionism, and over the course of two decades their efforts helped the artists establish national and international reputations.

Durand-Ruel, who first met Monet and Pissarro in 1870 when all three had fled to London to avoid the Franco-Prussian War, became the group's dealer, champion, and principal patron, buying as much from the various members as he could and sometimes making advances to the artists that they would later repay with paintings. Durand-Ruel's support had initially offered a small measure of financial security to the painters, which allowed them to contemplate independence from the Salon system. Ironically, it was the first of a number of financial reverses on the dealer's part that made the idea of an artists' cooperative exhibition seem so urgent in 1874.

The five shows that followed the Impressionists' group debut were plagued by internal dissension and commercial failure. When Gustave Caillebotte and Pissarro pro-

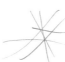

13

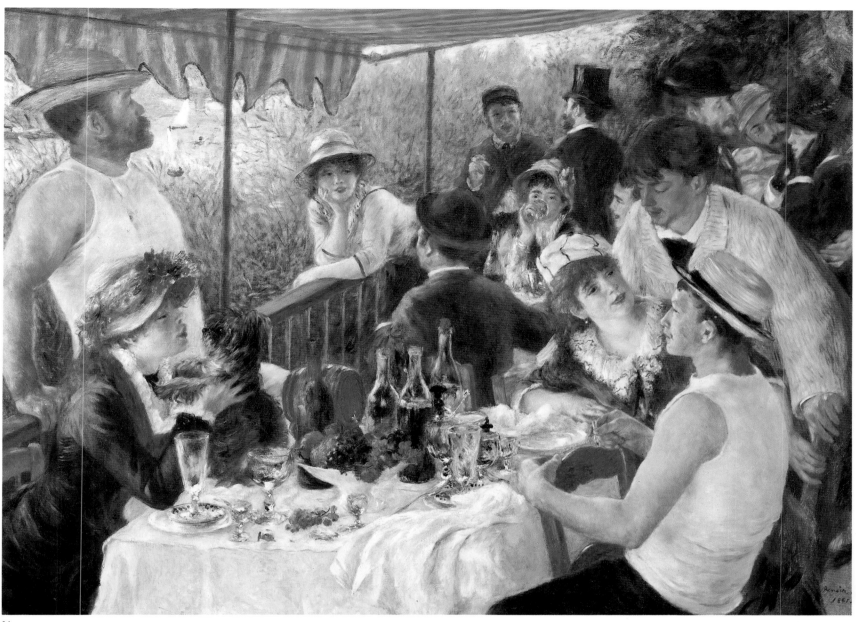

14

13. Edgar Degas (1834–1917). *The Rehearsal of the Ballet on the Stage*, n.d. Oil colors freely mixed with turpentine, on paper mounted on canvas, 21⅜ x 28¾ in. The Metropolitan Museum of Art, New York; Gift of Horace Havemeyer, 1929; The H. O. Havemeyer Collection.

14. Pierre Auguste Renoir (1841–1919). *The Luncheon of the Boating Party*, 1881. Oil on canvas, 50¾ x 68⅛ in. The Phillips Collection, Washington, D.C.

posed the idea of a seventh exhibition in 1882, Durand-Ruel personally undertook its organization. Negotiations were especially difficult, owing to Degas's repeated efforts to include nonlandscape painters. Monet refused to participate without Renoir, and the latter—ill at the time—was unwilling to compromise the new respectability that he had gained through three successful years of exhibiting at the Salon. Finally, Durand-Ruel persuaded the two painters to join in the group effort, and virtually all of the others followed. The only exceptions were Paul Cézanne, who did not respond to the invitation, and Degas, who was offended by the exclusion of his friends. This was the only group show that Degas missed, and it can be argued that his absence contributed to its more homogeneous character, which some critics noted. Indeed, the critical response to this exhibition was particularly encouraging. Manet's brother Eugène reported to his wife, Berthe Morisot, that Duret had judged "this year's exhibition . . . the best your group ever had." [7]

The prolonged resistance to Durand-Ruel's efforts to promote Impressionism must have been discouraging to him, but it was even more of a hardship for some of his

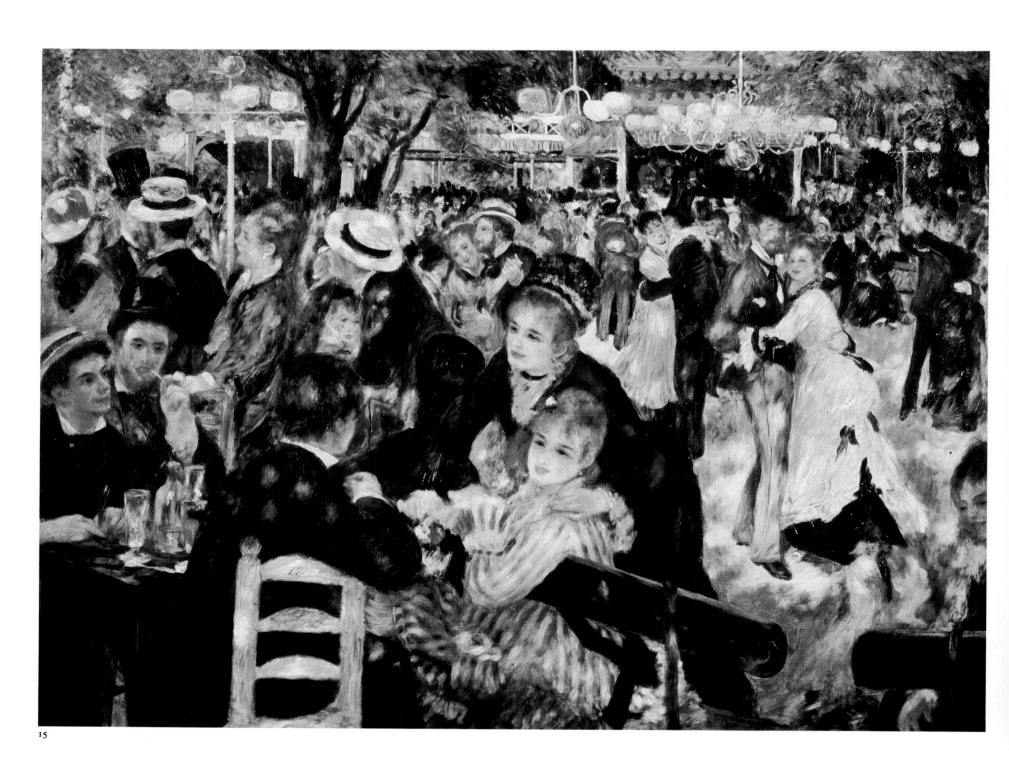

15

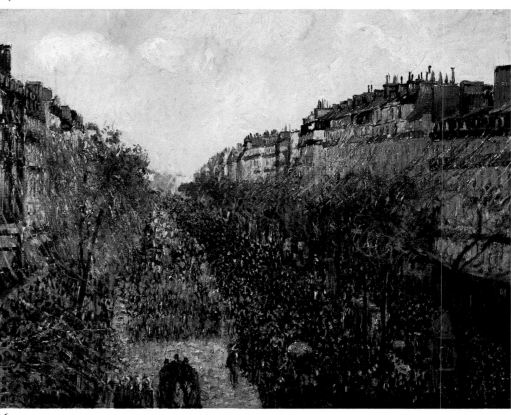

16

painters. Monet's and Renoir's decision to exhibit with another dealer, Georges Petit, who had opened large and sumptuous galleries in 1882, was prompted in part by a conviction that they had become too closely associated with the "official" dealer of the Impressionists. Unfortunately, Petit's attempt to attract buyers for their paintings by including them in shows with more fashionable artists met with only limited success.

The various foreign exhibitions that Durand-Ruel mounted in Europe and America between 1882 and 1886 indicated both his response to Petit's challenge and his new resolve to try untapped markets. While these shows gradually familiarized local artists with the works of the major Impressionists, the financial rewards were few. Nonetheless, in March 1886, Durand-Ruel again set out for America, this time with 290 paintings. His show, advertised as the *Special Exhibition of Works in Oil and Pastel by the Impressionists of Paris*, opened on April 10 in the gallery of the American Art Association in New York. The exhibition was so popular that the following month it was moved to the larger quarters of the National Academy of Design, where it remained for another month.

The unprecedented size of the exhibition would have been cause enough for excitement, but the quality of the works shown was also exceptional. A number of these paintings, including Degas's *Rehearsal of the Ballet on the Stage* (plate 13) and Renoir's *The Luncheon of the Boating Party* (plate 14), would later form the nucleus of some of the finest American museum collections of Impressionist painting. In contrast to the critics' indifference to the Impressionist works that Durand-Ruel had shown three years earlier in Boston, the reception in 1886 was encouraging. A writer for *The Art Amateur* observed prophetically: "The Impressionist movement means change, if not progress. There is little doubt that all the good painting of all the men who will come into notice during the next ten years will be tinged with Impressionism, not perhaps as it has been

15. Pierre Auguste Renoir (1841–1919). *Dancing at the Moulin de la Galette*, 1876. Oil on canvas, 31 x 44¾ in. Musée d'Orsay, Paris.

16. Camille Pissarro (1830–1903). *Boulevard Montmartre, Mardi-Gras*, 1897. Oil on canvas, 25 x 31½ in. © The Armand Hammer Collection, Los Angeles.

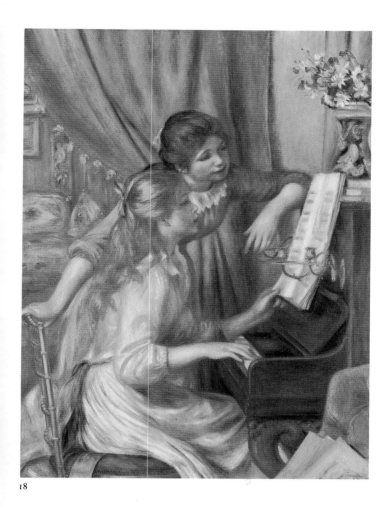

18

17. Detail of plate 18.

18. Pierre Auguste Renoir (1841–1919). *Young Girls at the Piano*, 1892. Oil on canvas, 45½ x 35⅜ in. Musée d'Orsay, Paris.

put into words by the critics, but as it has been put into paint by Manet and a few others." [8]

The cumulative effect of Durand-Ruel's efforts to launch Impressionism in America could be assessed at the massive World's Columbian Exposition held in Chicago in 1893. A major cultural event of the nineteenth century, the fair followed a well-established practice of including exhibitions devoted to the fine arts. The prevailing official style in France was represented by paintings by Jean Jacques Henner, William Bouguereau, and other academics. In contrast to these conservative works, the American show was an impressive exhibition of foreign works from private American collections. Among the 125 paintings and sculptures shown were some of the best Impressionist canvases available anywhere in the world. A French correspondent for the *Gazette des Beaux-Arts* described this collection as the "centerpiece" of the entire exhibition, and a writer for the magazine *Modern Art* boasted: "It is the most remarkable collection of modern art that has ever been made. . . . It is said that Frenchmen groan when they see how much of the best work of their greatest men has been allowed to come to this country." [9]

Fortunately for the French, the death of the painter Gustave Caillebotte in 1894 and the subsequent bequest to the Musée du Luxembourg, in Paris, of his collection of over sixty Impressionist paintings by Degas, Manet, Monet, Renoir, and Sisley provided them with a major treasury. However, it was a measure of the continuing resistance to Impressionism on the part of the French art establishment that while such paintings as Renoir's *Dancing at the Moulin de la Galette* (plate 15) and Manet's *The Balcony* were deemed acceptable by museum officials, twenty-nine others, including numerous Cézannes, Monets, and Sisleys, were rejected. Of all the painters represented in the collection, only Degas had all of his works accepted without reservation. Indeed, Caillebotte's heirs were so offended by the protracted negotiations that they bitterly terminated them and refused to consider belated government requests for a reconsideration when the "acceptable" paintings were finally put on public display in 1897.

The Last Years of the Impressionists

The 1890s witnessed a significant improvement in the market for Impressionist painting and in the attitude of the critics. The growing success of Durand-Ruel's activities abroad had enabled him to regain a measure of the power and prestige he had lost through the initiatives of Petit and another enterprising dealer, Theo van Gogh. Moreover, his earlier strategy of using solo exhibitions as a way to focus public attention on his artists' work was vindicated. Pissarro's and Renoir's large retrospectives in 1892 were enormously successful, providing the former with his first taste of popularity and confirming the broad acceptance of the latter that had been building for a decade. In the same year Renoir exhibited—and the State purchased—his *Young Girls at the Piano* (plate 18). Eight years later the one-time painter of teacups would be awarded the Legion of Honor, which sealed not only his recognition by the establishment but that of Impressionism as well.

By the time the State acquired *Young Girls at the Piano*, Renoir had evolved a serviceable formula that blended academic composition and the high color of Impressionism with domestic subjects that were often inspired by the painter's own comfortable home life. With some modification, this combination would sustain him throughout the difficult arthritis-ridden years of his old age. After 1903, when his sizable household moved to Cagnes on the Côte d'Azur, he turned repeatedly to the female nude—a theme that facilitated his personal synthesis of classicism and Impressionism, of the ideal and the natural, of timelessness and spontaneity.

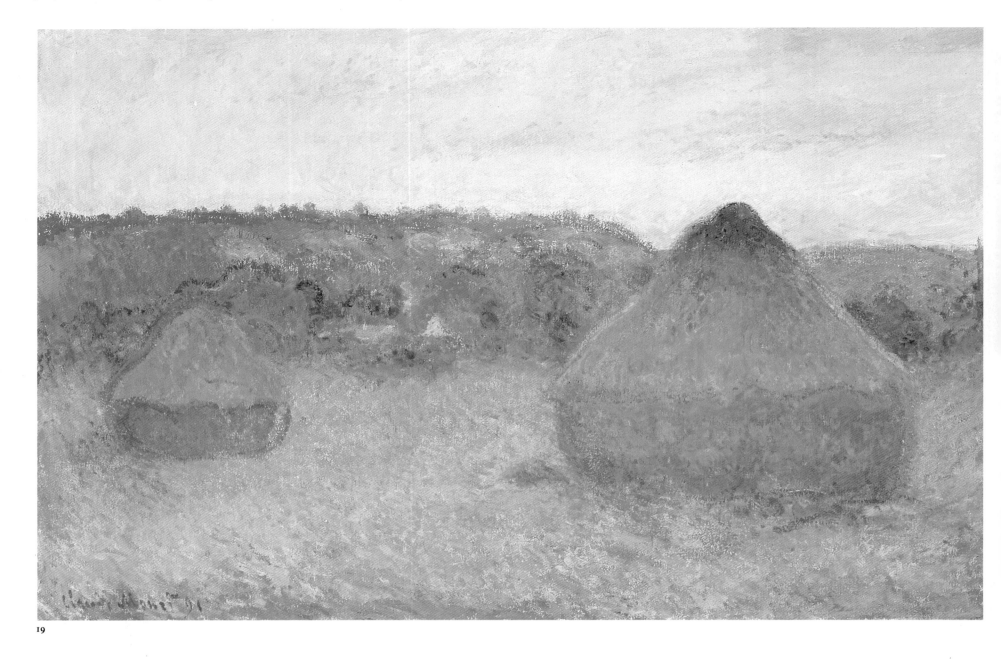

19

CLAUDE MONET

After the death of Theo van Gogh in 1891, Monet and Durand-Ruel reconciled, and Monet agreed to exhibit his series of fifteen Haystacks (plate 19) in Durand-Ruel's gallery. When he undertook the Haystacks, Monet had intended to paint only two canvases, one of gray weather and one of sunshine, but months later he was still struggling with the motif as his determination to capture a unique atmospheric moment made him aware of its replacement by another, and then still another. Describing his frustration, he wrote:

> . . . the more I continue, the more I see that a great deal of work is necessary in order to succeed in rendering what I seek: "instantaneity," especially in the *enveloppe*. The same light spreading everywhere, and more than ever I am disgusted with the easy things that come in one stroke. I am more and more driven by the need to render what I feel. . . .[10]

Evident in Monet's statement is his desire to render the ephemeral, but that desire is accompanied by a new sense of urgency. Indeed, the Haystacks series contributes a record not only of different conditions of light and weather but also of the artist's varying states of mind.

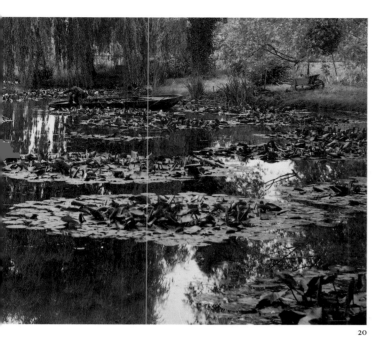

20

While Monet had engaged many years earlier in the practice of painting several canvases based on the same motif—his views of the Gare St. Lazare—it was only in the late 1880s that he had become more aware of an inner logic or consistency in his canvases. The Haystacks, as well as the Poplar (plate 21) and Rouen Cathedral series that followed, confirmed how far the artist had moved from his original method and goals. As Monet spent more time in his studio, the desire for uniqueness and spontaneity that had motivated his earlier plein-air paintings was replaced by a preoccupation with cumulative effect. In fact, Monet observed that the individual canvases only acquired "their value by the comparison and succession of the entire series." [11] Monet's friend the critic Gustave Geffroy perceptively identified the artist's new concerns when he maintained that the Haystacks ensemble provided "a single record both of change itself and of the process of its pictorial registration." [12] The other series paintings that followed, equally subtle in color and lyrical in mood, affirmed the remarkable transformation from the bright and literal canvases that in the 1870s had made Monet and Impressionism synonymous with compositions of more determinedly decorative character. Each ensemble was the result of a fusion of perception and imagination, of emotional response and pictorial logic that simultaneously conveyed both the transitory and the

19. Claude Monet (1840–1926). *Two Haystacks*, 1891. Oil on canvas, 25½ x 39¼ in. The Art Institute of Chicago; Mr. and Mrs. Lewis L. Coburn Collection.

20. Monet's water garden at Giverny, 1950.

21. Claude Monet (1840–1926). *The Poplars*, 1891. Oil on canvas, 32¼ x 32⅛ in. The Metropolitan Museum of Art, New York; Bequest of Mrs. H. O. Havemeyer; The H. O. Havemeyer Collection.

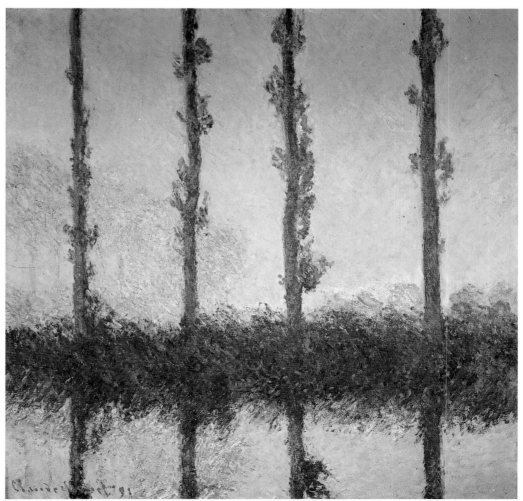

21

Monet began constructing his celebrated water garden in 1893. By introducing sluice gates at either end of the pond, he was able to control the flow of the water and regulate its temperature so that water lilies and other delicate plants could thrive there. Ever sensitive to the reflective properties of the pond's surface, Monet hired a gardener to clean the water and trim the lilies. Feathery willows and flowery Japanese cherry trees joined the existing poplars, and a small arched bridge at the narrow end of the pond provided a compositional mainstay for Monet's first series of canvases. The carefully orchestrated artifice of the ensemble inspired the artist's most private and contemplative works.

22

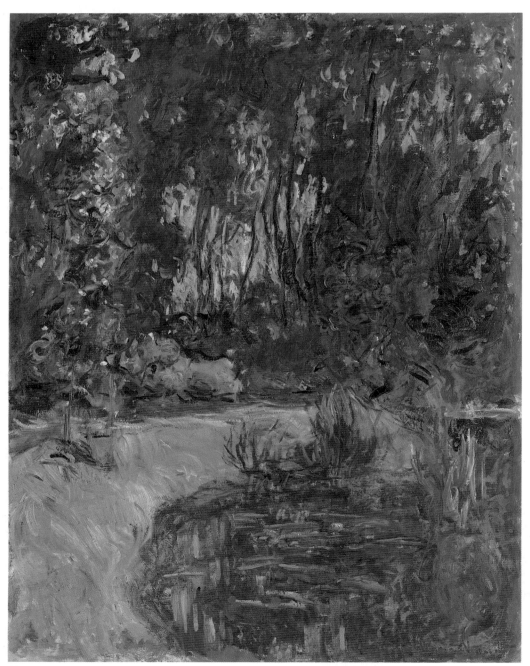

23

22. Claude Monet (1840–1926). *Flowering Arches—Giverny*, 1913. Oil on canvas, 30¾ x 36⅜ in. Phoenix Art Museum; Gift of Mr. and Mrs. Donald D. Harrington.

23. Claude Monet (1840–1926). *Water Garden at Giverny*, 1917. Oil on canvas, 46 x 32⅝ in. Musée de la Peinture et la Sculpture, Grenoble.

24. Claude Monet (1840–1926). *Wisteria*, 1919. Oil on canvas, 59½ x 78⅞ in. Allen Memorial Art Museum, Oberlin; Paul Rosenberg, Inc., R. T. Miller Fund.

constant aspects of nature. The 1891 exhibition of the Haystacks brought Monet his first popular success: all fifteen paintings were sold within a few days, marking the onset of a financial prosperity that would increase dramatically throughout the remainder of his long life. This prosperity enabled Monet to add to the property he had acquired at Giverny and to concentrate, after 1893, on creating a private world of contemplation and reverie that would manifest itself in the literally hundreds of works he painted after 1899. The nucleus of these paintings was his water garden (plate 20), a pond whose embellishment with exotic aquatic plants, including *nymphéas* ("water lilies"), and with a small arched bridge similar to those found in Japanese gardens stimulated his exploration of the ambiguous relationship between its atmospheric depth and its potential for translation into surface design. In the water garden, substance and reflection, light and shadow were so intermingled that the distinction of the real from the artificial and the objective from the subjective was no longer possible. The very character of the garden—hermetic and protected—was symbolic of the increasingly withdrawn and meditative quality of the paintings it inspired and of the artist who created them.

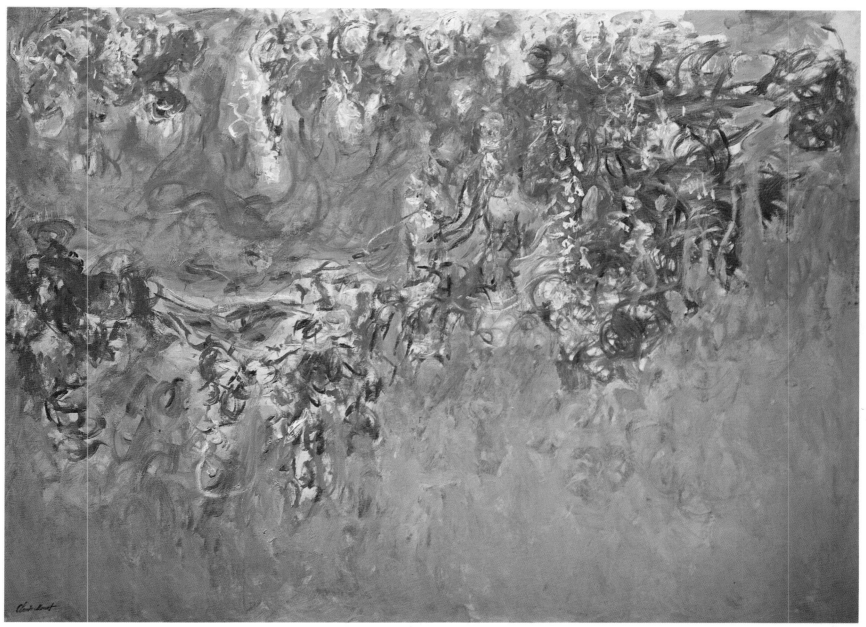

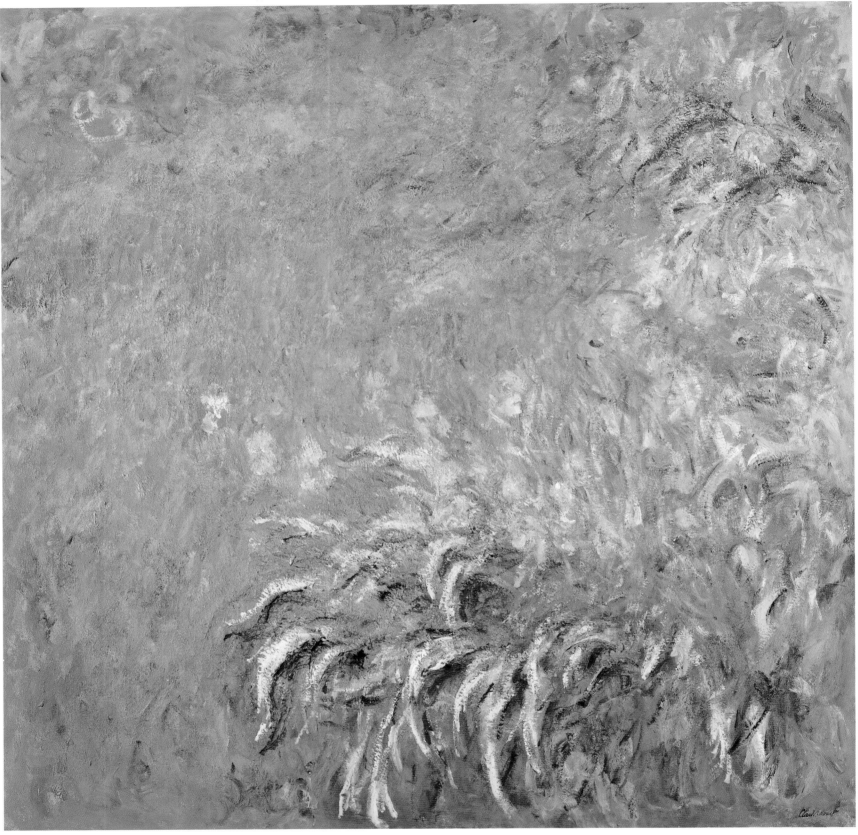

25

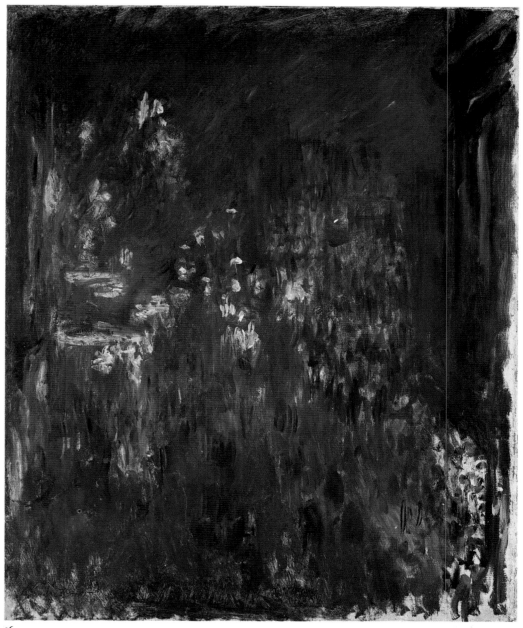

26

25. Claude Monet (1840–1926). *Iris at the Side of the Pond*, 1919–25. Oil on canvas, 79 x 79½ in. The Art Institute of Chicago.

26. Claude Monet (1840–1926). *View of London at Night*, c. 1918. Oil on canvas, 31½ x 25¼ in. Galerie Beyeler, Basel.

With rare exceptions, after 1909 Monet abandoned the views of London and Venice that had occasionally interrupted his almost continuous painting of the water garden in order to concentrate on the latter. He gradually enlarged the scale and altered the shapes of his canvases to accommodate the new pictorial effects he sought, often combining canvases to create diptychs or triptychs that stress the unity of their decorative vision.

In the later Water Lilies and related paintings (plates 22–25), Monet further enlarged the canvases, creating an expansiveness, a sense of unfolding change. In addition, he essentially stopped trying to create a formal structure. The paintings have no conventional focal point; the delicate forms seem wedded to the surface. By the time Monet executed these canvases, he was suffering from drastically deteriorating vision and could no longer distinguish the particulars of form or color, but his sensitivity to their nuances remained. The monumental scale of these late works and their replacement of the immediacy of vision with a remoteness at once physical and psychological offer testimony to the remarkable artistic ambition that had brought Impressionism's most inspired master from a modest naturalism to the threshold of Symbolism and abstraction.

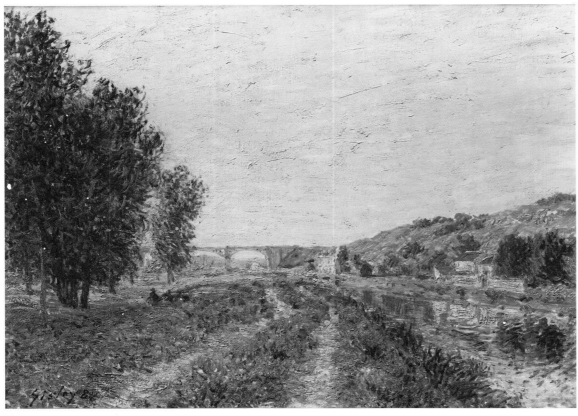

27

27. Alfred Sisley (1839–1899). *Landscape near Moret*, 1884. Oil on canvas, 21⅜ x 28⅞ in. Art Gallery of Ontario, Toronto; Purchase, 1932.

28. Alfred Sisley (1839–1899). *Seine at Verneuil*, 1889. Oil on canvas, 26 x 32 in. The Art Museum, Princeton University; Henry and Rose Pearlman Foundation, Inc.

ALFRED SISLEY

While Monet's and Renoir's reputations grew steadily in the 1890s and while even Pissarro began to enjoy a measure of critical and financial success, the situation of Alfred Sisley grew more desperate. Durand-Ruel had not managed to sell one of the paintings from his solo show in 1883, prompting Sisley to turn to Petit in a futile attempt to break the cycle of poverty that continued to dominate his life while his colleagues began to prosper. His work had progressed steadily in the 1880s (plates 27, 28): his sensitivity to atmospheric effects grew more acute, and he seems to have been untroubled by the crises of style that plagued so many of his contemporaries during those years. The only one of the Impressionists who did not turn to the painting of the human figure, Sisley remained committed to pleinairism with an almost religious fervor, which he communicated to a critic in touching language that summarized both the conviction and the limitations of his painting:

> The sky cannot be just a background. It contributes, on the contrary, not only to give depth by its planes (the sky has planes like the earth), it also gives movement by its form, by its arrangement, in relation to the effect or composition of the picture. Is there one thing more magnificent, more changing, than that which occurs frequently in the summer, I mean blue sky with beautiful erring clouds? What movement, what allure is not there? . . . It exalts, it pulls you along. Another sky, later in the evening. Its clouds lengthen, take often the form of furrows, movements which seem to be immobilized in the middle of atmosphere, and little by little disappear, absorbed by the setting sun. This one, more tender, more melancholic; it has the charm of things which are going away, and I love it particularly.[13]

While Sisley's 1897 exhibition at Petit's was well received, it was only in 1899, through the publication of a series of articles by Geffroy, that he began to attain critical recognition. Sadly, his death later that year prevented him from reaping the financial benefits that would accrue in the wake of the new prestige accorded his work.

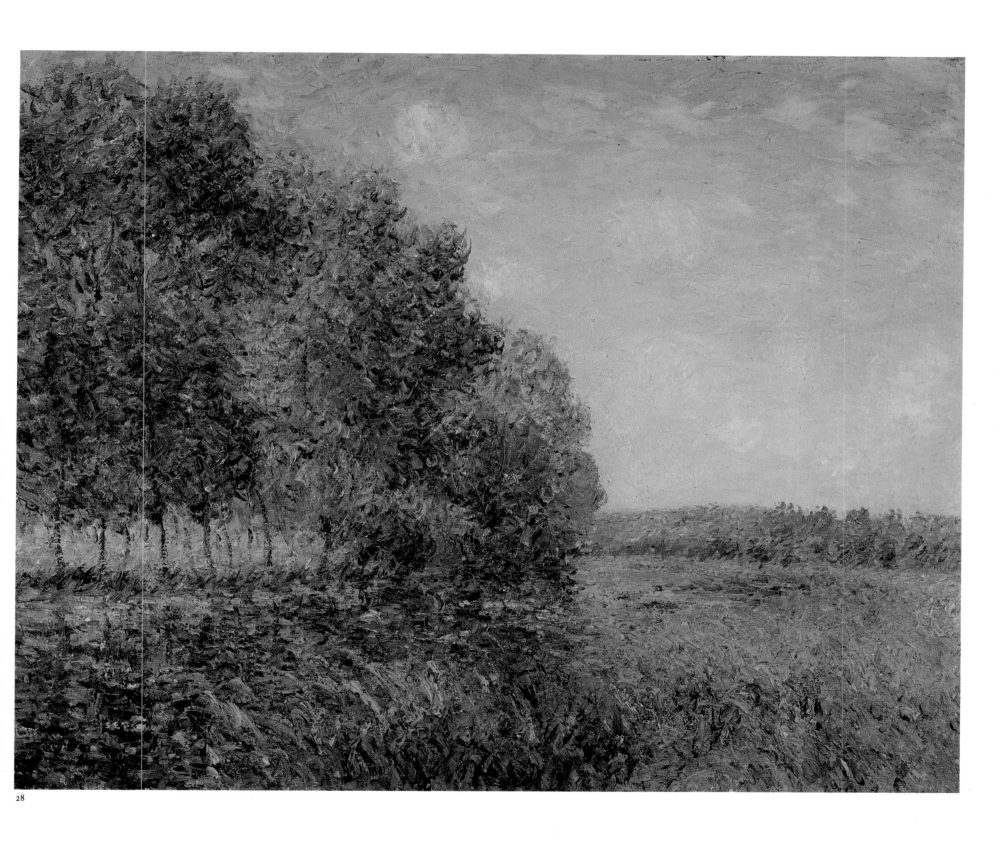

28

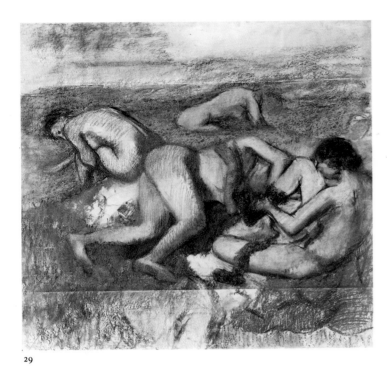

29

*Degas rarely depicted outdoor bathing scenes, prefer-
ring to confine his female subjects within artificially lit
chambers. His relatively late interest in portraying fig-
ures in landscape—as in this monumental pastel—
was likely stimulated by the late works of Renoir and
Cézanne. As was his habit, Degas executed this pastel in
his studio. Using tracing paper that he later mounted on
board, he adapted motifs from earlier studies of bathers
and probably combined them with more recent studies
done from the model. The result is a composition of de-
ceptive informality. By daringly introducing separate
strips pasted onto the top and bottom of the central ele-
ment, Degas called the viewer's attention to the step-by-
step process of the work's fabrication. Stressing the
rough grain of the pastel and adding touches of char-
coal, he achieved a strength and physicality not gener-
ally associated with that delicate medium.*

29. Edgar Degas (1834–1917). *The Bathers*, 1895–1905.
Pastel and charcoal on tracing paper pieced and mounted
on board, 41⅛ x 42½ in. The Art Institute of Chicago;
Gift of Nathan Cummings.

30. Edgar Degas (1834–1917). *The Letter*, 1888–92. Pas-
tel on paper, 19¾ x 23¼ in. Galerie Beyeler, Basel.

31. Edgar Degas (1834–1917). *Woman Having Her Hair
Combed*, c. 1885. Pastel on paper, 29⅛ x 23⅞ in. The
Metropolitan Museum of Art, New York; Bequest of
Mrs. H. O. Havemeyer, 1929; The H. O. Havemeyer
Collection.

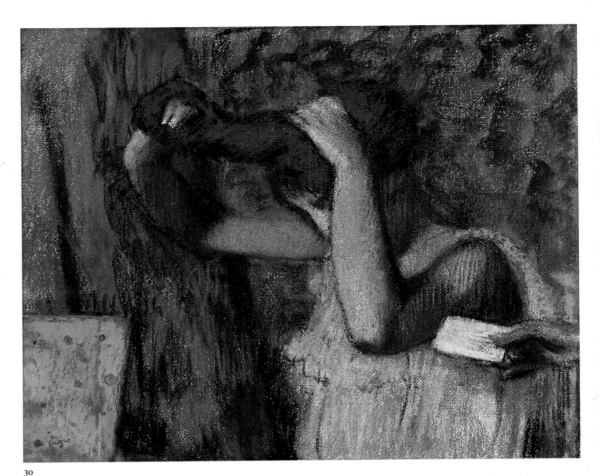

30

EDGAR DEGAS

Degas's interest in documenting diverse aspects of contemporary urban experience was
more intense than that of his fellow Impressionists, and it impelled him to frequent
places unknown to most of his peers. His fascination with physical activity—already
evident in his countless studies of dancers (plate 32), of jockeys and horses, of circus
performers—expanded in the 1880s to include such unlikely subjects as the laborers in
oppressive steam-filled laundries (plates 33, 35), who had provided the raw material for
Emile Zola's popular Naturalist novel *L'Assommoir* (The Dram Shop) of 1876–77.
Degas's own scrupulous naturalism, like that of his literary counterpart, prompted him
to haunt these dreary establishments, studying the equipment and carefully observing
the techniques and body language of the female workers. Whether they are engrossed in
their tasks or stealing a moment of relaxation, the intense physicality of their experi-
ence is uncannily conveyed in terse and telling designs.

In the 1880s Degas also frequently turned to the female nude, a subject that allowed
him to combine his penchant for the classical tradition and his commitment to modern
life. In hundreds of pastels he introduced viewers to the private world of the Parisian
brothel (plates 31, 34). Degas's nudes—for the most part engaged in bathing and
grooming—are far removed from the icy aesthetics of Jean Auguste Dominique Ingres
or the romantic sensuality of Eugène Delacroix. Their absorption in personal rituals,
the strident colors of their gas-lit rooms, and the daring intimacy of the formal concep-
tion proclaim a harsh modernity that shocked even sophisticated viewers when these
works were shown at the last Impressionist group exhibition, in 1886.

In the years that followed, Degas became more isolated from his former colleagues.
Unlike Monet, Pissarro, and Renoir, he manifested no interest in showing his work after

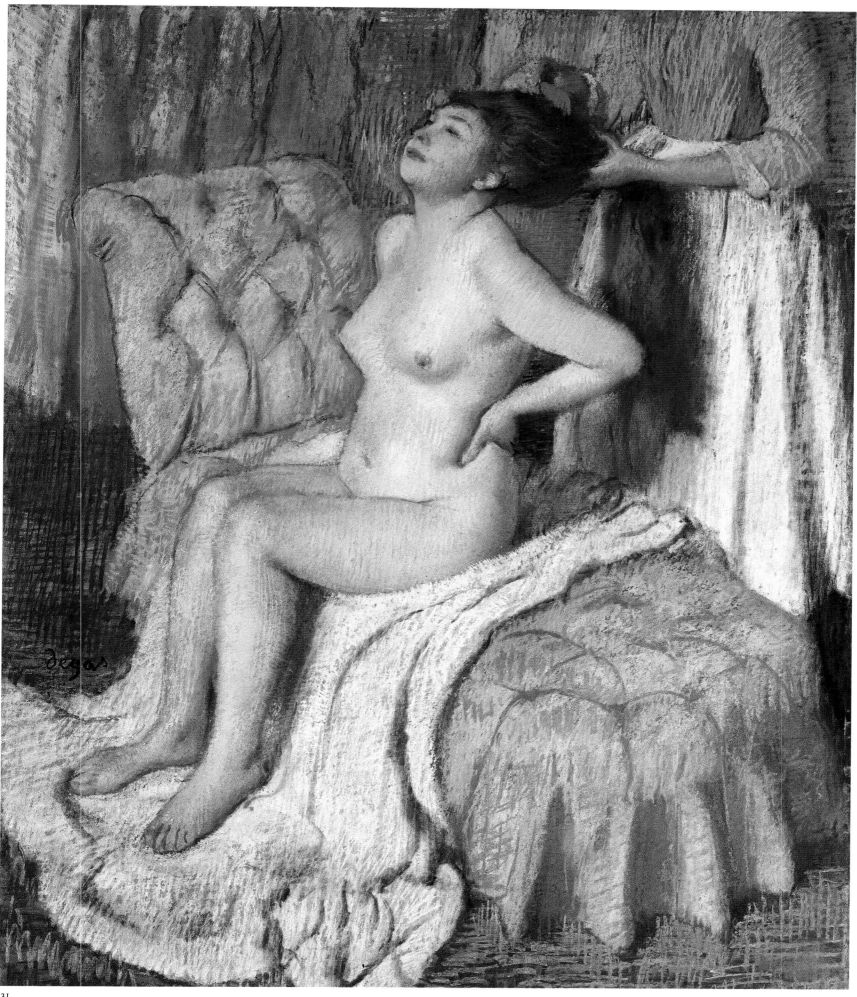

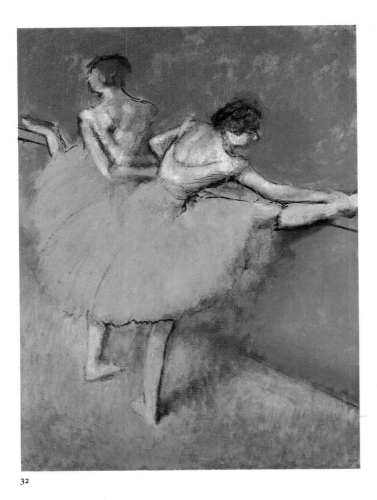

32

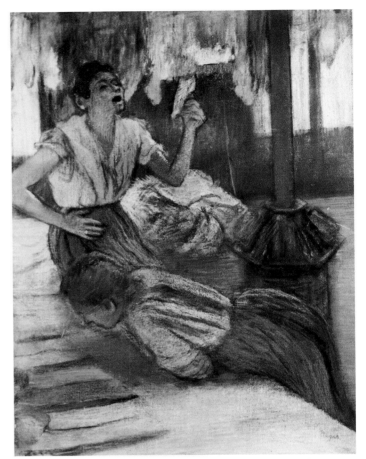

33

32. Edgar Degas (1834–1917). *Dancers at the Bar*, 1888. Oil on canvas, 51 x 38 in. The Phillips Collection, Washington, D.C.

33. Edgar Degas (1834–1917). *Scene in a Laundry*, 1884. Pastel on paper, 24¾ x 17⅝ in. Glasgow Museums and Art Galleries; The Burrell Collection.

34. Edgar Degas (1834–1917). *The Morning Bath*, c. 1883. Pastel on paper, 27¾ x 17 in. The Art Institute of Chicago; Potter Palmer Collection.

35. Edgar Degas (1834–1917). *The Ironers*, c. 1884. Oil on canvas, 32¼ x 29½ in. Norton Simon, Inc., Foundation, Pasadena, California.

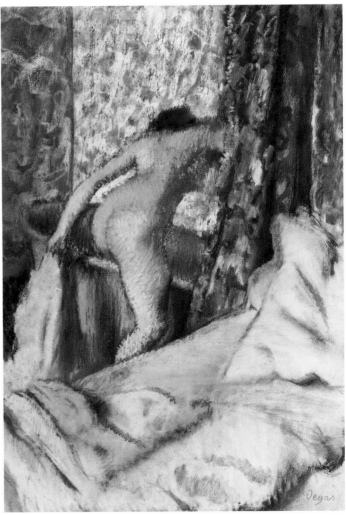

34

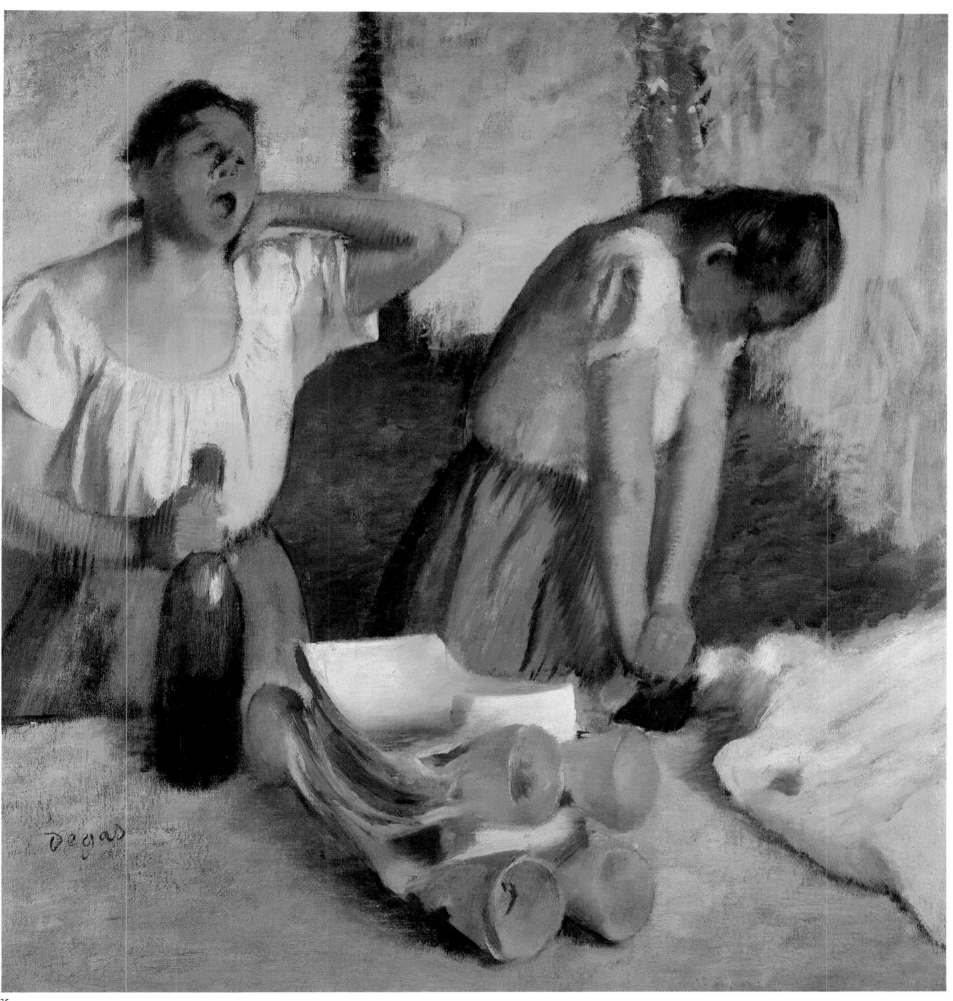

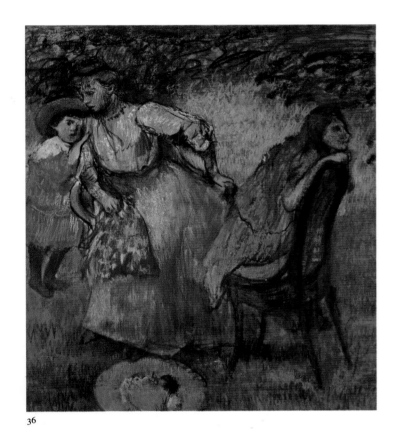

36

1893. Although expenses connected with his brother's bankruptcy had consumed a substantial part of his inheritance, Degas was not dependent on sales for survival, and he jealously guarded his work. His failing vision had so deteriorated that he was totally blind in one eye, making it virtually impossible for him to produce anything but large-scale pictures. Still driven by his need to work, he turned to sculpture and to pastel (plates 30, 36).

In the late pastels Degas returned to familiar subjects—primarily bathers and dancers. Relying on his visual memory and a storehouse of images in his studio, Degas intensified his colors and replaced the elegant contours of his earlier pastels with strong, often coarse lines. His placement of shapes had never been more arbitrary, his colors more expressive, or his sense of surface rhythm more urgent than in these works. The innovative style of Degas's late pastels grew out of his distinctly experimental approach to that heretofore delicate medium and to art in general. Even today, the technical complexity of his pastels—the way the pastels were applied, the combinations of substances that were used, and the nature of the fixatives employed—defy explanation. If Degas's attitude toward the graphic media was unorthodox, it was resoundingly progressive. His enthusiasm for pastel, which had traditionally been viewed as less important than painting, was prompted less by his handicap than by a fundamental desire to expand his creative horizons through the radical investigation of any medium's aesthetic potential.

36. Edgar Degas (1834–1917). *Madame Alexis Rouart and Her Children*, c. 1903. Pastel on paper, 62⅞ x 55⅝ in. Musée du Petit Palais, Paris.

37. Paul Cézanne (1839–1906). *Gardanne*, 1885–86. Oil on canvas, 31½ x 25¼ in. The Metropolitan Museum of Art, New York; Gift of Dr. and Mrs. Franz H. Hirschland, 1957.

38. Paul Cézanne (1839–1906). *Millstone in the Park of Château Noir*, 1892–94. Oil on canvas, 28¾ x 36¼ in. Philadelphia Museum of Art; Mr. and Mrs. Carroll S. Tyson Collection.

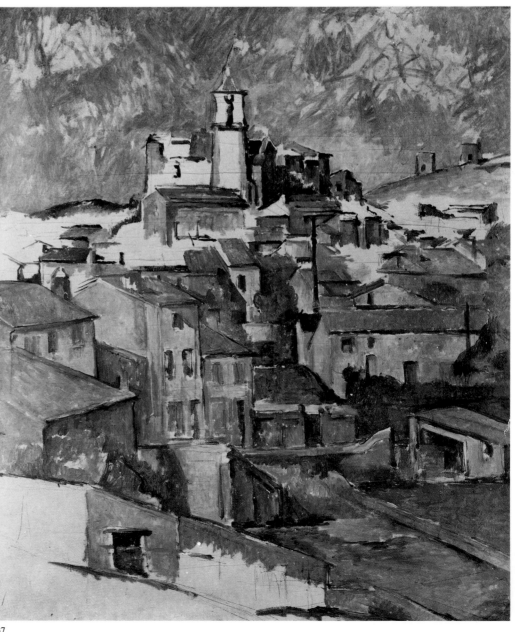

37

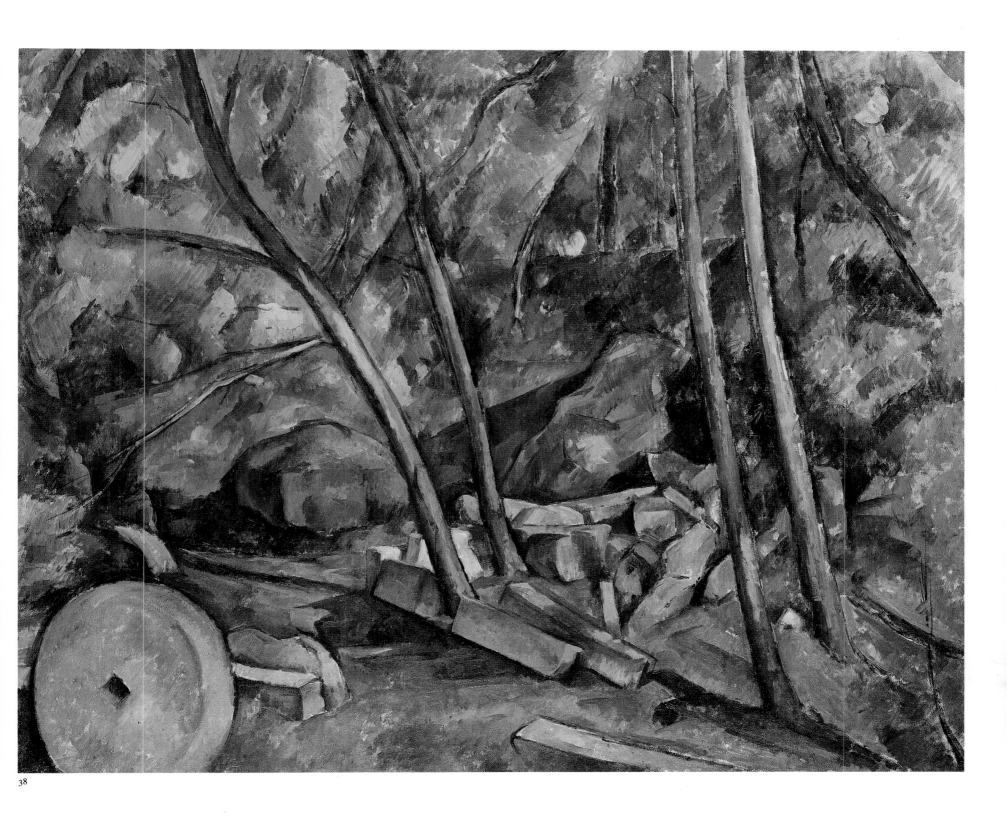

38

PAUL CÉZANNE

As one of the original Impressionists, Paul Cézanne had been so adversely affected by the critical attack on his contributions to the 1874 and 1877 exhibitions that he never again showed with the group. Repeatedly rejected by Salon juries in the 1880s, he occasionally left canvases with the paint seller Julien Tanguy (affectionately nicknamed *père* by his clients), who also displayed the work of other Impressionists in his establishment. By the mid-1880s, this unpretentious shop in Montmartre had become a mecca for younger artists and for collectors who had grown to appreciate the austere formal power of Cézanne's still-life, figure, and landscape compositions. Among this

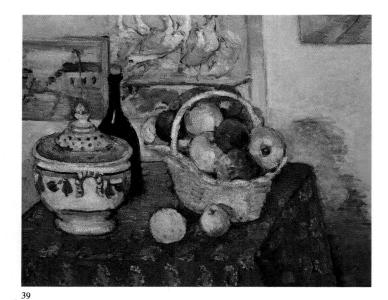

39

group was Paul Gauguin, an admirer of the older artist, whom he had met but once in 1881. Gauguin had retained one precious Cézanne still life from the small collection he had been forced to sell in order to maintain himself and his family after his decision to become a full-time painter. He transmitted his reverence for and understanding of the older master to such younger disciples as Emile Bernard and Maurice Denis, on whom Gauguin exerted considerable influence (see chapter 5), and they, in turn, helped to establish the greater recognition of Cézanne after 1900.

Cézanne was the first Impressionist to become dissatisfied with the superficial recording of atmospheric effects. When he turned to nature, it was not simply to depict the objects that occupied a given site but rather to consider relationships among those objects. Cézanne's obsession with the act of seeing prompted him to paint slowly, in marked contrast to his Impressionist colleagues, so that his canvases are more records of his hesitations than spontaneous affirmations of the optical sensations that had inspired them. His rigorous intellect and need for order found the Impressionist approach too simplistic: "Everything we see surely melts away? Nature is always the same but nothing of it endures. . . . Our art ought to give it that sense of duration with the elements, the appearance of all its changes. It ought to make us feel it is eternal." [14]

When the personal dissatisfactions and aesthetic differences that beset the Impressionists reached a crisis in the early 1880s, Cézanne retreated from Paris to his home near Aix-en-Provence. The vast Provençal landscape, so different from the domesticated spaces of the villages surrounding the capital, offered an expanded field of shifting planes—mountains, sky, and sea—illuminated by an intense, all-pervasive light. These dramatic physical conditions compelled Cézanne to undertake a more radical investigation of the mechanics of seeing than had been attempted by any of his contemporaries. If the Impressionists had allowed the site to dictate their composition, refusing to interfere with the immediacy of their optical sensations, Cézanne evolved a more deliberate approach, extracting forms from what he saw and conveying their plastic essence in a network of brushstrokes that ultimately became an independent structure parallel to observed reality rather than a simple description of it.

As Cézanne sought the means to convey his shifting optical sensations and still maintain pictorial order, he effaced the textural distinction of objects and arrived at a homogeneous painted surface. The overlapping patches of his paint brought forms to the surface of the canvas, while the modeling effect of the brushwork simultaneously pushed them back. The result was a vibrant tension between the physical surface of the canvas and the image.

From the late 1880s on, Cézanne made an effort to develop as a figure painter, doing numerous portraits, studies of card players, and groups of bathers. If his earlier male bathers had been inspired, at least in part, by a recollection of boyhood experiences, his new female bathers had their roots in a more complex and heroic tradition that included painters he venerated: Titian, Rubens, and, above all, Poussin. Cézanne's knowledge of the nude was limited: his art training had been sporadic, and the puritanical atmosphere of Aix did not encourage him to work with live models. Using drawings and photographs, adapting motifs from admired old masters, and combining these with elements of landscape both observed and imagined, he constructed figural ensembles of unparalleled monumentality (plate 41). At times his bathers almost resemble tribal sculpture in their powerful simplicity; at other times their massive limbs assume the character of the natural setting they inhabit. These heroic giants are as far removed from the cosmetic charms of the Salon nude as from the eclectic traditionalism of Renoir's bathers. They represent the culmination of Cézanne's thirty-year struggle to integrate classical values with modern sensibility. His first bathers had prompted an unusually perceptive observer at the Impressionist show of 1877 to characterize the

39. Paul Cézanne (1839–1906). *Still Life with a Tureen*, c. 1877. Oil on canvas, 25⅝ x 32 in. Musée d'Orsay, Paris.

40. Detail of plate 39.

artist as "a Greek of the great period." [15] Thirty years later, Maurice Denis, recognizing the complex dialogue of old and new in Cézanne's work, described it as "the climax of the classic tradition and the result of the great crisis of liberty and illumination which rejuvenated modern art. He is the Poussin of Impressionism." [16] Cézanne himself claimed that his goal was to "vivify Poussin in contact with Nature." [17]

Cézanne was fifty-six years old when, in 1895, he accepted the invitation of an enterprising young dealer, Ambroise Vollard, to show in his Paris gallery. This large retrospective, which included 150 paintings, proved a revelation to artists and critics who previously had seen only a few of Cézanne's works at a time. It inspired Gustave Geffroy to provide an appraisal of the artist's contribution to modern painting as well as a sensitive interpretation of his motivations:

> He loved [painting] and he loved nothing but this, to the point of remaining for hours and hours, days and days, before the same spectacle, determined to penetrate within it, to understand it, to express it. . . . Any canvas of Cézanne, simple and calm in appearance, is the result of desperate struggles, of a fever of work and of a patience of six months. . . . One is in the presence of a unified painting, which seems all of a piece and which is executed over a long period of time, in thin layers, which has ended up by becoming compact, dense. . . .[18]

In his last years, which were marked by worsening health, Cézanne often despaired at his failure to realize his goals: "Now being old, nearly seventy years, the sensations of color, which give light, are for me the reason for the abstractions that do not allow me to cover my canvases entirely or to pursue the delimitation of objects where their points of contact are fine and delicate; from which it results that my image or picture is incomplete." [19] In his search for completeness, Cézanne aspired to create a self-reflective pictorial space rather than a simulacrum of nature. By liberating painting from the exclusivity of representation and by emphasizing the constructivist aspects of picture-making, he carried Impressionism beyond its self-imposed limitations and provided the heroic model that would inspire and nurture the first generation of abstract painters (see chapter 7).

The long-delayed recognition of Cézanne coincided with the increasing popularity of Renoir and Monet. The publication of two sympathetic histories of Impressionism by Georges Lecomte (1892) and Gustave Geffroy (1894) contributed to a positive critical reappraisal of the movement that would shortly culminate in its broad acceptance. Enthusiasm for Impressionism spread beyond France with the publication of studies in Germany by Julius Meier-Graefe (1902) and the appearance of two books in English by Camille Mauclair (1903) and W. Dewhurst (1904). The surviving Impressionists saw their techniques superficially assimilated and grafted onto more conventional forms of painting as the movement acquired the status of an accepted, even official style. Ironically, as Impressionism moved toward respectability, the reaction against it that had been mounting since the 1880s was taking the form of increasing criticism from younger painters. Indictment of its empirical approach and its lack of concern with idea or spirit had persisted in the late 1880s and '90s, coming to a head in the early years of the next century. In those decisive years of early modernism, when aesthetic positions shifted with unaccustomed rapidity, the modifications of Impressionist technique effected by Renoir were to have negligible consequences beyond his own stylistic development, and the remarkable evolution of Monet's lyrical and decorative Impressionism was to be obscured by contemporaneous preoccupation with analysis and construction. The prestige that Cézanne enjoyed among the artists of the younger generation was largely due to their recognition of his long struggle to radically transform the concerns and procedures of Impressionism. The homage paid to Cézanne, while partially acknowledging the role Impressionism had played in his development, deflected attention

41. Paul Cézanne (1839–1906). *The Large Bathers*, 1900–1906. Oil on canvas, 50⅝ x 76⅝ in. The National Gallery, London.

from the movement's genuine achievements. If the term Impressionism, which had been conceived in derision of the artists' technique, neither pleased them nor accurately characterized their individual approaches, it did succeed in identifying that technique as radical and modern. Unorthodox color and irregular brushwork insistently called the viewer's attention to the processes of painting and to its two-dimensional character, which the Impressionists' conservative peers had worked hard to disguise. Moreover, by the mid-1880s the Impressionists had moved irrevocably from naturalistic observation to simplification of design and emphasis on a unified surface. Indeed, it can be argued that it was the strength and promise of Impressionism rather than its weakness that prompted the reformatory activities of the young artists who emerged in those years, as they themselves later affirmed.

When the Impressionists' work was finally welcomed into the mainstream of French art by the end of the century, it had arrived there by virtue of a series of courageous decisions that, for the most part, ignored the official system. The Impressionists' determination to exhibit independently, whether in group or one-man shows, was a way of attracting public attention, for better or worse. The group label may have seemed a stigma to some, but it eventually proved advantageous. Before the beginning of the Impressionist adventure, the dealers and critics who supported various movements were marginal participants in the activities of an art world largely controlled by bureaucrats. With the gradual rise to prominence of the Impressionists, their supporters became the shapers of popular taste, setting up the framework of the art world we know today.

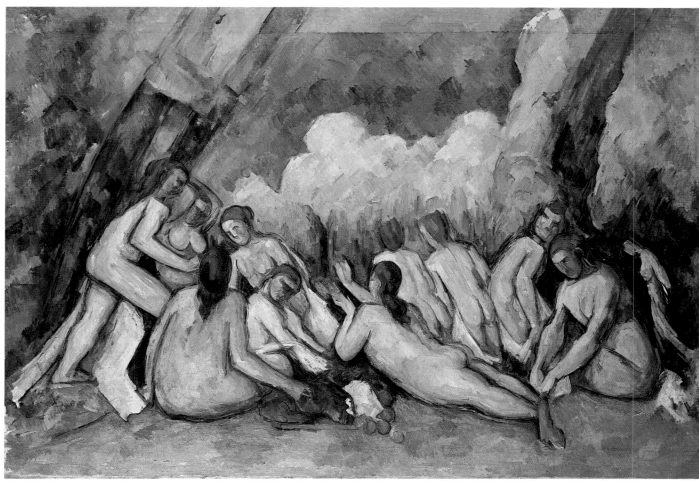

41

American Impressionism

Before Durand-Ruel's exhibitions in Boston (1883) and New York (1886) introduced large numbers of Americans to Impressionism, their knowledge of the style was extremely limited. Reports about Impressionism from visitors to France were often negative. One of the earliest American painters to study the work of the Impressionists first-hand was the landscapist George Inness, who probably saw their initial group show in 1874. The experience left him with an antipathy to the style that lasted a lifetime. Two years later the novelist and art lover Henry James reviewed the second Impressionist show for the *New York Tribune*, finding it "interesting" but professing a preference for the more traditional art of the museums.

It would be fascinating to know whether the cultivated and socially prominent Bostonian visited the Pennsylvania-born painter Mary Cassatt while he was looking at Impressionist painting in Paris. Similar family backgrounds and a passion for European culture would certainly have provided them with a common ground for conversation. A permanent resident of Paris since 1871, Cassatt had exhibited in the Salon the year that Impressionism made its historic debut. Her paintings were admired by Degas, and he invited her to exhibit with his colleagues in 1879. Thereafter, she participated in all but one of the remaining group shows, gaining recognition that culminated in the inclusion of her work in the Musée du Luxembourg in 1894. Yet even after Cassatt had achieved international stature as a painter, her own countrymen still failed to acknowledge her importance. The artist's heartfelt belief in her work and that of her colleagues stimulated her unwavering efforts to create an audience for Impressionism in America by advising numerous American collectors, and her counsel helped shape some extraordinary collections. Unfortunately, her influence on patrons was not matched by an impact on painters. Cassatt refused to take on any pupils herself, but she did encourage the young Americans who journeyed to France in increasing numbers to avoid the academies and study with such masters as Pissarro and Armand Guillaumin.

In the 1880s it was painters such as John Singer Sargent, Theodore Robinson, Childe Hassam, and Maurice Prendergast who were among the American vanguard actively

seeking the company and advice of the Impressionists. Easily the most celebrated was the expatriate Sargent, who was the first to absorb the lessons of Impressionism. Having attended the first group show in 1874, he sought out Monet, bought one of his canvases, and struck up an enduring friendship. He was a frequent visitor to the artist's home in Giverny, and in 1887 he depicted Monet working there on a landscape (plate 45). The rapid, summary brushwork and the immediacy of the image suggest Sargent's assimilation of the more accessible aspects of the French artist's technique, as does *A Morning Walk* (plate 46), which depicts Sargent's sister in a pose that recalls several earlier works by Monet. Robinson, whose eight-year stay in France (1884–92) reinforced his earlier attraction to Impressionism, moved to Giverny in 1887. There he soon became an intimate of Monet, painting the surrounding landscape with a freedom of brushwork and a chromatic range that he never equaled in his subsequent American works (plate 47). Like Robinson, Childe Hassam had been converted to Impressionism during a visit to France. After his return to the United States in 1889, he adapted the lessons he had learned from studying the Impressionist views of Paris to the squares of New York and the New England countryside, painting numerous compositions that are equally indebted to Monet and Pissarro (plate 48). Maurice Prendergast, who arrived in Paris in 1890 when Impressionism was already being challenged by the Symbolist writers and painters, displayed a receptiveness to the new concern with autonomous design, flat brushwork, and more explicitly decorative, as opposed to atmospheric, effects (plate 50).

With the establishment of a native Impressionist school in the 1890s, popular acceptance of the once-radical style followed. Paintings by American Impressionists figured prominently in the various national and international expositions held in the United States during the first two decades of this century. Indeed, the celebrated Panama-Pacific Exposition of 1915 offered a glittering showcase of American and foreign works, which enabled visitors to measure the achievements of the native exponents of the style against those of their historic predecessors.

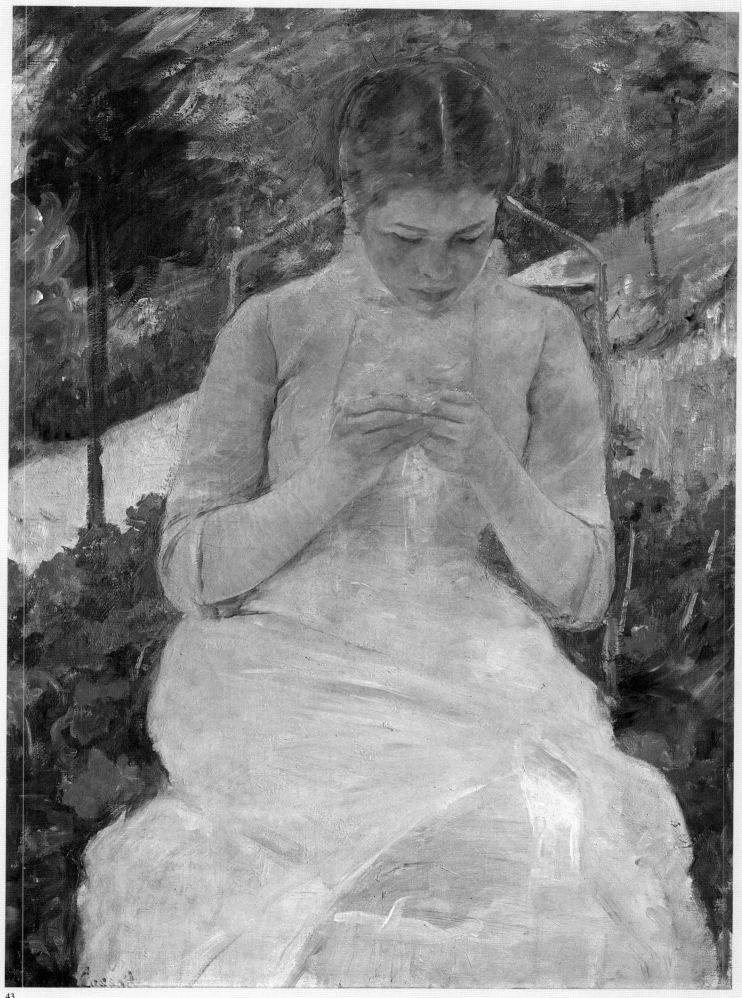

43

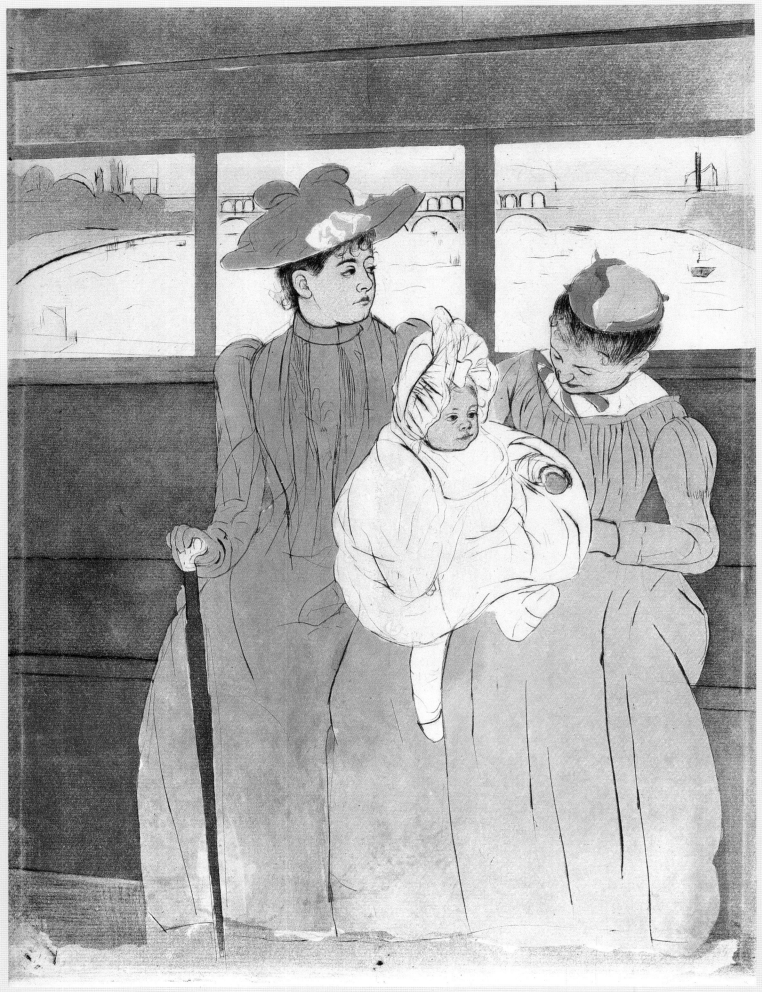

44

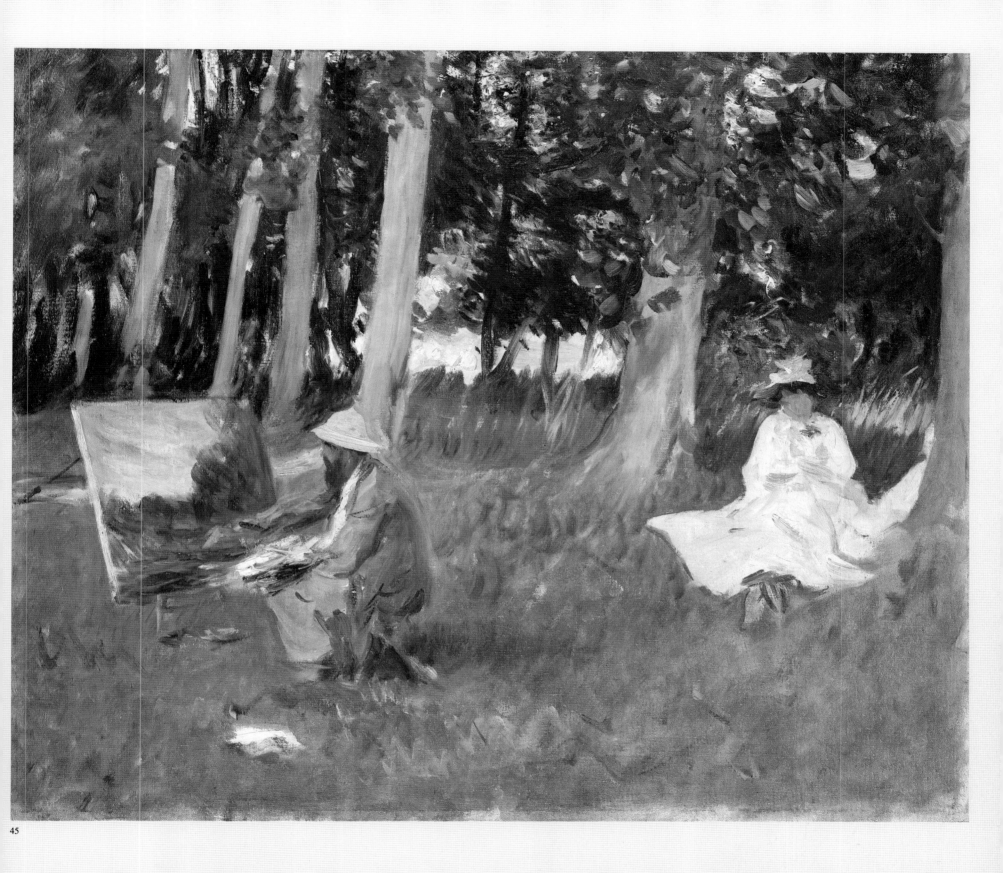

45

SEE PAGES 52–53:

42. Mary Cassatt (1845–1926). *Lydia Leaning on Her Arms, Seated in a Loge*, c. 1879. Pastel on paper, 21⅝ x 17¾ in. The Nelson-Atkins Museum, Kansas City, Missouri.

43. Mary Cassatt (1845–1926). *Young Woman Sewing in a Garden*, 1886. Oil on canvas, 36 x 25½ in. Musée du Louvre, Paris; Antonin Personnaz Collection.

44. Mary Cassatt (1845–1926). *In the Omnibus*, 1891. Color print with drypoint, softground, and aquatint, 14¹⁵⁄₁₆ x 10½ in. National Gallery of Art, Washington, D.C.; Rosenwald Collection.

45. John Singer Sargent (1856–1925). *Claude Monet Painting at the Edge of the Wood*, 1887. Oil on canvas, 21¼ x 25½ in. The Tate Gallery, London.

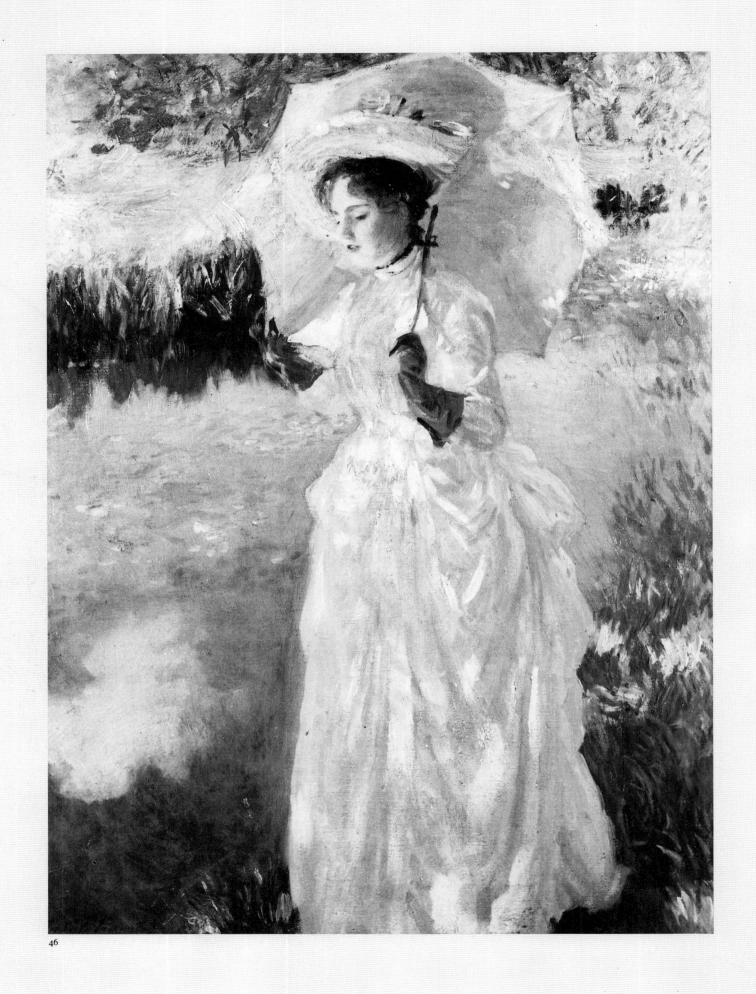

46

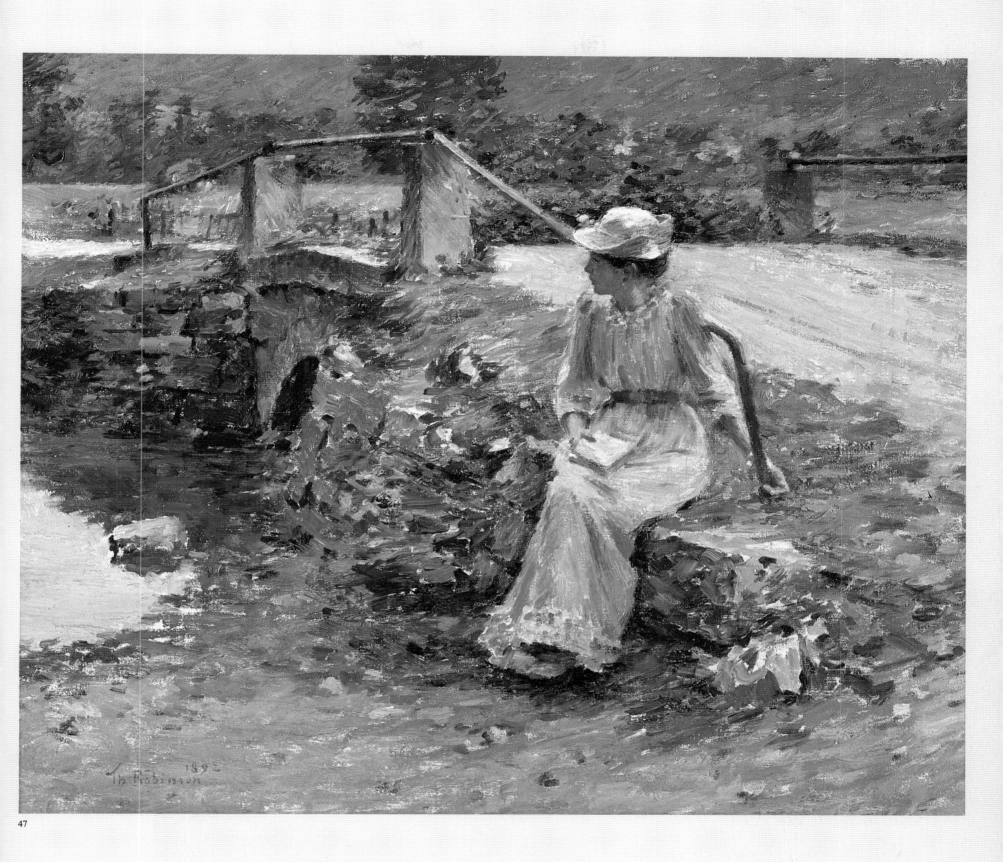

47

46. John Singer Sargent (1856–1925). *A Morning Walk*, c. 1888. Oil on canvas, 26⅜ x 19¾ in. The Ormond Family, England.

47. Theodore Robinson (1852–1896). *La Débâcle*, 1892. Oil on canvas, 18 x 22 in. Scripps College, Claremont, California; Gift of General and Mrs. Edward Clinton Young, 1946.

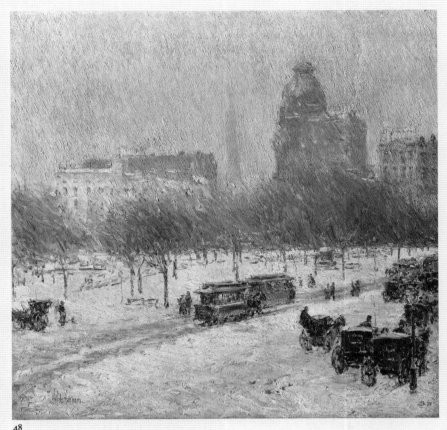

48

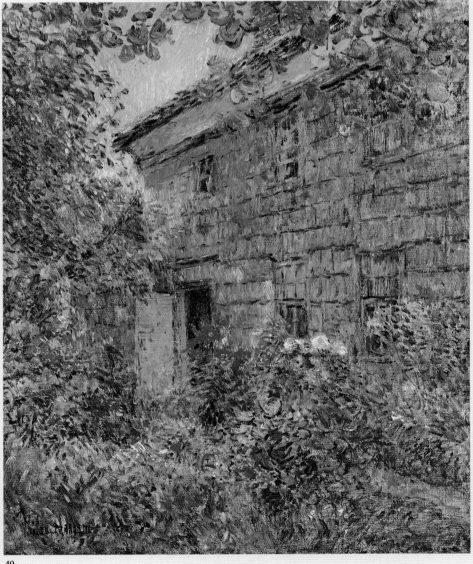

48. Childe Hassam (1859–1935). *Winter in Union Square*, 1890. Oil on canvas, 18½ x 18 in. The Metropolitan Museum of Art, New York; Gift of Miss Ethelyn McKinney, 1943, in memory of her brother, Glenn Ford McKinney.

49. Childe Hassam (1859–1935). *Old House and Garden, East Hampton, Long Island*, 1898. Oil on canvas, 24¹⁄₁₆ x 20 in. Henry Art Gallery, University of Washington, Seattle; Horace C. Henry Collection.

50. Maurice Prendergast (1859–1924). *Square of San Marco, Venice*, 1899. Watercolor and pencil on paper, 19¾ x 14¼ in. Collection of Alice M. Kaplan.

49

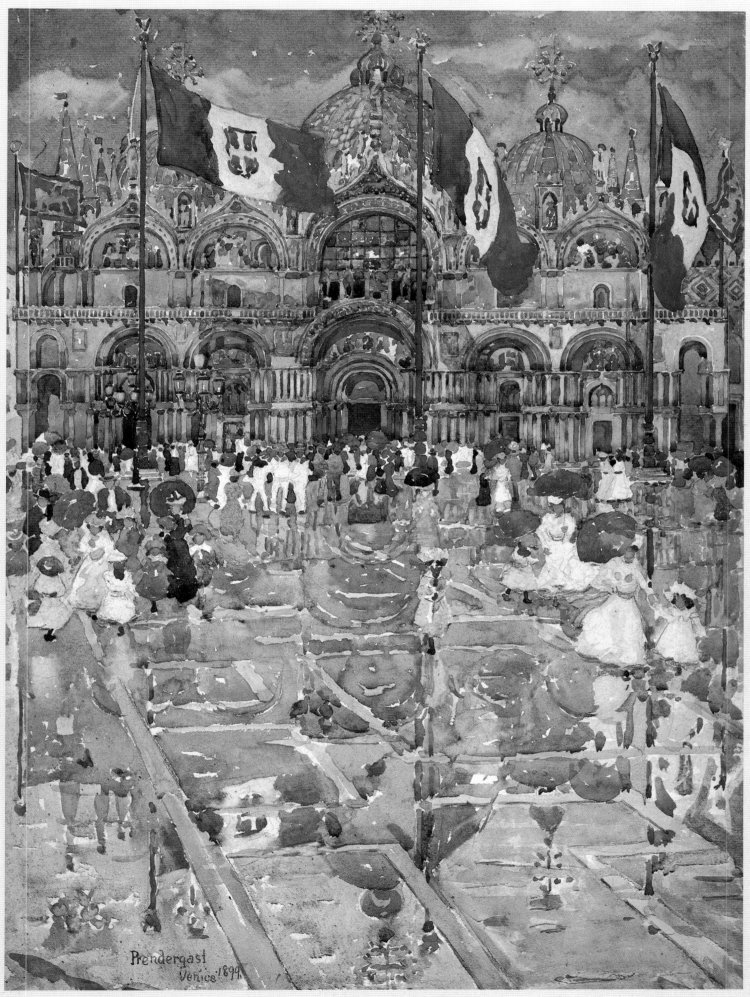

59

2 NEO-IMPRESSIONISM
Deliberate and Constant Technique

If these painters . . . have adopted this name of Neo-Impressionism, it was not in order to fawn upon success . . . but rather to render homage to the effort of precursors and to indicate that beneath the divergency of method, they shared a common goal: light and color. *It is in this sense that the word* Neo-Impressionists *should be understood, for the technique these painters use has nothing to do with that of the Impressionists: just as much as that of their predecessors is one of instinct and instantaneity, to the same degree theirs is one of reflection and permanence.*

Paul Signac, 1898

THE conservative admission policies that dominated the Salons had been liberalized somewhat in the 1860s and '70s, but an unexpected resurgence of orthodoxy resulted in the rejection of an unprecedented number of artists by the jury in 1884. In an effort to redress this situation, more than a hundred of the *refusés* decided to form the Groupe des Artistes Indépendants. Their action was inspired both by the historic example of the Salon des Refusés of 1863 and by the more recent activities of the Impressionists. When the group unveiled its first exhibition in a huge temporary structure in the Tuileries Gardens in May 1884, the number of participants had reached 400, and the variety of aesthetic concerns and styles was striking. Most of these artists were young men like Georges Seurat and Paul Signac, who had recently discovered Impressionism. Some, however, like the reclusive Odilon Redon, were mature artists whose work had little in common with either the mainstreams of academic painting or Realism.

Signac had been painting for just two years when he helped organize the Indépendants' exhibition. By his own admission, he had modeled his compositions after works by Monet, whose guidance he sought in a letter: "I have been following the wonderful path you broke for us. I have always worked regularly and conscientiously, but without advice or help, for I do not know any impressionist painter who would be able to guide me, living as I am in an environment more or less hostile to what I am doing. And so I fear I may lose my way and I beg you to let me see you, if only for a short visit." [1] Unlike Pissarro, who selflessly encouraged younger painters, Monet was a loner who believed little in theory and even less in the possibility of improvement through study with a master. We do not know whether he ever replied to Signac's request. The latter was not easily discouraged, however, and he began to frequent the studio of a less prominent Impressionist, Armand Guillaumin. Sometimes working in the older painter's company, Signac turned to landscape and produced a group of lively Paris scenes (plate 52), painted with the vivid palette and broad brushwork associated with Impressionism.

In the sprawling Indépendants' exhibition, at which he showed some of these landscapes, Signac was attracted to a large and unusual canvas of bathers, which he described as having been executed

51. Detail of plate 55.

61

52

52. Paul Signac (1863–1935). *The Louis-Philippe Bridge on the Seine*, 1884. Oil on canvas, 13 x 18 in. Mr. and Mrs. Ludvig Neugass, New York.

53. Armand Guillaumin (1841–1927). *The Quai St. Bernard in Springtime, Paris*, c. 1880. Oil on canvas, 23⅝ x 31¾ in. Private collection.

54. Pierre Auguste Renoir (1841–1919). *Oarsmen at Chatou*, 1879. Oil on canvas, 32⅛ x 39⅝ in. National Gallery of Art, Washington, D.C.; Gift of Sam A. Lewisohn.

SEE PAGES 64–65:

55. Georges Seurat (1859–1891). *Bathers at Asnières*, 1884. Oil on canvas, 79⅛ x 118⅛ in. The National Gallery, London.

. . . in great, flat strokes, brushed one over the other, fed by a palette composed, like Delacroix's, of pure and earthy colors. By means of these ochres and browns the picture was deadened and appeared less brilliant than the works of the impressionists painted with a palette limited to prismatic colors. But the understanding of the laws of contrast, the methodical separation of elements—light, shade, local color, and the interaction of colors—as well as their proper balance and proportion gave this canvas its perfect harmony.[2]

The author of this remarkable painting, *Bathers at Asnières* (plate 55), was Georges Seurat, a former student at the Ecole des Beaux-Arts who was just three years older than Signac. The possessor of a keen intellect and equally formidable willpower, Seurat had supplemented his academic training with considerable independent study. Not completely satisfied with the emphasis on draftsmanship espoused by his teacher, Henri Lehmann, a disciple of Ingres, Seurat began to delve into color theory. He found inspiration in the works of the chemist M. E. J. Chevreul, whose ideas on color harmony had influenced Eugène Delacroix some forty years earlier. One of Seurat's observations on Delacroix's work indicates the direction in which his own painting would move in a few short years: "Here is the strictest application of scientific principles seen through a personality."[3] Chevreul's ideas on color were modified with the publication of the American physicist O. N. Rood's *Modern Chromatics*, which was translated into French in 1881. Seurat's discovery of Rood's book contributed to his belief that a partnership between art and science could be extremely fruitful.

The harmonious color and perfect correspondence of subject matter and technique that so impressed Signac when he saw *Bathers at Asnières* at the Indépendants were realized not through the direct, spontaneous methods advocated by the Impressionists but through a painstaking process of editing. A multitude of drawings and fourteen oil sketches made on the spot recorded different aspects of a motif, which the artist then retained or rejected in the final composition. Seurat's consuming interest in color theory had not led him to abandon drawing. His rich, sensuously textured Conté crayon drawings complement the painted sketches for *Bathers at Asnières* and reveal a conception

53

of drawing as essentially tonal rather than linear (plates 56, 57). With methodical attention to the total effect of his canvas, Seurat integrated these fragments of observed reality into a deceptively seamless whole.

Although Seurat knew about Impressionism at least from the date of his visit to the 1879 group show, there is little evidence of sympathy for it beyond the superficial similarity of his theme to one that had also interested the earlier artists. Comparison of *Bathers at Asnières* and Renoir's *Oarsmen at Chatou* (plate 54), a work for which Seurat had expressed admiration, reveals the enormous formal and psychological distance that separated him from the older generation. *Oarsmen at Chatou* is a typical plein-air subject. Bold, short brushstrokes and vivid color animate the canvas, communicating an infectious joie de vivre. In contrast, the mood of classic calm that permeates Seurat's canvas seems the inevitable result of a concerted effort to eliminate the

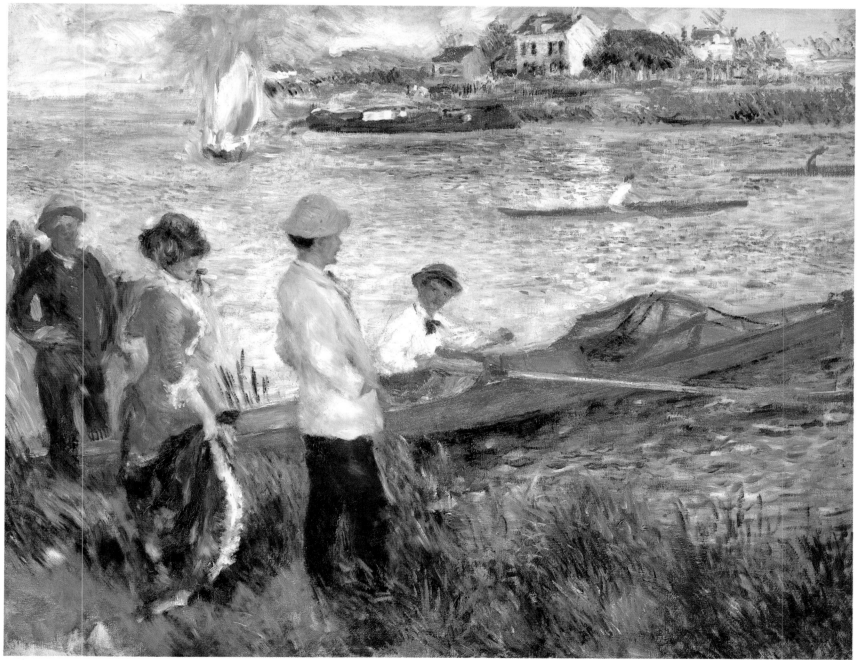

54

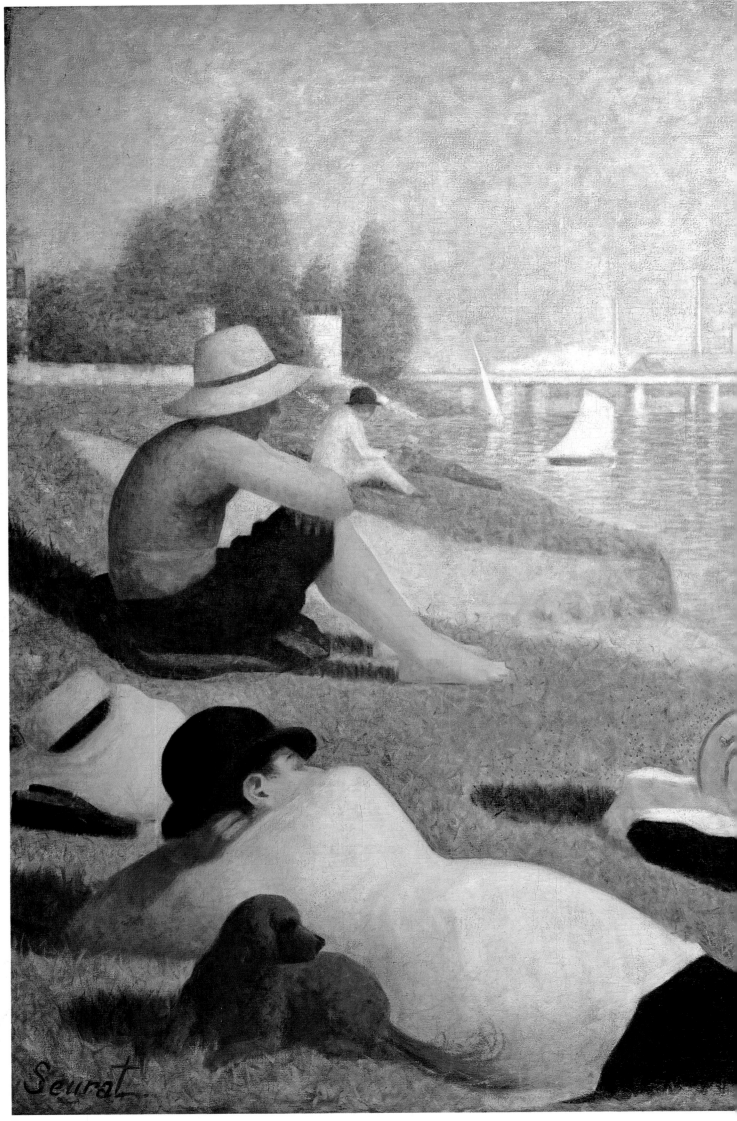

Seurat

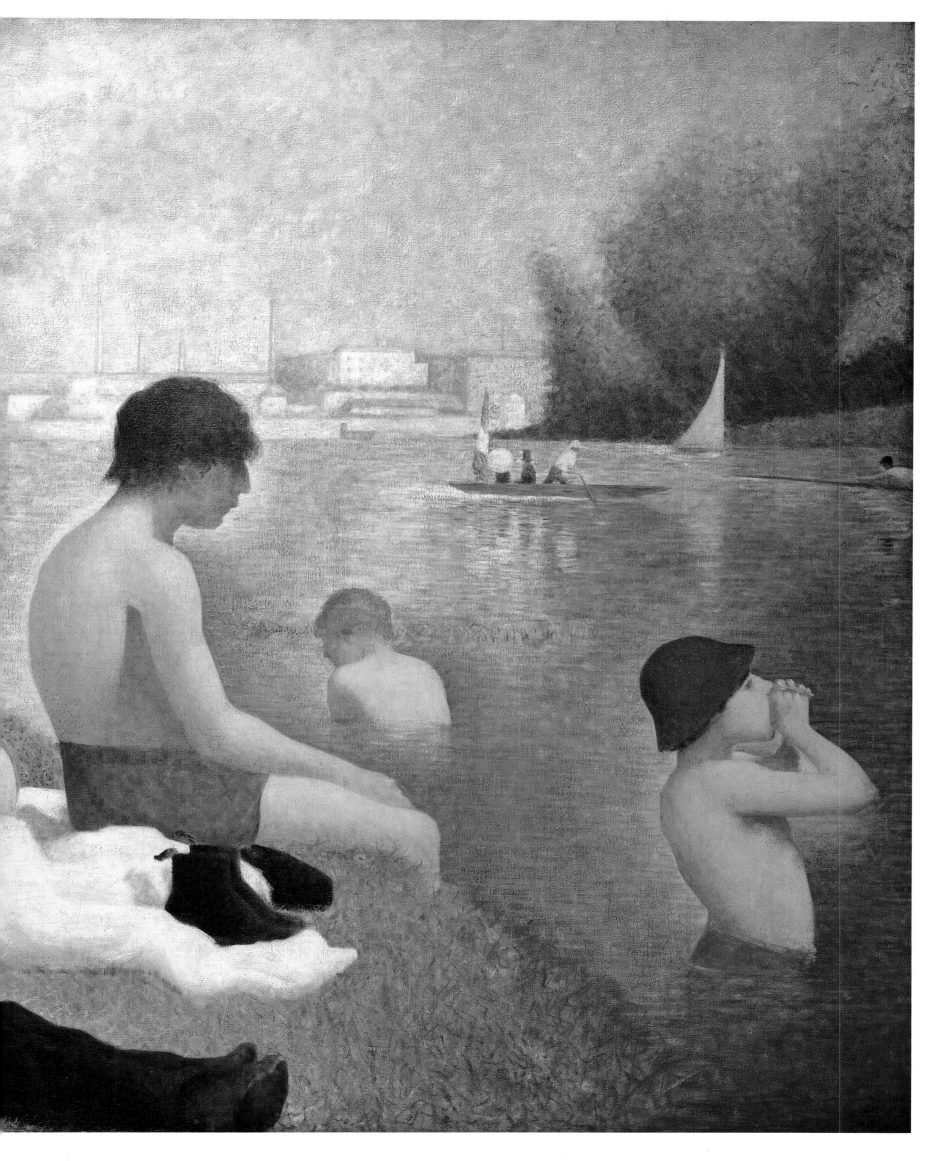

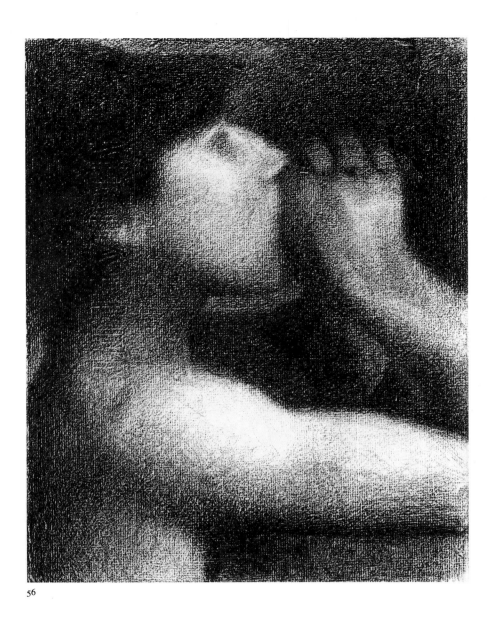

56

56. Georges Seurat (1859–1891). *Echo*, 1882–83. Conté crayon on paper, 12¼ x 9¼ in. Yale University Art Gallery, New Haven, Connecticut.

57. Georges Seurat (1859–1891). *Seated Boy with Straw Hat*, 1883–84. Conté crayon on paper, 9½ x 12¼ in. Yale University Art Gallery, New Haven, Connecticut.

58. Pierre Puvis de Chavannes (1824–1898). *The Sacred Wood*, 1884. Fresco, 18 x 41¾ in. Musée des Beaux-Arts, Lyon.

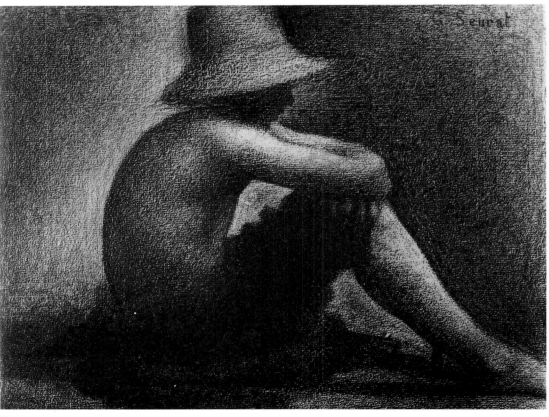

57

casual or the incomplete. In place of Renoir's modish pleasure seekers, Seurat has depicted the men and boys who toiled in the factories that dotted the somewhat barren industrial suburb of Asnières. Through the careful engineering of vertical and horizontal elements—which articulate the clear pictorial structure—the regularized brushstrokes, and the modification of color, no single aspect of the painting has been allowed to assert itself at the expense of any other. In the process the proletarian topicality of the picture's subject has been transformed into an arcadian universality.

If Seurat's painting implied a serious critique of Impressionism, it also suggested a clear connection to art well outside the orbit of that movement. The paintings of Pierre Puvis de Chavannes, for example, endowed traditional religious and mythological themes with a simplified form and strong design that were admired by many of Seurat's contemporaries at the Ecole des Beaux-Arts. Seurat had frequented Puvis's studio in the late 1870s, and the abstract harmony of such works as *The Sacred Wood* (plate 58), which was shown with considerable success in the same Salon that had rejected *Bathers at Asnières*, made a profound impression on the younger artist. In a Salon crowded with academic nudes, pastiches of history and genre paintings, and even hybrid Realism, Puvis's grave and lucid compositions were outstanding. The critics were not impervious to the similarity of Seurat's and Puvis's painterly ambitions: Félix Fénéon, in fact, dubbed the former a "modernizing Puvis."[4]

The impulse that had prompted the establishment of the Groupe des Artistes Indépendants took firm hold in the months following the first exhibition. Having survived both a round of artistic quarrels and a change of name, the Société des Indépendants came to constitute a permanent alternative to the conservatism of the official Salon. In the first months of the group's existence, Seurat and Signac became close friends and virtual collaborators. Under the former's influence, Signac turned to a more disciplined study of color theory while his comrade began to banish earth tones from his palette.

The Last Impressionist Exhibition

It was Signac's mentor, Guillaumin, who introduced him and Seurat to the senior Impressionist, Pissarro. In discussions with these young men, who were the same age as his son Lucien, Pissarro gained a new energy that enabled him to develop a fresh perspective on his own painting and to solve the problems that had been troubling him in the previous years. The plausibility of their theories persuaded him to abandon the Impressionists' spontaneous approach and irregular brushwork in favor of a more ana-

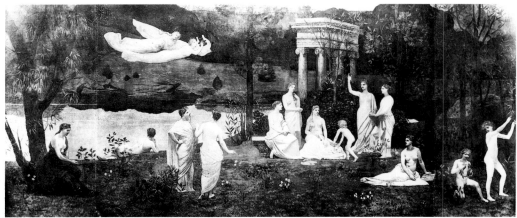

58

lytical study of color and a more controlled application of pigment. When Durand-Ruel expressed shock at some of Pissarro's canvases executed in this new technique, the painter explained that he was seeking ". . . a modern synthesis by methods based on science, . . . to substitute optical mixture for the mixture of pigments, which means to decompose tones into their constituent elements, because optical mixture stirs up luminosities more intense than those created by mixed pigments."[5] This technique, which Seurat variously called Chromoluminarism and Divisionism, represented a rigorous systematizing of Impressionist painting practices that would become the subject of heated controversy in a few months' time.

Pissarro was eager for his new friends Seurat and Signac to exhibit within the context of the older Impressionist group, thus establishing a link between the new "scientific impressionism" and what he had come to regard as "romantic impressionism." It had been nearly four years since the group's previous showing together. Pissarro's proposal that Seurat and Signac be invited to participate in a new group exhibition met with strong resistance from some of the founding members. Finally, after protracted negotiations—which included an agreement to place the work of Pissarro, his son Lucien, and the newcomers in a separate room—the various factions agreed to open an exhibition on May 15, 1886. Caillebotte, Sisley, Monet, and Renoir declined to be involved, however; the latter two had been invited to show in Georges Petit's fashionable gallery. Therefore only Degas, Morisot, and Pissarro remained from the original group. Ironically, in what was to be the last official celebration of Impressionism that still-controversial name was shunned, and the enterprise was matter-of-factly designated *Eighth Exhibition of Painting*.

It was not the work of the senior artists that elicited the curiosity of visitors to this show, but a monumental painting by the newcomer Seurat: *A Sunday Afternoon on the Island of La Grande Jatte* (plate 62). This disquieting canvas, executed in the new style that Pissarro had described to Durand-Ruel, quickly achieved a notoriety that recalled the response to Manet's *Déjeuner sur l'herbe* of 1863.

As the oldest and certainly one of the most famous artists in the group, Pissarro was singled out for criticism, since it was believed that he was responsible for the startling technical innovations on view. But with characteristic honesty, he disavowed leadership and gave Seurat credit for their discovery and development. Some observers professed inability to differentiate the canvases by one artist from those of another, arguing that the new technique had virtually eliminated individual temperaments. Only one critic, a man of Seurat's own generation, seemed to recognize the significance of the exhibition. Félix Fénéon was a twenty-five-year-old government official with a passionate interest in art and literature; he was also one of the founders of a magazine, *La Revue indépendante*, that played an active part in disseminating new ideas in the arts. Fénéon sought out Seurat and his colleagues, familiarized himself with their work, discussed their ideas at length, and eventually assumed the function of apologist for the group, following the example of such older critics as Emile Zola, Edmond Duranty, and Théodore Duret. In a series of perceptive articles that appeared in 1886, Fénéon assessed the contributions of Seurat and his followers:

> We can understand why the Impressionists, in striving to express extreme luminosities . . . wish to substitute optical mixture for mixing on the palette. Monsieur Seurat is the first to present a complete and systematic paradigm of this new technique. His immense canvas, *La Grande Jatte*, whatever part of it you examine, unrolls, a monotonous and patient tapestry: here in truth the accidents of the brush are futile, trickery is impossible. . . .[6]

Stimulated by his enthusiasm for Seurat's painting, Fénéon christened its style Neo-Impressionism, thereby acknowledging the historic efforts of the older generation while at the same time proclaiming the reformatory goals of the younger one. His re-

59. Camille Pissarro (1830–1903). *River, Early Morning: Isle la Croix*, 1888. Oil on canvas, 18¼ x 21⅞ in. The Philadelphia Museum of Art; John G. Johnson Collection.

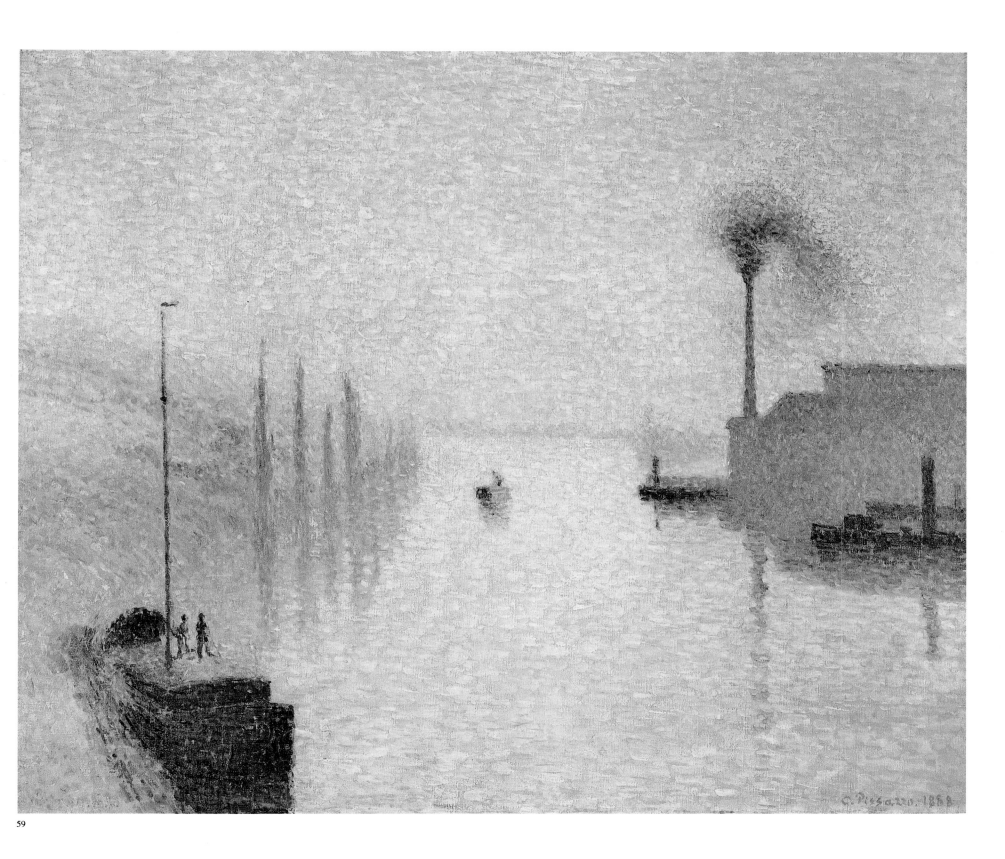

59

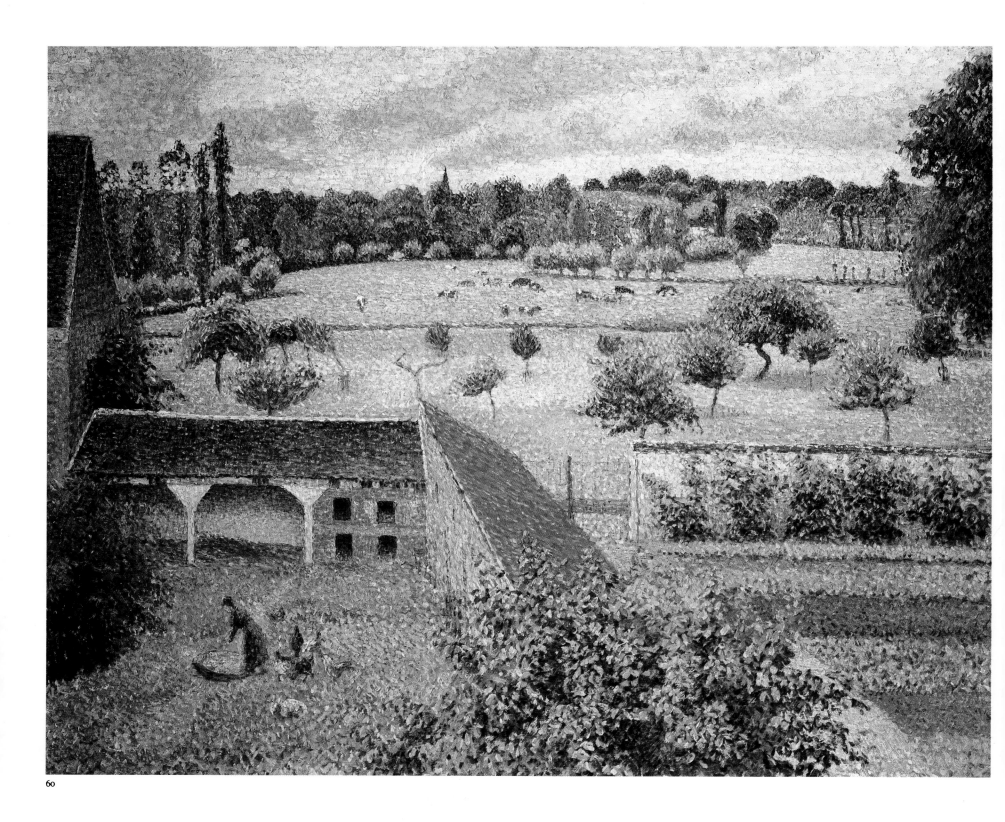

60

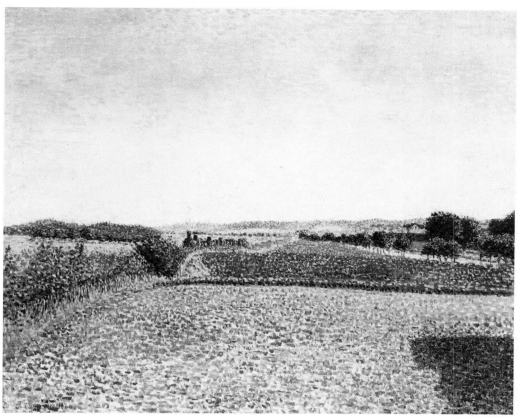

61

views, which made it clear that he felt Impressionism had been superseded by Seurat's "conscious and scientific manner," served as both announcement of the new movement and virtual obituary for its predecessor. In a period when many of the major Impressionists were afflicted by doubt—a situation that was vividly captured in Zola's 1886 novel *L'Oeuvre* (The Masterpiece), whose hero, the failed painter Claude Lantier, was regarded by many as a composite of Manet, Monet, and Cézanne—Seurat's resolute and confident technique seemed a welcome cause for optimism about the future of French painting.

Georges Seurat
and the Emergence of Neo-Impressionism

The Impressionists had purposely used uneven brushwork and a vivid palette to transmit the intensity and immediacy of nature, whereas the Neo-Impressionists utilized methodically applied dots, a technique commonly described as *peinture au point* (Pointillism), to achieve their rationalist goal of eliminating the fugitive and the casual in order to seize a more fundamental reality. Thus Seurat's rejection of what has been called the "hedonism of the retina"[7] was accompanied by a rejection of the exuberant execution that served it as well. In *La Grande Jatte*, whose authority provided the new movement with a pictorial manifesto, Seurat not only identified the crisis that had befallen Impressionism, he provided its programmatic resolution.

If the composition of *La Grande Jatte* superficially recapitulated earlier Impressionist depictions of picnics and promenades, its explicit sense of order and of a predeter-

60. Camille Pissarro (1830–1903). *View from the Artist's Window at Eragny*, 1888. Oil on canvas, 25⅝ x 31⅞ in. Ashmolean Museum, Oxford.

61. Camille Pissarro (1830–1903). *The Railroad to Dieppe*, 1886. Oil on canvas, 21¼ x 25¾ in. Private collection.

OVERLEAF:

62. Georges Seurat (1859–1891). *A Sunday Afternoon on the Island of La Grande Jatte*, 1884–86. Oil on canvas, 81 x 120⅜ in. The Art Institute of Chicago; Helen Birch Bartlett Memorial Collection.

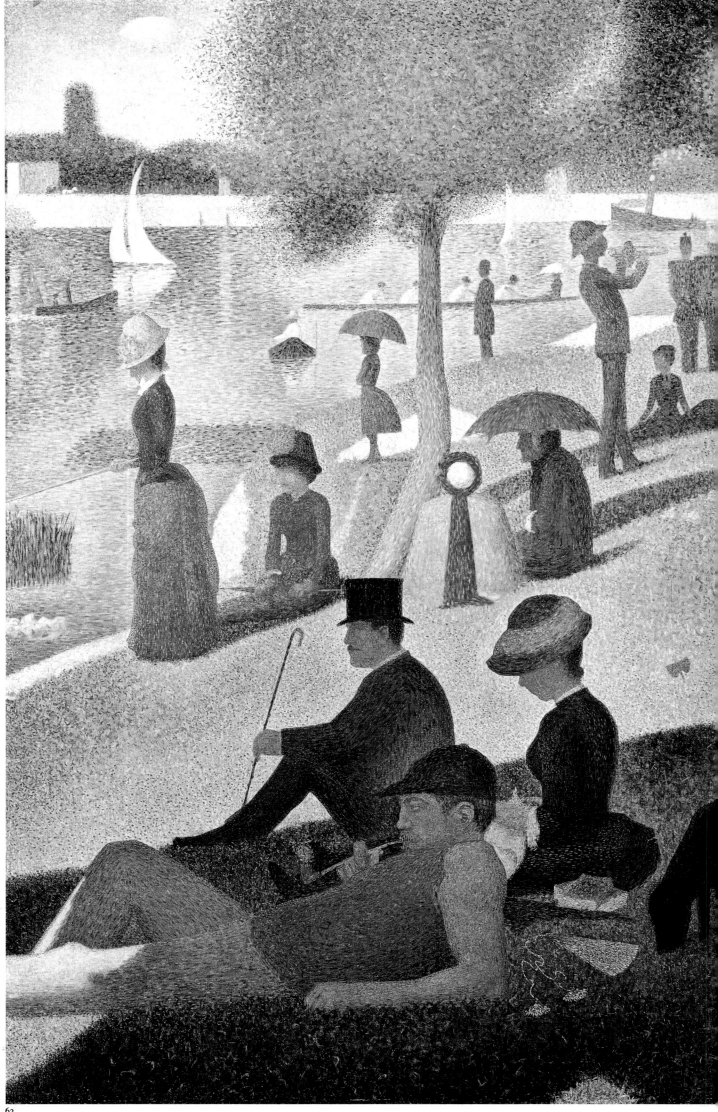

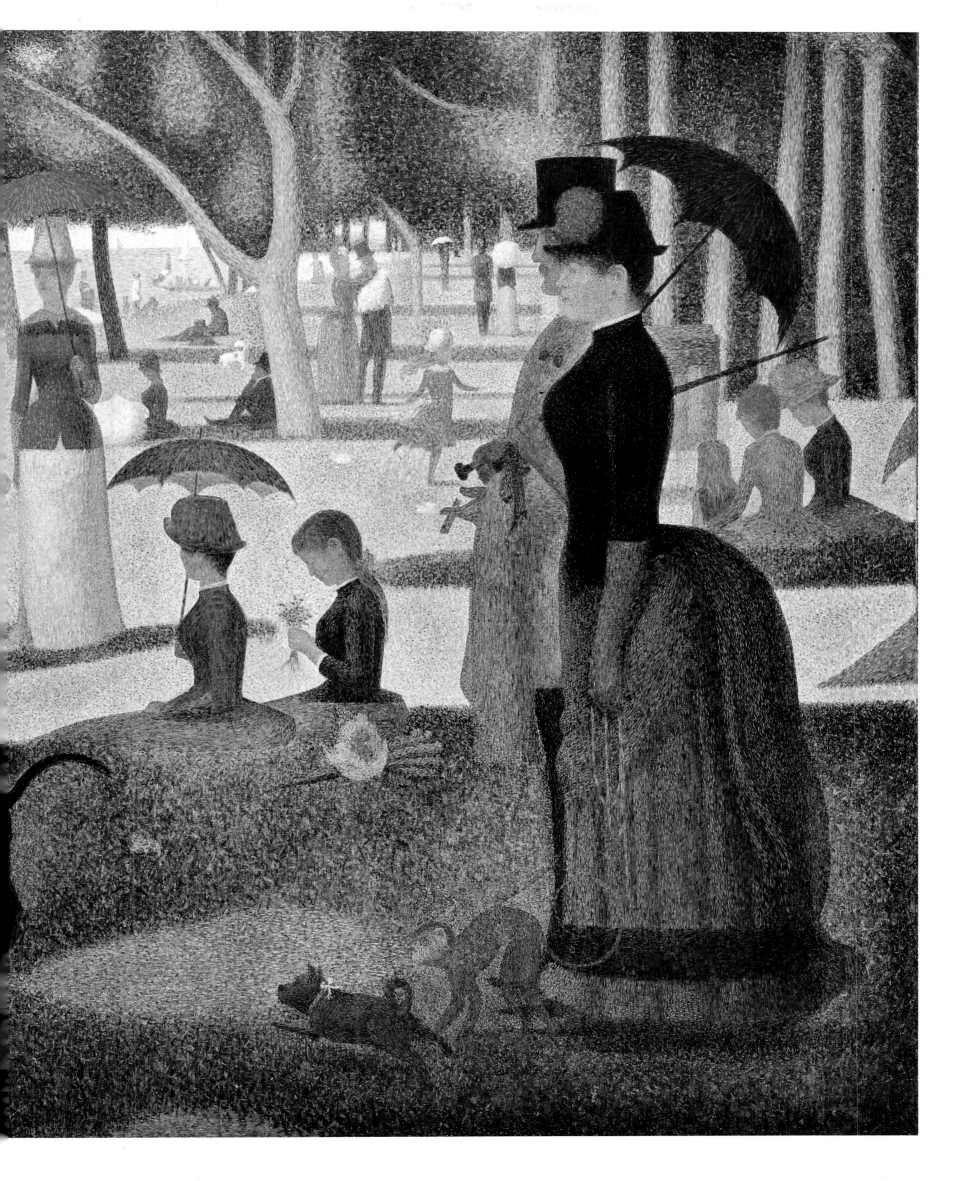

63

mined rather than intuitive structure could only be interpreted as a critique of the aesthetic values that had produced those works. In place of a particular moment Seurat posited an ideal time and space, objective rather than personal. Although he used contemporary urban imagery, his conception of modernity was intellectual rather than literal, a conclusion supported by his statement that he wished the painting to be understood as the Parthenon frieze was understood: "I want to make the moderns file past like the figures on that frieze, in their essential form, to place them in compositions arranged harmoniously by virtue of the directions of the colors and lines. . . ."[8]

Emile Verhaeren, editor of the Belgian magazine *L'Art moderne* and a secretary of the progressive artists' organization in Brussels called Les XX, was so impressed by *La Grande Jatte* when he saw it at the last Impressionist show that he purchased Seurat's *Lighthouse at Honfleur* (plate 66) and wrote a sensitive appraisal of the artist's means and objectives: "Just as the old masters risked rigidity, by arranging their figures hieratically, so too, M. Seurat synthesizes attitudes, poses, and movements. What they did to express their time, he attempts for his own. . . . He does not repeat what

they did. He makes original use of their profound method in order to sum up modern life. The gestures of these strollers, their groupings, their comings and goings, are *essential*. . . ."[9]

Fénéon's and Verhaeren's positive evaluations of the new art contrasted sharply with the opinions expressed publicly by most of the popular critics and privately by the Impressionists themselves. Most were too involved with their own professional struggles to weigh seriously the implicit challenge of *La Grande Jatte*. Among the members of the old group, only Pissarro found consolation in the recognition that a serious reappraisal of Impressionism was under way and that he had been an active force in bringing that reappraisal about. With the close of the final group exhibition, Pissarro found himself strangely isolated from his old comrades and even more deeply involved with the exponents of the new style.

While a few younger painters were immediately attracted to the innovative concepts of color and design embodied in Seurat's *La Grande Jatte*, most artists remained indifferent or even openly hostile, condemning them as little more than aberrant footnotes to Impressionism. But by the time the work was shown again just two months later, under better viewing conditions at the Salon des Indépendants, the number of adherents to the new style had grown. To the familiar names of Signac and Lucien Pissarro were added those of Charles Angrand, Albert Dubois-Pillet, and Henri Edmond Cross. Seurat, an extremely reticent man, had been reluctant to discuss his theories with outsiders and became increasingly apprehensive about the interest expressed in them by other painters. Far from being encouraged by the diffusion and the intellectual impact of Neo-Impressionism, Seurat developed a virtual paranoia about how easily some painters adopted it. In a letter to Signac he stubbornly maintained that "the more numerous we are, the less originality we have, and the day when everybody uses this technique it will no longer have any value and one will look for something else, as has already happened. . . ."[10] Fénéon tried to reassure Seurat by arguing that "the neo-impressionist method requires an exceptional delicacy of vision: all of the skills that cover up visual insensitivity with manual dexterity must flee in terror before its dangerous honesty.

63. Georges Seurat (1859–1891). *Study for "A Sunday Afternoon on the Island of La Grande Jatte,"* 1884–86. Oil on wood, 6¼ x 9⅞ in. National Gallery of Art, Washington, D.C.; Ailsa Mellon Bruce Collection.

64. Georges Seurat (1859–1891). *Study for "A Sunday Afternoon on the Island of La Grande Jatte,"* 1884–86. Oil on canvas, 6 x 9½ in. Mr. and Mrs. Paul Mellon, Upperville, Virginia.

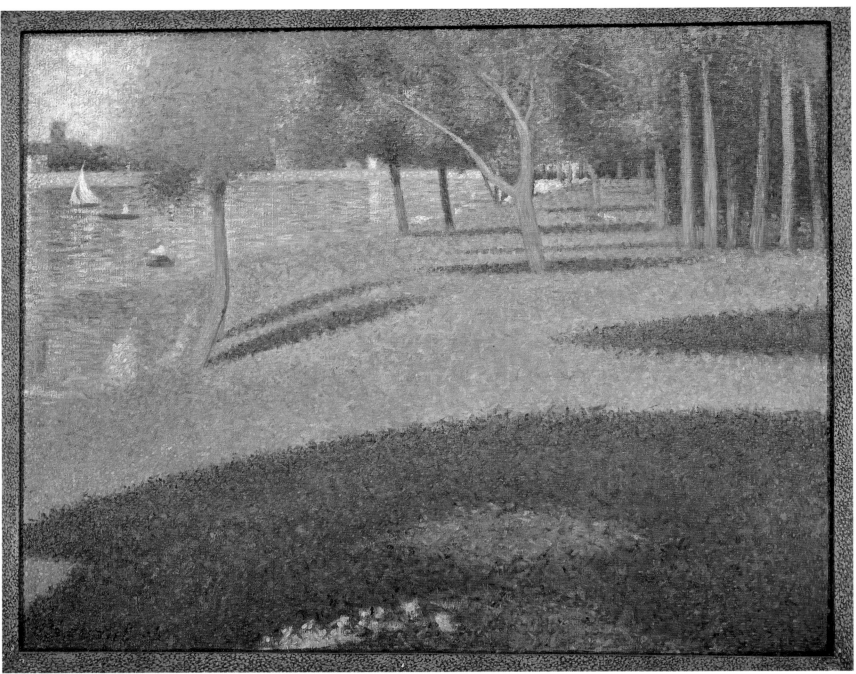

65

"You were a serious, good, simple, courteous man, who resembled nothing so much as the Sunday strollers who come from Montrouge or the Place Blanche and take the horse bus to the Bois, when they walk, alone or in twos and threes, to the islands of Puteaux or La Grande Jatte. . . .

"You seemed no more than another passerby, but you carried them all away in your mind, and in the silence of your studio in grim determined labor, you constructed, with lines and dots of color, those great paintings in which color and light are united in a unique and logical way, and that . . . show . . . in the precision of their optical mixing a splendor that is modern and hieratic."

Henri de Regnier, 1920

65. Georges Seurat (1859–1891). *The Island of La Grande Jatte*, 1884. Oil on canvas, 27½ x 33¾ in. Private collection.

66. Georges Seurat (1859–1891). *The Lighthouse at Honfleur*, 1886. Oil on canvas, 26¼ x 32⅜ in. National Gallery of Art, Washington, D.C.; Collection of Mr. and Mrs. Paul Mellon, 1983.

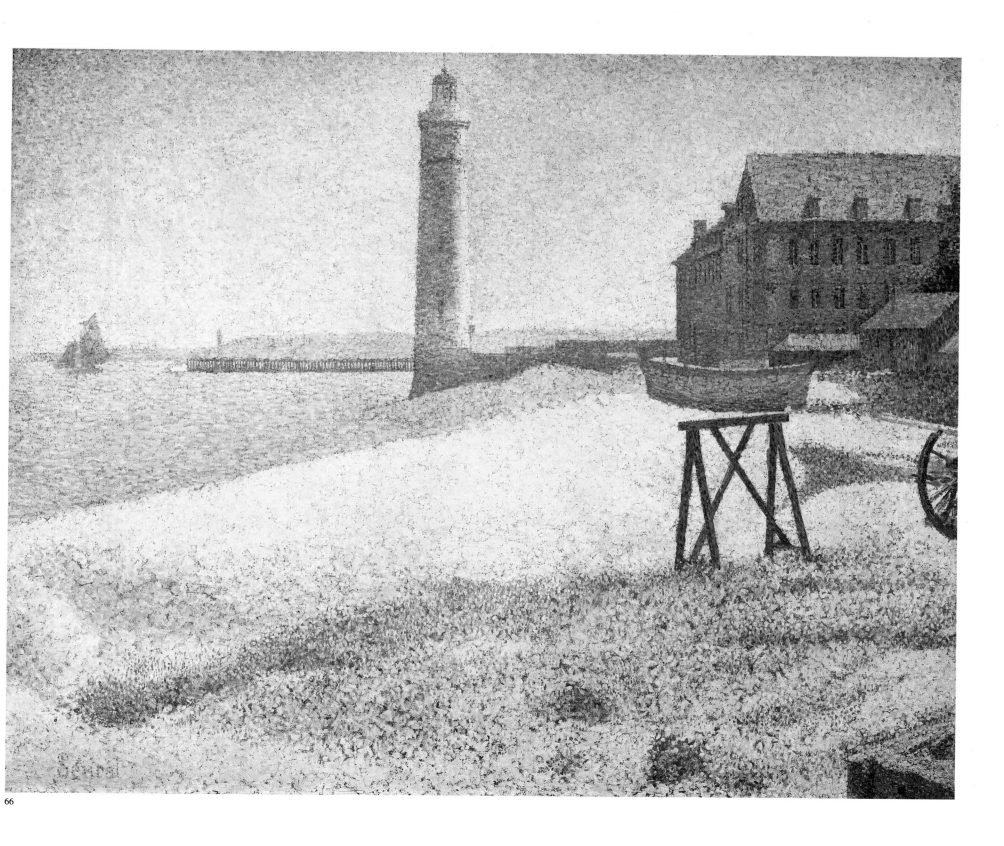

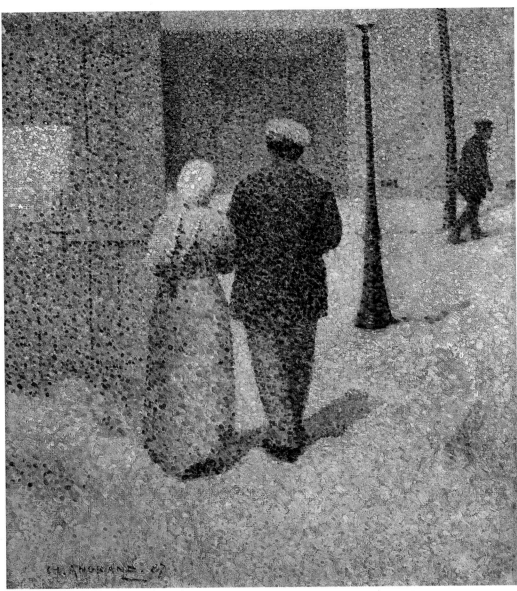

67

This type of painting is accessible only to *painters*."[11] Nonetheless, Seurat continued to view the spread of his ideas with suspicion.

It was likely Fénéon who introduced Seurat to the brilliant young scientist, aesthetician, and Sorbonne professor Charles Henry in 1886. The latter's highly original research in mathematics, physics, and chemistry was complemented by his deep understanding of music, literature, art, and psychology. Already the author of nearly twenty books when Seurat met him, Henry had an insatiable appetite for ideas. He was a frequent contributor to *La Vogue* and an intimate of such influential poets as Jules Laforgue and Gustave Kahn, who introduced him to other prominent figures in the Symbolist movement (see chapter 3). Seurat had already become interested in the possible analogies between science, music, and psychology on the one hand and art on the other, and Henry's books and articles offered a wealth of theoretical support. In particular, his *L'Esthétique scientifique* (1885), which argued that effects of sadness, calm, or happiness could be achieved through manipulation of color and design (ascending lines connote happiness, descending lines prompt depression; bright colors stimulate feelings of ebullience, dark ones, of melancholy), corresponded to Seurat's own observations.

67. Charles Angrand (1854–1926). *Couple on the Street*, 1887. Oil on linen mounted on cardboard, 15 x 13 in. Musée du XIXe Siècle, Paris.

68. Charles Angrand (1854–1926). *The Seine at Dawn*, 1889. Oil on canvas, 25½ x 31¾ in. Petit Palais, Geneva.

69. Albert Dubois-Pillet (1845–1890). *The Marne at Dawn*, 1888. Oil on canvas, 12⅝ x 18⅛ in. Musée d'Orsay, Paris.

68

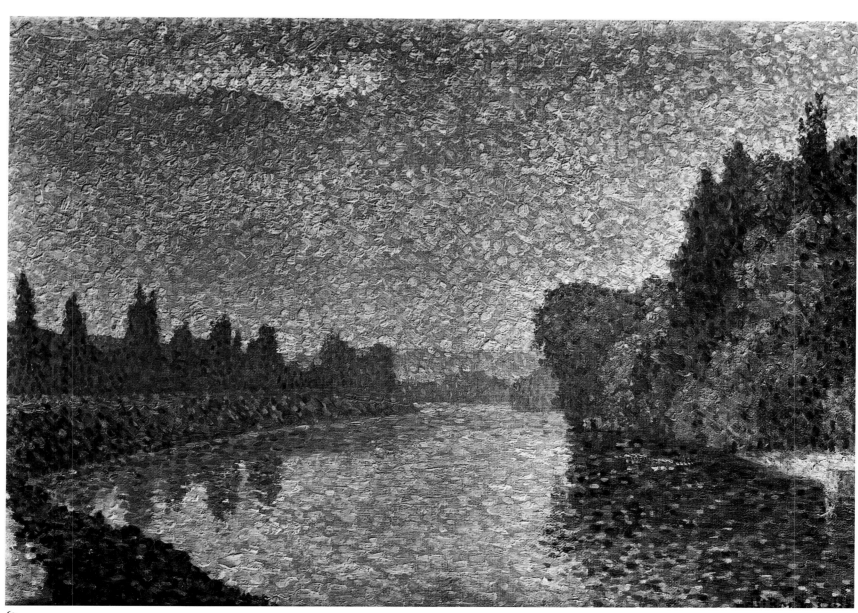

69

In the five years that followed the tumultuous initial showing of *La Grande Jatte*, Seurat assiduously explored the implications of Henry's theory of the expressive function of line and color. In the process, he abandoned outdoor subjects on a monumental scale, reserving the large format for works executed entirely in his studio. The first of these compositions, *Les Poseuses* (plate 70), is dominated by a representative segment of *La Grande Jatte*, suggesting that the painter wished to call attention to the work that had established his reputation and, at the same time, to emphasize the distinction between outdoor and indoor subjects, between elaborately clothed and nude figures. In fact, *Les Poseuses* virtually announced a working program, for henceforth Seurat consciously divided his labors between small-scale seascapes, harbor or river views and large-scale, mainly interior scenes of urban amusement.

In his review of the last Impressionist show, Fénéon had commented on Seurat's abandonment of the traditional gold frame and its replacement by the neutral white one that had already been adopted by some of the Impressionists. By 1887 Seurat had begun to color the frames of his paintings. Later he introduced a small border or band within the canvas itself whose colors complemented those of the adjacent pictorial surface and mediated between the painted image and its enclosure. Pissarro, who had followed the progress of *Les Poseuses*, was particularly struck by this innovation: ". . . what will be very surprising is the treatment of the frame. . . . The picture is not at all the same with white or anything else around it. One has . . . no idea of the sun or of gray weather except through this indispensable complement. I am going to try it out myself. . . . I shall exhibit . . . only after our friend Seurat has made known the priority of his idea. . . ."[12]

In another picture—originally entitled *A Circus Parade* when it was exhibited at the Salon des Indépendants in 1888 but now known as *Invitation to the Sideshow* (plate 71)—Seurat continued his exploration of urban scenes by focusing on the performers

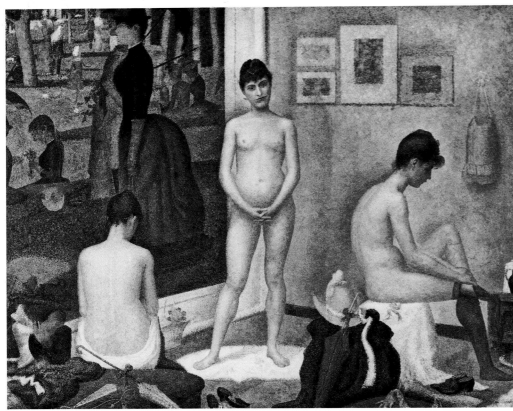

70

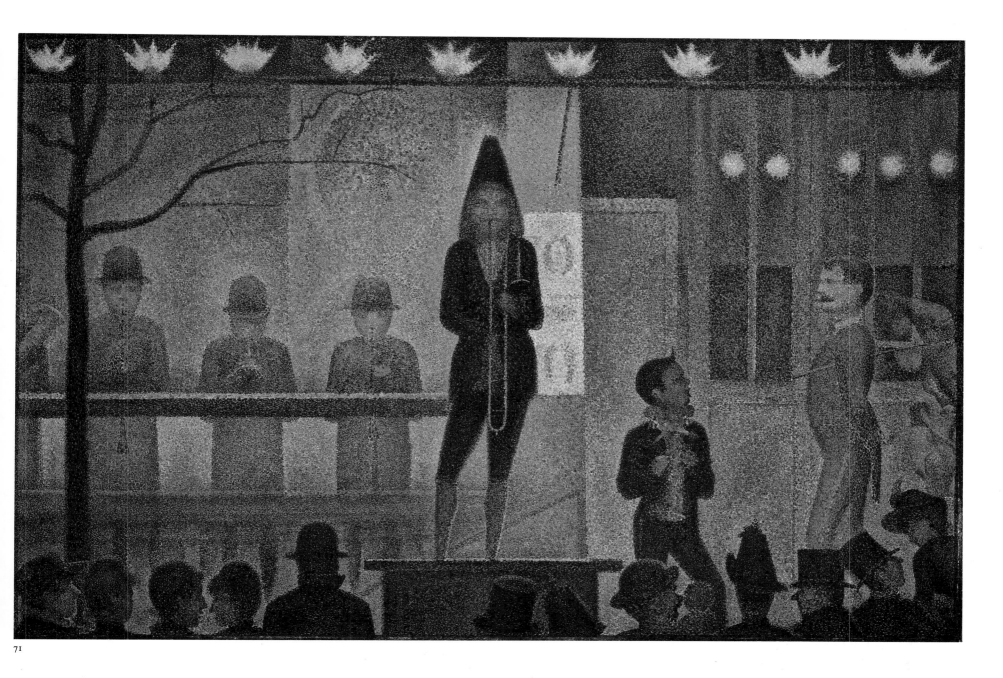

71

70. Georges Seurat (1859–1891). *Les Poseuses*, 1887. Oil on canvas, 79 x 98¾ in. The Barnes Foundation, Merion, Pennsylvania.

71. Georges Seurat (1859–1891). *Invitation to the Sideshow (La Parade)*, 1887–88. Oil on canvas, 39¼ x 59 in. The Metropolitan Museum of Art, New York; Bequest of Stephen C. Clark, 1960.

in a sideshow illuminated by the glare of gas jets. His visual point of departure was the pitch made by a barker to lure customers into one of the circuses that performed indoors during the winter. Nowhere is there the slightest suggestion of the raw vitality that one might expect from the depiction of such a gay, if commonplace, subject. Instead, the figures seem transfixed—as rigid, stylized, and two-dimensional as warriors in an Egyptian or Assyrian wall relief. The bright colors of the spectrum were banished from this shady world of nocturnal pleasure as Seurat invested the surface with a predominantly brownish monochrome, adding greens, yellows, oranges, and blues to accentuate such particulars as footlights, decor, and costumes. At the very bottom of the canvas the oddly fragmented silhouettes of the audience provide a foil for the eccentric flower-shaped gaslights, and the irregular forms of both contrast strangely with the surreal immobility of the musicians and other performers. The qualified three-dimensionality of Seurat's earlier landscapes has been replaced by an emphatically two-dimensional composition whose flatness is reiterated by rectangular veils of color. While color is the principal vehicle for conveying the sense of melancholy detachment

72

that pervades *Invitation to the Sideshow*, the line within it is so stylized as to approach caricature. At the time of the painting's initial showing, one critic spoke for a vast segment of the public when he wryly noted that "spectators would have as readily flocked to a public hanging" [13] as attended the ghostly performance.

Invitation to the Sideshow announced the subjective color and linear stylization of Seurat's last works. In *Le Chahut* (named for the acrobatic, cancanlike dance it portrays), the viewer is confronted once again with a radical transformation of an essentially Impressionist theme (plate 73). Yet Seurat made the odd vantage point used earlier by Degas, for example, with its intersection of audience and performers, even more improbable by telescoping space and by imposing an abstract order that denies the lively premise and promise of the subject. The crisp silhouettes of the dancers have a decorative rhythm, mechanical rather than human, that is conveyed with a sweeping line. In the treatment of the dancers' anatomies and accessories, nature has been rejected in favor of signs, and the repetition of gesture and costume seems a travesty of the dancers' precision rather than a good-humored endorsement of it.

72. Georges Seurat (1859–1891). *The Café Concert*, c. 1887. Conté crayon and gouache on paper, 11½ x 8¾ in. Museum of Art, Rhode Island School of Design, Providence; Gift of Mrs. Murray S. Danforth.

73. Georges Seurat (1859–1891). *Le Chahut*, 1889–90. Oil on canvas, 66½ x 54¾ in. Rijksmuseum Kröller-Müller, Otterlo, The Netherlands.

74. Georges Seurat (1859–1891). *Study for "Le Chahut,"* 1889. Oil on panel, 8½ x 6½ in. Courtauld Institute Galleries, London.

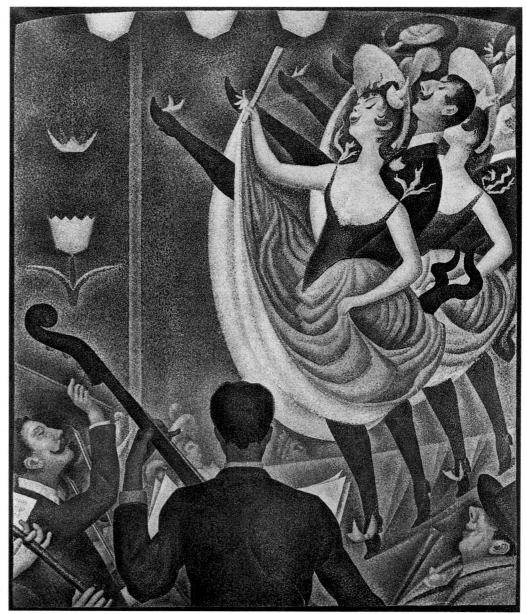

73

74

While we know that Seurat had witnessed performances like the one depicted in *Le Chahut* at cafés in his neighborhood, the metamorphosis from inspiration to painting was doubtless assisted by his interest in contemporaneous developments in popular art. The contributions of Eadweard Muybridge and E. J. Marey to the development of stop-action photography were certainly known to him. Charles Henry had utilized Marey's photographs as illustrations in his books, and a few years earlier Marey himself had

75

Both the form and content of Seurat's work proclaim his strong identification with modern industrial aesthetics and anticipate twentieth-century art's love affair with the machine. His painstaking methodology, with its emphasis on balance and order, made Seurat seem more of an engineer than a painter to many of his contemporaries. Even the pristine views of silent harbors, jetties, and lighthouses painted during his summers in Normandy emphasize the man-made elements in the natural environment. It should come as no surprise, therefore, that this disciple of the brave new world of technology regarded Gustave Eiffel's controversial iron tower as a vital symbol of progress and that he rushed out to depict its distinctive outline and shimmering painted surface even before the structure was completed in 1889.

75. Georges Seurat (1859–1891). *Eiffel Tower*, 1889. Oil on canvas, 9½ x 6 in. The Fine Arts Museums of San Francisco; William H. Noble Bequest Fund.

76. Georges Seurat (1859–1891). *The Circus*, 1891. Oil on canvas, 72 x 60 in. Musée d'Orsay, Paris.

predicted that what he called his "chronophotography" would furnish artists "with true attitudes of movement; positions of the body during unstable balances in which a model would find it impossible to pose."[14] The visual situation in *Le Chahut* is precisely one of "unstable balances," and it is tempting to speculate that this most scientifically inclined of painters detected a congenial note in Marey's publications. Seurat was also

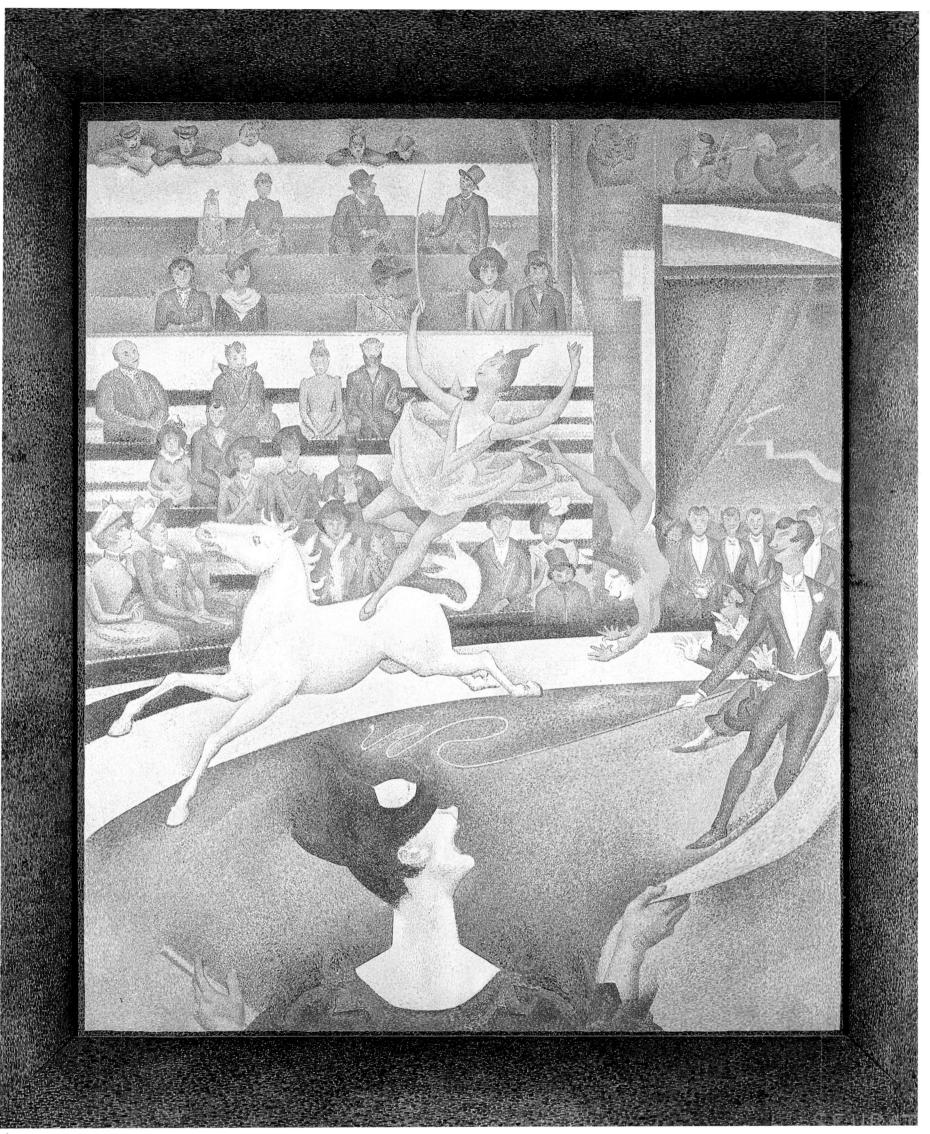

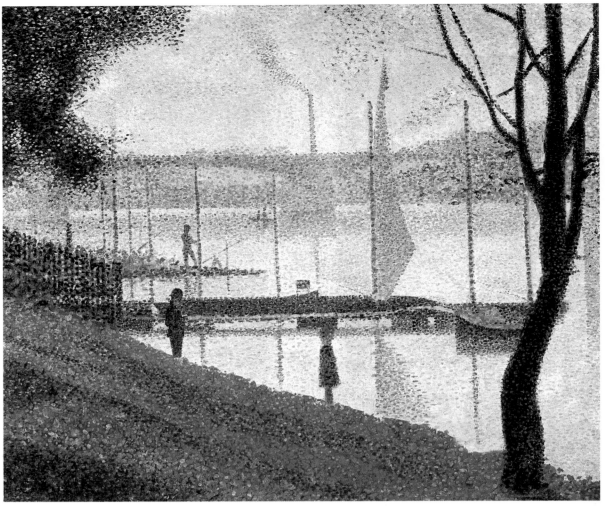

77

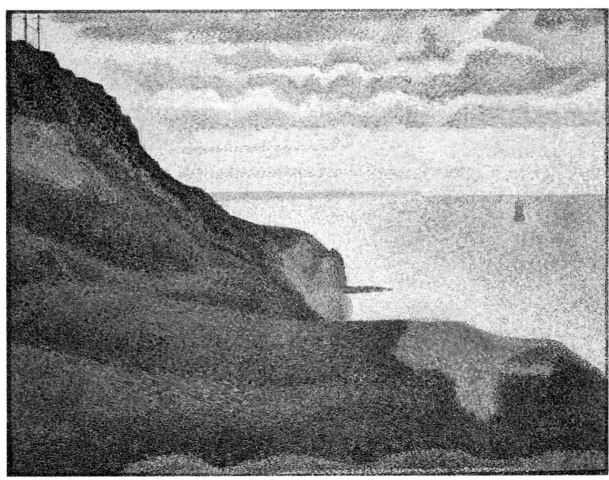

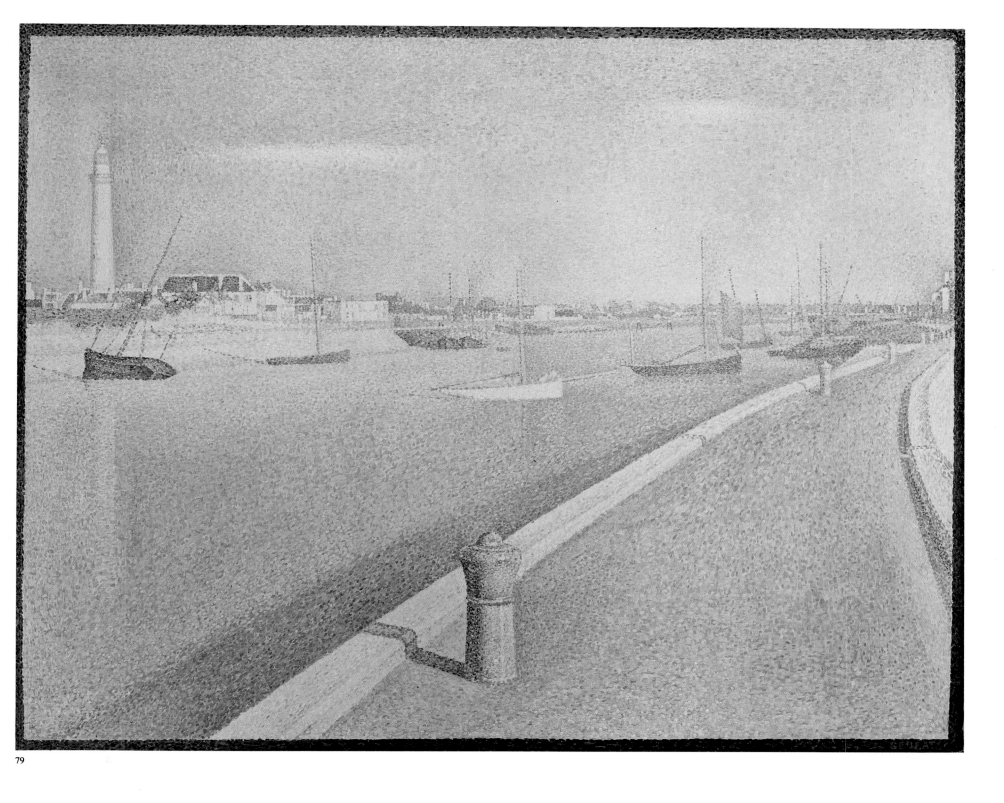

79

77. Georges Seurat (1859–1891). *Bridge at Courbevoie*, 1886–87. Oil on canvas, 18 x 21½ in. Courtauld Institute Galleries, London.

78. Georges Seurat (1859–1891). *Seascape at Port-en-Bessin, Normandy*, 1888. Oil on canvas, 25⅝ x 31 in. National Gallery of Art, Washington, D.C.; Gift of the W. Averill Harriman Foundation in memory of Marie N. Harriman, 1972.

79. Georges Seurat (1859–1891). *The Channel of Gravelines, Petit Fort Philippe*, 1890. Oil on canvas, 28⅞ x 36½ in. Indianapolis Museum of Art; Gift of Mrs. James W. Fesler in memory of Daniel W. and Elizabeth C. Marmon.

drawn to the commercial art of billboards and posters; indeed, he possessed a sizable collection of the latter, whose influence is apparent both in *Le Chahut* and in his unfinished and provocative *Circus* (plate 76). The spatial compression evident in *Invitation to the Sideshow* and *Le Chahut* is even more pronounced in *The Circus*, as is the assertion of the surface with upward swinging arabesques, which exhibit a humorous energy that seems a far cry from the grave classicism of *Bathers at Asnières* and *La Grande Jatte*.

Seurat's last seascapes reflect a heightened sensitivity to man-made, as opposed to natural, objects. In *The Channel of Gravelines, Petit Fort Philippe* (plate 79), painted during the last summer of his life, the bright colors of Impressionism have disappeared. Nowhere in this etiolated and serene view is there evident the casual vitality of the harbor scenes by the earlier painters. Indeed, human forms would have constituted an in-

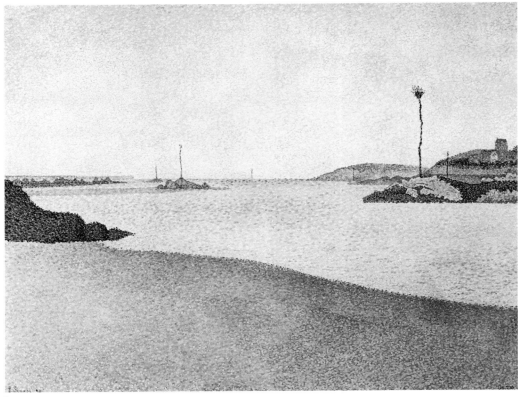

80

80. Paul Signac (1863–1935). *Saint Briac*, 1885. Oil on canvas, 19⅜ x 31¼ in. Private collection, New Jersey.

81. Paul Signac (1863–1935). *Woman Dressing: Purple Corset*, 1892. Encaustic on remounted canvas, 23 x 27¼ in. Madame Ginette Signac, Paris.

trusion of the casual on the schematic design so willfully imposed by Seurat on the surface of his canvas.

About the same time that he painted *The Channel of Gravelines*, Seurat made a rare attempt to clarify his views on aesthetics and technique, which he undoubtedly felt had been oversimplified or misrepresented by the various painters and critics who had acted as apologists for Neo-Impressionism. Like the formulations of the scientists and mathematicians he so esteemed, Seurat's statement is characteristically dispassionate:

> *Art is Harmony.*
> Harmony is the analogy between opposites and the analogy between elements similar in *tonal value*, *color*, and *line*, considered in terms of the dominant, and under the influence of lighting, in gay, calm or sad combinations. . . .[15]

Seurat's life was tragically short (he died in 1891 at the age of thirty-two), and his rapid rise to artistic prominence is all the more impressive if one compares it with the careers of the Impressionists. None of the latter exerted a comparable influence during youth, and none enjoyed the clarity of purpose and determination that marked Seurat's development. With his entry into the Paris art world in 1884, Seurat had immediately established himself as a serious artist, one whose cool, intellectualizing compositions reflected his reverence for ancient art and his appreciation of the academic tradition. The calm clarity of his forms and the detachment that characterized his early outdoor subjects reached their climax in *La Grande Jatte*. The manifestolike character of that historic work was never to be repeated, and Seurat's painterly ambition proved to be as receptive to contemporary art forms as it had been to those of the past. The all-inclusiveness of his outdoor subjects became more restrictive as Seurat sought to marshal the emotional qualities inherent in a given motif into a coherent pictorial structure. In less than five years his vision changed from one of clinical objectivity to one of calculated subjectivity.

Paul Signac

Signac was not only Seurat's closest friend and confidant—insofar as the latter permitted intimacy—he was also Neo-Impressionism's most dedicated proselytizer and historian. A common belief in social progress through radical political activity had cemented Signac's friendship with the avowed anarchist Pissarro, and the younger man's commitment to social and political activism permeated his aesthetic ideas. His close friendships with Fénéon and other key literary figures provided Signac with ready access to the numerous magazines that appeared in the 1880s and '90s. In his articles and in his major theoretical and historical study of 1898–99, *D'Eugène Delacroix au Néo-Impressionisme*, Signac voiced the enthusiasm for science that characterized much of late nineteenth-century thought and pervaded Neo-Impressionism. He believed that art, music, and literature were governed, like science, by laws that were, in turn, responsible for maintaining vital harmonies in life. Signac labored tirelessly over the produc-

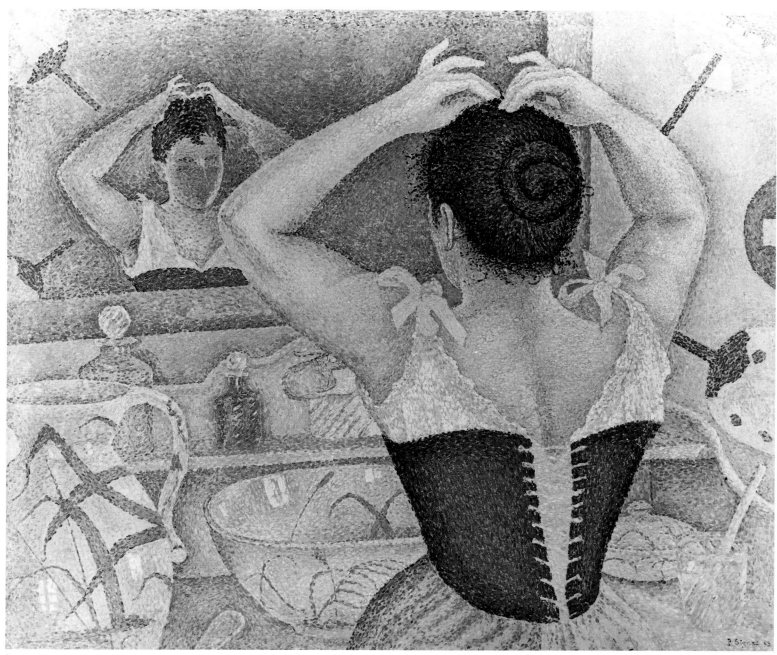

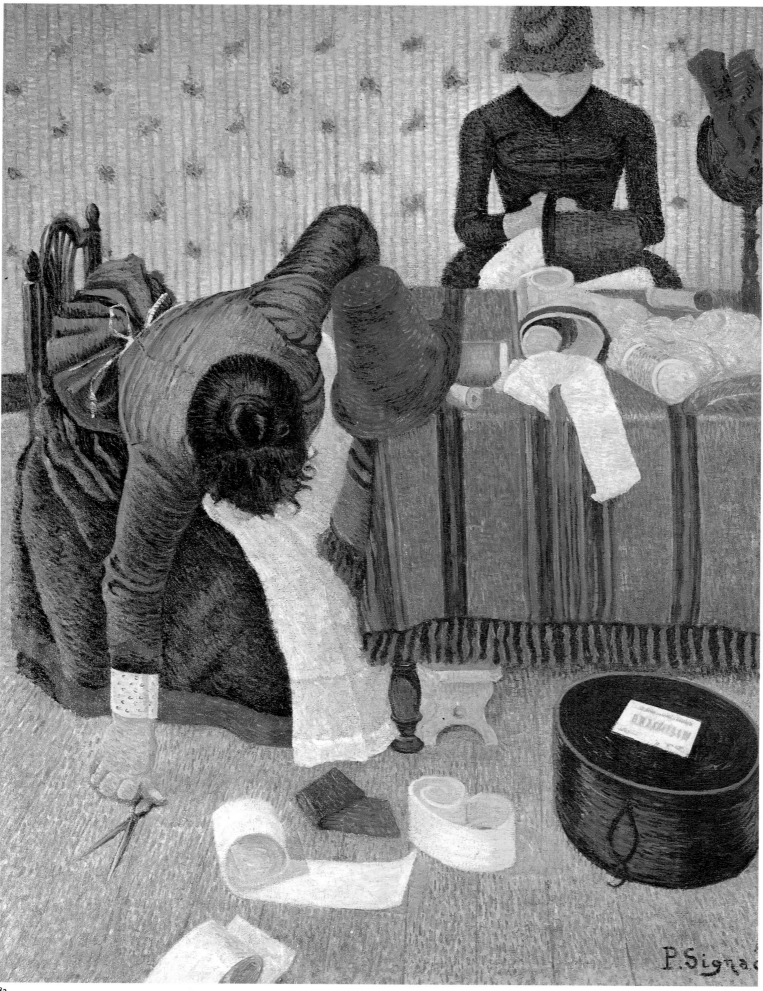

82. Paul Signac (1863–1935). *The Milliners*, 1885. Oil on canvas, 39⅜ x 31⅞ in. Bührle Foundation, Zurich.

83. Paul Signac (1863–1935). *Gasometers at Clichy*, 1886. Oil on canvas, 25½ x 32 in. National Gallery of Victoria, Melbourne; Felton Bequest, 1948.

In 1886, the year this painting was exhibited, Arthur Rimbaud proclaimed in Les Illuminations*: " . . . the suburbs are lost grotesquely in the countryside." Indeed, a no-man's-land where the boxy shapes of industrial structures were beginning to obscure the remaining farmhouses already marked the northern periphery of Paris. Given his addiction to Naturalist literature and his precocious commitment to the anarchist-socialist cause, it is not surprising that the twenty-three-year-old Signac undertook a series of suburban landscapes in 1886. Sympathetic critics such as Fénéon and Huysmans lauded the stark modernity of Signac's approach in these paintings, which avoided any trace of sentiment or anecdote. The detached clarity of Signac's conception is brilliantly conveyed through his systematic division of colors, a method he had just begun using when this canvas was painted.*

tion of illustrations and announcements for Charles Henry's texts, a collaboration that was indicative of his desire to educate the masses to see and understand works of art. In a letter to Vincent van Gogh, whose humanitarian concerns and utopian aspirations were congenial to his own anarchist-socialist views, Signac argued that Henry's books had didactic and social value: "We teach the workers . . . whose esthetic education until now has been based on empirical formulas or dishonest or stupid advice, how to see correctly and well." [16] In an article written in 1891 for *La Révolte*, the principal organ of French anarchism, and in unpublished writings of that year, Signac argued the relevance of Neo-Impressionist subjects to "the great social struggle that is now taking place between the workers and capital. . . ." [17] He also reiterated Henry's belief in the educability of the working class: "When the eye is educated, the people will see other things besides the subject in pictures. When the society we dream of exists, when the worker, rid of the exploiters who brutalize him, has the time to think and instruct himself, he will appreciate the varied qualities of the work of art." [18]

Unlike Seurat, whose training at the Ecole des Beaux-Arts had contributed to his profound respect for the art of the past and shaped his initial conception of pictorial structure, Signac had little formal art education. His experience with Guillaumin had awakened his interest in landscape, and his social and political beliefs may have made him more sensitive to the aesthetic potential of such industrial motifs as that depicted in *Gasometers at Clichy* (plate 83), which he painted shortly before the opening of the last Impressionist group exhibition. The center of this work is dominated by opposing hues—orange-red-blue—that illustrate the Divisionist formula that he and Seurat had evolved, and the work has a broader execution and more straightforward sense of color than Seurat's *La Grande Jatte*. While Signac was by no means dependent on Seurat, he does seem to have been influenced by the more insistently decorative quality that Seurat's work began to take on after 1887. In *Breakfast* (plate 85), which was probably inspired by Signac's own bourgeois home life, there is a stylization that suggests a relation to Seurat's *Les Poseuses*.

Of all the paintings produced during Signac's long career—he lived until 1935—easily the most compelling in its originality is his portrait of Fénéon (plate 84). The full title of the painting provides insight into the significance of the elaborate background, which competes with the celebrated critic for our attention: *Against the Enamel of a Background Rhythmic with Beats and Angles, Tones and Colors, Portrait of M. Félix Fénéon in 1890*. The arcane title betrays the inherently playful intentions of the painter, referring to the mathematical language that he and Seurat so often used in their discussions, and the background may be understood as an invocation of Charles Henry. As the principal spokesman for Neo-Impressionism in its early years, Fénéon is seen as a modern alchemist caught in the act of explicating the complexities of its color theories. Evident in the swirling patterns of the intensely decorative "chart" (which Signac adapted from a Japanese textile) are globes, crescents, and stars, references to the occult and cosmological aspects of the Symbolism with which Fénéon was identified at the time. In addition, the juxtaposition of these stars with the stripes that swing out behind his head may have been an allusion to the critic's commonly held resemblance to Uncle Sam. Aside from the mock-serious content of the composition, which reveals the artist's ability to develop a humorous perspective on the serious rationalist objectives of Neo-Impressionism, the work also summarizes the transformation of Seurat's and Signac's styles in the few years before its execution. The stylization of the ornamental elements can certainly be traced to Seurat's inspired use of arabesques in *Le Chahut*, but the intensification of their purely decorative function underscores the dichotomy of painting as representation and as abstraction, which was emerging as the principal aesthetic issue of the decade.

84. Paul Signac (1863–1935). *Against the Enamel of a Background Rhythmic with Beats and Angles, Tones and Colors, Portrait of M. Félix Fénéon in 1890*, 1890. Oil on canvas, 29⅛ x 37⅜ in. David Rockefeller, New York.

84

In her monograph on Signac, Françoise Cachin has shown that the "chart" in the background of this portrait of Fénéon was adapted from a kimono pattern that the artist had found in one of the many folios of Japanese prints he kept in his studio. Yet critics like Arsène Alexandre, who reviewed the painting when it was exhibited in the Salon des Indépendants, chose to disregard the evident humor of Signac's conception and to consider the background pattern as the embodiment of some arcane color theory by Signac's friend Charles Henry.

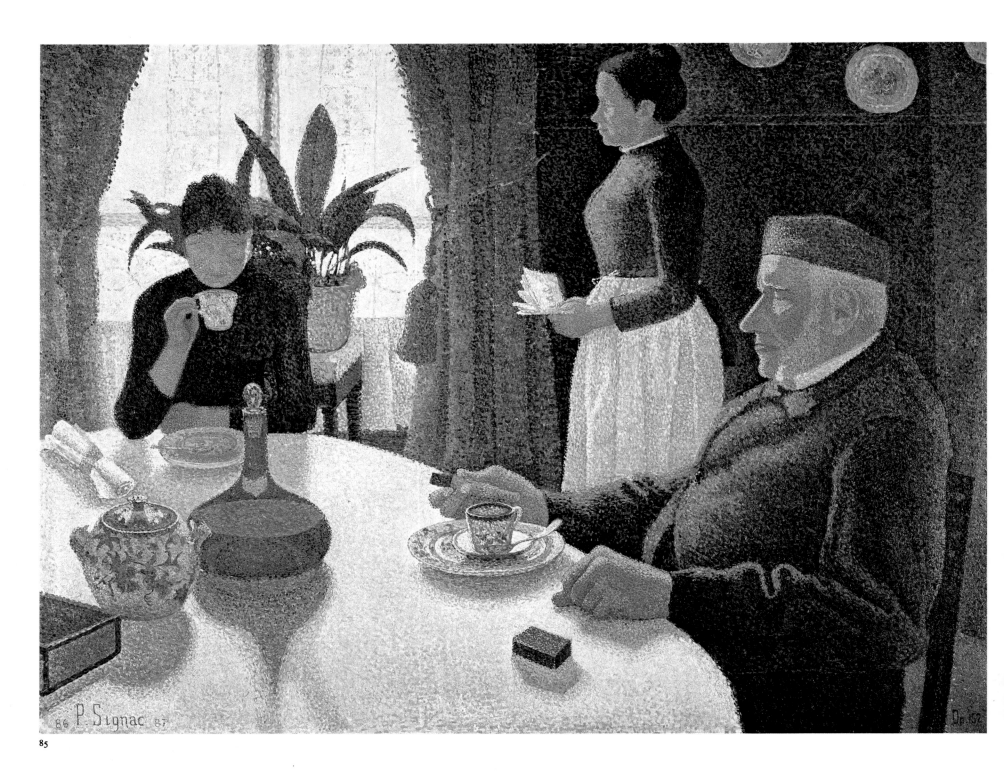

85. Paul Signac (1863–1935). *Breakfast*, 1886–87. Oil on canvas, 35 x 45¼ in. Rijksmuseum Kröller-Müller, Otterlo, The Netherlands.

86. Louis Hayet (1864–1940). *The Vegetable Market*, 1889. Encaustic on paper mounted on canvas, 7¼ x 10⁷⁄₁₆ in. Mr. and Mrs. Arthur G. Altschul, New York.

87. Maximilien Luce (1858–1941). *Outskirts of Montmartre*, 1887. Oil on canvas, 17¾ x 31¾ in. Rijksmuseum Kröller-Müller, Otterlo, The Netherlands.

86

New Converts and New Concerns

After the much-discussed appearance of Seurat's paintings at the Salon des Indépendants in 1886 and at an exhibition in Brussels the following year, the number of conversions to Neo-Impressionism grew impressively. Louis Hayet, a good friend of Lucien Pissarro who had supported himself as a house painter and decorator, joined in the research-oriented spirit of the group and experimented with encaustic, mixing wax and other substances with pigments in paintings such as *The Vegetable Market* (plate 86). Maximilien Luce, who shared the political sympathies of Signac and the Pissarros, began exhibiting views of the industrial outskirts of Paris executed in the new style at the Salon des Indépendants in 1887 (plates 87, 88).

Indicative of the widespread impact of Neo-Impressionism is a canvas by Vincent van Gogh, *Restaurant Interior* (plate 89), painted during the summer of 1887. Van Gogh, who had arrived in Paris in time to see the last Impressionist group exhibition, developed a friendship with Signac, whom he met at Père Tanguy's. Signac's enthusiasm and congeniality inspired the Dutch painter to work with him in the working-class suburb that Seurat had immortalized in *Bathers at Asnières*. Although van Gogh produced a number of landscapes that feature the dotlike brushstrokes associated with Neo-Impressionism, his enthusiasm for that systematic approach was short-lived, and his temperament was incompatible with its theoretical underpinnings. Nonetheless, his contact with Signac introduced him to a new way of seeing the decorative potential of color, which is evident in *Restaurant Interior*. Far removed from the dark palette and grim mood of the paintings he had done before his arrival in Paris, this colorful depiction of an overdecorated, unpopulated space conveys none of the heightened emotionalism of van Gogh's later work. Rather, its emphasis on structure and technique suggests that Neo-Impressionist color and execution had imposed an uncharacteristic self-control on the painter.

Hayet's experimentation with encaustic expanded the technical horizons of Neo-Impressionism, as did Albert Dubois-Pillet's investigations of the transition from one hue to another. Some of the Neo-Impressionists, such as Luce, never completely as-

87

88

88. Maximilien Luce (1858–1941). *Montebello Wharf and the Colline, St. Geneviève*, 1901. Oil on canvas, 26 x 31¾ in. Mr. and Mrs. Arthur G. Altschul, New York.

89. Vincent van Gogh (1853–1890). *Restaurant Interior*, 1887. Oil on canvas, 18 x 22¼ in. Rijksmuseum Kröller-Müller, Otterlo, The Netherlands.

similated the methodical division of colors or the regular Pointillist execution, while others, such as Henri Edmond Cross, bent the system to accommodate fundamentally decorative interests. While retaining the elegant finish and equilibrium associated with Neo-Impressionism, Cross's work progressed from the low-keyed, almost monochromatic palette evident in *Woman Combing Her Hair* (plate 90) to one of intense, expressive hues that would serve as a model for numerous painters in the early years of the twentieth century. Having come of age when Neo-Impressionism still accepted the Impressionist assumption that it was necessary to paint directly before nature, Cross learned to appreciate the formal and expressive aspects of painting that were emerging more clearly in the 1890s. He subsequently described the conflict between the obligations of representation and the autonomous character of painting as follows: "Every time I feel tied down to the true fact, the documentation . . . I must ignore it and remember the final aim of rhythm, harmony, contrasts." [19]

The public persisted in ignoring the differences that distinguished the various members of the Neo-Impressionist circle, but the painters themselves were keenly aware of these differences and did not refrain from criticizing one another. Signac, for example,

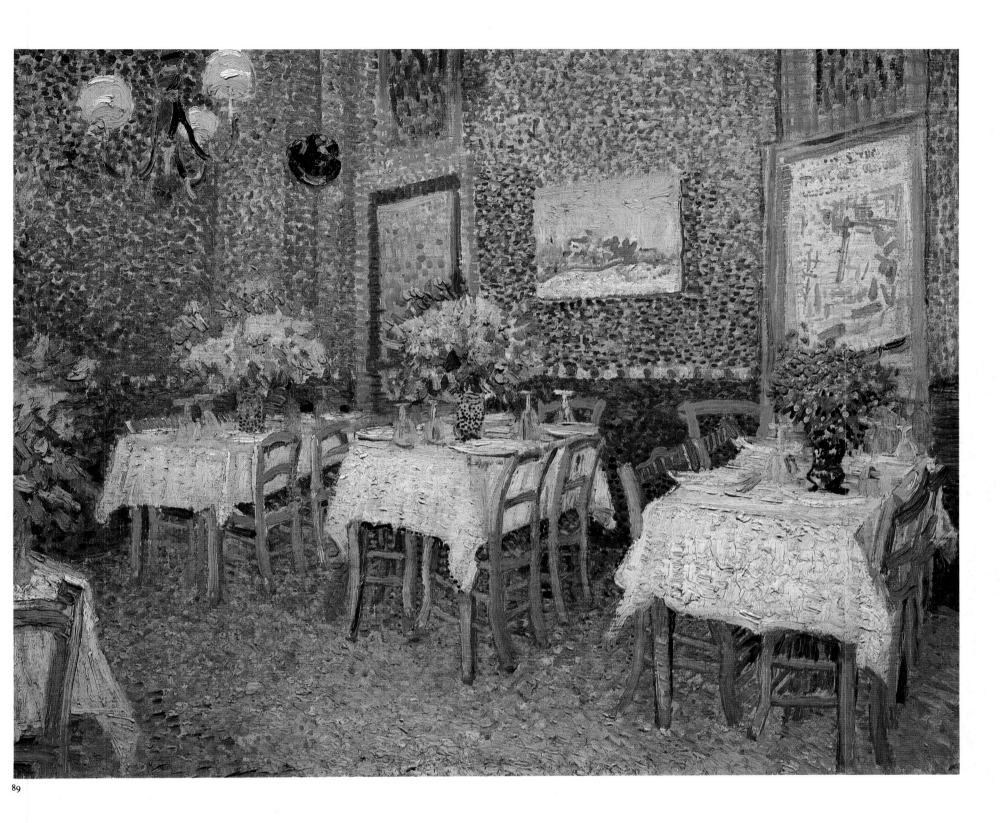

89

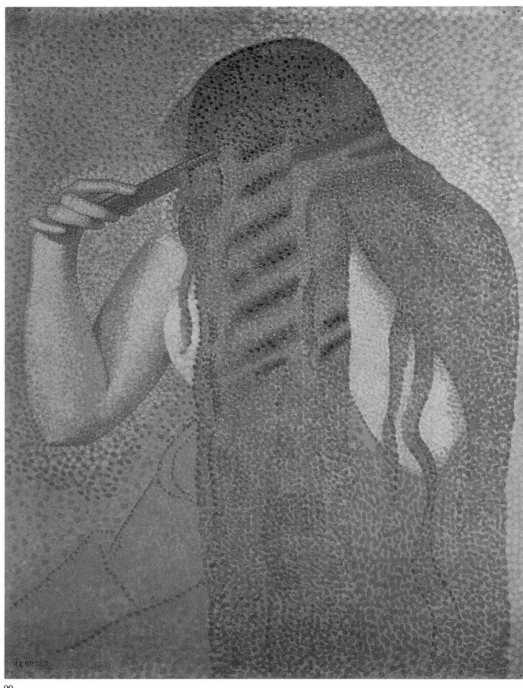

90

91

92

93

90. Henri Edmond Cross (1856–1910). *Woman Combing Her Hair*, 1892. Oil on canvas, 23⅝ x 17¾ in. Musée du Louvre, Paris.

91. Henri Edmond Cross (1856–1910). *Grape Harvest*, 1892. Oil on canvas, 37 x 55 in. Mrs. John Hay Whitney, New York.

92. Paul Signac (1863–1935). *Entrance to the Bertin Mines, Clichy*, 1886. Pen and ink on paper, 9½ x 14⅜ in. The Metropolitan Museum of Art, New York; Robert Lehman Collection, 1975.

93. Albert Dubois-Pillet (1845–1890). *The Seine in Paris*, c. 1888. Oil on canvas, 31½ x 39 in. Mr. and Mrs. Arthur G. Altschul, New York.

considered certain aspects of Seurat's execution to be weak. After studying *Les Poseuses*, he complained that in it "Divisionism is carried too far, the dot is too small."[20] Signac also found the overall effect of the canvas mechanical and the color grayish, revealing the preference for larger brushstrokes and more intense color that would characterize his later work. At the same time, he, Dubois-Pillet, and Pissarro began to produce a considerable body of ink drawings in which they explored contrasts of light and dark, achieving a surprisingly wide range of values within the stringent limitations imposed by the medium (plate 92).

For Seurat and Signac, Divisionism was fundamental to a rigorous conception of art that many of their colleagues neither understood nor shared. "We are reproached for being too learned,"[21] Signac complained in 1891, but he might easily have substituted the word *limited* for *learned*. The superficial assimilation of the dotlike brushstroke, which was the most obvious aspect of Neo-Impressionist style, became little more than a mindless mannerism in the hands of lesser artists. Even a sincere and serious painter like Pissarro, who had adopted Divisionism with unqualified optimism, had become frustrated with its straitjacket methodology by 1890: ". . . it was impossible for me to be true to my sensations and consequently to render life and movement, impossible to be faithful to the effects, so random and so admirable, of nature. . . . I had to give it up. And none too soon! Fortunately, it appears that I was not made for this art which gives me the impression of the monotony of death!"[22]

This passage, written a few years after Pissarro had broken with the Neo-Impressionists, reveals how difficult it was for an artist who had helped shape Impressionism to relinquish its spontaneity; it also helps to explain why so many of Pissarro's older colleagues found little positive to say about the "New" Impressionism. Yet even though Neo-Impressionism provided only a temporary solution to the problems that Pissarro had encountered in his painting during the early 1880s, it at least rejuvenated him by providing contacts with congenial younger artists who shared his political and social views.

The Neo-Impressionists had initially continued their predecessors' concerns with scenes from modern life and with land- and seascapes, though with some innovative emphases. The Impressionists, with the exception of Pissarro, were an apolitical group:

94

94. Maximilien Luce (1858–1941). *Portrait of Georges Seurat*, 1890. Charcoal on paper, 11¾ x 9 in. Mr. and Mrs. Arthur G. Altschul, New York.

95. Henri Edmond Cross (1856–1910). *The Golden Islands*, 1892. Oil on canvas, 23⅝ x 21⅝ in. Musée National d'Art Moderne, Paris.

their preferred subjects—elegant crowds in parks, boating scenes, comfortable social gatherings—generally reflected their essentially middle-class backgrounds and perspectives. They generally tended to avoid the dreary sections of the sprawling city, and their occasional representations of industrial reality appear to have been motivated not by any political concerns but by an interest in the atmospheric or compositional potentials of such motifs, as evident in Monet's Gare St. Lazare paintings and Caillebotte's depictions of laborers. In contrast, Seurat and Signac pioneered the Neo-Impressionist concern with modern proletarian reality, searching working-class neighborhoods for new urban subjects. Thereafter, Dubois-Pillet and Luce expanded these themes: the former produced numerous canvases of the working barges along the Seine (plate 93), and the latter seemed drawn to Paris in transition, with its clutter of demolition and reconstruction. The common bond of anarchism that united Signac, Pissarro, and Luce was perhaps most deeply rooted in the last, whose political activities led to a four-month imprisonment in 1894. His subsequent move to Belgium, where he painted the grim realities of industrialization in the city of Charleroi, contributed to the growing popularity of the Neo-Impressionist style there.

95

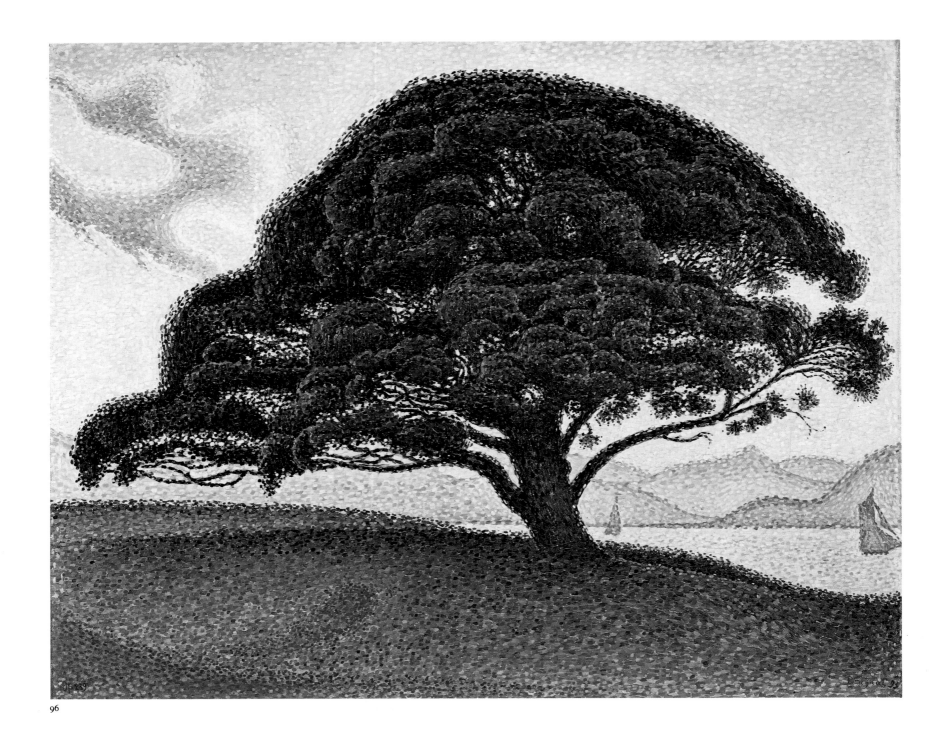

96

The Late Years

The death of Seurat in 1891 deprived Neo-Impressionism of its most original and accomplished master and dealt a severe blow to the development of the style. The defection of Pissarro and the death of Dubois-Pillet in 1890 had already shortened the official roster of Neo-Impressionists in Paris, and the attention that the artists had garnered from vanguard critics was deflected by growing awareness of the achievements of Gauguin and his followers (see chapter 5). On the occasion of Seurat's death, Teodor de Wyzewa, a Symbolist critic who was not particularly sympathetic to Seurat's innovations, nonetheless wrote an acute appraisal of his character and convictions:

> . . . on the first evening I met him I discovered that his soul was a soul of yesteryear. The secular disillusionment which renders the task of today's artists so difficult never had any hold over him. He believed in the power of theories, in the absolute value of methods. . . .

A depression provoked by Seurat's death in 1891 induced Signac to abandon Paris for Brittany that summer. He sought solace in sailing, one of his lifelong passions. His friend Cross had settled in the south of France, and his enthusiastic descriptions of the landscape convinced Signac to sail his boat down the Atlantic coast and into the Mediterranean. There he discovered St. Tropez, then an isolated and modest little port, and was enraptured by its surrounding area. The luxuriant vegetation of the gardens and the majesty of the abundant pines inspired the high-key palette and curvilinear design that increasingly characterized Signac's paintings of the 1890s.

And I was overjoyed to discover in a corner of Montmartre such an admirable specimen of a race that I had thought extinct, the race of painter-theorists, uniting practice to ideas and unconscious fantasy to reasoned effort. Yes, I sensed very clearly in Seurät a kinsman of Leonardo, of Dürer, of Poussin. I never tired of hearing him explain the details of his researches, the order in which he intended to pursue them, the number of years he planned to devote to them. . . .[23]

With the death of Seurat, Signac assumed active leadership of the group. He also took on the task of sustaining Seurat's memory through his activities in the Société des Indépendants and his contacts in Les XX and of defending Neo-Impressionism's accomplishments in the face of serious challenge by other aesthetic positions. In the years that followed Seurat's death, his achievements were virtually forgotten, prompting Signac to voice resentment about the disparity between the public's perception of his friend and of van Gogh, who had died less than a year before him. It was in this defensive spirit that Signac wrote *D'Eugène Delacroix au Néo-Impressionisme*, utilizing his impressive gifts as a propagandist to vindicate the movement, to establish its genealogy, and to correct erroneous assumptions that had dogged it since its inception. After citing the contributions of the Impressionists and their successors, he predictably underscored the superiority of the technique that he and Seurat had pioneered: "By the elimination of all muddy mixtures, by the exclusive use of the optical mixture of pure colors, by a methodical divisionism, and a strict observation of the scientific theory of colors, the neo-Impressionist insures a maximum of luminosity, of color intensity, and of harmony—a result that had never yet been obtained." [24]

If Seurat's death gave a new urgency to Signac's propagandizing, it can be argued that it also liberated him from the protective shadow of his friend and enabled him to find his own unique voice. Signac recognized this when he acknowledged the stylistic shift that took place in the mid-1890s in his own work and that of Cross: "We are emerging from the arduous and necessary period of analysis, which resulted in a certain uniformity of painting, to enter a new phase, that of individual and varied creation." [25] At the time he wrote these words, Signac had left Paris with Cross to live and work in the south of France. A passionate sailor, he had discovered the fishing village of St. Tropez on the Mediterranean a few years before. There he labored, sometimes in Cross's company, developing a new chromatic opulence and altering the size of the brushwork to suit the more decorative ends of his large landscapes and figure compositions.

In a period of general reaction against the art of the Impressionists, the Neo-Impressionists offered coherent, persuasive formulations of their practices and objectives. While their search for a style expressive of their own scientific age required them to sacrifice immediacy in painting, it provided a new emphasis on the medium's intellectual and self-reflexive character that in many ways paralleled the example of Cézanne. Paradoxically, the reform of the picture surface that was inspired by the rationalist and scientific spirit of Neo-Impressionism was to have its most immediate appeal to the Fauves, a group of artists whose name has become synonymous with the irrational and the instinctual (see chapter 6).

97

96. Paul Signac (1863–1935). *A Pine on the Road to St. Tropez*, 1893. Oil on canvas, 25⅞ x 31⅞ in. The Museum of Fine Arts, Houston; The John A. and Audrey Jones Beck Collection.

97. Henri Edmond Cross (1856–1910). *Artist's Garden at St. Clair*, 1908. Watercolor on paper, 10½ x 14 in. The Metropolitan Museum of Art, New York; Harry Brisbane Dick Fund, 1948.

Neo-Impressionism in Belgium

With its scientific and progressivist overtones, Neo-Impressionism inspired a fervor akin to that aroused by religion. Nowhere was this more apparent than in Belgium, where a powerful renaissance of the arts took place during the 1880s. Emulating the Impressionists, liberal Belgian artists and critics formed an organization in opposition to the local Salon, which they called the Cercle des Vingt or Les XX. With membership limited to twenty, the group sought to promote a new spirit in the visual arts. In 1887 the members of Les XX invited Seurat and Pissarro to exhibit in Brussels, and with this exhibition the Neo-Impressionists established a firm foothold in Belgium. The prestige they enjoyed there gave a foretaste of the international popularity the style would acquire in the following decade.

Among the Belgian converts, the names of Théo van Rysselberghe and Henry van de Velde are the most celebrated. As a student at the Brussels Academy, van Rysselberghe had been attracted to the works of Degas, Manet, and Whistler, and his attachment to these artists is still visible in the *Portrait of Madame Charles Maus* (plate 98), painted about a year after he had begun to adopt the Pointillist technique. Van de Velde, who would later turn his talents to architecture and interior design, responded immediately to the technical allure of Neo-Impressionism, as can be seen in his daringly simplified view of the beach at Blankenberghe (plate 100). The uniformity of the texture, the contrast of the saturated yellows of its center with the darker areas of sky and shadow, and the bold stylizations of natural and man-made forms reflect his sensitive application of Seurat's and Signac's new ideas about color and compositional harmony.

In subject matter and execution, the paintings of other Belgian Neo-Impressionists such as Willy Finch (plate 102) and Georges Lemmen (plate 104) reveal a closeness to Pissarro. Those of the Dutch painter Jan Toorop, who was an active member of Les XX until his return to Holland in 1889, display a certain freedom in the more widely spaced placement of the dots, which imparts an almost textilelike character to his canvases, such as *The Shell Gatherer* (plate 103).

98

98. Théo van Rysselberghe (1862–1926). *Portrait of Madame Charles Maus*, 1890. Oil on canvas, 22 x 18⅛ in. Musées Royaux des Beaux-Arts, Brussels.

99. Théo van Rysselberghe (1862–1926). *Heavy Clouds, Christiana Fjord*, 1893. Oil on canvas, 19½ x 24½ in. Indianapolis Museum of Art; The Holliday Collection.

99

100

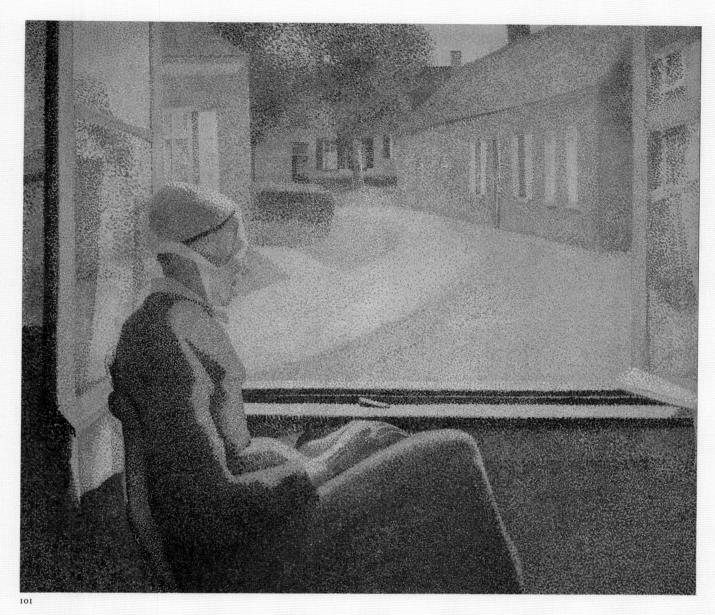

101

100. Henry van de Velde (1863–1957). *Blankenberghe*, 1888. Oil on canvas, 27½ x 39⅜ in. Kunsthaus, Zurich.

101. Henry van de Velde (1863–1957). *Woman at a Window*, 1889. Oil on canvas, 43⅝ x 49⅛ in. Koninklijk Museum, Antwerp.

102. Willy Finch (1854–1930). *Orchard at La Louvière*, 1891. Oil on canvas, 21¼ x 26¼ in. The Art Museum of the Ateneum, Helsinki.

102

103

104

103. Jan Toorop (1858–1928). *The Shell Gatherer*, 1891.
Oil on canvas, 24¼ x 26 in. Rijksmuseum Kröller-Müller,
Otterlo, The Netherlands.

104. Georges Lemmen (1865–1916). *The Thames*, 1892.
Oil on canvas, 24⅜ x 33½ in. Museum of Art, Rhode
Island School of Design, Providence; Anonymous gift.

105. Jan Toorop (1858–1928). *The Print Lover*, c. 1891.
Oil on canvas, 25⅝ x 29⅞ in. Rijksmuseum Kröller-
Müller, Otterlo, The Netherlands.

106. Jan Toorop (1858–1928). *The Sea*, 1899. Oil on
canvas, 18⅛ x 19⅝ in. Rijksmuseum Kröller-Müller,
Otterlo, The Netherlands.

105

106

109

Divisionismo

In Italy, where an independent response to the optical theories of O. N. Rood had produced a movement that explored light and color somewhat less systematically than did Neo-Impressionism, the style known as Divisionismo gained prominence in the 1880s. Despite the similarity of the name—which, like the French term, derived from Rood's notion of dividing and juxtaposing colors—the two movements were essentially unconnected. Unlike their French counterparts, the Italian artists never exhibited as a group, and their work displays considerable diversity in subject matter and execution. The paintings of Angelo Morbelli (plate 108) and Giuseppe Pellizza da Volpedo (plate 109) reveal a rigorous study of color theory, methodical brushwork, and explicit social concerns, whereas those of Vittore Grubicy de Dragon (plate 107), Gaetano Previati, and Giovanni Segantini often employ irregular brushwork and more subjective color to express their essentially philosophical and symbolic interests.

Despite their different emphases, most of the Divisionisti shared progressive ideas and a commitment to social reform that paralleled those of the major Neo-Impressionists. The evident socialist message of Volpedo's *The Fourth Estate* would have pleased Signac or Luce had it been shown, as originally intended, at the Paris world's fair in 1900. But the demanding scale of the composition (nine by seventeen feet) kept the artist from finishing it in time. On first glance the work may appear to be little more than a realistic depiction of a surging mass of agricultural workers; yet on closer examination the painted surface reveals a network of minute brushstrokes of vibrant pigmentation.

107

107. Vittore Grubicy de Dragon (1851–1920). *At the Warm Spring*, 1890–1901. Oil on canvas, 18½ x 15½ in. Civica Galleria d'Arte Moderna, Milan.

108. Angelo Morbelli (1853–1919). *The Christmas of Those Left Behind*, 1903. Oil on canvas, 23½ x 41 in. Museo d'Arte Moderna Ca' Pesaro, Venice.

108

109

109. Giuseppe Pellizza da Volpedo (1868–1907). *The Fourth Estate*, 1904. Oil on canvas, 9 ft. 2¾ in. x 17 ft. 2¾ in. Civica Galleria d'Arte Moderna, Milan.

3 SYMBOLISM
The Escape from Nature

The whole visible universe is but a storehouse of images and signs to which imagination will give a relative place and value; it is a pasture which the imagination must digest and transform. All the faculties of the human soul must be subordinated to the imagination.

Charles Baudelaire, 1859

FROM 1884 on, a plurality of styles enlivened the exhibitions organized by the Société des Artistes Indépendants, in which Neo-Impressionism mingled with modified Impressionism, with academic paintings, and with the works of genuine independents such as Odilon Redon, whose highly personal subject matter and technique represented an alternative and determinedly antinaturalist aesthetic.

The growing disenchantment with Impressionism in artistic circles was complemented and, in fact, nourished by a rejection of literary Naturalism. The publication of Arthur Rimbaud's prose poems *Les Illuminations* in 1886 and of Stéphane Mallarmé's collected poems the following year, as well as the appearance of several literary magazines, lent credence to the claim of the poet Jean Moréas that a new movement was under way in literature and art. In his "Manifeste littéraire: Le Symbolisme" (1886), Moréas asserted that this movement was opposed to the "false sensibility . . . of . . . objective description."[1] Its goal was evocation, not depiction. Like Mallarmé, who had admonished artists to "paint not the thing, but the effect it produces,"[2] he believed that objective experience could serve only as a point of departure for the creative act.

Published in the widely read newspaper *Le Figaro*, Moréas's audacious theories predictably excited criticism and provoked indignant responses from such conservative writers as Anatole France. They also inspired the poets Jules Laforgue and Gustave Kahn to express equally radical views regarding subject matter, language, and syntax that had serious implications for the visual arts. For example, Kahn argued:

> As to subject matter, we are tired of the quotidian, the near-at-hand, and the compulsorily contemporaneous; we wish to be able to place the development of the symbol in any period whatsoever, and even in outright dreams (the dream being indistinguishable from life). We want to substitute the struggle of sensations and ideas for the struggle of individualities, and for the center of action, instead of the well-exploited decor of squares and streets, we want the totality or part of the brain. The essential aim of our art is to objectify the subjective (the externalization of the Idea) instead of subjectifying the objective (nature seen through the eyes of a temperament).[3]

The view that objective experience was limited and that it acquired significance only when transformed into a symbol of something otherwise inexpressible was shared by

111

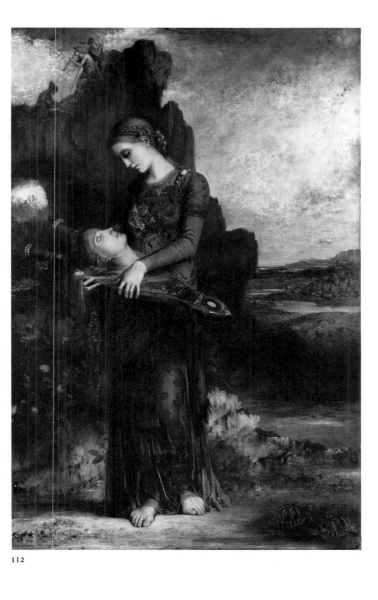

112

111. Gustave Moreau (1826–1898). *Jupiter and Semele*, 1895. Oil on canvas, 83⅝ x 46⅜ in. Musée Gustave Moreau, Paris.

112. Gustave Moreau (1826–1898). *Orpheus*, 1865. Oil on panel, 60⅝ x 39⅛ in. Musée du Louvre, Paris.

the artists and writers who rallied under the banner of Symbolism. Yet this fundamental ideology was hardly new: Moréas himself acknowledged the historic contributions that had been made at mid-century by the poet and critic Charles Baudelaire, whom he designated as Symbolism's "true precursor." Baudelaire was particularly struck by the way that imagination enabled the artist, whether poet, painter, or composer, to grasp an inner reality and transmit it through the senses. His perception that the arts shared an essential character led him to define the components of color, for example, in musical terms: "In color, we find harmony, melody, and counterpoint." [4]

Baudelaire's sensitive response to music—in particular, to the operas of Richard Wagner—prefigured the enormous enthusiasm for the visual, dramatic, and musical innovations of the German composer that gripped the painters and poets of the Symbolist generation. Writing about a performance of *Tannhäuser*, Baudelaire articulated the interconnection of music and painting: ". . . for what would be truly surprising would be to find that sound *could not* suggest color, that colors *could not* evoke the idea of melody, and that sound and color were unsuitable for the translation of ideas, seeing that things have always found their expression through a system of reciprocal analogy. . . ." [5] Wagner's unique gifts enabled him to combine the elements of opera— music, text, and spectacle—in a heretofore-unrealized aesthetic whole, and this *Gesamtkunstwerk*, or total work of art, provided a compelling model for the theorists and practitioners of Symbolism. The mélange of Nordic mythology and medieval mysticism in the composer's music-dramas bestowed a sacred character on them; by extension, many Symbolists began to see the creative act itself as essentially religious.

The appearance of the journal *Revue wagnérienne* in Paris in 1885 was not only a confirmation of the sweeping popularity enjoyed by the composer at that time but also an indication of the extent to which the Wagnerian aesthetic was being incorporated into emerging Symbolist theories about the evocative functions of art. The review's founder, Edouard Dujardin, became one of the most aggressive proselytizers of antinaturalism:

> In painting as well as in literature the representation of nature is idle fancy. . . . The aim of painting, of literature, is to give the sensations of things through means specific to painting and literature; what ought to be expressed is not the image but the character. . . . Therefore, why retrace the thousands of insignificant details the eye perceives? One should select the essential trait and reproduce it—or, even better, produce it. . . . Scorning photography, the painter will set out to retain, with the smallest possible number of characteristic lines and colors, the *intimate reality*, the essence of the object he selects. Primitive art and folklore are symbolic in this fashion. . . . And so is Japanese art. [6]

This disdain for representational art as well as the rejection of contemporaneous subjects as inherently trivial reflected a widely shared conviction among the Symbolists that such art was unintellectual and unpoetic. Moreover, this conviction was coupled with the idea that folk and non-Western art possessed a powerfully expressive character, a notion that was gaining currency with such painters as Paul Gauguin and Emile Bernard, among others (see chapter 4).

Another contribution to the genesis of the Symbolist movement had been provided in 1884 by the publication and subsequent popularity of Joris Karl Huysmans's novel *A Rebours* (Against Nature). A former ally of Zola and the literary Naturalists, Huysmans announced his rupture with them in this flamboyant novel, whose reclusive and decadent protagonist, des Esseintes, seemed a spokesman for the nascent aesthetic. An admirer of the sensuous and evocative poetry of Baudelaire and Mallarmé, des Esseintes is also an avid collector of art whose favorite painters are Gustave Moreau and Odilon Redon. Huysmans's description of the former's work captures the almost suffocating opulence of his canvases and appropriately links them with the exotic imagery of Baudelaire:

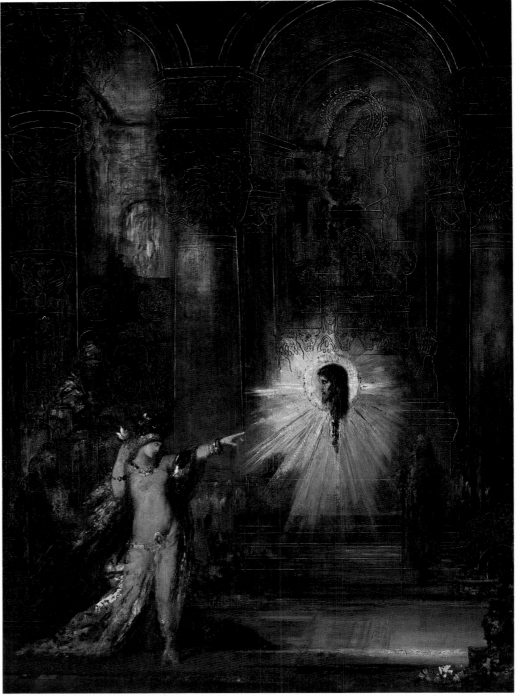

113

The growing public acclaim of Moreau's work, typified by his enormous success in the Salon of 1876, came at a time when the Impressionists were struggling to organize their second group show in the face of strong critical and popular resistance. Both the "retrograde" content and elaborate style of Moreau's canvases were so repugnant to Emile Zola, the major exponent of literary Naturalism and an early champion of Impressionism, that he wrote a scathing article about them in an influential Russian periodical, The Messenger of Europe. *For perhaps the first time, Moreau was linked with the word* Symbolism, *which Zola invoked as a pejorative.*

[Moreau's] sad and scholarly works breathed a strange magic, an incantatory charm which stirred you to the depths of your being like the sorcery of certain of Baudelaire's poems, so that you were left amazed and pensive, disconcerted by this art which crossed the frontiers of painting to borrow from the writer's art its most subtly evocative suggestions, from the enameller's art its most wonderfully brilliant effects, from the lapidary's and etcher's art its most exquisitely delicate touches.[7]

113. Gustave Moreau (1826–1898). *Apparition (Salome)*, 1874–76. Oil on canvas, 55¾ x 40⅜ in. Musée Gustave Moreau, Paris.

114. Gustave Moreau (1826–1898). *Oedipus and the Sphinx*, 1864. Oil on canvas, 81¼ x 41¼ in. The Metropolitan Museum of Art, New York; Bequest of William H. Herriman, 1921.

Gustave Moreau

One of the first painters to make the transition from academicism to Symbolism, Moreau had been a pupil of Théodore Chassériau, himself a follower of Delacroix. Moreau began to exhibit in the Salon during the 1850s, but it was not until the following decade that his eccentric renderings of biblical and mythological subjects began to provoke critical consternation. Well-to-do and thus not obliged to sell his work,

Moreau lived a reclusive existence with his adored mother, pursuing his interests in archaeology, philosophy, and religion. In his huge Paris studio—today a museum devoted to his work—Moreau increasingly indulged his imagination in grandiose compositions. So complex were the multitude of painterly and other effects in his canvases that their bizarre, dreamlike subject matter was often all but smothered.

Moreau made his initial impact on the public with the exhibition of *Orpheus* (plate 112) in the Salon of 1866. The carefully modulated colors, glazed finish, and evident quotations of Leonardo's landscapes (*Madonna of the Rocks* and *Mona Lisa*) might suggest an academician's reverent eclecticism were it not for the unsettling novelty of the painting's content. Disdaining traditional representations of the classical legend, Moreau seized upon the macabre moment when a young maiden recovered the severed head and lyre of the tragic musician after he had been murdered by Thracian women infuriated by his rejection of female love. The viewer confronts here the essential ingredients of Symbolist art and literature: death, longing, and passionate devotion to art. Radically different from the fashionable Salon style of Alexandre Cabanel and the problematic modernity of Manet, Moreau's *Orpheus* exercised an almost hypnotic fascination on contemporary viewers and was purchased by the French government.

The fetishistic and decadent atmosphere associated with Moreau's early work reached its most dazzling expression in *Apparition* (*Salome*) (plate 113), whose protagonist was to become the quintessential *femme fatale* for such writers as Oscar Wilde. Combining the sumptuous reds and golds of the principal figures with an etched line that suggests the ghostly contours of a palace, Moreau endowed this painting with a visual and tactile appeal so evocative that it stimulates the other senses as well.

In *Jupiter and Semele* (plate 111), considered by some to be Moreau's greatest painting, and certainly a tour de force of Symbolist imagery, the glittering opulence of his architectural inventions and the complex intermingling of human, animal, and decorative elements project an iconic power. Moreau himself described this painterly construction as "aerial, colossal, with neither foundation nor summit"[8] and indicated that he wished to express through its metamorphosing forms the ascent of life toward the divine. Yet this world of telescoped distances and mysterious twilight evolved as a result of careful analysis and calculation. Moreau's painstaking studies of real animals at the Jardin des Plantes in Paris enhanced the authenticity of his zoological detail even after it had been transmogrified into dragon, griffin, or sphinx. It was, in fact, his cool organizational skill, his innate sense of color, and his encyclopedic store of images that enabled Moreau to fashion visual equivalents for the words of poets. More than a magician, he was a superb aesthetic engineer.

In his later works, Moreau's handling of color and design became more arbitrary and more expressive. Hundreds of watercolors and oil sketches made in the 1880s and '90s but never exhibited document the painter's increasing tendency to emphasize the emotional power of color. In the years after 1892, when he assumed a professorship at the Ecole des Beaux-Arts, he transmitted this love for color to a group of young painters, including Henri Matisse, Albert Marquet, and Georges Rouault. Moreau discouraged emulation and urged his students to develop independent styles. While unanimously acknowledging the breadth of his knowledge and the value of his teaching, they paid him the compliment of taking his advice. Rouault later stated that his teacher had an intuition about the relevance of his art to the future, maintaining, "I am the bridge over which certain of you will pass."[9] In the years following Moreau's death, appreciation of the profound significance of his artistic achievement grew even deeper. The young André Breton visited the painter's studio-museum in 1912, and the revelations of that initial experience would later prompt him to claim Moreau as one of the major precursors of Surrealism.

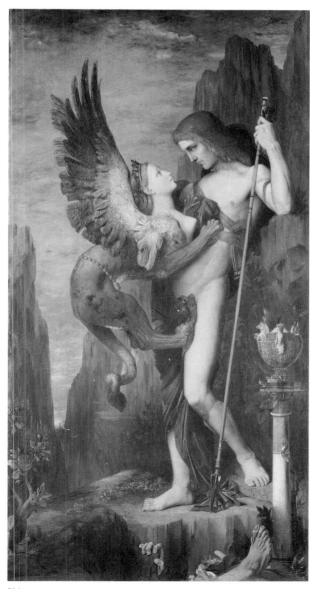

114

Dutch Jan Toorop, the Swiss Ferdinand Hodler, and the Belgian Fernand Khnopff—distinguished themselves from the uninspired and superficial imitators of Moreau and Puvis de Chavannes. Indeed, the strength and originality of Khnopff's work was so apparent in that first Salon that it elicited the Sâr's unqualified praise.

The history of the Salon de la Rose+Croix is but one example of the philosophic and aesthetic complexity of the Symbolist movement at the beginning of the 1890s, and it underscores the problem of defining Symbolism's character and objectives. Clearly, not all of what has come to be regarded as Symbolist art shares identical concerns about subject or form. Whereas the repertory of early Symbolism, as exemplified in the works of Moreau, Puvis de Chavannes, and Redon, was more dependent on such literary sources as the Bible, mythology, or the occult, the artists whom these masters inspired would develop a patently more introspective approach. Nonetheless, certain characteristics common to the initial phase of Symbolism as well as to the later manifestations of the style—which are the concern of chapter 5—can be identified: the rejection of objective naturalism and its concomitant materialism in favor of the realm of feeling and imagination; the belief that the artist's eye was subordinate to his creative intellect; and the conviction that line and color had deeply expressive functions, not simply descriptive ones. The rejection of the idea that art was obliged to reproduce nature enabled artists to focus on its independent character and structure and led them to appreciate it as an equivalent rather than an imitative reality. By freeing art from its dependence on the external world, the Symbolist painters could willfully manipulate both natural and invented forms to serve their emotional and intellectual objectives. One of the consequences of the new approach to composition, announced in the work of Puvis de Chavannes, was an increasing tendency to assert the two-dimensional picture plane through continuous line and flat color. This, in turn, would lead many artists in the 1890s to stress the decorative character of painting.

The Symbolists' obsession with theory was rivaled only by that of the Neo-Impressionists, who shared their aversion to the unsystematic approach of Impressionism. Ironically, the reassessment of the nature and function of painting that both groups so energetically promoted would be most radically advanced by two artists whose development had been crucially linked to Impressionism: Paul Gauguin and Vincent van Gogh.

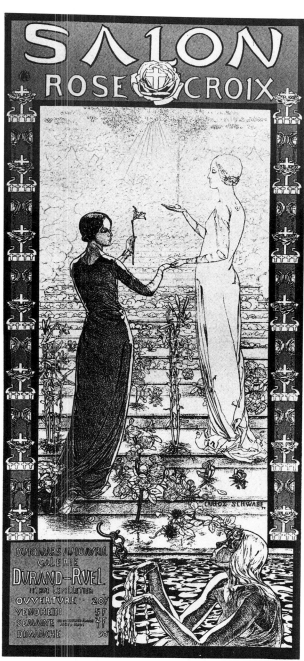

126. Carlos Schwabe (1866–1926). *Poster for the Salon de la Rose+Croix*, 1892. Dimensions unknown. Bibliothèque Nationale, Cabinet des Estampes, Paris.

Symbolism in the Low Countries

The rebellion against the established art of the academies that had given rise to Impressionism in the 1870s was slow to arrive in neighboring Belgium and Holland. But by the early 1880s, when Symbolism was making headway in Paris, innovations in art and literature began to appear in those countries as well. In Brussels a group of twenty Belgian painters, outraged by the rejection of their works by the Salon, founded an organization called Les XX to present annual exhibitions. While they shared no clear aesthetic program, the many Belgian artists associated with Les XX—including such founding members as Fernand Khnopff and James Ensor—were motivated by a common desire to move beyond representing the external world in order to communicate ideas and feelings. Their quest for a new idiom made them responsive to many sources of inspiration, including their own native heritage of brilliant color, but they were most powerfully affected by the French Symbolists and by the various manifestations of vanguard painting that came directly from Paris to their exhibitions in Brussels.

Fernand Khnopff

Although he achieved international fame as a painter of symbols and allegory, Khnopff never abandoned the Realism that had been the dominant force in Belgium at the time he began his art studies. He was keenly interested in photography and often utilized photographs in painting portraits, though only as a point of departure for transforming external reality into a deeper, spiritual reality. For a decade, Khnopff explored the theme of solitude, frequently utilizing his adored younger sister Marguerite as his model (plate 128). Indeed, in the enigmatic *Memories* (plate 130), for which he had made numerous photographic studies, he depicted her in seven different poses. It has been suggested that the celibate Khnopff's obsession with his sister reflected an incestuous, if sublimated, eroticism, and certainly her uncommon presence in his oeuvre lends credence to this speculation.

The inspiration for *I Lock My Door upon Myself* (plate 129) was provided by a poem written nearly thirty years earlier by Christina Rossetti, the sister of the Pre-Raphaelite painter-poet Dante Gabriel Rossetti. The only relief from the painting's somber browns is provided by the orange lilies, which form a barrier between the woman and the

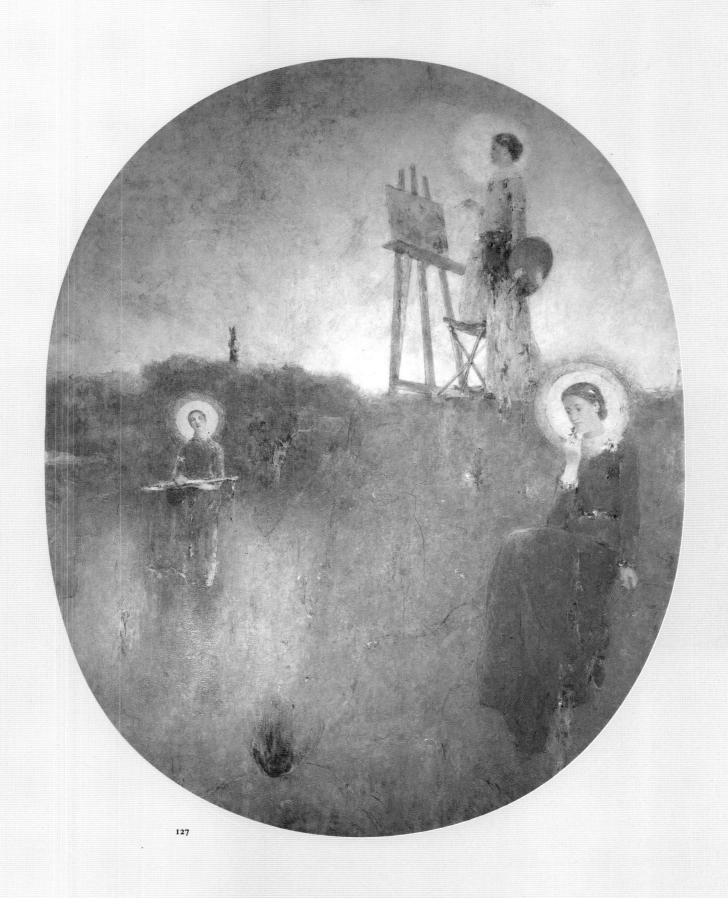

127

127. Fernand Khnopff (1858–1921). *A Ceiling: Painting, Music, Poetry*, 1880. Oil on canvas, 126 x 94½ in. Barry Friedman, Ltd., New York.

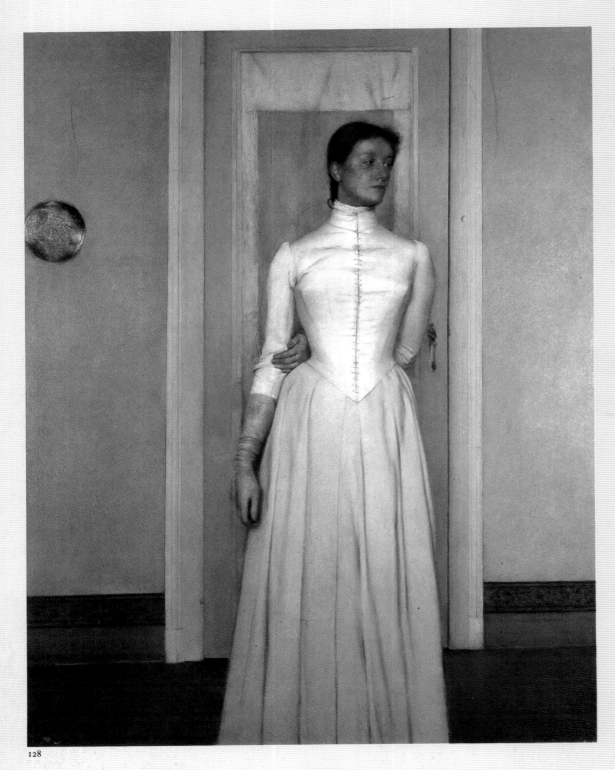

128

128. Fernand Khnopff (1858–1921). *Portrait of Marguerite Khnopff*, 1887. Oil on canvas mounted on board, 38 x 29½ in. Private collection, Brussels.

129. Fernand Khnopff (1858–1921). *I Lock My Door upon Myself*, 1891. Oil on canvas, 28⅜ x 55 in. Staatsgalerie Moderner Kunst, Munich.

130. Fernand Khnopff (1858–1921). *Memories*, 1889. Pastel on paper, 49⅞ x 78⅝ in. Musées Royaux des Beaux-Arts, Brussels.

viewer, and by the blue wings of the marble head of Hypnos, god of sleep, whose features are strikingly similar to those of Marguerite. The careful manipulation of surfaces, both reflective and opaque, and the rigidly compartmentalized structure function as visual metaphors for the psychic or spiritual closure that is the painting's subject.

Khnopff explored the diametrically opposite female personae that had figured prominently in the imaginations of writers and artists since the 1880s: the ideally frail virgin versus the potent sexual aggressor. Yet there was another image of sexuality that began to challenge the supremacy of the blessed damozel and the *femme fatale* in the last decade of the century: the androgyne. It was to this haunting image, which combined and transcended both sexes, that Khnopff turned in his most celebrated canvas, *The Caress (The Sphinx)* (plate 131), which was deeply influenced by various writings of Péladan that celebrated the aesthetic superiority of androgyny.

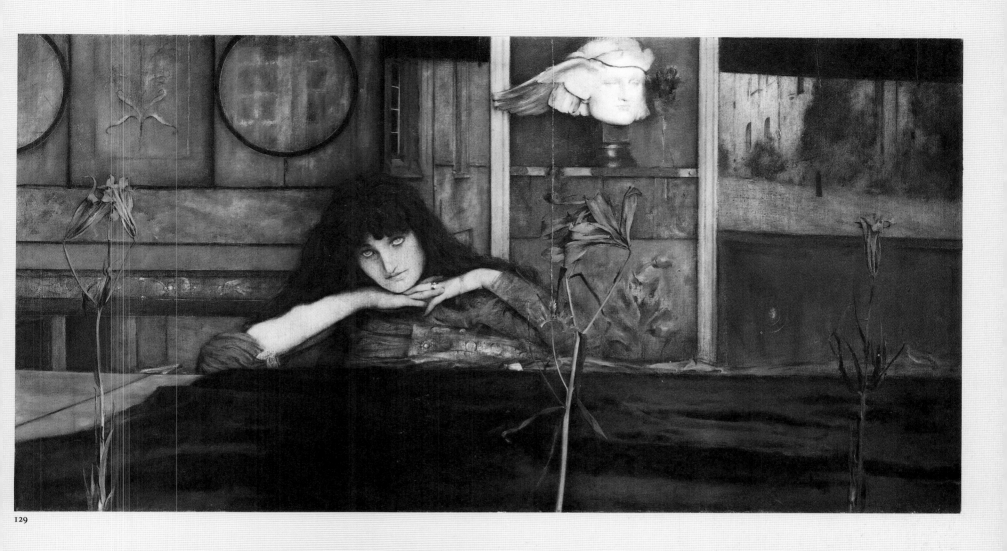

129

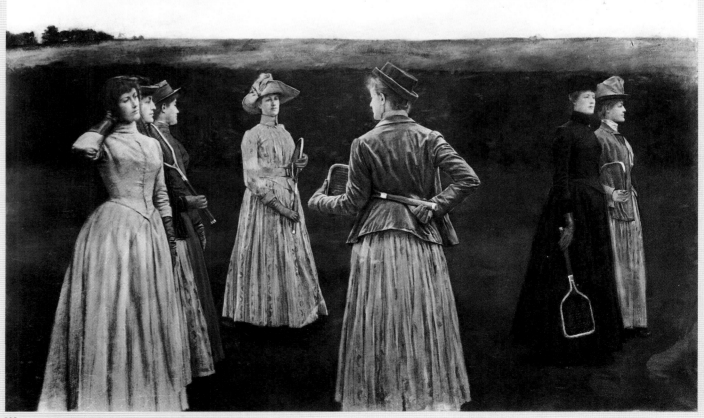

130

131

131. Fernand Khnopff (1858–1921). *The Caress (The Sphinx)*, 1896. Oil on canvas, 19⅞ x 59 in. Musées Royaux des Beaux-Arts, Brussels.

132. Fernand Khnopff (1858–1921). *Ygraine in the Doorway*, 1898. Pastel and white chalk on gray paper, 9 x 15¼ in. Barry Friedman, Ltd., New York.

OVERLEAF:
133. Jan Toorop (1858–1928). *The Young Generation*, 1892. Oil on canvas, 37⅞ x 43¼ in. Museum Boymans-van Beuningen, Rotterdam.

134. Jan Toorop (1858–1928). *Autumn Landscape in Surrey*, c. 1892. Oil on canvas, 25¼ x 30¼ in. Stedelijk Museum, Amsterdam.

135. Johannes Thorn-Prikker (1868–1932). *Descent from the Cross*, 1892. Oil on canvas, 34¾ x 57¾ in. Rijksmuseum Kröller-Müller, Otterlo, The Netherlands.

132

137

133

Jan Toorop

The introduction of Neo-Impressionism into the Low Countries in 1887, on the one hand, and the expanding interest in Symbolism, on the other, resulted in a rapid, and at times confusing, assimilation by native artists of seemingly antithetical styles. For example, the Dutch painter Jan Toorop, an early exhibitor with Les XX, had been quick to embrace the Divisionist technique, as is evident in such canvases as *The Print Lover* and *The Shell Gatherer* (plates 105, 103). But within a year of exhibiting his Divisionist paintings, Toorop had evolved a distinctly Symbolist approach, which was announced in *Autumn Landscape in Surrey* (plate 134) and fully realized in *The Young Generation* (plate 133).

Unlike most of his contemporaries, whose attraction to non-Western art and religion was stimulated by literature and by the few exotic artifacts that reached Europe, Toorop had direct knowledge of such works. Born in the Dutch colony of Java, he had been exposed to the indigenous art of batik, and the memory of those intricate textile patterns may well have shaped the expressive linearity employed in *The Young Generation* and subsequent works. The artist totally rejected the natural world in this vision of an eerie and airless jungle whose dense vegetation almost overwhelms the two humans

134

who inhabit it. The title of this picture obviously refers to the child in the high chair—the artist's own daughter—but also implies a future that she must confront. That future, whose technical sophistication is far removed from this primitive jungle, intrudes abruptly with the arbitrary inclusion of a telegraph pole that intersects a segment of railroad track at lower left. If the dreamlike clash of time, cultures, and symbols is confusing to present-day viewers, it was complex enough in its ambitions to be included in the first Salon de la Rose+Croix.

Johannes Thorn-Prikker

After completing his studies at the Academy in The Hague, Johannes Thorn-Prikker also began to display an interest in Neo-Impressionism, but his exposure to the work of Gauguin and, above all, to that of the somewhat older Toorop, quickly converted him to Symbolism. His close friendship with the painter and architect Henry van de Velde opened his eyes to the possibility of using textiles and stained glass as sources for his paintings. The impact of the latter on his composition is visible in *Descent from the Cross* (plate 135), in which sweeping elliptical outlines unite the central figure of Christ with the mourners in a tight, symmetrical unit. Like other Symbolists, Thorn-Prikker here replaced traditional narrative with interpretation, utilizing low-keyed colors and downward curving lines to convey a feeling of restrained sadness.

135

136

James Ensor

Of all the members of Les XX, James Ensor easily had the most original and certainly the most disquieting style. A product of the staid Brussels Académie des Beaux-Arts, he originally painted relatively conventional works, exhibiting locally and even at the Salon in Paris in 1882. Aspects of Impressionism were assimilated into his work, yielding a looseness of execution that eventually took on a distinctly expressive character. Though an interior scene such as *Russian Music* (plate 137) depicts an apparently benign domestic theme, it nonetheless suggests an unspecified gloom through its dark color and dense brushwork. Within a few years Ensor would go beneath this world of barely surfacing emotions to explore its psychic underpinnings.

By 1885, the year he painted *Skeleton Looking at Chinoiseries* (plate 139), Ensor had moved from the realm of comfortable clutter to a private world of his own invention, inhabited by the masks, dolls, and toy skeletons that were sold in his family's souvenir shop in the seaside resort of Ostend. The color contrast between the summarily painted but still recognizable Oriental images and the somber figure with skeletal head is as startling as the crudely energetic brushwork. Ensor repeatedly used masks and death's-heads to symbolize falseness and mortality. In this particular work, the roughly painted interior appears to represent the artist's studio. Since the lonely and introspective Ensor depicted himself as a skeleton on a number of occasions, this image was likely intended as a grotesque metaphor of his own obsession with death. Indeed, the artist's identification with death is underscored by his placement of a skull next to his signature in the lower left corner.

Ensor's pathological fascination with human folly found its most extreme expression in a monumental canvas, *The Entry of Christ into Brussels in 1889* (plate 136), whose

140

controversial subject, crude design, and brutal coloration were so problematic that Les XX refused to exhibit it. The work seems like an anachronistic and primitive attack on the highly civilized images recently produced by the Neo-Impressionists. In fact, it has been suggested that the painting was conceived specifically as a response to Seurat's orderly and arcadian *Grande Jatte*, which had been shown at Les XX a year earlier.

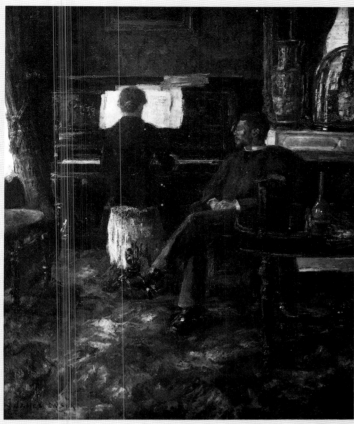

137

138

139

136. James Ensor (1860–1949). *The Entry of Christ into Brussels in 1889*, 1888. Oil on canvas, 8 ft. 5½ in. x 14 ft. 1½ in. Private collection, London.

137. James Ensor (1860–1949). *Russian Music*, 1881. Oil on canvas, 52½ x 43¼ in. Musées Royaux des Beaux-Arts, Brussels.

138. James Ensor (1860–1949). *The Ray*, 1892. Oil on canvas, 31½ x 39¼ in. Musées Royaux des Beaux-Arts, Brussels.

139. James Ensor (1860–1949). *Skeleton Looking at Chinoiseries*, 1885. Oil on canvas, 39½ x 23½ in. Julian Aberbach.

Symbolism in Germany, Switzerland, and Scandinavia

The rapid development of French painting from the Realism of Courbet to Impressionism and subsequently to Symbolism had no counterpart in Germany, where artists generally worked in isolation and were still heavily influenced by a long tradition of romantic idealism. The native reverence for nature, celebrated by such earlier nineteenth-century figures as Caspar David Friedrich and Philipp Otto Runge, asserted itself once again toward the end of the century. Woods, silent mountain lakes, and gloomy moors became the settings for works that attempted to express the ineffable mysteries of life and death. Painters like Arnold Böcklin—a Swiss-born artist who, in the 1870s, had gained a reputation in Germany for his sentimentalizing, classical landscapes—turned in the 1880s to such evocative and fantastic subjects as the celebrated *Island of the Dead* (plate 140). These compositions combined enigmatic figures, tombs, ominous skies, and murky waters to produce an atmosphere capable of transporting the viewer far away from the everyday cares or pleasures of life.

140

141

Ferdinand Hodler

In the international milieu of Central Europe, artists moved easily from one German-speaking country to another. A case in point is Hodler, born in Switzerland but also at home in Germany and France, where one of his paintings was awarded a prize at the world's fair in 1889. In the early 1880s Hodler had experienced a severe emotional crisis, prompted in part by a compelling sense of religious vocation; like another northern Symbolist painter, van Gogh, he was to satisfy his desire for spiritual fulfillment through his art. From the mid-1880s on, Hodler's painting reflected his increasing concern with the symbolic representation of the relationship between the rhythms of nature and those of emotion. He conceived a series of paintings based on the times of day, of which *Night* (plate 141), painted in 1890, and *Day* (plate 142), executed a decade later, indicate his formal and thematic intentions. The earlier work, while retaining vestiges of the naturalism that Hodler was in the process of relinquishing, already conveys the strong symmetry that would become iconic rigidity in *Day*. In the later painting, the repetitive movements of the female figures have an overwhelming sense of energy, as if the painter wished to express their communion with light, the very source of life.

In 1891 Hodler spent some months in Paris, where he experienced the full impact of French Symbolism. Soon after that he began work on *The Chosen One* (plate 143), which depicts his young son kneeling in prayer before a ceremonially planted small tree whose youthful fragility symbolically unites it with the child. Six levitating angels protectively surround the boy as if he were a latter-day Christ Child, and the overall effect of the intensely hieratic arrangement of strong lines and chilly colors is comparable to that of an altarpiece.

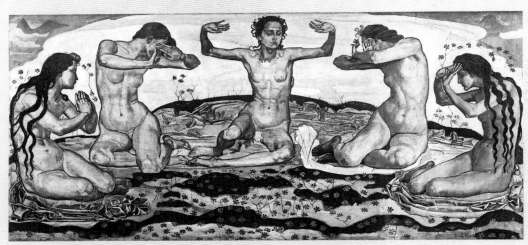

142

SEE PAGES 142–43:

140. Arnold Böcklin (1827–1901). *Island of the Dead*, 1880. Oil on canvas, 29 x 48 in. The Metropolitan Museum of Art, New York; Reisinger Fund, 1926.

141. Ferdinand Hodler (1853–1918). *Night*, 1890. Oil on canvas, 45¾ x 119 in. Kunstmuseum, Bern.

142. Ferdinand Hodler (1853–1918). *Day*, 1900. Oil on canvas, 63 x 135 in. Kunstmuseum, Bern.

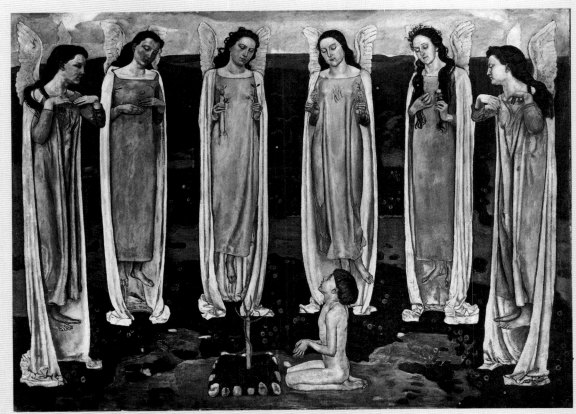

143

Edvard Munch

Edvard Munch was obsessed by death throughout his long life. His firsthand knowledge of mortality came early: his mother fell victim to tuberculosis when he was just five years old, and the death of his beloved sister eight years later left the sensitive youth with a memory that time would never efface. Years after, he observed: "Sickness, insanity and death were the black angels that hovered over my cradle and have since followed me throughout my life. . . . At an early age I was taught about the perils and miseries of life on this earth, about life after death, and also about the agonies of Hell that lay in store for children who sinned." [25]

After studying art in Christiana (modern Oslo), Munch received a government scholarship that enabled him to spend nearly three years in Paris. He familiarized himself with the dizzying variety of aesthetic alternatives offered in its Salons and galleries, and his rapid assimilation of Impressionist imagery and technique is demonstrated in such summarily executed and brightly colored canvases as *Outdoor Scene* and *Rue Lafayette* (plates 144, 145). Then, as an adjunct to his conscious effort to depict internal rather than external life, Munch gradually adopted a simplified approach to form. As the artist expressed it: "There should be no more paintings . . . of people reading and women knitting. In the future they should be of people who breathe, who feel emotions, who suffer and love." [26]

By 1893, when he painted *The Voice* (plate 146), Munch had developed a distinctive pictorial language to express his profoundly melancholy view of the human condition. This haunting vision of a young woman silhouetted against a stark Nordic landscape leaves the sun-filled Impressionist world far behind. The intensely frontal and rigid pose of the woman echoes the insistent verticality of the tree trunks and the schematized shaft of moonlight, linking these images both formally and psychologically.

144

144

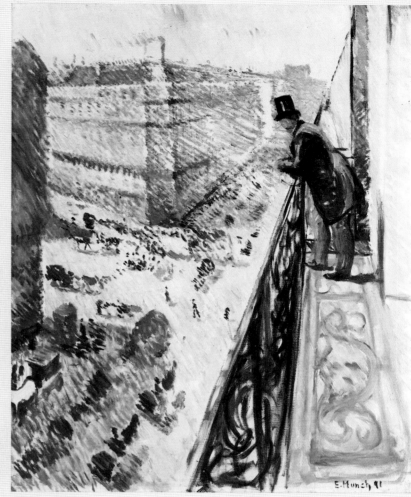

145

The woman's white dress (a traditional symbol of virginity) and the painful tension of her body—arms locked tightly behind her torso—provide the keys to the meaning of the painting. *The Voice*, like most of Munch's works, was inspired by personal experience, in this case the memory of an adolescent love affair, the artist's first sexual encounter, with a girl older than himself. Thus, it may be meant to convey both the awakening of physical desire and the fearful ambivalence associated with that awakening. The strategic placement of a tiny image in the background confirms and completes this meaning of the painting: the black and white spots summarily indicate a boat containing a male-female couple, which symbolizes the source of both the girl's longing and her apprehension.[27] If *The Voice* captures the disquieting emotions associated with the awakening of love, such paintings as *Ashes* (plate 147) convey the tortures it unleashes and the agonized emptiness that attends its loss.

Munch once likened his pictures to diaries, and he maintained that they had offered the only cure for the existential anxiety that continually plagued him. His extensive writings about art often provide insights into his painting and also illuminate Symbolism and his place within it:

> All in all, art results from man's desire to communicate with his fellows. All nature is a means to an end, not an end in itself. If it is possible to produce the desired effect by changing nature, then it should be done. A landscape will alter according to the mood of the person who sees it, and in order to represent that particular scene the artist will produce a picture that expresses his own feelings. It is these feelings which are crucial: nature is merely the means of conveying them. Whether the picture resembles nature or not is irrelevant, as a picture cannot be explained; the reason for its being painted in the first place was that the artist could find no other means of expressing what he saw. The finished work can give only a hint of what was in the artist's mind.[28]

143. Ferdinand Hodler (1853–1918). *The Chosen One*, 1893–94. Tempera and oil on canvas, 81½ x 109 in. Kunstmuseum, Bern.

144. Edvard Munch (1863–1944). *Outdoor Scene*, 1891. Oil on canvas, 25½ x 47½ in. Munch Museet, Oslo.

145. Edvard Munch (1863–1944). *Rue Lafayette*, 1891. Oil on canvas, 36¼ x 28⅝ in. Nasjonalgalleriet, Oslo.

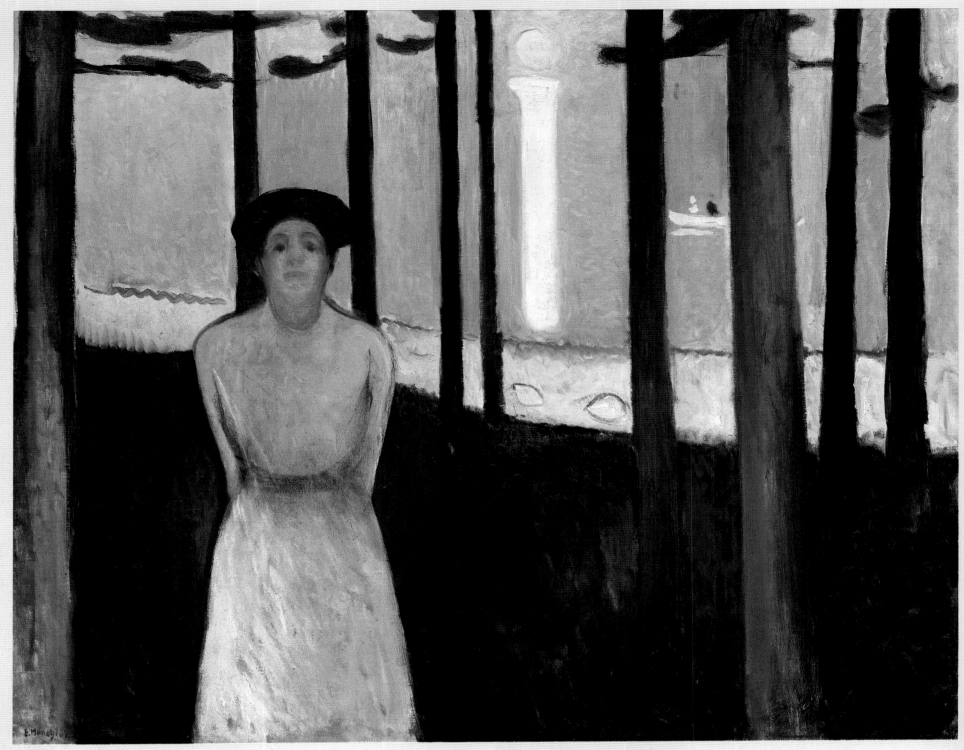

146

146. Edvard Munch (1863–1944). *The Voice*, 1893. Oil on canvas, 34½ x 43¼ in. Museum of Fine Arts, Boston; Ernest Wadsworth Longfellow Fund.

147. Edvard Munch (1863–1944). *Ashes*, 1894. Oil on canvas, 47½ x 55 in. Nasjonalgalleriet, Oslo.

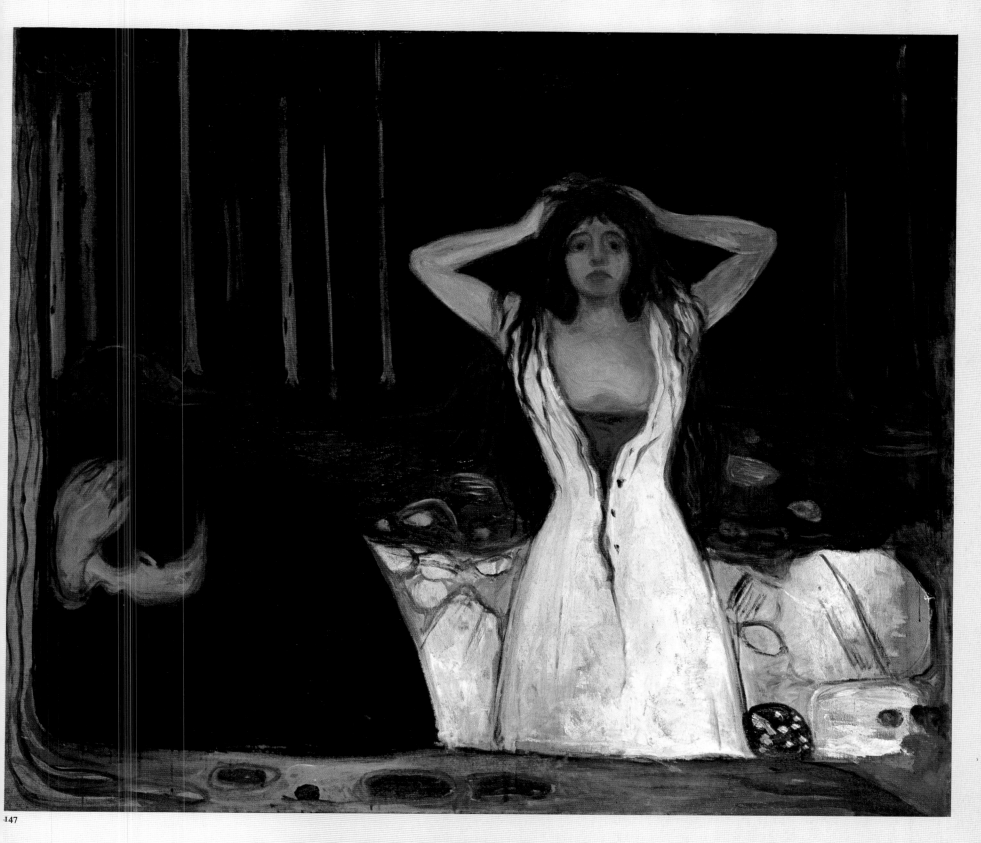

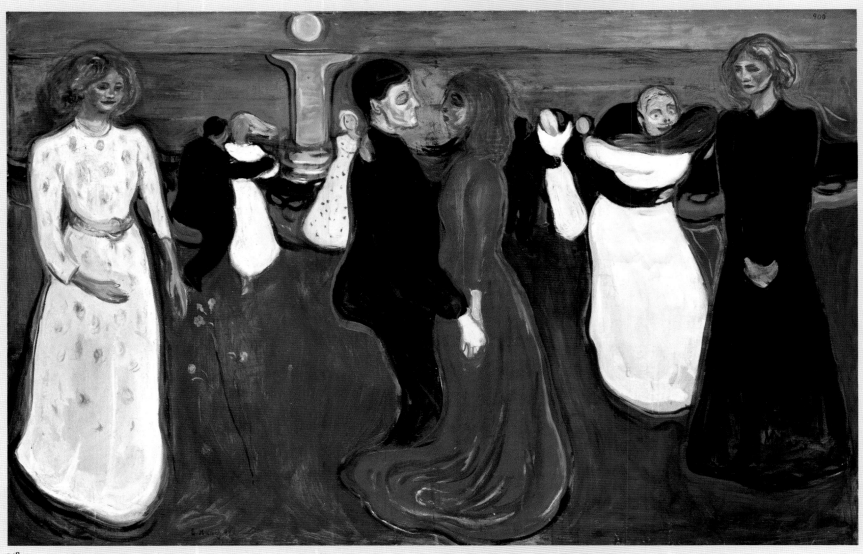

148

148. Edvard Munch (1863–1944). *The Dance of Life*, 1899–1900. Oil on canvas, 40½ x 70 in. Nasjonalgalleriet, Oslo.

149. Edvard Munch (1863–1944). *Puberty*, 1895. Oil on canvas, 59½ x 43¼ in. Nasjonalgalleriet, Oslo.

150. Edvard Munch (1863–1944). *Two People*, 1895. Etching and drypoint, 6⅛ x 8⅜ in. The Art Institute of Chicago.

151. Edvard Munch (1863–1944). *Coast at Aasgard*, 1906–7. Tempera on canvas, 35¾ x 62¾ in. Nationalgalerie, Berlin.

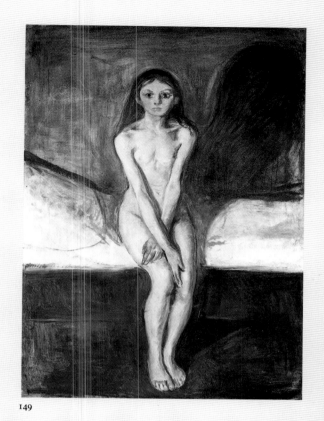

149

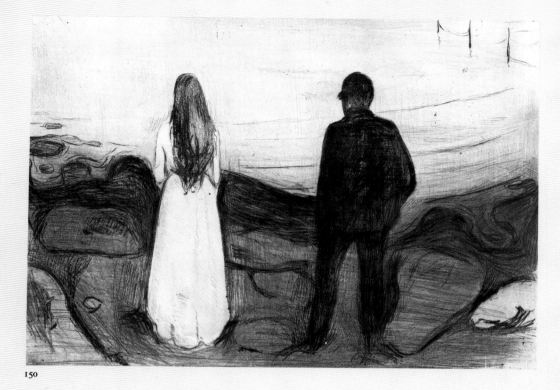

150

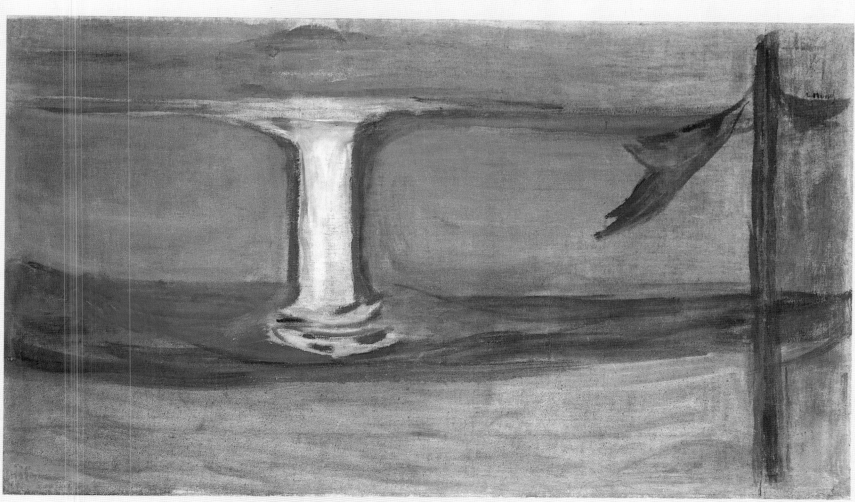

151

149

4 BERNARD, GAUGUIN, AND VAN GOGH
The Isolated Ones

WHILE most of the older Symbolist painters continued to depend on literary sources as inspiration for their work, a few members of the younger generation were searching for new subjects and more direct formal means of conveying the expanded definition of reality espoused by the poets. During the five years that followed the final Impressionist exhibition and the publication of Moréas's manifesto in 1886, three painters—Emile Bernard, Paul Gauguin, and Vincent van Gogh—cut through the elevated rhetoric of Symbolism and forged powerful personal styles that would influence the course of painting for nearly a quarter of a century.

The closeness of these three men between 1888 and 1890, before van Gogh's tragic suicide and the rupture of the others' friendship, was to have a decisive effect on their lives. Rejection of Impressionism and Neo-Impressionism was the common starting point for all three artists; they also shared a belief that art was a calling, akin to religion in its extreme demands of dedication and self-sacrifice. Bernard and Gauguin were attracted to the clarity and sincerity of Puvis de Chavannes's murals and to the conceptual rigor of ancient Egyptian art; they shared with van Gogh an enthusiasm for the flat color and insistently decorative character of Japanese woodcuts and for the naive directness of folk and popular art forms. The three painters fused these various sources with a distinctly original synthesis of line and color. For all three, removal from the sophisticated milieu of Paris was to prove the crucial factor in the radical transformation of their styles.

The Origins of the Pont-Aven School

Although Bernard and Gauguin had met briefly at Pont-Aven in Brittany during the summer of 1886, their historic friendship and collaboration would not begin for two years. Each man was drawn to the remote Breton village because it offered respite from the frustrations and intrigues of the Paris art world. While Gauguin still regarded himself as an Impressionist, painting in a style that betrayed the influence of his mentor, Pissarro, he was becoming increasingly dissatisfied with his work and with his lack of critical and financial success. Moving away from Pissarro and his Neo-Impressionist

152. Detail of plate 189

152

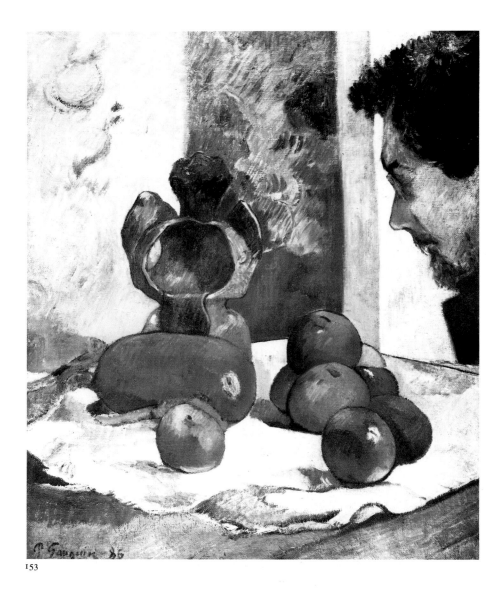

153

153. Paul Gauguin (1848–1903). *Still Life with Portrait of Charles Laval*, 1886. Oil on canvas, 18⅛ x 15 in. Josefowitz Collection.

154. Louis Anquetin (1861–1932). *Place Clichy*, 1887. Oil on canvas, 27 x 21 in. Wadsworth Atheneum, Hartford, Connecticut; The Ella Gallup Sumner and Mary Catlin Sumner Fund.

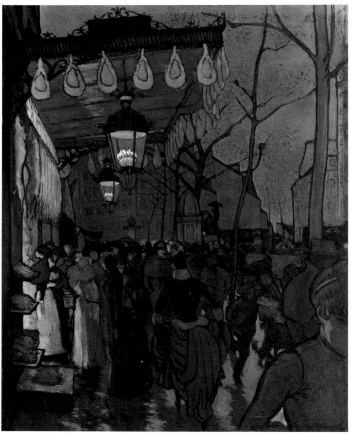

154

colleagues, Gauguin sought the company of the independent Degas, drawn to the subtle color and forceful, simplified design of the master's compositions. At the same time, Gauguin was becoming more responsive to the work of Cézanne. These new aesthetic stimuli can be seen in Gauguin's portrait of his painter-friend Charles Laval (plate 153), where the daring cropping of the sitter's head and the vastly simplified modeling of the still life already reveal a distinct departure from his earlier style.

At the time Gauguin painted Laval's portrait, the eighteen-year-old Bernard, recently expelled from the studio of Félix Cormon for being headstrong and unreceptive to his teachers, was gravitating toward the then-fashionable Neo-Impressionism, only to reject it abruptly in 1887 when he began to seek a way of permitting "ideas to dominate the technique of painting."[1] With Louis Anquetin, a companion from Cormon's studio, he developed a manner of painting that combined simplified shapes, bold outlines, and flat color. This antinaturalist style, already evident in such canvases as Bernard's *Bridge at Asnières* and Anquetin's *Place Clichy* (plates 156, 154), was dubbed Cloisonnism by the Symbolist critic Edouard Dujardin because its heavy outlines resembled those of medieval enamel work and the lead borders of stained glass. In later years the contested priority of this stylistic innovation would become a source of bitter resentment between Bernard and Gauguin, especially as the latter's reputation grew while Bernard's foundered. While there is still some dispute regarding the importance of Bernard's contributions to Gauguin's development, it is generally agreed that his association with the precocious and widely read younger artist helped him to crystallize his ideas about form and subject matter.

At the time of their second meeting in Pont-Aven, in August 1888, Gauguin responded positively to the radically simplified sense of composition evident in Bernard's

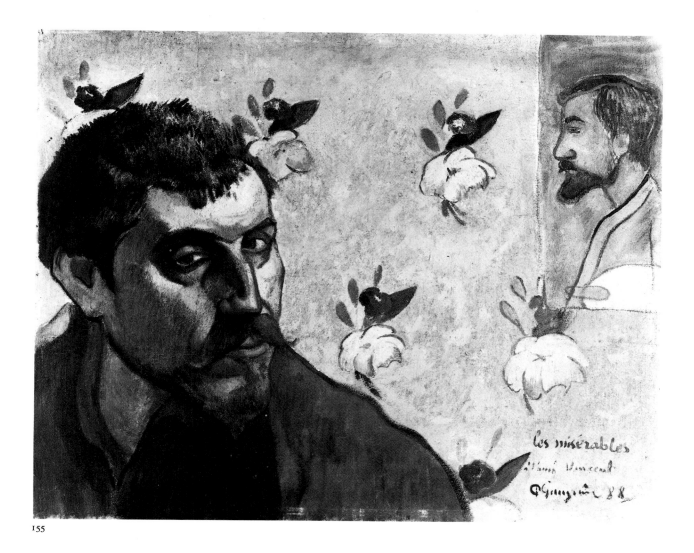

155

156

Gauguin painted this self-portrait for van Gogh, including in it a profile drawing of Bernard, which suggests how close the three artists were at the time. In a letter written to the painter Schuffenecker on October 8, 1888, Gauguin outlined his objectives: "I have sacrificed everything—execution, color—for style. . . . I believe it is one of my best things . . . it is so abstract. Head of a bandit in the foreground, a Jean Valjean (Les Misérables) personifying also a disreputable Impressionist painter shackled always to this world. The design is absolutely special, a complete abstraction. The eyes, mouth, and nose are like the flowers of a Persian carpet, thus personifying the symbolic aspect. The color is far from nature. . . ."

155. Paul Gauguin (1848–1903). *Les Misérables*, 1888. Oil on canvas, 17¾ x 22 in. Rijksmuseum Vincent van Gogh, Amsterdam.

156. Emile Bernard (1868–1941). *Bridge at Asnières*, 1887. Oil on canvas, 18⅛ x 21⅜ in. The Museum of Modern Art, New York; Grace Rainey Rogers Fund.

depictions of his sister Madeleine painted that summer (plate 158). That he began to adopt aspects of Bernard's approach is demonstrated in many of the landscapes he produced after their second encounter (plate 159). Moreover, Gauguin was surely taken by the erudition of his younger colleague, his familiarity with the theories of Symbolist art and literature, and his friendship with such insightful young writers as Georges Albert Aurier, who would play an important role in the dissemination of Symbolism and its affinities.

Both painters were deeply affected by the rustic novelty and the intense religiosity of Breton life. Bernard's Catholicism was stimulated by the naive fervor of the peasants, and Gauguin's abiding fascination with the exotic, already nurtured by a brief sojourn in

157

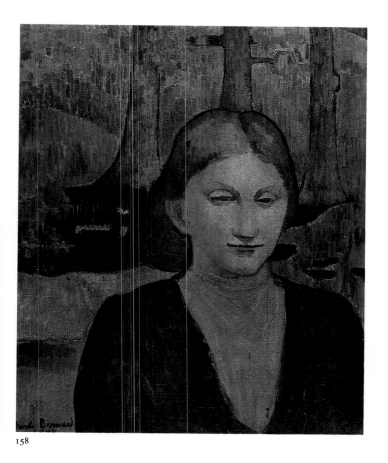

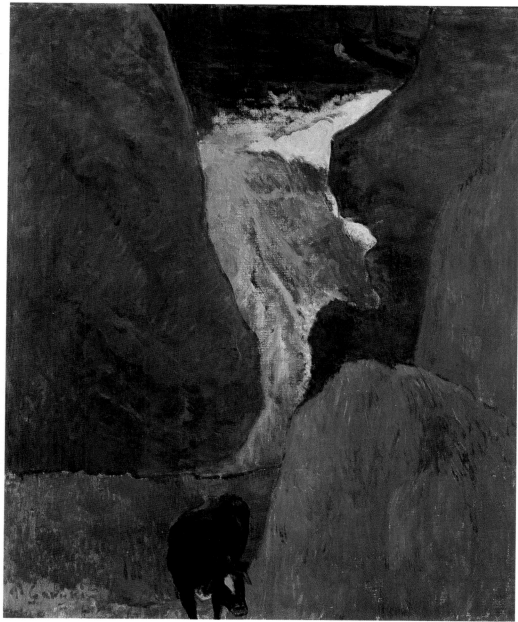

157. Emile Bernard (1868–1941). *Fireworks on the River*, 1888. Oil on panel, 34½ x 23¼ in. Yale University Art Gallery, New Haven, Connecticut; Gift of Arthur G. Altschul, B.A. 1943.

158. Emile Bernard (1868–1941). *Portrait of the Artist's Sister, Madeleine*, 1888. Oil on canvas, 24 x 19¾ in. Musée Toulouse-Lautrec, Albi, France.

159. Paul Gauguin (1848–1903). *Above the Chasm*, 1888. Oil on canvas, 28 x 23⅝ in. Musées des Arts Décoratifs, Paris.

Panama and Martinique the previous year, was strengthened by his stay in Pont-Aven. The profoundly religious and ritualistic character of the archaic agrarian society inspired both artists to paint idealized images of piety, labor, and repose. Indeed, some of these works prefigure the concerns that Gauguin was to explore in the South Pacific. In a letter written to his friend the painter Emile Schuffenecker in August 1888, Gauguin described his sense of belonging in the "savage and primitive" Breton environment and recounted his progress in effacing the vestiges of Impressionism from his work. His attempts to replace direct observation with reliance on his memory were convincing him of the futility of copying nature, and he offered the following advice, which clearly came from his recent experience: "Art is an abstraction; derive this abstraction from nature while dreaming before it, but think more of creating than of the actual result. . . . My latest works are well under way and I believe that you will find in them . . . an affirmation of my previous researches, the *synthesis* of form and color derived from the observation of the dominant element only." [2] Because Gauguin never provided a clear definition of the term Synthetism, which he often used to describe his efforts to

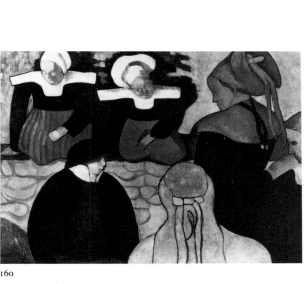

160

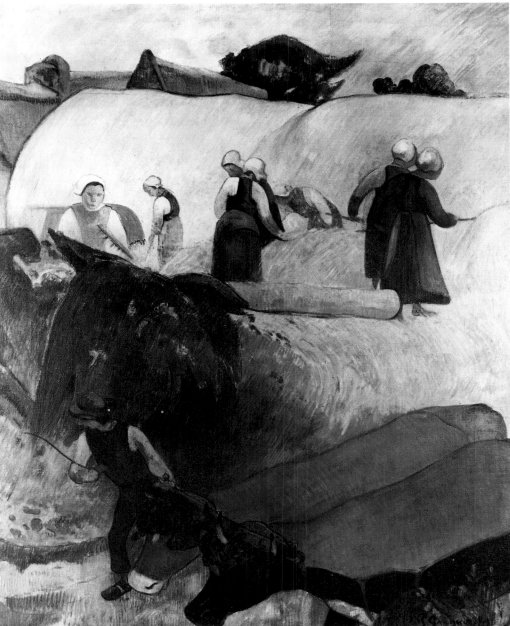

161

create a new pictorial language (and which later was applied to the entire Pont-Aven style), one must intuit its meaning from his writings and his paintings. It seems likely that it signified for him a selective and simplified arrangement of colors and shapes as well as a distillation of images that would succinctly convey meaning or emotion.

If one compares canvases done by Gauguin and Bernard during 1888 and 1889, it becomes evident that each found a distinctive way of embodying conceptual and emotional realities that transcended mere physical appearance. In Bernard's *Black Wheat* and Gauguin's *Haymaking* (plates 162, 161), for instance, contours have been simplified dramatically, line has assumed a rhythmic function, and color is highly subjective. While these subjects inevitably recall Realist and Impressionist images of farm labor, the representational concerns and atmospheric effects associated with those earlier works have been eliminated. The primary appeal of Bernard's consciously stylized compositions can only be described as decorative and poetic.

Gauguin's *Vision after the Sermon: Jacob Wrestling with the Angel* (plate 164) surpasses Bernard's paintings in conveying the atavism and mystery that permeated the life of the Breton peasants. The ostensible subject of the work is the impact on a group of farm women of a sermon about Jacob struggling with the angel. Yet the "vision" of the title could also refer to the painter's own attempt to express his personal reaction to the

160. Emile Bernard (1868–1941). *Breton Women on the Wall*, 1892. Oil on board, 31¾ x 46¼ in. Josefowitz Collection.

161. Paul Gauguin (1848–1903). *Haymaking*, 1889. Oil on canvas, 36¼ x 28¾ in. Courtauld Institute Galleries, London.

162. Emile Bernard (1868–1941). *Black Wheat*, 1888–89. Oil on canvas, 28½ x 35 in. Josefowitz Collection.

OVERLEAF:

163. Emile Bernard (1868–1941). *The Four Seasons* (recto), 1892. *Peinture à la colle* on canvas, double-sided screen, four panels, each 69 x 25½ in. Private collection.

women and to the unswerving faith that dominated their lives. While the curving diagonal of a tree trunk separates the realm of the "real" from that of the vision, the rich red ground unites both zones formally and emotionally. Presented as flat shapes with little or no modeling, the various elements of the composition derive from several sources: the motif of the wrestling figures is a composite of images from a Japanese woodcut and a painting by Puvis de Chavannes; the perspective directly acknowledges the eccentric spatial devices of Degas's theater scenes and, indirectly, the dependence of Degas's works on Japanese models. But Gauguin's astonishing transformation of these diverse sources transcends their eclecticism. The notion of combining a real and an imaginary scene was hardly new; indeed, it recalled both a long tradition of Catholic devotional painting and some of the more recent secular work of the Symbolists. However, Gauguin emphatically rejected the naturalism selectively employed by many Symbolists because he believed it smacked of a self-conscious literary quality, which he viewed as being compromising to painting in general. What he aimed for was the replacement of narrative with a clear and simple pictorial statement that conveyed ideas or emotions in terms of color and shape.

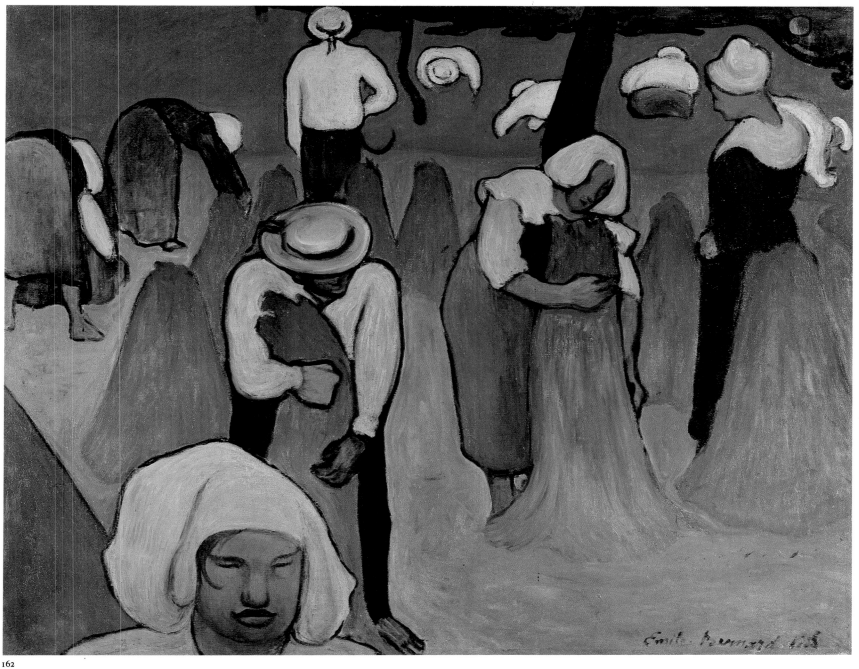

162

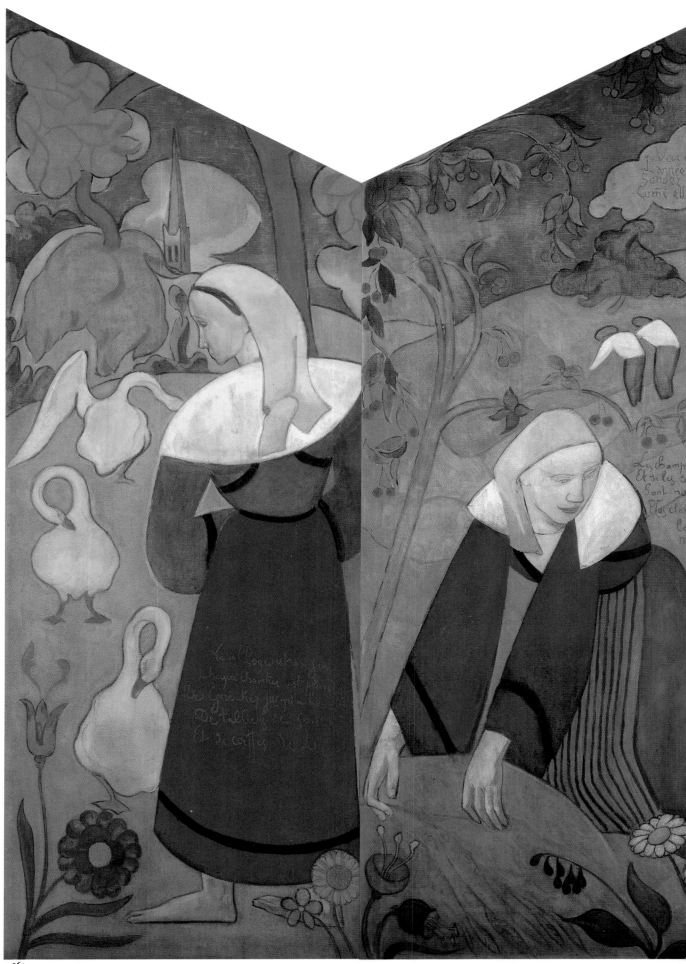

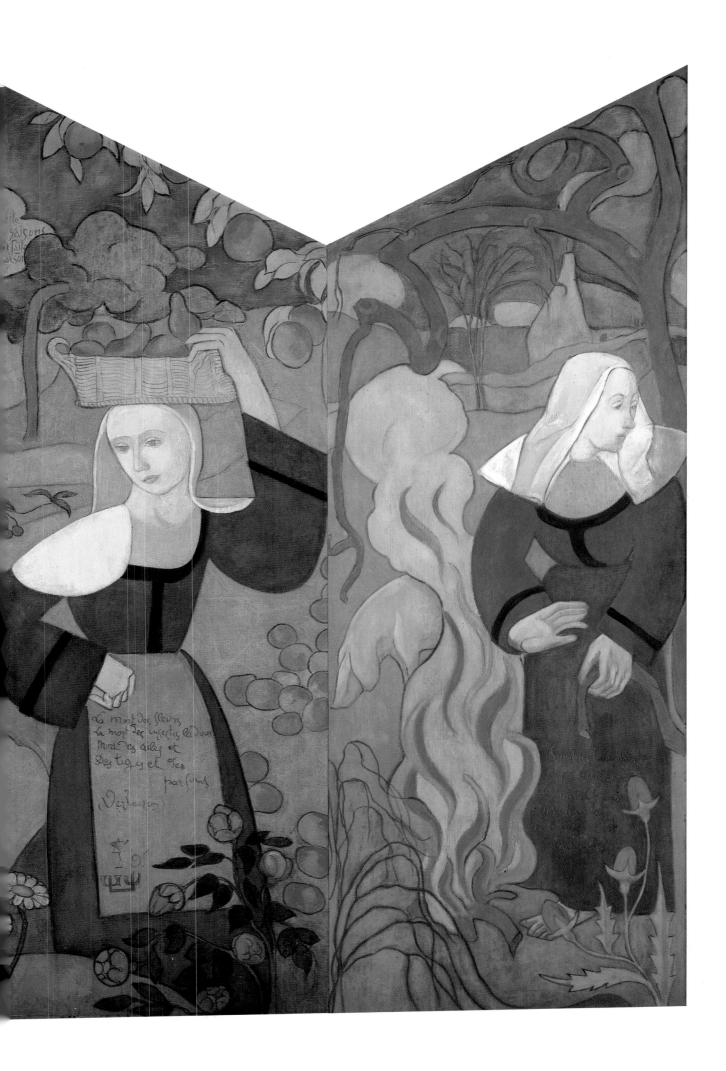

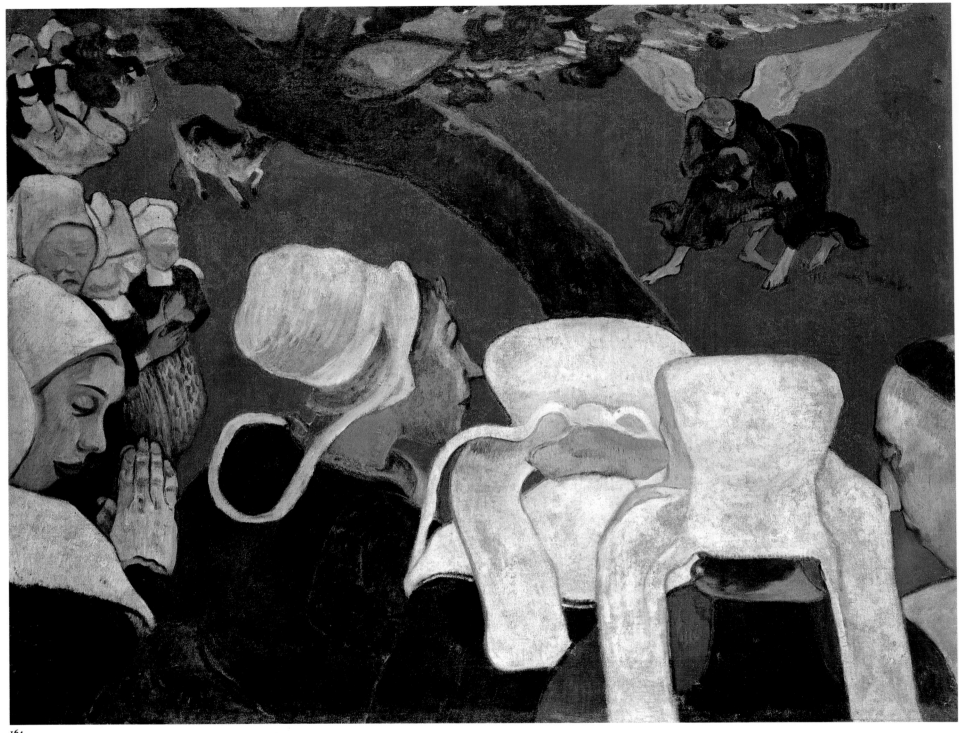

164

164. Paul Gauguin (1848–1903). *The Vision after the Sermon: Jacob Wrestling with the Angel*, 1888. Oil on canvas, 28¾ x 36¼ in. National Galleries of Scotland, Edinburgh.

165. Emile Bernard (1868–1941). *The Yellow Tree*, 1888. Oil on canvas, 24 x 15 in. Musées des Beaux-Arts, Rennes.

166. Poster for the Café Volpini show, 1889.

In the fall of 1888, shortly after completing *The Vision after the Sermon*, Gauguin accepted an invitation from van Gogh to join him in Arles. Gauguin found the atmosphere of that town uncongenial, however, and his presence had a tragic effect on his unstable Dutch friend. Gauguin then returned to Brittany, where he remained for much of the next two years. Joined by other friends—Laval, his companion in Panama and Martinique, and a Dutch painter, Jacob Meyer de Haan—he was soon presiding over a colony of similarly inspired painters who would come to be known as the Pont-Aven School.

165

The Exhibition at the Café Volpini

While Gauguin was beginning to exert an increasing influence on his friends and on the aspiring painters who gravitated to his Breton orbit, preparations were being made in Paris for a spectacular world's fair to celebrate the one hundredth anniversary of the French Revolution. Plans called for the inclusion of a huge exhibition to publicize France's contribution to the fine arts. Despite the attempts of a courageous organizer to represent such still-controversial painters as Manet, Monet, Pissarro, and Cézanne, the roster of artists was dominated by Salon favorites, and no plans were made to include younger artists. However, the opportunity presented by the fair was sufficiently compelling for Gauguin to conceive of an independent show. Lacking the funds to emulate Courbet and Manet, who had constructed their own pavilions on a similar occasion in 1867, Gauguin and his friends sought out the owner of the Café Volpini, which was located next to the building in which the official exhibition was to be housed, and persuaded him to lend the walls of his establishment to their cause. Adamant about the nature and number of participants, Gauguin clearly envisioned the exhibition as a showcase for himself and his innovative ideas. Excluding old friends like Pissarro, he turned to such allies as Bernard, Laval, and Anquetin. Gauguin's invitation to van Gogh, who was then hospitalized in Provence, was declined by his art-dealer brother on the grounds that the enterprise was in bad taste and would compromise van Gogh's reputation. While the Café Volpini exhibition did contain a preponderance of works by Gauguin and Bernard, the inclusion of other painters—such as Gauguin's friend Schuffenecker, who was not part of the Pont-Aven School but who had been instrumental in persuading the Italian owner of the café to cooperate—made for less coherence in the show's content than Gauguin had originally envisioned.

Finding a name that would describe his and Bernard's new method of painting was difficult. Gauguin finally dubbed the exhibition "impressioniste et synthétiste," thus

GROUPE IMPRESSIONNISTE ET SYNTHÉTISTE

CAFÉ DES ARTS
VOLPINI, Directeur
EXPOSITION UNIVERSELLE
Champ-de-Mars, en face le Pavillon de la Presse

EXPOSITION DE PEINTURES
DE

Paul Gauguin	Émile Schuffenecker	Émile Bernard
Charles Laval	Louis Anquetin	Louis Roy
Léon Fauché	Daniel	Nemo

Paris. Imp. E. WATELET, 55, Boulevard Edgar Quinet.　　　　Affiche pour l'intérieur

166

168

167. Paul Gauguin (1848–1903). *The Yellow Christ*, 1889. Oil on canvas, 36¼ x 28⅞ in. Albright-Knox Art Gallery, Buffalo, New York; General Purchase Funds, 1946.

168. Paul Gauguin (1848–1903). *The Green Christ (The Calvary)*, 1889. Oil on canvas, 36¼ x 29 in. Musées Royaux des Beaux-Arts, Brussels.

indicating the connection he still felt to a movement whose methods and themes must have appeared remote from those of the participating artists. The coupling of the words *impressionist* and *synthetist* was puzzling, since the latter term implied the Pont-Aven School's efforts to present not an immediate image of the visible world but a deeper, generalized, and even spiritual response to it. Gauguin may have hit upon this combination of words because he hoped to take advantage of any sympathy for the older group while at the same time indicating some of the new formal and thematic concerns reflected in his work and that of other exhibitors. In any event, the juxtaposition of the terms only succeeded in promoting confusion and creating resentment on the part of Gauguin's former colleagues.

Among the few critics who attended the Café Volpini show, only Georges Albert Aurier perceived the connection between Gauguin's paintings and the Symbolist movement. He urged the readers of his review, *Le Moderniste*, to see the paintings, maintaining that they manifested "a marked tendency towards a synthesis of drawing, composi-

169

169. Paul Gauguin (1848–1903). *Agony in the Garden*, 1889. Oil on canvas, 28½ x 35¾ in. Norton Gallery and School of Art, West Palm Beach, Florida.

170. Paul Gauguin (1848–1903). *The Loss of Innocence*, 1890. Oil on canvas, 35½ x 51¼ in. The Chrysler Museum, Norfolk, Virginia; Gift of Walter P. Chrysler, Jr.

tion, and color, as well as an effort to simplify the means of expression which appears very interesting . . . at this particular moment when empty prowess and cheap tricks are the rule."[3]

Bitterly disappointed at the lack of sales and the overwhelmingly negative reaction to the Café Volpini show, Gauguin returned to Brittany, where he settled in Le Pouldu, a village even more remote and austere than Pont-Aven. There his mood of gloomy introspection may have made him especially sensitive to the mysticism of the local inhabitants. In *The Yellow Christ* and *The Green Christ* (*The Calvary*) (plates 167, 168) he utilized indigenous religious art as the point of departure for compositions in which the abiding piety of the peasant and the anguish of the painter seem to have fused. The principal motif of the first work was adapted from a polychrome wood Christ in the Chapel of Trémalo in Pont-Aven, whereas *The Green Christ* was probably inspired by one of the moss-covered stone pietàs found in the countryside of Brittany. In each

OVERLEAF:

171. Paul Gauguin (1848–1903). *Ia Orana Maria*, 1891. Oil on canvas, 44¾ x 34½ in. The Metropolitan Museum of Art, New York; Bequest of Samuel A. Lewisohn, 1951.

172. Detail of plate 171.

painting, the distinctive coloration of the devotional object saturates both the figures and the surrounding landscape to produce a sustained effect of sadness that intensifies and extends the Christian significance of the subject. Yet this effort to evoke an aura of pure faith through starkly simplified means also incorporated certain sophisticated devices favored by the Impressionists: the asymmetrical placement of the cross in both compositions, for example, and the cropping that artfully underscores the two-dimensionality of the canvases. In these works Gauguin realized his goal of creating a pictorial statement that would reflect the deep subjectivity of its inspiration while still conveying the objective logic and order he believed to be intrinsic to all great art.

Gauguin and Tahiti

Gauguin's move to a remote part of France where he could confront basic human emotions and values such as desire, fear, and faith had only partially satisfied his urge to liberate himself from the conventions of a middle-class society he had come to despise. His sojourn in the Caribbean had provided a glimpse of a veritable Garden of Eden whose exotic landscape and handsome natives seemed to offer the ideal mix of unspoiled nature and humanity that his imagination required to sustain his unique aesthetic. Already receptive to non-Western art, Gauguin had frequented an exhibition at

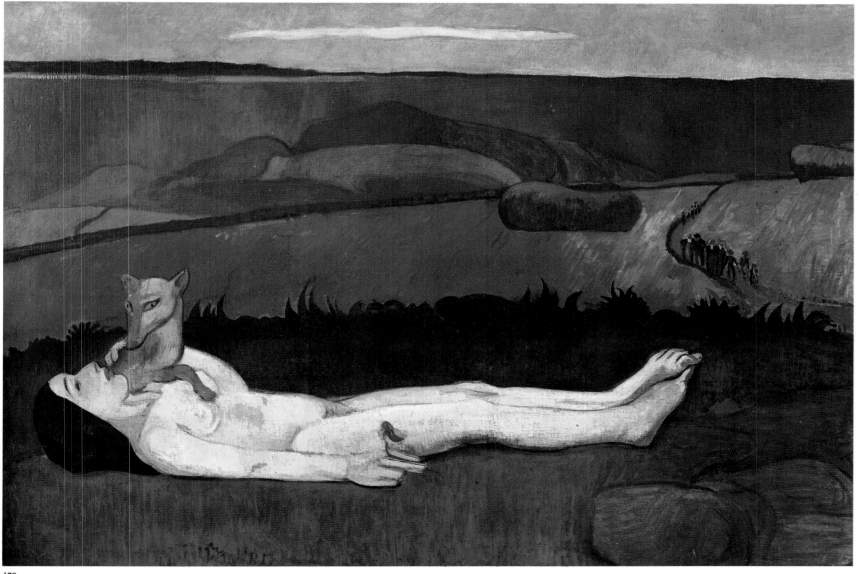

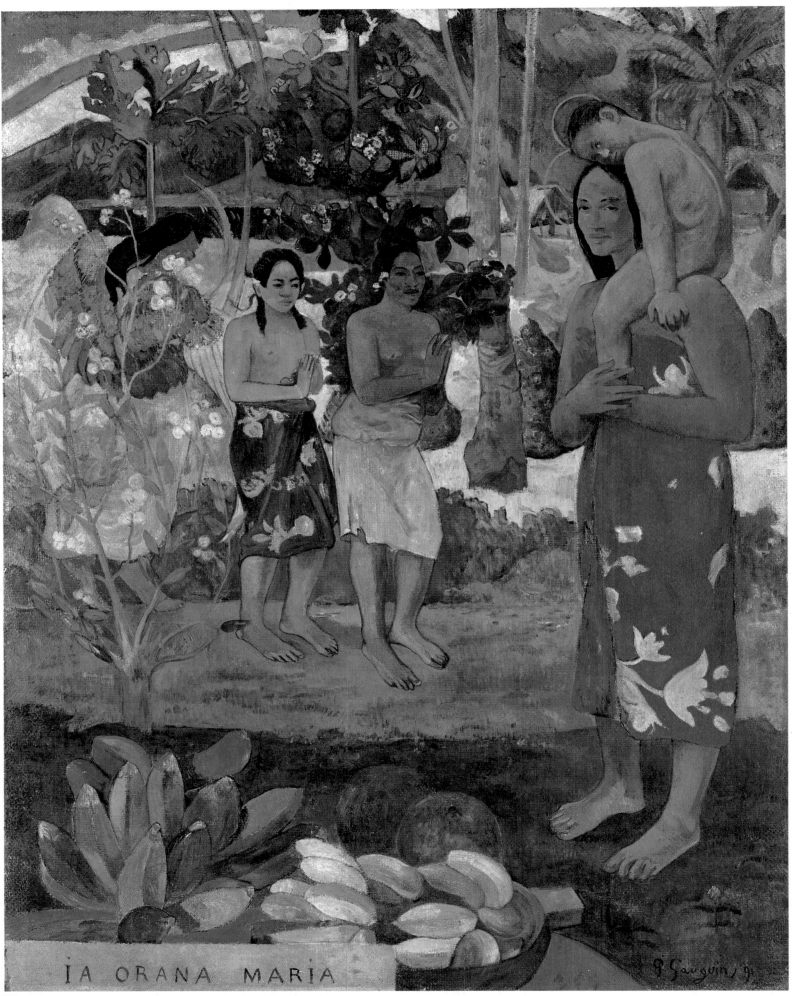

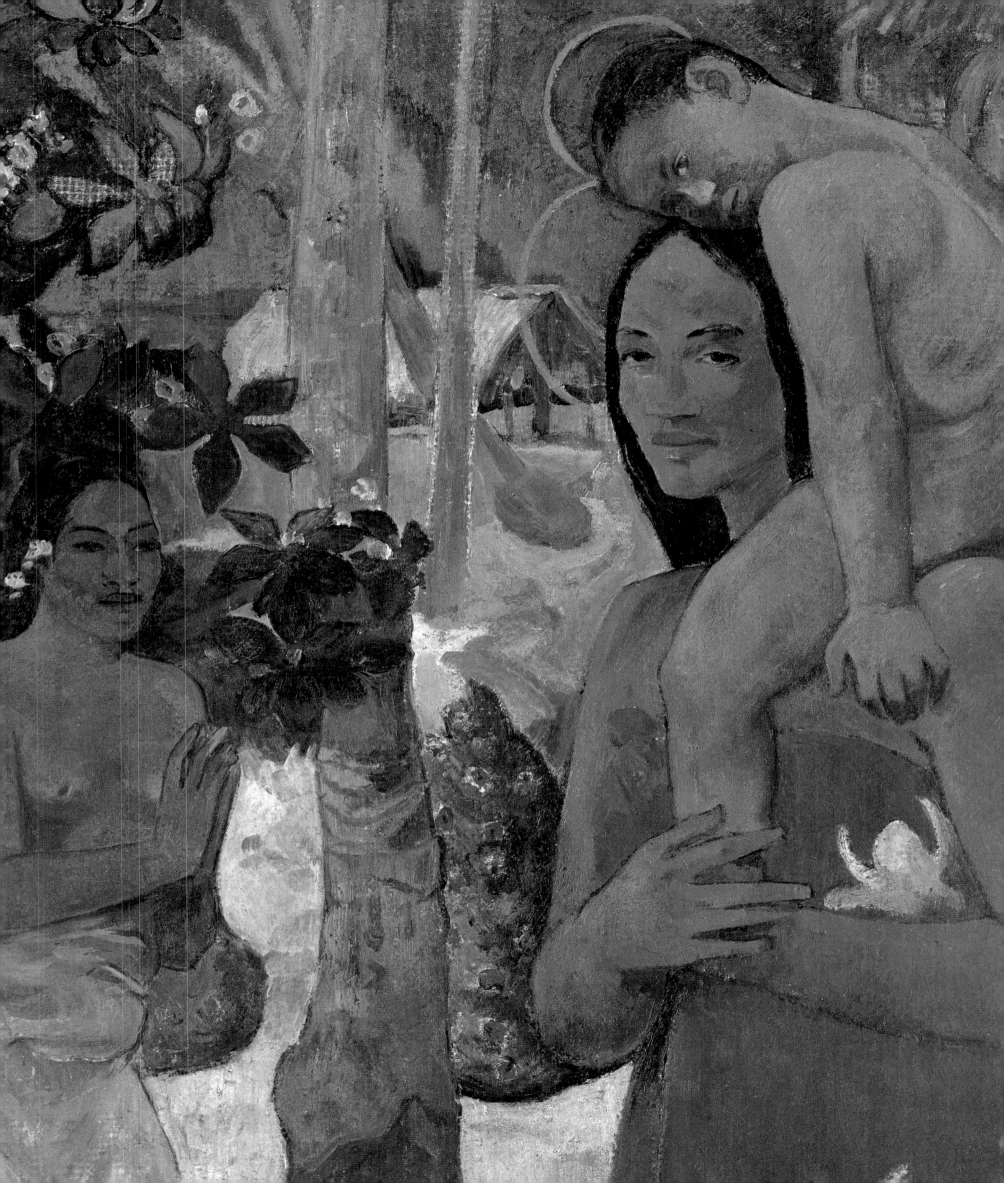

the world's fair that featured a Javanese village where native dances were regularly performed. This experience and subsequent exposure to Indian and Cambodian art fed his longing for the tropics and inspired a vague plan to leave for the Far East or Madagascar. His attempts to raise funds by selling a group of paintings proved unsuccessful, and his financial situation grew so desperate that he decided to act on Bernard's suggestion that he seek assistance from a government agency. Gauguin conceived a program to study the customs and scenery of the French colony of Tahiti, which was finally approved. A letter to Schuffenecker underlines Gauguin's highly emotional optimism:

> I only live in the hope of this promised land. . . . With work and will power we can form there a hale and happy little circle, for you know that Tahiti is the healthiest country that exists. . . . The future of our children is pretty black . . . in this rotten and mean Europe. . . . But the Tahitians, happy inhabitants of the unexplored paradise of Oceania, know only the sweet aspects of life. For them to live is to sing and to love. Here is the food for thought for Europeans who complain about their existence.[4]

Before his departure in April 1891, Gauguin went to Paris, where he sought the company of such writers as Aurier, Moréas, and Charles Morice, who gathered regularly at the Café Voltaire. This lively Symbolist milieu—so radical a contrast to Gauguin's simple, solitary existence in Brittany—provided him with an intellectual forum in which to test his evolving ideas and ultimately gave him the critical support he was seeking. Working intermittently, whenever he could borrow the studios of painter-friends, he executed a fairly large and dramatic canvas, *The Loss of Innocence* (plate 170), whose mysterious, sexually charged theme and exotic coloring prefigure the psychological and aesthetic concerns that he would explore more thoroughly in Tahiti.

After a brief trip to Denmark, where he took leave of his family, Gauguin returned to Paris in March 1891. His Symbolist friends honored him with a farewell banquet at the Café Voltaire, which was attended by over forty guests. Mallarmé offered a toast "to the return of Paul Gauguin, but not without admiring his superb conscience which drives him into exile, at the peak of his talent, to seek new strength in a far country and in his own nature."[5]

Ironically, Gauguin's departure from Paris took place at a time when his work was beginning to garner serious attention and even praise from such critics as Aurier and Octave Mirbeau. In a long, important article for the *Mercure de France*, "Le Symbolisme en peinture," which had the impact of an artistic manifesto, Aurier placed Gauguin in the vanguard of a movement whose various exponents he described as "synthetists, ideologists, symbolists." Disregarding the contributions of Bernard and others, Aurier singled out Gauguin as "the initiator of a new art," and he made it clear that the purpose of this art was not the representation of objects but the expression of ideas "by translating them into a special language." The critic also acknowledged the essentially decorative spirit of Gauguin's painting: "Sometimes one is tempted to consider [his compositions] as fragments of immense frescoes . . . in our dying century we have only one great decorator, possibly two if we count Puvis de Chavannes, and our imbecile society of bankers and polytechnicians refuses to give this rare artist [Gauguin] the smallest palace, the tiniest national hovel in which to hang the sumptuous garments of his dreams. . . . A little common sense, please! You have among you a decorator of genius . . . give him walls!"[6]

Gauguin's decorative power was fully realized in his Tahitian paintings. Though these were more obviously exotic in subject and more sumptuous in color, their thematic concerns remained close to those of his Breton paintings. While he responded directly to the color harmonies of Tahiti's dense vegetation, the brightly patterned costumes of its natives, and the mystery of its folklore and religious beliefs, he had also brought with him a collection of photographs of Egyptian sculpture, the Parthenon frieze, and reliefs from a Javanese temple. Gauguin frequently combined motifs from this personal ar-

173. Paul Gauguin (1848–1903). *Mata-mua, In Olden Times*, 1892. Oil on canvas, 36 x 27 in. Private collection.

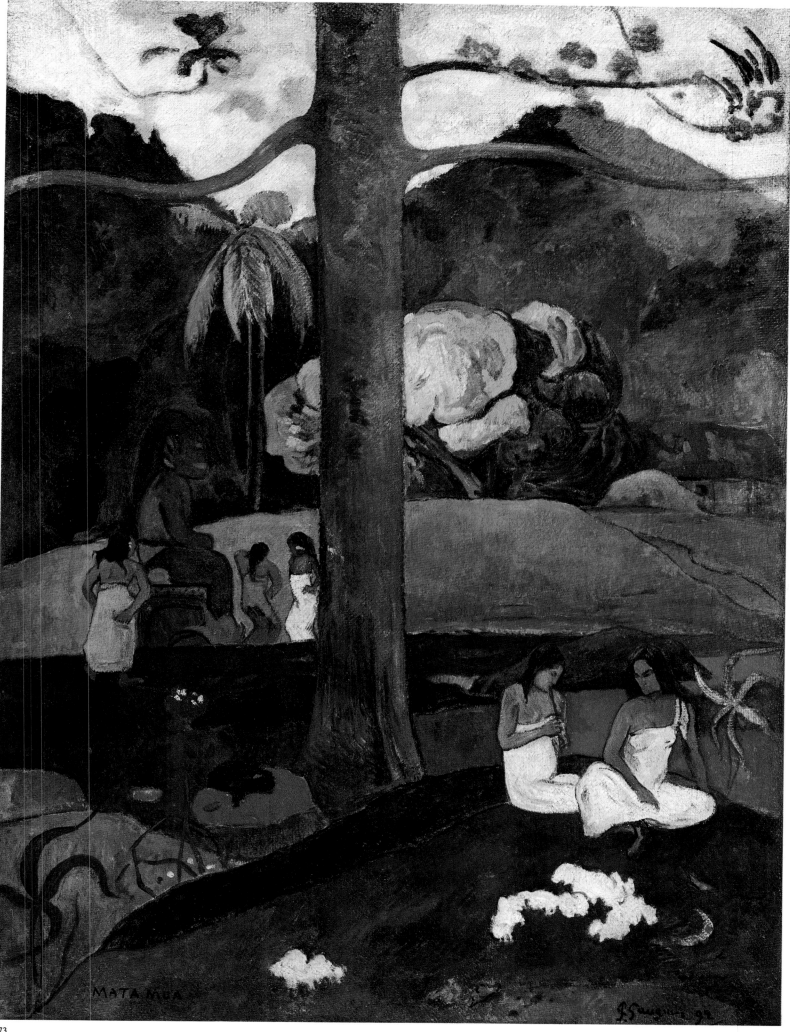

MATA MUA

chive with elements from daily life, with the result that his Tahitian paintings often seem more consciously constructed, more sophisticated than his earlier work. In *Ia Orana Maria* (whose title is the equivalent in Maori of the angelic salutation "Hail Mary"), the artist recreated the Christian mysteries of the Annunciation and the Nativity in a Polynesian setting (plate 171). With its miraculous union of real and ideal, of specific and abstract, of metamorphosed Western and non-Western elements, the composition seems the very paradigm of the Symbolist aesthetic.

174. Paul Gauguin (1848–1903). *Arearea Joyousness II*, 1892–95. Watercolor on linen, fan-shaped, 10¾ x 21¾ in. (maximum width). The Museum of Fine Arts, Houston; John A. and Audrey Jones Beck Collection.

175. Paul Gauguin (1848–1903). *Woman with a Mango (Vahine No Te Vi)*, 1892. Oil on canvas, 28¼ x 17½ in. The Baltimore Museum of Art; The Cone Collection, formed by Dr. Claribel Cone and Miss Etta Cone of Baltimore, Maryland.

176. Paul Gauguin (1848–1903). *The Ford*, 1901. Oil on canvas, 30 x 37 in. Pushkin Museum of Fine Arts, Moscow.

176

Like Cézanne's self-imposed exile in Aix-en-Provence, Gauguin's isolation in Tahiti provided the necessary condition for his artistic and spiritual fulfillment. If his art never fully realized the primitive qualities he so admired, its vehement antinaturalism, its celebration of the autonomy of color and design, its utilization of the imagination and the unconscious, and its adaptation of non-Western compositional strategies were to serve as models for the artists who followed him, from the Nabis, who quickly absorbed the lessons of Pont-Aven, to the Fauves and the Cubists, whose discovery of Gauguin's achievement was fostered by the memorial exhibition that followed his death in Tahiti in 1903.

Vincent van Gogh

In contrast to Gauguin, who had been pulled into the orbit of Impressionism through his friendship with Pissarro and who had participated in three of the group's exhibitions, van Gogh's encounter with the movement was, at most, superficial. In the first months after his arrival in Paris in March 1886, he was determined to see everything he had heard about and, in particular, to familiarize himself with the new theories of color being proclaimed by some of the younger painters exhibiting in the Salon des Indépendants. The speed with which van Gogh assimilated what he saw was as remarkable as his industry, for in less than a year he produced some one hundred paintings whose subject matter and style were indicative of his new environment and contacts. He was certainly affected by his exposure to the work of Monet, Sisley, and Pissarro, and the last especially helped him to rid his palette of the dark and muddy tonalities that had characterized his previous works.

By the time van Gogh arrived in Paris, he had been painting for about six years. Although he had spent brief intervals at art schools in The Hague and Antwerp, he was

essentially self-taught. He greatly admired Delacroix, but before his move to Paris it was the Barbizon painters, especially Millet, who represented modern art for him. Had van Gogh not decided to leave the Low Countries, he might have remained a painter of peasant life, developing its limited range of themes in the dark colors and powerful outlines that characterize such early masterpieces as *The Potato Eaters*. But he was a dreamer, and his artistic ambitions required a larger stage than that offered by the comparatively provincial art centers of Belgium and Holland. His sudden decision to move to Paris was surely influenced by news he received from Theo, whose activities as an art dealer had recently brought him into contact with Pissarro, Degas, and Monet.

177

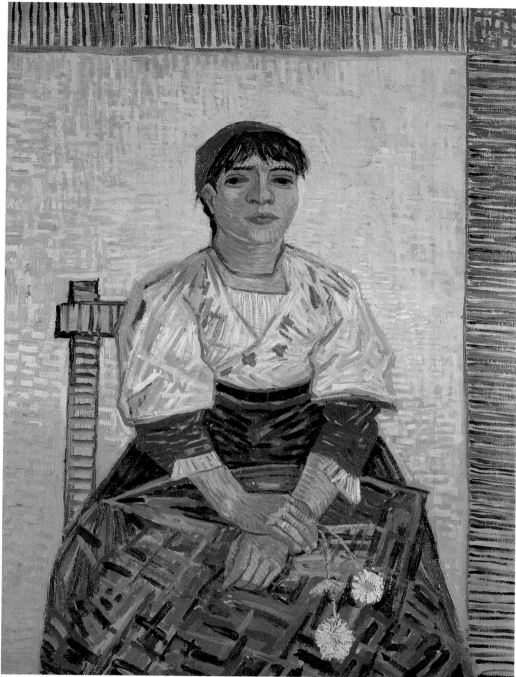

178

177. Vincent van Gogh (1853–1890). *Japonaiserie: The Courtesan*, 1887. Oil on canvas, 41¼ x 24 in. Rijks-museum Vincent van Gogh, Amsterdam.

178. Vincent van Gogh (1853–1890). *The Italian Woman (La Segatori)*, 1887. Oil on canvas, 32 x 23½ in. Musée du Louvre, Paris.

Although van Gogh's exposure to Impressionism resulted in his numerous views of Montmartre and the outskirts of Paris and in the lightening of his palette, he was conscious of the style's weaknesses and was particularly critical of the Impressionists' draftsmanship. He viewed drawing as indispensable to a concept of artistic expression that was taking shape in his often-confused mind. His friendship with Signac brought more control to van Gogh's brushwork, but he was unmoved by the theoretical aspects of Neo-Impressionism and never completely subscribed to its systematic technique. He often bent the restrictive methodology of Divisionism to accommodate the emotional energy generated by a subject, so that the uniformity of brushstroke and surface associated with that mode gave way to a heterogeneity of line and texture.

It may have been a search for another kind of decorative order that attracted van Gogh to Japanese art by 1887. He had already accumulated a large number of woodcuts before his move to Paris, where he began to frequent the celebrated shop of Samuel Bing. There he spent countless hours examining the finest works of Hokusai and Hiroshige and pondering their formal messages. His enthusiasm for the clarity of contour, emphatic contrasts of color, and distinctive spatial perspective of these prints was

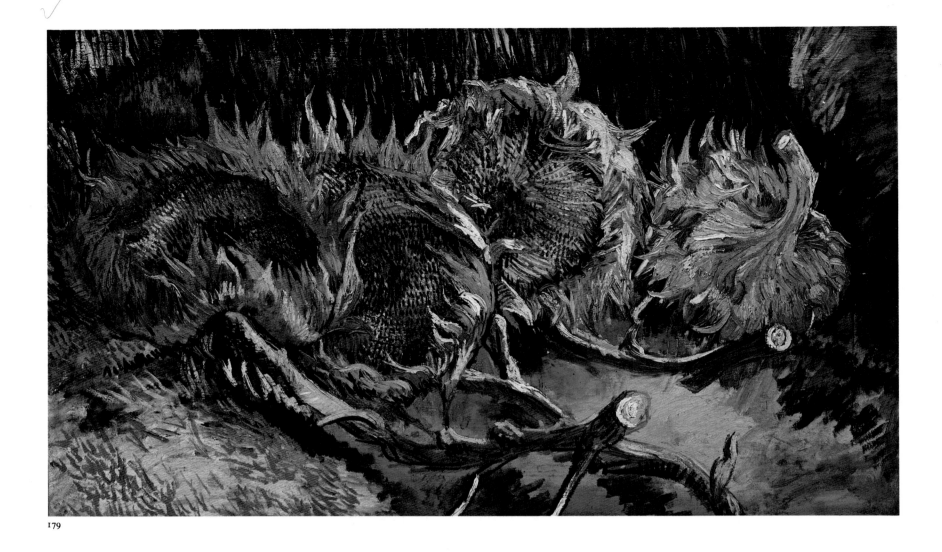

179

shared by Anquetin, Bernard, and Henri de Toulouse-Lautrec, all of whom he had met in the studio of Félix Cormon.

Van Gogh's experimentation with the formal properties of the woodcuts initially took the form of highly original copies, in which he often exaggerated the colors of a motif or introduced new Orientalizing imagery of his own (plate 177). But gradually he came to work even more freely from his sources, producing compositions such as the vividly colored portrait of an Italian café owner, *The Italian Woman (La Segatori)* (plate 178), in which Japanese influence is evident in the emphatic flatness of the image but where the elegance implicit in the Oriental approach has been replaced by an almost crude energy.

By the time he painted *The Italian Woman*, van Gogh had succeeded in establishing himself as a serious, if unorthodox, member of the Parisian art world. He displayed uncommon initiative in organizing exhibitions of his own work and that of his new friends Anquetin, Bernard, and Toulouse-Lautrec in popular cafés and restaurants and in the foyer of the newly opened avant-garde Théâtre Libre. In 1888 he even took part in the Salon des Indépendants. But he was also growing disenchanted with the self-interest and pettiness that surrounded him. His struggle to find his own creative voice in an environment essentially alien to his idealistic dreams of support and collaboration was damaging his physical and mental health, and in 1888 van Gogh left Paris for the south of France. From the beginning of his stay, he cherished the hope that his mission would encourage such friends as Bernard and Gauguin to join him in establishing a

179. Vincent van Gogh (1853–1890). *Sunflowers*, 1887. Oil on canvas, 23½ x 39⅜ in. Rijksmuseum Kröller-Müller, Otterlo, The Netherlands.

180. Vincent van Gogh (1853–1890). *The Sower*, 1888. Oil on canvas, 12¾ x 15¾ in. Rijksmuseum Vincent van Gogh, Amsterdam.

community of artists inspired by shared goals. He also hoped to find in Arles the intense light, strong color, and distinct sense of form that he had come to appreciate through his prolonged study of Japanese prints. Shortly after settling there in February he wrote a letter to Bernard, which reveals that his hopes were confirmed: "This country seems to be as beautiful as Japan as far as the limpidity of the atmosphere and the gay color effects are concerned. Water forms patches of a beautiful emerald or a rich blue in the landscape, just as we see it in the crepons [a type of Japanese woodblock print]."[7]

When he arrived in Arles, about the only element of Impressionism that van Gogh retained was the habit of working out of doors, directly in front of his subject. His first months there were marked by generally high spirits and feverish activity, notable even for a painter as unusually productive as he. He made over a hundred paintings—land-

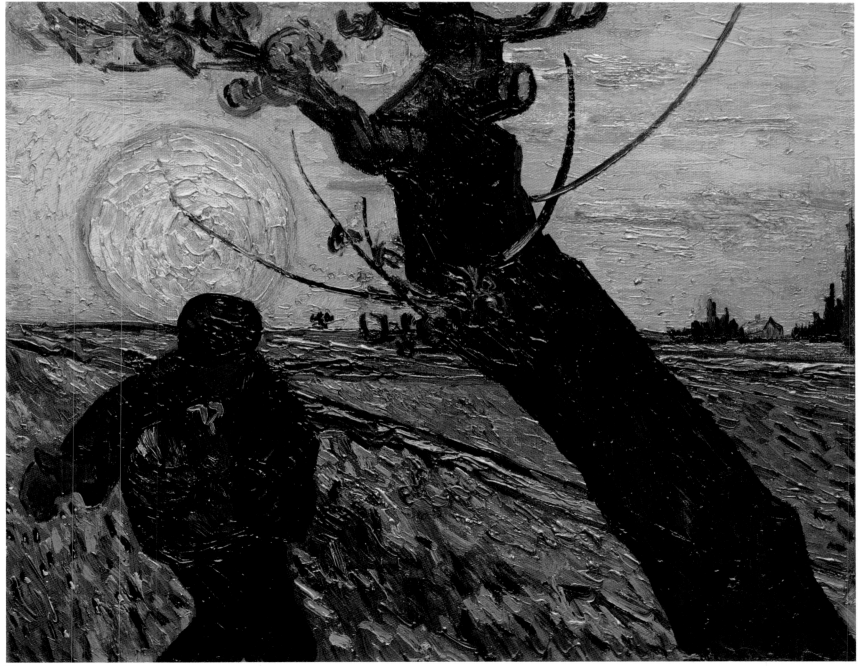

180

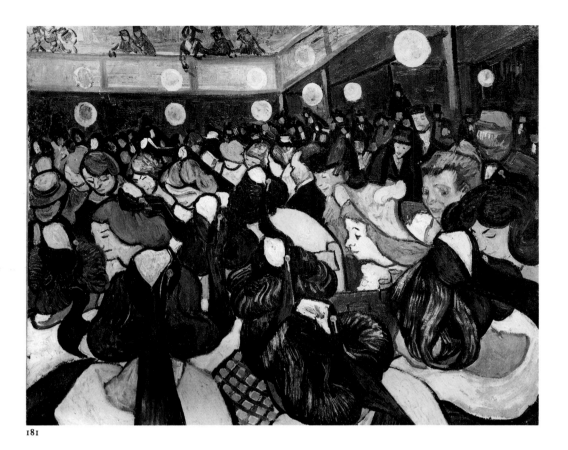

181

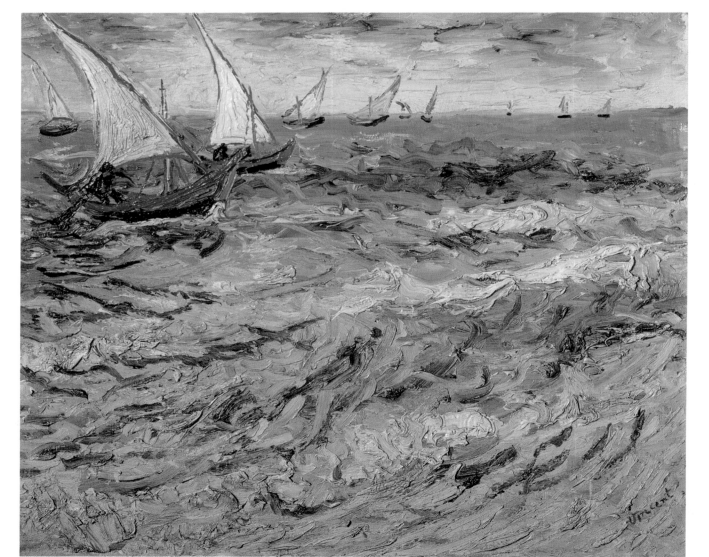

182

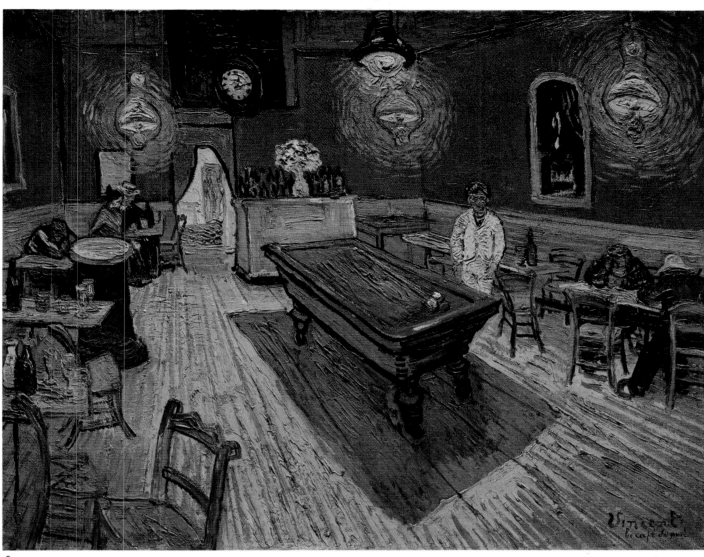

183

181. Vincent van Gogh (1853–1890). *Dance Hall*, 1888. Oil on canvas, 25½ x 31⅞ in. Musée d'Orsay, Paris.

182. Vincent van Gogh (1853–1890). *Seascape at Saintes-Maries*, 1888. Oil on canvas, 17¼ x 20¾ in. Pushkin Museum of Fine Arts, Moscow.

183. Vincent van Gogh (1853–1890). *The Night Café*, 1888. Oil on canvas, 27½ x 35 in. Yale University Art Gallery, New Haven, Connecticut; Gift of Stephen C. Clark.

scapes, portraits, interiors, and still lifes—infusing them with the almost unbearable energy with which he responded to his new surroundings. Reacting to the intense, life-giving force of the southern sun, he produced scenes of orchards and wheat fields.

In June, van Gogh turned to a subject, the sower (inspired by a work of his early idol Millet), that was to become one of the central and most recurrent themes in his entire oeuvre. The genesis of van Gogh's *The Sower* (plate 180), documented in letters and sketches, reveals a great deal about his passionately poetic and idealistic conception of art and, in particular, underscores the emotional basis of his theories of color. Writing to Bernard, van Gogh included a crude sketch with this general description:

Here is a sketch of a sower: large ploughed field with clods of earth, for the most part frankly violet. A field of ripe wheat, yellow ocher in tone with a little carmine. The sky, chrome yellow, almost as bright as the sun itself. . . . So very yellow. . . . There are many hints of yellow in the soil, neutral tones resulting from mixing violet with yellow; but I

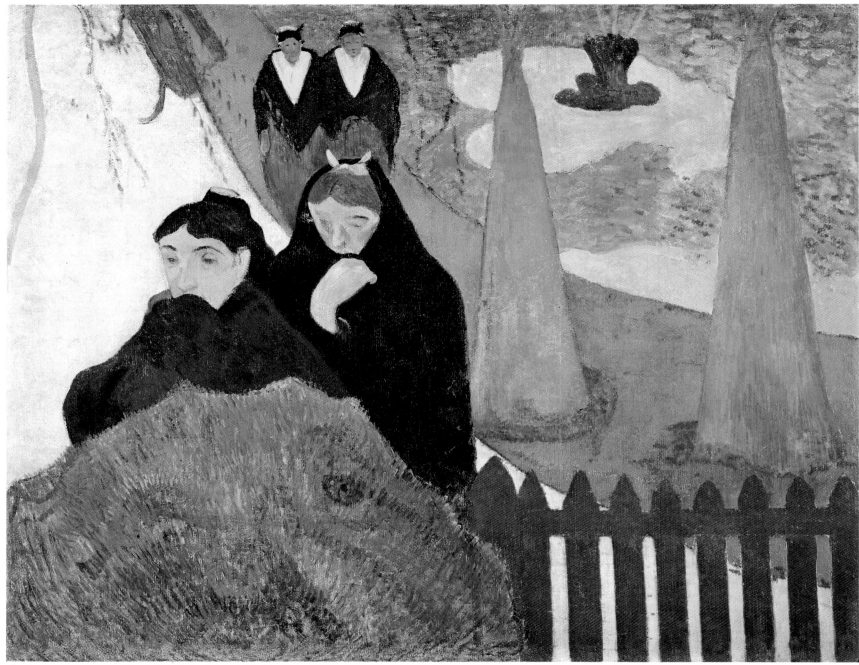

184

have played hell somewhat with the truthfulness of the colors, I would much rather make naive pictures out of old almanacs, those old "farmer's almanacs" in which hail, snow, rain, fair weather are depicted in a wholly primitive manner. . . . I am still charmed by the magic of hosts of memories of the past, of a longing for the infinite, of which the sower, the sheaf are the symbols. . . .[8]

Weeks of struggle in the studio followed van Gogh's initial work on this painting. He made significant changes in the colors and in the pose of the figure, simplifying forms and enhancing the contrast of complementary hues by adding green and orange. As a result, the space was flattened and the surface densely encrusted with pigment. While certain features—the stylized radiations of the sun and the addition of a narrow painted frame of yellow and violet at the sides—recall the lessons the artist had absorbed from the Neo-Impressionists, the daring schematization of the composition and, above all,

185

its deliberate exploitation of emotional color represented a startling break with the pictorial vocabularies he had encountered in Paris.

If van Gogh seemed close to realizing his dream of fraternal collaboration when he succeeded in persuading Gauguin to join him in October 1888, his letters to Theo make it clear that he was physically and emotionally exhausted as he awaited his friend's arrival. Still, neither man could have predicted the brevity of Gauguin's stay (nine weeks) or the violence it would provoke. Gauguin's own health was poor, weakened by poverty and by the dysentery he had contracted in Brittany. His immediate dislike of Arles, which he found tawdry and dirty, and of the disorderly habits of his friend created an almost constant tension. Gauguin's self-assurance, born of more prolonged artistic experience, and his clarity of purpose expressed verbally and in his paintings contrasted with van Gogh's humility and self-doubt. The latter compared his own works with those of Gauguin and found them ugly and uncultivated; his own aesthetic vision seemed vulgar. Whereas van Gogh required direct contact with nature to stimulate his creative impulses, Gauguin had come to rely primarily on imagination and memory to produce works that his friend characterized as ''abstractions.'' Nevertheless, in canvases such as *Dance Hall* (plate 181), whose strong artificial colors and flat Cloisonnist patterns once again call to mind Japanese prints, van Gogh made a valiant effort to adopt the practices of Gauguin and Bernard.

The presence of Gauguin strained van Gogh's precarious emotional stability to the breaking point, but it also afforded an extraordinary opportunity for the two painters to learn from each other. Shortly after his arrival in Arles, Gauguin responded to the challenge of the seething color and slashing brushwork in van Gogh's emotionally charged *The Night Café* (plate 183) by painting his own cool and patently Orientalized critique of the same subject. He subsequently adopted another of van Gogh's favorite motifs: the garden that faced the little house where they lived. In *Garden at Arles* (plate 184),

184. Paul Gauguin (1848–1903). *Garden at Arles*, 1888. Oil on canvas, 28¾ x 36¼ in. The Art Institute of Chicago; Mr. and Mrs. Lewis L. Coburn Memorial Collection.

185. Vincent van Gogh (1853–1890). *Sketch for ''Memory of a Garden at Etten,''* 1888. From a letter to his sister Wilhelmina. Rijksmuseum Vincent van Gogh, Amsterdam.

186. Vincent van Gogh (1853–1890). *The Red Vineyards at Arles*, 1888. Oil on canvas, 31 x 36½ in. Pushkin Museum of Fine Arts, Moscow.

186

187

Van Gogh arrived in the small farm town of Auvers-sur-Oise on May 20, 1890. He was to live just two months longer, and the feverish pace at which he worked suggests that he had a premonition of his death. Just four days after his arrival, he wrote a letter stating that he had already done four paintings and two drawings. On June 3 he wrote to his sister that he intended to spend one or two days with Dr. Gachet, his art-loving physician, in order to work in his garden, and he indicated that he had already painted two views of it, one of which he described as including "aloes, cypresses, and marigolds."

187. Vincent van Gogh (1853–1890). *Cypresses*, 1889. Reed pen and ink over pencil sketch on paper, 24½ x 18½ in. The Brooklyn Museum; Frank L. Babbott and A. Augustus Healy Funds.

188. Vincent van Gogh (1853–1890). *The Garden of Dr. Gachet*, 1890. Oil on canvas, 28¾ x 20½ in. Musée d'Orsay, Paris.

which bears comparison with van Gogh's contemporaneous *Memory of a Garden at Etten* (plate 185), Gauguin further exaggerated the uncommon vantage points, emphatic flatness, and arbitrary color that he had developed in Pont-Aven. For his part, van Gogh achieved a sense of space, an unusually fluent design, and, in his own words, a more "deliberate choice of color" that indicate a conscious effort to accommodate Gauguin's aesthetic.

Van Gogh's frustration erupted into violence just before Christmas, when he threatened Gauguin with a razor. Having subsequently mutilated his own left ear, he required hospitalization, and in the interim Gauguin departed for Paris. The next sixteen months of van Gogh's life were spent largely in a mental hospital near Arles, where he painted whenever his condition permitted it. Upon leaving the hospital in May 1890, van Gogh settled in Auvers-sur-Oise, near Paris, where he put himself under the care of Dr.

189

189. Vincent van Gogh (1853–1890). *The Ravine*, 1889. Oil on canvas, 28¾ x 36¼ in. Museum of Fine Arts, Boston; Bequest of Keith McLeod.

190. Vincent van Gogh (1853–1890). *Trees—Roots and Branches*, 1890. Oil on canvas, 20 x 39½ in. Rijksmuseum Vincent van Gogh, Amsterdam.

Paul Gachet, a physician specializing in nervous disorders. Between his arrival and his death by his own hand on July 29, the artist again produced an astonishing body of work, consisting of about seventy-five canvases. In works such as *The Garden of Dr. Gachet* (plate 188), the anxiety and psychic torment that once again gripped van Gogh are communicated in the writhing and twisting and unhealthy coloration of the vegetation, which seems to wrench itself desperately from the confines of its domesticated setting. Yet any psychological interpretation of such a work is clearly inadequate to explain the range of feelings and sources that inspired it. For while this picture certainly reflects van Gogh's intention of avoiding the literal or the obviously symbolic, it also recalls the broadly allusive approach of the Symbolists, who wished to evoke, without naming or describing, the frequently disturbing reality hidden in the visible.

Just six months before van Gogh's suicide, Bernard sent Aurier a short article he had written about van Gogh's painting. His observations prompted the critic to undertake a

Van Gogh's confinement in the mental hospital at Saint-Rémy was relieved by painting during his periods of lucidity. This landscape with its tortuous rocky path, dense vegetation, and rushing torrent was presumably inspired by one of his walks in the surrounding countryside, but topographical veracity was doubtless overwhelmed by the artist's turbulent state of mind. The melancholy blue-green coloration of the canvas is occasionally relieved by touches of red and yellow, but the general impact is oppressive. Violent movement, expressed in heavy dark outlines and curvilinear shapes, dominates the work and pressures the viewer with a sense of desperate energy.

penetrating study of his own, which he entitled "The Isolated Ones: Vincent van Gogh." In this article Aurier attempted to place van Gogh within the mainstream of Symbolism. If his efforts were not totally convincing, he did succeed in identifying the major links between van Gogh's art and Symbolism:

> No doubt . . . he is very much aware of the importance and beauty of pigment, but even more often, he only considers this bewitching pigment as a kind of marvelous language destined for the translation of the Idea. He is almost always a symbolist . . . a symbolist who feels the continual need to clothe his ideas in precise, ponderable, tangible forms, in intensely sensual and material envelopes. Beneath the morphic envelope . . . there lies in almost all his canvases . . . a thought, an Idea, and this Idea, the essential substratum of his work, is, at the same time, its efficient and final cause. . . .[9]

Despite Aurier's proselytizing and the subsequent organization of retrospective exhibitions by Les XX and the Salon des Indépendants in 1891, the full significance of van Gogh's art would not be appreciated until the early years of the next century, when the exponents of Fauvism and Expressionism, seeking more direct means of conveying their own emotional realities, acknowledged its pioneering achievement.

With the death of van Gogh, the departure of Gauguin, and the increasing preoccupation of an embittered Bernard with the art of the early Italian Renaissance, the most vital and original manifestations of Symbolism in France appeared to be over. But the force of Gauguin's poetic and decorative aesthetic had fired the imagination of a group of young art students who would interpret and expand its message in the waning years of the century.

5 THE NABIS
Prophets and Painters

Thus at the perfect moment it had been Gauguin's role to project into the spirit of several young men the dazzling revelation that art is above all a means of expression. He had taught them, perhaps without wanting to, that all objects of art must be decorative. And finally, by the example of his work, he had proven that all grandeur, all beauty is worth nothing without simplification and clarity, or without homogeneity of matière.

Maurice Denis, 1903

THE young artists who responded to the aesthetic message transmitted through the works of Gauguin had almost all been pupils at the venerable Lycée Condorcet in Paris, where the Symbolist poet Stéphane Mallarmé had taught English for many years. Sharing middle-class backgrounds and a passionate interest in literature, music, and art, they came together at the Académie Julian, a private art school established to absorb the overflow from the Ecole des Beaux-Arts. The Académie's founder, an undistinguished painter named Rodolphe Julian, cleverly engaged visiting professors from the Ecole, and his easygoing establishment was soon crowded with aspiring painters—both French and foreign—who were drawn to it either by the prestige conferred by its visiting professors or as an alternative to the rigid and hierarchical Ecole. The atmosphere at the Académie was, from all reports, chaotic, and there were many aesthetic factions, although most of the students were poorly educated and unambitious. In this undisciplined environment Paul Sérusier, a young man of impressive appearance and serious demeanor, was outstanding. Older by five years than most of the others, he was a gifted student who had taken degrees in science and literature and had also immersed himself in theology and Near Eastern languages. Sérusier brought an intellectual rigor to the disorderly studios of the Académie Julian, quickly achieving a reputation for leadership and attracting a circle of lively and curious younger students.

Paul Sérusier and the Evolution of the Nabis

For years, students from the Académie Julian had been vacationing in Brittany, since it offered them the chance to work in a picturesque environment where accommodations were cheap. Sérusier and some school friends decided to spend the summer of 1888 in Pont-Aven and moved into the Pension Gloanec, where Gauguin had been residing for some months. Gauguin and his companions kept very much to themselves, and Sérusier was not encouraged to approach the formidable looking and already legendary master. By the time they finally met, in the early fall, Sérusier's stay was nearly over. Yet he managed in the remaining weeks to persuade the older artist to take an interest in his work and even painted a small but remarkable landscape of the neighboring Bois d'Amour under Gauguin's supervision (plate 192). Later this work would be given the

191. Detail of plate 222.

185

honorific title *The Talisman* because of its catalytic effect on the young painters of Sérusier's immediate circle.

According to Sérusier, Gauguin encouraged him to paint the colors of the Bois d'Amour landscape exactly as they appeared to him. The resulting palette is bold indeed. Applying pigments in broad, flat strokes, Sérusier simplified forms in *The Talisman* to the point of virtual abstraction. Moreover, probably in emulation of the older artist, he insistently stressed the two-dimensionality of his surface. In concentrating on the formal elements of painting rather than on subject matter, Sérusier was moving inexorably in the direction of Symbolist painting as practiced by Gauguin.

Sérusier was in a state of emotional and intellectual agitation when he returned to his duties as assistant at the Académie Julian in October, and he was eager to share his new ideas with his serious young friends. According to Maurice Denis, then an eighteen-year-old student at the Académie, Sérusier displayed the small *Talisman* panel as if it were a sacred icon: "He showed us—not without making a certain mystery of it—a cigar-box lid on which we could make out a landscape that was all out of shape and had been built up in the Synthetist manner with patches of violet, vermilion, Veronese green and other colors, all put on straight from the tube and with almost no admixture of white. . . . Thus we learned that every work of art was a transposition, a caricature, the passionate equivalent of a sensation experienced."[1] In addition to Denis, two other young painters at the Académie—Pierre Bonnard and Paul Ranson—subsequently acknowledged the importance of this introduction to ideas that would profoundly affect their own development and that of others who gravitated to their circle at a later date.

Most of these would-be painters had barely become familiar with Impressionism when they were abruptly diverted from their traditional artistic training to Gauguin's exotic path. Their intense discussions about painting took on a new urgency, and they

192. Paul Sérusier (1864–1927). *Landscape, Le Bois d'Amour (The Talisman)*, 1888. Oil on panel, 10¾ x 8¾ in. Musée d'Orsay, Paris.

193. Paul Sérusier (1864–1927). *Landscape at Le Pouldu*, 1890. Oil on canvas, 29¼ x 36¼ in. The Museum of Fine Arts, Houston; Gift of Alice C. Simkins in memory of Alice N. Hansen.

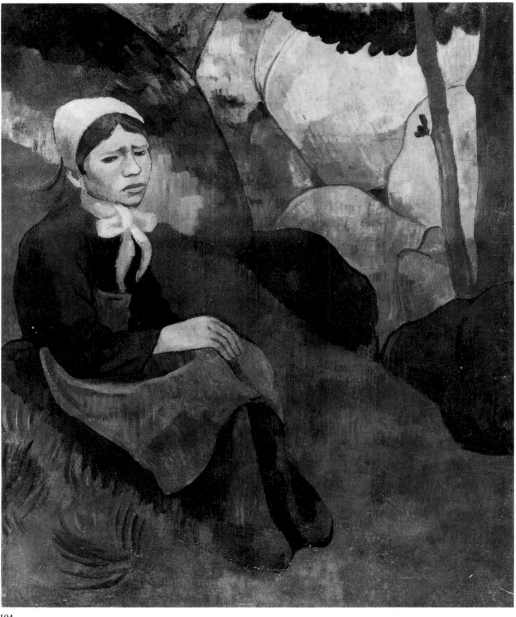

194

194. Paul Sérusier (1864–1927). *Solitude*, 1890–92. Oil on canvas, 29½ x 23⅝ in. Musée des Beaux-Arts, Rennes.

195. Maurice Denis (1870–1943). *Sun Spots on the Terrace*, 1890. Oil on canvas, dimensions unknown. Private collection.

began to seek out works by other provocative artists. At Theo van Gogh's gallery they saw Impressionist paintings as well as canvases by his brother and by Gauguin. In the paint shop of Père Tanguy, they studied the few works by Cézanne that could be seen in Paris at the end of the 1880s. While the impact of this exposure was not immediate, Sérusier and his companions were already thinking differently about painting than they had before. Just two and a half years later they would organize themselves into a group called the Nabis (Hebrew for "prophet").

The members of this group—in which Sérusier assumed a crucial, almost paternal position—initially included Denis, Bonnard, and Ranson. Denis may have been drawn to Sérusier because of the latter's reputation at the Lycée, where the precocious youngster was finishing a degree in philosophy. Denis had entered the Académie Julian to prepare himself for the strenuous examination for admission to the Ecole des Beaux-Arts, which his parents viewed as the only serious training ground for an artistic career. Bonnard, who was twenty-one when he saw *The Talisman*, had come to the Académie

196

197

198

just a year before. His father was a government official who was determined that his son become a lawyer, but he finally relented and allowed the younger Bonnard to attend both the Académie and the Ecole des Beaux-Arts, where he specialized in drawing. Ranson was only slightly younger than Sérusier and had attended the Ecole des Arts Décoratifs in his native Limoges before transferring to a similar institution in Paris; he began studying at the Académie in 1886.

Sometime in the spring of 1889 the small circle around Sérusier expanded to include two newcomers: Edouard Vuillard and Ker-Xavier Roussel. These close friends had also attended the Lycée Condorcet and had studied briefly at the Ecole des Beaux-Arts. It is clear from the copious journals of Denis, who would emerge with Sérusier as the principal theorist of the group, that by this time a keen esprit de corps had developed and that the group's existence was becoming known to other students at the Académie. As a measure of both the ignorance and the conservatism that reigned in that institution, the young eccentrics were labeled Impressionists by their more conventional peers, despite the fact that the older group had ceased to be clearly defined or to represent a homogeneous style.

Like so many of their contemporaries who came of age when the Symbolist poets were attacking the foundations of Naturalism, the would-be prophets were attracted to the numerous occult groups then so much in vogue who identified positivism and science as their common enemy. The aesthetic programs of the Rosicrucians, for example, may have inspired the Nabis to assume the characteristics of a quasi-religious movement, a brotherhood with an aesthetic mission. They began to convene regularly, first in a local bistro and subsequently in Ranson's studio, which they solemnized as the "Temple." There, at weekly meetings, for which they frequently dressed up in Middle or Far Eastern costumes, their discussions ranged from painting to avant-garde theater and music to the aesthetic implications of writings by Henri Bergson and Arthur Schopenhauer. They communicated among themselves in a vocabulary shaped by their esoteric interests, and they often brought to their gatherings works in progress— sketches or paintings—which they designated as *icones*, indicating the reverence they accorded their activities. Their intimacy and sense of community did not prevent each member from expressing his individual intellectual concerns and in turn enriching the evolving collective aesthetic. Ranson, for example, was deeply interested in the popular cult of Theosophy. Sérusier's training in Platonic philosophy and his fascination with Semitic civilizations and Denis's abiding commitment to the mysteries of Catholicism provided shifting points of reference in their wide-ranging discourses on art and life. Though they took their commitment to art very seriously, the Nabis were still able to view themselves with a humor that often found expression in their writings and in their nicknames for each other: Sérusier was "The Bearded Nabi," Vuillard became "The Zouave Nabi," Denis was "The Nabi with the Beautiful Icons," and Bonnard was "The Very Japanese Nabi."

Buoyed by months of intense discussion with his friends and inspired by Gauguin's exhibition at the Café Volpini, Sérusier returned to Brittany in the summer of 1889. When he arrived he unhesitatingly proclaimed himself one of Gauguin's followers and moved into a small inn in the seaside village of Le Pouldu. Reminiscences by the owner indicate that Gauguin, the Dutch-born painter Jacob Meyer de Haan, and others had turned the place into a veritable gallery; there were statuettes, a few of the ceramics with which Gauguin was experimenting, drawings, and paintings, some executed directly on the plastered walls.[2] To these Sérusier made his own contribution, a handwritten declaration of his aesthetic faith quoted from the pronouncements of a composer he much admired, Richard Wagner:

I believe in a Last Judgement at which all those who in this world have dared to traffic with

196. Edouard Vuillard (1868–1940). *The Stevedores*, c. 1890. Oil on canvas, 17¾ x 24 in. Mr. and Mrs. Arthur G. Altschul, New York.

197. Maurice Denis (1870–1943). *Portrait of Madame Paul Ranson*, 1890. Oil on canvas, 35 x 17⅜ in. Musée du Prieuré, St. Germain-en-Laye.

198. Edouard Vuillard (1868–1940). *Portrait of Lugné-Poë*, 1891. Oil on canvas, 8¾ x 10½ in. Memorial Art Gallery of the University of Rochester, New York; Gift of Fletcher Steele.

199

sublime and chaste art, all those who have sullied and degraded it . . . by their vile lust for material enjoyment, will be condemned to terrible punishments. I believe on the other hand that the faithful disciples of great art will be glorified and that . . . they will return to lose themselves forever in the bosom of the divine source of all Harmony.[3]

From Le Pouldu, Sérusier corresponded with Denis, recounting his conversations with Gauguin and using his friend as a sounding board for his own ideas. Sérusier's primary desire, like that of the Symbolists, was to establish the importance of imagination as opposed to that of representation: ". . . should one work directly from nature or merely study and remember it? Too much freedom frightens me . . . and yet my head is filled with so many images evoked by what I see around me at all times that nature seems insignificant and banal."[4] His keen intellect, pronounced tendency to philosophic speculation, and exotic tastes made Sérusier an ideal companion for Gauguin. While his relationship to the older painter was certainly that of disciple to master, Sérusier's capacity to think clearly and write eloquently made him a skillful interpreter of the ideas that seemed to flow inexhaustibly, if unsystematically, from Gauguin. Indeed, given the absence of any definitive theoretical statement by Gauguin, the correspondence between Sérusier and Denis and their subsequent writings on painting offer the most extensive development of the concepts implicit in Gauguin's work.

The 1890s witnessed the appearance of a number of magazines dedicated to new ideas in art and literature. While most of these were ephemeral, a few had a major impact on the younger artists, offering a forum for their aesthetic views and stimulating their graphic activity. It was in one of these magazines, in 1891, that the youthful Denis published his first, and ultimately most influential, writing about art. Entitled "Définition du Néo-Traditionnisme," the article indicted the bankrupt illusionism of academic painting, the naturalism of Impressionism, and the literary pretensions of anecdotal painting. The essay's much-quoted first paragraph restated some of the ideas that Sérusier had communicated from Brittany in a terse and radical admonition: "One must

remember that a painting, before becoming a war horse, a nude woman or some anec-
dote, is essentially a flat surface covered with colors arranged in a certain order."[5] The
passage reveals a precocious understanding of the autonomous nature of painting and
appears to place more emphasis on form than content, but it does not mean that Denis
was an advocate of nonrepresentational art. Indeed, his article's title proclaimed his
belief in the supremacy of a tradition of art dedicated to expressing a "state of the soul"
as opposed to merely copying nature.

200

199. Maurice Denis (1870–1943). *Annunciation*, 1891.
Oil on canvas, 10⅝ x 16⅛ in. Rijksmuseum Kröller-
Müller, Otterlo, The Netherlands.

200. Maurice Denis (1870–1943). *April*, 1892. Oil on
canvas, 14¾ x 24 in. Rijksmuseum Kröller-Müller,
Otterlo, The Netherlands.

201. Paul Ranson (1862–1909). *Nabi Landscape*, 1890.
Oil on canvas, 35⅜ x 44¾ in. Josefowitz Collection.

201

202

203

202. Paul Ranson (1862–1909). *Christ and Buddha*, 1890. Oil on canvas, 28⅝ x 20¼ in. Mr. and Mrs. Arthur G. Altschul, New York.

203. Paul Sérusier (1864–1927). *Apple-picking*, 1892–93. Oil on canvas, three panels, 28⅝ x 52¼ in. overall. Collection Jean-Claude Bellier.

While his writings contributed significantly to the development of the modern sensibility, Denis nonetheless sought in his own work a union with the line of great masters that he traced from the early Renaissance to such contemporary figures as Puvis de Chavannes and Gauguin. Although the interest in the mystical and the occult that pervaded Symbolism and was especially appealing to the Nabis assumed a distinctly Catholic perspective in his writings and painting, Denis was always responsive to "the great art which one calls decorative, the Hindus, the Egyptians, the Greeks, the art of the middle-ages and the Renaissance, and the decidedly superior works of modern art . . . what are they if not the transformation of vulgar sensations—of natural objects . . . into sacred icons, hermetic, imposing."[6]

By the time Denis's article was published, he and some of his fellow students were beginning to make headway in the Paris art world. Ambroise Vollard asked him to illustrate *Sagesse*, a book by the Symbolist poet Paul Verlaine, and Bonnard received a commission for a poster advertising champagne. This willingness to explore illustration as well as posters was indicative of the integrated approach that permeated the Symbolist movement and was particularly characteristic of the art of the Nabis. Within the period that marked their most intense activity as a group (1889–96), they were to expand existing concepts of artistic collaboration and revolutionize the graphic arts. In this connection, Denis's friendship with the actor Aurélien Lugné-Poë proved most helpful. The latter brought Denis and his friends into the larger circle of Symbolist writers involved with the avant-garde *Théâtre Libre* and the later *Théâtre d'Art*. Vuillard was invited to design a program cover for the *Théâtre Libre* in 1891, and within a year several of the Nabis would design sets and costumes for productions in the *Théâtre d'Art*, which became a showcase for international Symbolist drama in the 1890s.

204. Pierre Bonnard (1867–1947). *Paris, rue de Parme on Bastille Day*, 1890. Oil on canvas, 31¼ x 15¾ in. Mr. and Mrs. Paul Mellon, Upperville, Virginia.

205. Edouard Vuillard (1868–1940). *Two Women by Lamplight*, 1892. Oil on canvas mounted on wood, 13 x 16 in. Musée de l'Annonciade, St. Tropez.

204

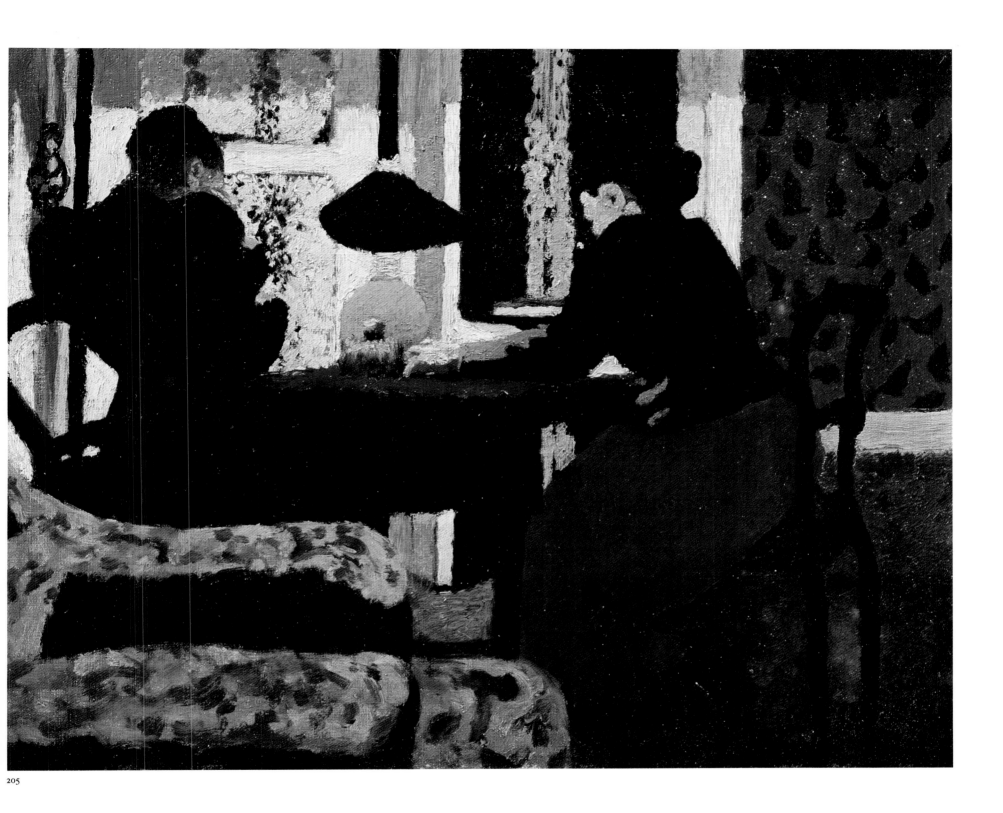

205

The Nabi Exhibitions

The months of 1890–91 proved to be a particularly critical period in the history of
modern painting. Manet's *Olympia* entered the Musée du Luxembourg, the first leg
of its long journey to the Louvre; van Gogh and Seurat died; and Gauguin finally set
out for the South Pacific. Against this background the Nabis, who had entered the
mainstream of Symbolism, now prepared to make their public debut in the Salon des
Indépendants. The large show contained works by Seurat, Signac, and other Neo-

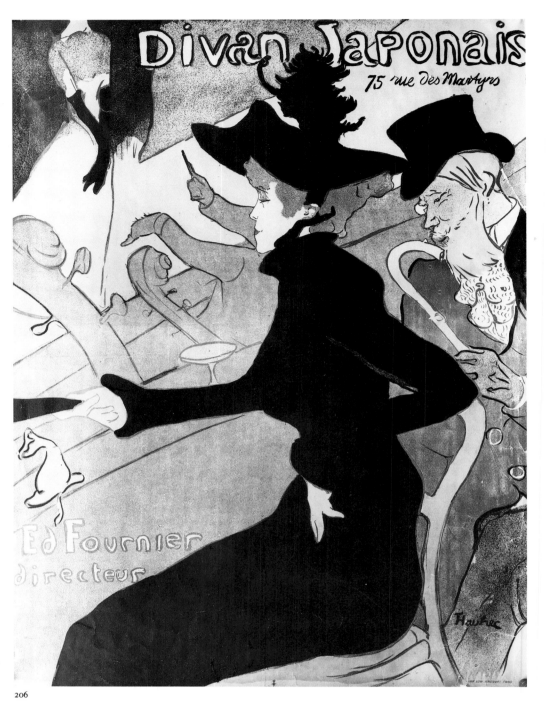

206

From the mid-1880s, when he established his studio in Montmartre, Toulouse-Lautrec devoted himself to the study of the area's animated night life. The intersection of reality and artificiality in the cabarets and dance halls offered an inexhaustible source of inspiration for his many images of patrons and performers. Toulouse-Lautrec's fascination with the legendary dancer of the Moulin Rouge, Jane Avril, prompted him to depict her many times. Here, uncharacteristically, we see her not as a performer but as a spectator at a rival cabaret, the Divan Japonais. Toulouse-Lautrec's poster drastically simplifies form and exaggerates color contrasts, creating a visual language that combines immediacy and succinctness.

Impressionists as well as a retrospective dedicated to van Gogh, but the inclusion of substantial contributions by Bernard, Denis, Bonnard, and others associated with Gauguin seemed to many a confirmation of the ascendance of the Symbolist aesthetic.

With this experience behind the group, Denis busied himself during the summer of 1891 with plans for the initial Nabi exhibition, to be held in his hometown, a suburb of Paris called St. Germain-en-Laye. His entrepreneurial skill was matched by his ability to attract critics, and when reviews of the exhibition appeared in some of the new magazines, a few of the participants were singled out: Bonnard's charm and elegance were lauded, Vuillard's simplicity was noted, and Denis was judged a superb ornamental painter. The exhibition even attracted the attention of Félix Fénéon, the erstwhile champion of Neo-Impressionism, whose growing interest in Symbolist art and literature would ultimately lend strong support to the Nabis' later endeavors. In addition, the

St. Germain-en-Laye show prompted an adventurous dealer with the colorful name Le Barc de Boutteville to consider showing the Nabis in his gallery. He initially approached Bonnard and Edouard Vuillard, who were then sharing a studio in Montmartre, and subsequently made the rounds of the others, gathering a substantial number of canvases and cementing ties that would endure for five years. In December 1891 eighteen paintings by the Nabis were shown with works by Signac and other Neo-Impressionists, Toulouse-Lautrec, Bernard, and a few independent artists under the title *Exposition de peintres Impressionistes et Symbolistes*.

The success of the Nabis' first show encouraged Le Barc de Boutteville to schedule two more exhibitions in 1892. In the spring most of the members also sent works to the Salon des Indépendants, and their critical reputations received an enormous boost from a lengthy review of the Salon by Aurier. Entitled ''Les Symbolistes'' and accompanied by illustrations of works by Gauguin, Bernard, Denis, Bonnard, Sérusier, Vuillard, and Ranson, the essay stressed the younger artists' connection with Gauguin while acknowledging their poetic and decorative contributions. Subsequently, the critic agreed to write the introduction to the catalog that accompanied their second appearance at Le Barc de Boutteville's in July.

As time went by, the underlying decorative impulse that Aurier perceived in the works of Denis, Sérusier, Ranson, and Bonnard became a more expansive commitment to art as decoration. In June 1892, Denis was given a commission to decorate part of a ceiling in the home of a painter, Vuillard began work on six panels for dressing rooms in a country house, Bonnard turned to painting ornamental screens, and Ranson tried his hand at designing china. These activities, like their endeavors for the stage or their essays in illustration, embodied the Nabis' belief that a fundamental creative bond linked the fine and applied arts, and their commitment to this belief was to survive long after the group had lost its sense of common identity and purpose.

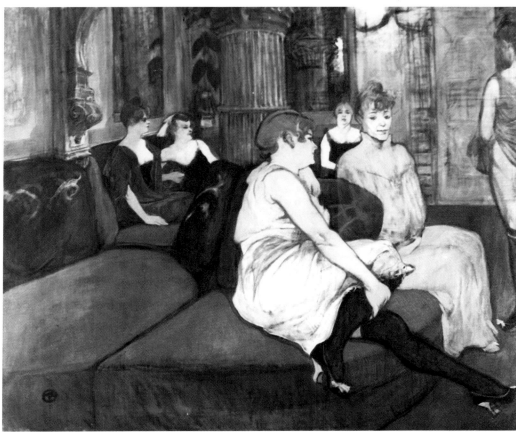

206. Henri de Toulouse-Lautrec (1864–1901). *Le Divan Japonais*, 1892. Lithograph poster, 31¼ x 23½ in. Victoria and Albert Museum, London.

207. Henri de Toulouse-Lautrec (1864–1901). *In The Salon at the rue des Moulins*, 1894. Oil on canvas, 43⅞ x 52⅛ in. Musée Toulouse-Lautrec, Albi, France.

207

The third and largest group exhibition, at Le Barc de Boutteville's in December 1892, gave the critics and public a real opportunity to focus on the individual styles of the participants. Bonnard—"The Very Japanese Nabi"—garnered the praise of more than one critic for his elegant design and his evident assimilation of Oriental decorative strategies, though it should be acknowledged that the critics attributed a shared exotic inspiration to virtually all the Nabis. In a long article for *La Revue indépendante*, Charles Saunier grouped the painters stylistically, opposing those who were consciously archaic (Denis and Sérusier) to those who tried to apply the Japanese aesthetic to contemporary European life (Bonnard, Vuillard, Toulouse-Lautrec). Saunier's classifications do shed some light on the individual interests that were beginning to appear by the end of 1892.

In its subject matter, for example, Bonnard's *Paris, rue de Parme on Bastille Day* (plate 204) invites comparison with Impressionist antecedents, as does Vuillard's *Two Women by Lamplight* (plate 205), whereas the spiritual or allegorical content of Denis's *Annunciation* and *April* (plates 199, 200) is rooted in the art of such masters as Fra Angelico and Puvis de Chavannes. While all the Nabis tended to simplify shapes and to stress the flatness of the painted surface, their approach to design could be quite individual. The whimsical calligraphy of Bonnard's street scene or the insistent patterning of Vuillard's domestic interior contrasts strikingly with the lyrical line and formal restraint in Denis's canvases.

Japonisme and the Modern Print

Critics in the 1890s repeatedly noted the affinity between Japanese woodcuts and art by Bonnard, Vuillard, and Toulouse-Lautrec—a non-Nabi but a close friend of several members. While these prints had provided earlier artists such as Manet and Degas with new viewpoints that helped to dispel the authority of illusionistic space, the woodcuts' stylization, boldly nondescript color, and nonnarrative approach to subject matter now began to capture the imagination of artists who were already sensitive to the formal properties of non-Western and folk art. In particular, Japanese woodcuts offered a welcome solution to the problem that increasingly preoccupied the Nabis, namely, how to reconcile pictorial illusionism with the inherent two-dimensionality of the canvas. The appearance in April 1890 of an exhibition of more than seven hundred Japanese woodcuts at the Ecole des Beaux-Arts offered an unparalleled visual survey of the medium. The stylistic reverberations of the Nabis' confrontation with this panorama would be evident in many of their subsequent paintings, though its most profound impact was on their graphic output.

Toulouse-Lautrec's love affair with Japanese art had begun in the early 1880s and intensified with time, as he became a knowledgeable amateur and one of the most sensitive interpreters of Japanese woodcuts. His friendship with van Gogh and Bernard, who were avid collectors, stimulated him to haunt shops like Bing's and Goupil's. Treating lithography with the same seriousness he accorded painting, Toulouse-Lautrec began making lithographs long before the Nabis turned to them, producing 357 between 1891 and 1901. His posters gained him instant recognition with the public and with critics. Borrowing compositional devices from woodcuts, he juxtaposed flat areas of pure color and animated them in such a way as to unite pictorial elements and lettering. In *Le Divan Japonais* (plate 206), named after a popular Montmartre nightclub, a Degas-inspired kaleidoscope of spectators, orchestra, and performers—in this case, Jane Avril and Yvette Guilbert—supplies the main image, but the expected spatial tensions are resolved because color and line force the viewer to read the semiabstract shapes as a unified, two-dimensional surface. With his effortless, witty calligraphy, his

208

208. Henri de Toulouse-Lautrec (1864–1901). *Moulin Rouge: The Dance*, 1890. Oil on canvas, 45½ x 59 in. Henry P. McIlhenny.

economy of shape and color, and his sensitivity to the creative function of the paper itself, Toulouse-Lautrec revolutionized the art of the poster, uniting form and content by means of the same system of design that informed his painting.

The popularity of lithography and particularly of the poster reached a crescendo at precisely the moment when the Nabis were coming of age artistically. The efforts of the critic Claude Roger-Marx to generate enthusiasm for lithography among artists and collectors bore fruit between 1893 and 1899, when an unprecedented number of publishing ventures brought hundreds of prints to the attention of a growing audience. Roger-Marx claimed that the poster's popularity was due to the dissolution of the hierarchical value system that had long relegated the graphic arts to a minor position. He argued that "the poster addressed itself to the universal soul. . . . Its art was no less significant, nor less prestigious than that of the fresco."[7] Roger-Marx's fellow critic André Mellerio regarded the original print as nothing less than the quintessence of contemporary artistic expression.

Roger-Marx and the publisher André Marty joined forces to produce limited-edition portfolios of color lithographs, of which *L'Estampe originale*, which appeared in nine quarterly installments between 1893 and 1895, was the pioneer. The first issue, with a cover by Toulouse-Lautrec, contained prints by Bonnard, Denis, Ranson, Roussel, Vuillard, and Félix Vallotton, a Swiss-born artist who had gravitated toward the Nabis in 1890 and who exhibited with them regularly. The Nabis and their friend Toulouse-Lautrec dominated *L'Estampe originale* and the various portfolios that followed. Color lithography seemed an ideal medium for their collective and individual styles, and, indeed, the Nabis never seemed closer stylistically than in their shared graphic debut. Flat, stylized forms, unexpected Japanese viewpoints, and an implicit sense of pattern characterized the efforts of all. The abilities of Bonnard, Vuillard, and Toulouse-Lautrec to exploit the expressive potential of this comparatively restrictive medium were remarkable, and—if we are to believe Bonnard, who claimed that "color lithography taught me much about painting"[8]—producing prints had a profound effect on their other art.

209. Henri de Toulouse-Lautrec (1864–1901). *Tête-à-Tête Supper*, 1899. Oil on canvas, 21⅝ x 18⅛ in. Courtauld Institute Galleries, London.

210. Pierre Bonnard (1867–1947). *La Revue blanche*, 1894. Lithograph in four colors, 31⅜ x 24⅜ in. The Art Institute of Chicago.

210

211

211. Félix Vallotton (1865–1925). *The Third Gallery: Théâtre du Châtelet*, 1895. Oil on canvas, 19¾ x 24½ in. Musée du Louvre, Paris.

212. Félix Vallotton (1865–1925). *Intimacy: Interior with Lovers and a Screen*, 1898. Oil on canvas, 13¾ x 22½ in. Josefowitz Collection.

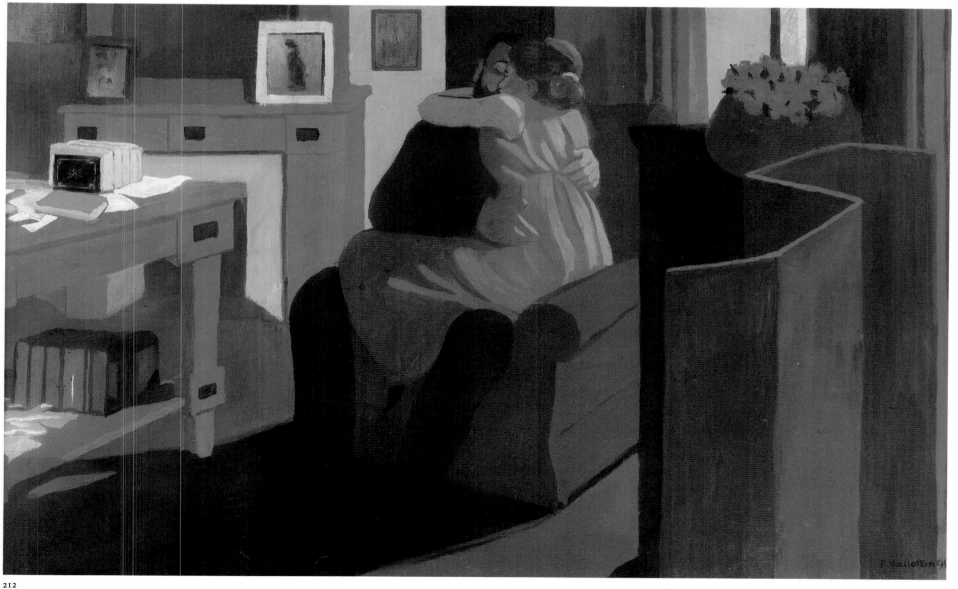

Easily the most brilliant art and literary critic of the Symbolist era, the virtual discoverer of Seurat and Signac, Fénéon became the authoritative intellectual force behind La Revue blanche *after assuming the magazine's editorship in 1894. Just two years earlier, the militant anarchist writer had been imprisoned in the sweeping crackdown on leftist political groups that followed the assassination of the president of France, Sadi Carnot. It seems appropriate that Vallotton, the only politically committed member of the Nabis, should have painted Fénéon at work in the offices of the magazine whose owners had staunchly supported him during that turbulent period. With his genius for stripping down form and his sensitive exploitation of light and dark contrasts, Vallotton conveys in compact pictorial terms the concentration and intensity that stamped the personality of the sitter.*

213

The Nabis have been called "The Painters of *La Revue blanche*," in reference not only to their historic artistic collaboration with that celebrated magazine but also to the collections of their work, the *Album de la Revue blanche* and *Petite Suite de la Revue blanche*, that were published in 1894 and 1896. In addition, the Nabi painters enjoyed warm relationships with the magazine's owners, the Natanson brothers, who were avid collectors of their work. From its appearance in 1889 until its demise fourteen years later, *La Revue blanche* embraced the literature and art of the day. It published works by virtually all the leading writers of its time, including Mallarmé, Verlaine, Maeterlinck, Proust, Strindberg, Ibsen, Tolstoy, and Chekhov, and it also provided spirited discussions of music, theater, and politics that reflected the multiple interests and liberal views of its owners.

From 1895 to 1899 the dealer Ambroise Vollard devoted lithographic albums to the work of individual Nabis: Bonnard, Vuillard, Denis, and Roussel. The lively decorative spirit of Japanese art found its counterpart in such albums as Bonnard's twelve-part series *Some Aspects of the City of Paris*. Clearly inspired by Hiroshige's *One Hundred Views of Edo*, the French suite translated the spaces and activities of a bustling metropolis into an inspired decorative shorthand that prompted one writer to remark: "Paris [has become] the Edo of the West and Bonnard its Hiroshige." [9]

Thematic and Stylistic Differences

While the Nabis contributed significantly to the development of abstraction, they never totally abandoned representation. Although Sérusier, Denis, and Ranson were united by interests in religion and the occult, Roussel, Bonnard, Vuillard, and Vallotton were scarcely affected by their colleagues' enthusiasms and were also less indebted to Gauguin and his Pont-Aven affiliates. The works of Bonnard and Vuillard perpetuate

214

213. Félix Vallotton (1865–1925). *Félix Fénéon in the Office of the "Revue blanche,"* 1896. Oil on board, 20¾ x 26 in. Josefowitz Collection.

214. Edouard Vuillard (1868–1940). *Café in the Bois de Boulogne,* c. 1893. Oil on canvas, 13½ x 15 in. Private collection, St. Germain-en-Laye.

215. Edouard Vuillard (1868–1940). *The Promenade,* 1894. Tempera on canvas, 84¼ x 38⅜ in. The Museum of Fine Arts, Houston; Robert Lee Blaffer Memorial Collection.

215

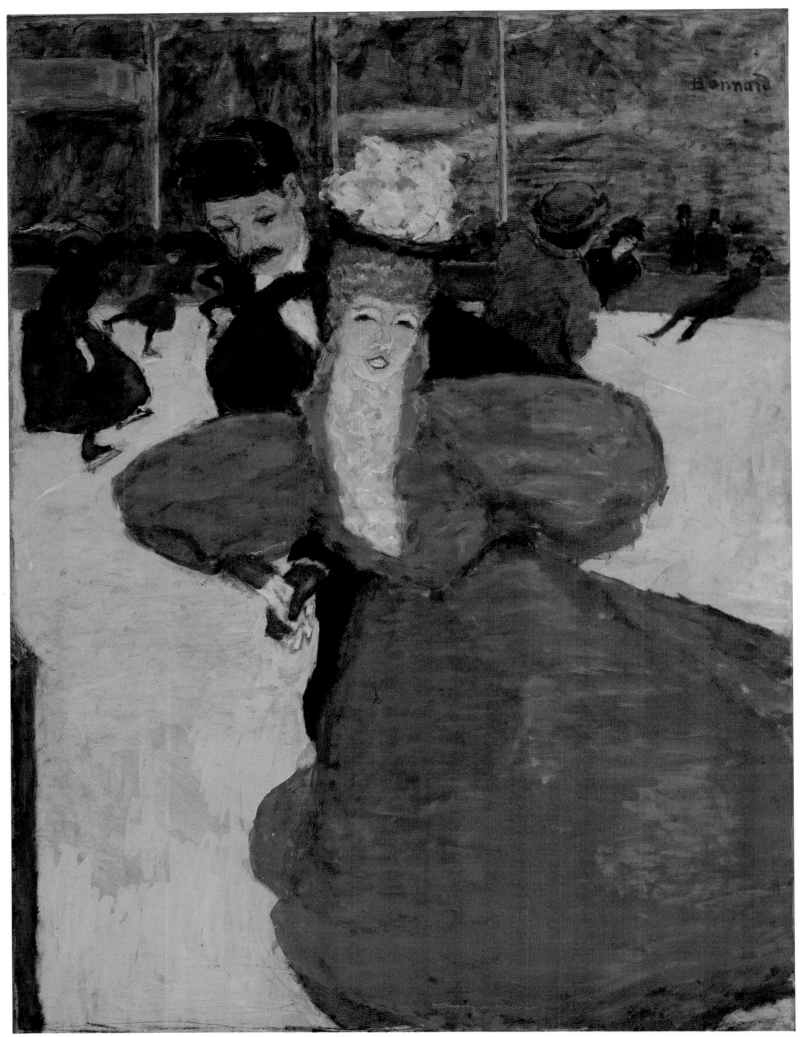

216. Pierre Bonnard (1867–1947). *Ice Palace*, 1898. Oil on paper mounted on canvas, 39⅜ x 29½ in. Private collection, Switzerland.

217. Pierre Bonnard (1867–1947). *Luncheon (Le Déjeuner)*, 1899. Oil on canvas, 21¼ x 27¾ in. Bührle Foundation, Zurich.

the Impressionists' involvement with modern life and especially with the pleasures of affluence. They shared with the Swiss-born Vallotton (who had come to be known as "The Foreign Nabi") an interest in the public and private aspects of social intercourse; but whereas Bonnard and Vuillard sought to capture the patterns and rhythms of an urban promenade or a private garden party, Vallotton often pursued a wider variety of urban types and engaged in more penetrating study of social and psychological relationships.

In such paintings as *Café in the Bois de Boulogne*, *The Promenade*, *Ice Palace*, and *Luncheon* (plates 214–17), Bonnard's and Vuillard's style comes closest to Impressionism. Nonetheless, in these compositions there is scarcely a trace of the Impressionist obsession with capturing atmospheric ephemera. Rather, the two artists try to seize the feeling of a motif by stylizing gesture, intensifying contrast of light and color, and stressing pattern or texture to provoke sensory reactions in the viewer. Cropping forms radically, emphasizing the pictorial surface through the overlapping of figures and furnishings, insisting on a totally integrated composition in which each component has equal value, they created a vivid decorative order. Although the novelty and humor of their work had struck critics from their very first exhibition at Le Barc de Boutteville's, their subtle use of color to evoke atmosphere and mood drew special attention from Gustave Geffroy, who reviewed Bonnard's one-man show at Durand-Ruel's in 1896 and compared his sensibility with that of his close friend Vuillard:

Vuillard is a clearer and more vivid colorist . . . boldly bursting forth in rich patterns of

217

218

219

blue, red, golden yellow: and at the same time one feels that his spirit is melancholy. . . .
Bonnard, on the other hand, is a gray painter, fond of purplish, russet, somber tones; and
yet in every stroke his shrewd observation, his impish gaiety are revealed with charming
distinction. . . . A curious line in movement, of a monkeylike suppleness, captures
[Bonnard's] casual gestures of the streets, these fleeting expressions born and vanished in
an instant.

It is the poetry of a life that is past, the remembrance of things, of animals, of human
beings.[10]

Geffroy's sensitive reading of Bonnard's work, especially his appreciation of its intelligent wit and its ability to transmit the essential visual characteristics of an experience, recalls the artist's affinity with Degas and Toulouse-Lautrec, as does his skill at locating each form in just the right place to underscore the dominant rhythm of a composition. No more impressive demonstration of this gift can be found than in *Nannies Promenade, Frieze of Carriages* (plate 218), a five-color lithograph in four parts combined to form a screen. Bonnard's keen eye for peculiarities of dress and movement, his exploitation of the contrast between the fixed and the fleeting, and, above all, his spectacular sense of placement resulted in a delightful balance of the artful and the spontaneous, of the real and the artificial, that remains one of his most notable achievements. It also provides a powerful demonstration of the Nabi belief that distinctions between fine and decorative art were invalid.

Vuillard's attraction to pattern and decorative surfaces—wallpaper, rugs, screens, and clothing—was, if anything, stronger than Bonnard's. Vuillard's mother had conducted a dressmaking business from their home, and her activities provided her son with the subjects for countless pictures and even inspired his brother-in-law, Roussel, to try a similar scene (plate 219). In such works, the requisites of portraiture were subordinated to pictorial considerations as the sitters were absorbed in a veritable tapestry of pigments. At times, Vuillard's concern with pattern and texture virtually overwhelmed the figures or objects in his paintings, so that figures, furnishings, walls, and doorways are transformed into vague reverberations of themselves.

220

218. Pierre Bonnard (1867–1947). *Nannies Promenade, Frieze of Carriages (Screen)*, 1897. Lithograph in five colors, four panels, each panel 54 x 18¾ in.; 59 x 79 in. overall. The Museum of Modern Art, New York; Abby Aldrich Rockefeller Fund.

219. Ker-Xavier Roussel (1867–1944). *The Seamstresses*, c. 1894. Oil on canvas, 44⅛ x 30⅛ in. Mr. and Mrs. Arthur G. Altschul, New York.

220. Edouard Vuillard (1868–1940). *Breakfast*, c. 1904. Tempera on panel, 23 x 28¼ in. Collection Jean-Claude Bellier.

221

221. Edouard Vuillard (1868–1940). *The Library*, 1896. Oil on canvas, 83⅜ x 30⅜ in. Musée du Petit Palais, Paris.

222. Edouard Vuillard (1868–1940). *The Piano*, 1896. Oil on canvas, 82 x 60 in. Musée du Petit Palais, Paris.

The term Intimiste has been used to describe these glimpses of bourgeois domesticity, which had more immediate popular appeal than the remote and ethereal images of Denis and the more idealistic Nabis. While most of the works that Vuillard initially executed in this mode were very small, usually no more than thirteen by fifteen inches, he, like Bonnard, also responded to the challenge of creating large decorative panels. In 1896 Vuillard received a commission to produce four such works for the library of a Parisian doctor. Collectively entitled *Characters in an Interior Setting*, they offer quiet fragments of family life. In *The Library* (plate 221), for example, the variegated patterns of the rug, the woman's blouse, and the wallpaper vie with the more insistently geometric formality of the shelved books, with the result that the figure is gradually absorbed by her sumptuous environment. The impulse to integrate the human figure with its surroundings is even stronger in the panel devoted to an evening of piano music (plate 222). Here the mood of reverie so often encountered in Symbolist art and literature enfolds the entire family unit. A delicate melancholy pervades the stifling richness of the room; the slightly muted tonalities envelop all the forms, blurring spatial distinctions between them and transforming them into fragile approximations.

The Nabis most enjoyed painting their families and their close friends. Among the latter, the most frequently depicted were Thadée Natanson and his wife, Misia. Bonnard and Vuillard did many portraits of them, singly, together, or with other friends. One of the latter's canvases shows the legendary beauty and her husband in the company of Vallotton (plate 223). In an attempt to capture the sense of unselfconscious informality that had marked Impressionist portraiture, Vuillard cropped the image of Thadée at the left edge of the canvas to the point where his presence, much less his identity, is barely discernable. While the canvas vibrates with colors and patterns, Misia's decorative form dominates. She later claimed that Vuillard had been in love with her at the time he painted this work, which might explain the extraordinary force of personality that radiates from the intensely artificial composition. In the few years preceding the Natansons' divorce in 1904, Vuillard often painted the garden of their country home in Villeneuve-sur-Yonne. In a typical luncheon scene (plate 224), we once again confront a theme that had its origins in Impressionism. Indeed, Vuillard's palette had lightened considerably by the time he painted this canvas, which projects a more conventional sense of space and a buoyancy that signal a departure from his earlier formal and psychological concerns. The change in Vuillard's work after 1900 must have proven contagious, for his closest friend, Bonnard, also turned to brighter color. Bonnard's discovery of the south of France may have played a part in this gradual conversion, and the light-filled landscapes he produced on the Côte d'Azur in the summer before World War I (plate 225) predict the personalized and sensuous Impressionist manner that he subsequently adopted.

The Dissolution of the Nabis

The personal and philosophical differences that had once been subordinated to a common sense of cause began to isolate certain of the Nabis toward the end of the 1890s. The theoretical aspects of their aesthetic as represented in the art and writings of Sérusier and Denis were in apparent conflict with the more empirical approaches evolved by Bonnard, Vuillard, Vallotton, and, to a lesser extent, Roussel. In letters to Vuillard in 1898, for instance, Denis expressed his belief that it was wrong to seek "immediate pleasure in a work of art," and he stressed his developing notion of a classical art that clearly opposed Vuillard's reliance on "instinct" as his supreme guide.[11]

While the Nabis continued to exhibit as a group at Durand-Ruel's in 1899 and later at Bernheim-Jeune's—and though they remained friends in the years that followed—the

Whether inspired by Oriental philosophy, Catholic doctrine, or domestic life, the Nabis shared the common purpose of conveying some fundamental of inner experience. The energy and torment so often the subject of van Gogh or Munch is never encountered in their works. A fondness for the Impressionist world of comfortable interiors and pleasurable gardens unites Bonnard and Vuillard, but comparison of the latter's canvases with those of the Impressionists reveals what an enormous psychological as well as aesthetic distance separates them. In place of exuberant well-being, Vuillard's gardens and interiors seem to offer silence and reverie. The artist's gift for creating a distinctive ambience was unrivaled in the Nabi group. His sensitivity to delicate emotional complexities found expression in exquisite tonal shifts of light and dark in deftly synthesized forms that merge tantalizingly with their environment. No painter of his generation could seriously challenge Vuillard's claim to the title Master of the Ambiguous.

223

223. Edouard Vuillard (1868–1940). *Misia, Vallotton, and Thadée Natanson*, 1899. Oil on board, 27⅜ x 20¹/₁₆ in. William Kelly Simpson.

224. Edouard Vuillard (1868–1940). *Luncheon at Villeneuve-sur-Yonne*, c. 1902. Oil on canvas, 86 x 75 in. The National Gallery, London.

solidarity and vitality that had marked their early years was gone by the beginning of the century. A large canvas painted by Denis in 1900 (plate 226), when the members of the group were in their thirties, depicts them in Vollard's gallery paying symbolic homage to Cézanne, whose work was enjoying unusual critical attention at the time. Denis's composition was inspired by Fantin-Latour's *Homage to Delacroix*, painted in 1863, the year of the historic Salon des Refusés. In that picture the artist had gathered painter-friends, including Manet, Whistler, and Frédéric Bazille, and noted writers such as Baudelaire and Duranty around a portrait of the great Romantic master, thus

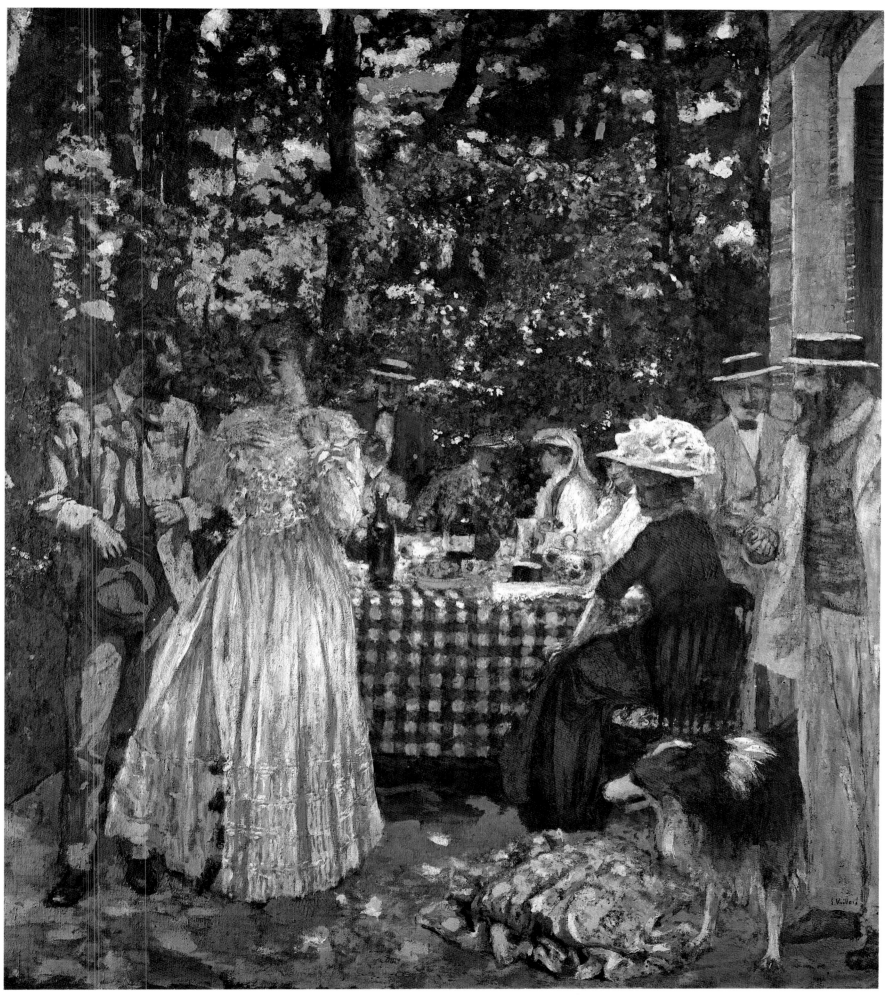

225

225. Pierre Bonnard (1867–1947). *In a Southern Garden*, 1913. Oil on canvas, 33 x 44⅜ in. Kunstmuseum, Berne.

226. Maurice Denis (1870–1943). *Homage to Cézanne*, 1900. Oil on canvas, 70¾ x 94½ in. Musée du XIXe Siècle, Paris.

implying a reverent solidarity. Denis's intentions were clearly similar, for the Cézanne still life that is the object of veneration in this picture had once belonged to Gauguin, who had clung to it through years of desperate poverty and who had undoubtedly praised its virtues to Sérusier when the two met in Pont-Aven some twelve years earlier. Thus Denis's painting, through the inclusion of a work held in such high esteem by Gauguin, links Gauguin with the Nabis' own appreciation of Cézanne, whose achievements were already leading the way to a new understanding of the nature of painting.

Although none of the Nabis would participate in the revolutionary development toward abstraction that was to take place in the first decade of the twentieth century, they had helped to chart its direction by emphasizing the formal and decorative nature of painting at the expense of verisimilitude. By reducing the canvas to "a flat surface covered with colors arranged in a certain order," Denis insisted that painters and viewers alike accept it for what it was, not for what it resembled. This fundamental premise was indispensable to the intense investigations of the intrinsic nature of painting that would soon be made by the Fauves and the Cubists.

This group portrait depicts, from left to right: Redon, Vuillard, André Mellerio, Vollard, Denis, Sérusier, Ranson, Roussel, Bonnard, and Mme. Denis. At the time Denis painted it, both he and Sérusier were becoming increasingly aware of the importance of Cézanne to present and future art. Just a few years later, in 1905, Sérusier offered an appraisal of Cézanne's contributions that complements this painted act of acknowledgment and underscores the older artist's significance for the Nabis: "Cézanne . . . showed clearly that imitation is merely a means and that the only aim is to arrange lines and colors on a given surface . . . to create a language by purely plastic means. . . . If, as I dare to hope it will, a tradition is born of our time it will be born of Cézanne."

6 FAUVISM
An Orgy of Pure Colors

WHEN the critic Louis Vauxcelles characterized a small classicizing bust of a child by the sculptor Albert Marque—which shared a room at the Salon d'Automne of 1905 with paintings by Henri Matisse, André Derain, Maurice de Vlaminck, Henri Rousseau, and others—as "Donatello chez les fauves"[1] ("Donatello among the wild beasts"), he contributed a label that was adopted as quickly as Louis Leroy's term Impressionism had been. Unfortunately, neither name adequately characterizes the nature and goals of the movement it purportedly describes. It may have been the subject matter of Rousseau's *Hungry Lion* that provoked the critic's appellation, but he was surely just as disturbed by the chromatic and formal distortions of the pictures. At the time that Vauxcelles reacted in shock to the "orgy of pure colors"[2] emblazoned on their canvases, the Fauves were even less a homogeneous group than their predecessors had been. They did not adopt the critic's mocking label until later, after their collective exploration of high color and aggressive execution had given way to more individual styles. Indeed, Georges Duthuit, the first historian to chronicle the development of Fauvism, stated that Matisse professed ignorance of the meaning of the term.[3]

In the narrowest sense, Fauvism can be said to characterize an interval when a radical approach to color and design, pioneered by Matisse but adopted by a small group of associates and admirers, fired the imagination of a dozen or so French painters. As the dominant figure of this period, Matisse influenced various members of this small group—especially Derain—and thus had a determining effect on the nature and duration of Fauvism. The radical shifts in technique and composition that can be seen in Matisse's and Derain's paintings of 1905 through 1907 underscore both the rapid development of each artist's painterly consciousness and the inherently transitional character of Fauvism.

The public response to the Fauvist paintings in the Salon d'Automne was as negative as the reception that had greeted Manet in the Salon des Refusés in 1863 and the Impressionists in 1874. Some critics dismissed the artists as inept and incoherent, disparaging their canvases as "the uncouth and naive games of a child playing with a box of colors."[4] If Fauvist paintings shock us less today, it should be remembered that most of the scoffers had not yet come to terms with even the work of van Gogh or Gauguin. In retrospect, the paintings of the Fauves can be seen more as the logical culmination of

227. Detail of plate 253.

228

attitudes initiated thirty years earlier than as statements of a radical new aesthetic program. In an era still much involved with Symbolism, the Fauves looked to Impressionism for many of their themes and, for a time, turned to Neo-Impressionism for their technique, all the while exploring the more subjective use of color that had emerged in the late 1880s.

Energy and excitement have been cited as common attributes of Fauvist paintings, but there was an underlying current of anxiety as well. The movement's brief lifespan suggests that it provided a useful stimulus for some painters but not a self-sufficient aesthetic. Georges Braque, who entered the orbit of Fauvism when he worked with Othon Friesz and Derain, described the intensity it demanded and, at the same time, acknowledged the impossibility of sustaining that intensity: ". . . I couldn't have done it again, I'd have to go to the Congo the next time to get the same effect. . . . You can't remain forever in a state of paroxysm. The first year there was the pure enthusiasm of the Parisian who discovered the Midi. The next year that had already changed." [5] Nor was Braque the only painter to experience difficulty: Albert Marquet, Derain, and Vlaminck, among the early adherents to the new expressive painting, lost their initial fervor and succumbed to the irresistible lure of Cézannism. By 1908, with Matisse absent from the Salon des Indépendants and many of his former colleagues in flight from Fauvism, Vauxcelles could only wax nostalgic: "Alas! The heroic period is over. Where are the days when the Indépendants, with their violent excesses, provoked the . . . mirth of the bourgeoisie and the press?" [6]

The Formative Years

Fauvism was conceived in the unlikely atmosphere of the Ecole des Beaux-Arts. Having arrived at the Académie Julian in 1891, Matisse missed by one year the excitement generated in that institution by the activities of Sérusier and the other disciples of Gauguin. After briefly working there with the perennial Salon favorite William Bouguereau, he followed in the footsteps of many an earlier Académie pupil and applied to the Ecole des Beaux-Arts. He was accepted there by Gustave Moreau, who, at the age of sixty-six, had become a professor of painting. At the time of his appointment Moreau had not exhibited publicly for twenty years, though he still remained the darling of the literary Symbolists. His presence in that fortress of official art served as a magnet that soon attracted a formidable group of aspiring painters, encouraged, no doubt, by the famed master's reputation for open-mindedness and his emphasis on individual expression. It was in Moreau's studio that Matisse encountered Georges Desvallières, one of the future organizers of the 1905 Salon d'Automne, as well as some of the artists who would join them in making that event memorable: Marquet, Charles Camoin, and Georges Rouault.

The force of Moreau's personality, his erudition, and his own inspired eclecticism encouraged his students. While constantly stressing the value of studying the old masters in the Louvre, Moreau also opened his students' eyes to the color of Delacroix and even directed them to such unorthodox works as the canvases of Henri Rousseau. In contrast to his conservative colleagues at the Ecole, Moreau urged his pupils to seek "inner feeling," and his faith in art's ennobling mission had a profound impact on Matisse. Fifty years after he entered Moreau's studio, Matisse still reiterated his teacher's precepts when he claimed that "the only necessary painters are those who have the gift of conveying their intimate feelings by color and drawing." [7] Moreau's influence may not be obvious in Matisse's paintings, but the older artist's appreciation of what lay behind the visible indelibly stamped his pupil's sensibility.

Moreau never discouraged his pupils from looking at contemporary art; he even de-

228. Henri Matisse (1869–1954). *Dessert*, 1897. Oil on canvas, 39⅞ x 51½ in. Private collection.

229. Albert Marquet (1875–1947). *"Fauve" Nude*, 1899. Oil on paper mounted on canvas, 28¾ x 19¾ in. Musée des Beaux-Arts, Bordeaux.

230. Henri Matisse (1869–1954). *Nude in the Studio*, 1899. Oil on canvas, 25½ x 19⅝ in. Bridgestone Museum of Art, Ishibashi Foundation, Tokyo.

Already evident in the nudes painted by Matisse and Marquet in 1899 are some of the ingredients of Fauvism that would emerge so dramatically in the Salon d'Automne exhibition six years later. Both treatments of this conventional academic subject are marked by an unprecedented wildness of execution and of color. Combining almost reckless brushwork with liberal use of the palette knife, they stress the continuity of the figure and ground rather than its traditional distinctness. While there is considerable similarity between the two canvases—prompted by the fact that the artists were working together with the same model—Matisse's fragmentation of the human form and his virtual obliteration of the surrounding details reflect his more aggressively subjective approach.

229

230

231

231. Albert Marquet (1875–1947). *Notre-Dame in Sun*, 1903. Oil on canvas, 28⅝ x 23⅝ in. Musée des Beaux-Arts, Pau.

232. Henri Matisse (1869–1954). *A Glimpse of Notre-Dame in the Late Afternoon*, 1902. Oil on paper mounted on canvas, 28½ x 21½ in. The Albright-Knox Art Gallery, Buffalo, New York; Gift of Seymour H. Knox, 1927.

233. Albert Marquet (1875–1947). *Sergeant of the Colonial*, 1904. Oil on canvas, 31¾ x 25⅝ in. Musée des Beaux-Arts, Bordeaux.

fended Matisse when his colleagues complained about the evident influence of contemporary styles on *Dessert* (plate 228), a work that Matisse exhibited in the Salon of 1897. Matisse's recent encounter with Impressionism at the exhibition of paintings bequeathed by Caillebotte to the Musée du Luxembourg is apparent in his ambitious attempt to assimilate some of its characteristics: loose brushwork, rather ambiguous space, attention to light, and a thoroughly bourgeois theme. But his confrontation with Impressionism also made him aware of the choice between an objective and a subjective approach to painting, which was exemplified in the conflict between naturalism and Symbolism—still a vital issue in the 1890s. Whereas most of his contemporaries accepted this conflict as a given, Matisse would struggle for years to reconcile the seemingly irreconcilable. He later described his efforts as "a meditation on nature, on the expression of a dream inspired by reality."[8]

During the summer of 1897 Matisse traveled through Brittany, where he became friendly with John Russell, an English artist who had been on intimate terms with Monet and van Gogh. His exchanges with Russell expanded his knowledge of Impressionist painting, as did his contact that year with Pissarro. It was the latter who encouraged him to work directly from nature and to seek inspiration outside of Paris, as so many others had done. Following Pissarro's advice, Matisse spent six months in Corsica, where the radiant southern light inspired a bold new freedom in his use of color.

On his return to Paris, Matisse discovered that Moreau had died, and he enrolled in 1899 at the Académie Carrière, where he began to work on the human figure, exploring his newfound enthusiasm for constructing form exclusively with color. To his group of old friends from the Ecole, he added a newcomer from the Académie Carrière, André Derain. Matisse, who at age thirty was somewhat older than the other students, quickly assumed the position of leader in this ever-growing circle, sharing with the others his deepening appreciation of Cézanne, whose works he had seen at Vollard's gallery. The strong color and reckless, slashing execution of Matisse's *Nude in the Studio* (plate 230) impressed some of his less daring colleagues, one of whom remarked: "He had no hesitation about introducing extreme and wholly artificial elements in his pictures."[9] Yet this experimentation with bright color was short-lived.

Matisse's subsequent work involved a generally more conservative approach to color and a deeper concern with drawing. Moreover, his admiration for Cézanne began to play a formative role in the development of his aesthetic consciousness between 1901 and 1904. He had purchased Cézanne's *Three Bathers* (plate 235) from Vollard in 1899, when he could scarcely afford the luxury of collecting, and it was to remain in his studio for thirty-seven years as a cherished reminder of what great painting was and as a constant exhortation to equal Cézanne's achievement. Although Matisse made no effort to meet the master, the presence of this canvas was sufficient to change his approach: "Little by little the notion that painting is a means of expression asserted itself and that one can express the same things in several ways. . . . Notice that the classics went on redoing the same painting and always differently." Matisse said that he found in Cézanne's work "constructional laws . . . which are useful to a young painter. He had among his great virtues, this merit of wanting tones to be forces in a painting. . . ."[10] Matisse empathized with Cézanne's legendary hesitancy and frustration, maintaining that each time he stood before a canvas it seemed that he was painting "for the first time."[11]

Matisse and Neo-Impressionism

While Cézanne's methodology continued to exert an influence on Matisse, toward 1904 he began to express renewed interest in color and in landscape. He had read Signac's *D'Eugène Delacroix au Néo-Impressionisme* when it was published in serial form in

233

232

235

234

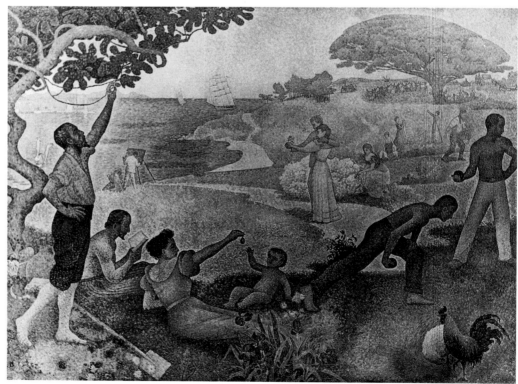

236

234. Henri Matisse (1869–1954). *Luxe, calme, et volupté*, 1904. Oil on canvas, 37 x 46 in. Musée National d'Art Moderne, Centre Georges Pompidou, Paris.

235. Paul Cézanne (1839–1906). *Three Bathers*, 1879–82. Oil on canvas, 20⅜ x 21⅝ in. Musée du Petit Palais, Paris.

236. Paul Signac (1863–1935). *In Time of Harmony*, 1893–95. Oil on canvas, dimensions unknown. Mairie, Montreuil, France.

237. Detail of plate 234.

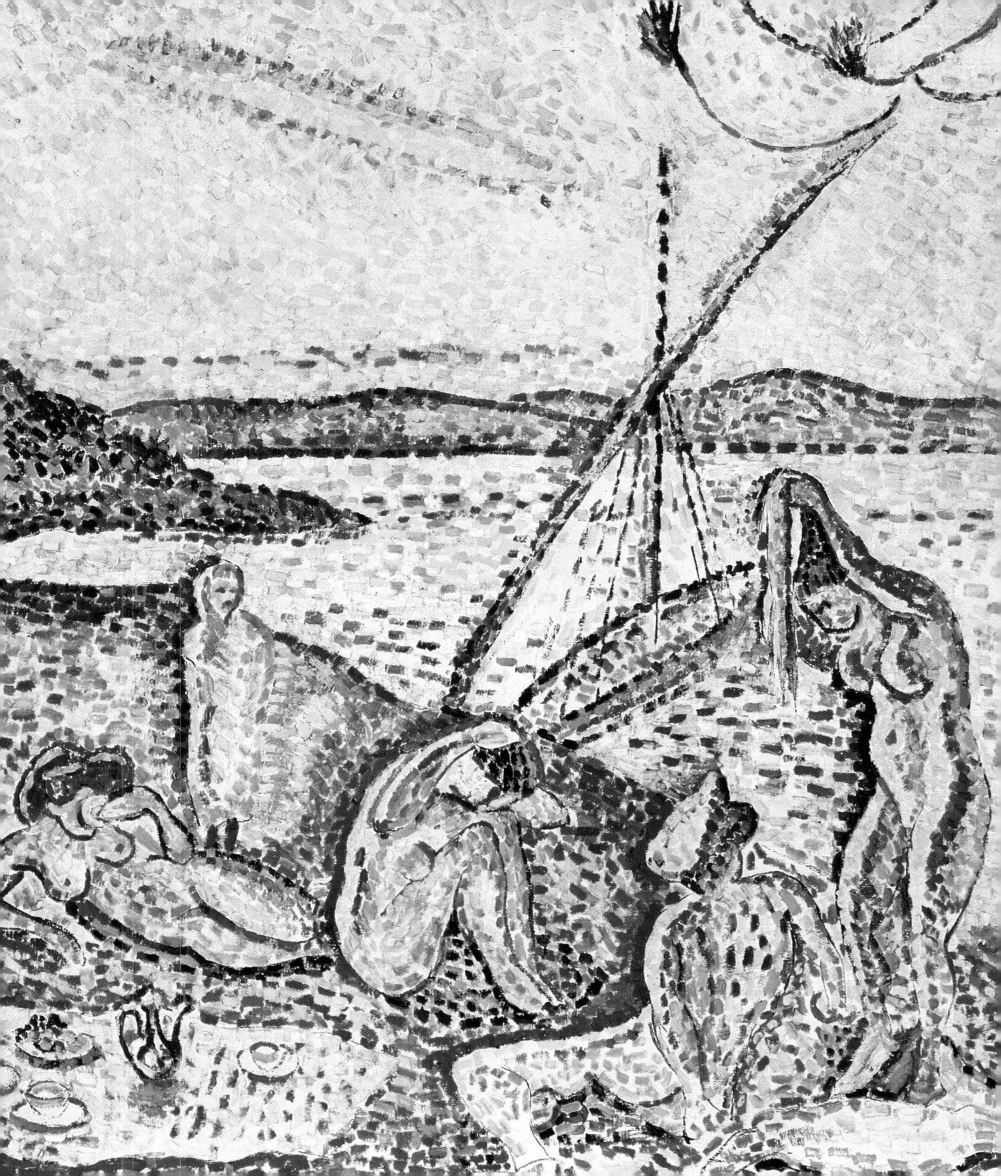

La Revue blanche in 1898, and in 1904 he met Signac himself, who was the president of the Salon des Indépendants. In the years that followed the publication of Signac's book, he and Henri Edmond Cross, the major surviving practitioners of Neo-Impressionism, had enjoyed a new prestige and popularity. Yet even as Signac formulated his celebration of the style, he was aware that it had not helped resolve the conflict between nature and the imagination that still plagued the Post-Impressionists. And, once Signac had admitted that his own use of color oppositions was dictated by personal preference, he could no longer sustain his belief that Divisionist methods were the most faithful to nature.[12] Increasingly in the 1890s he and Cross employed Divisionism to achieve decorative ends. But even though Neo-Impressionism provided no solution to a philosophic dilemma, its consistent emphasis on the properties of color and the methodology of painting did provide a critical focus for younger painters like Matisse.

In the spring of 1904 Matisse, Marquet, and Camoin all showed at the Salon des Indépendants, and in June, Vollard, who had been observing the work of Matisse and his circle, gave him his first one-man exhibition, of forty-six paintings. That summer Matisse accepted Signac's invitation to stay at his home near St. Tropez, where the older artist had worked every year since 1892.

During that summer Matisse was exposed to different ways of working: Cross frequently painted directly from nature, while Signac generally developed his compositions in the studio from visual notes made earlier. Matisse had the opportunity to weigh the advantages of each approach in the months that followed. By the time he left St. Tropez, Matisse had completed several sketches for what was to be his major Divisionist statement, *Luxe, calme et volupté* (plate 234), a painting he finished the following winter in Paris. In contrast to those Fauvist canvases that continued the Impressionist concern with the immediate and the contemporary in landscape or urban scenes, Matisse's composition seemed to look nostalgically to the past. Thematic and formal sources for the picture can be located in the work of such diverse painters as Ingres, Puvis de Chavannes, Cézanne, and Gauguin. Matisse's respect for Signac and his recent close association with that painter may have influenced his selection of the subject, for the latter had painted *In Time of Harmony* (plate 236), an allegorical work with anarchist and utopian overtones, some ten years earlier. Cross had also painted a number of bathing scenes in conjunction with landscapes, and the facture of Matisse's work resembles that of Cross.

Whether conceived as a tribute to Signac or indicative of a new interest in idealizing themes, *Luxe, calme et volupté* embodies a crucial phase in Matisse's development and highlights the role that color played in that development. The title of the painting was taken from the refrain of Baudelaire's poem "L'Invitation au voyage," written nearly fifty years before. Thus Matisse may also have intended it as an homage to a poet revered equally by the Impressionists and the Symbolists, implying a connection with his own ambitions. In the poem Baudelaire—who had exhorted artists to take to the boulevards of Paris in order to capture the spirit of their own time—fashioned the most seductive images of escape to a faraway land:

Là, tout n'est qu'ordre et beauté, (There is nothing but order and beauty there,
Luxe, calme et volupté. Luxury, calm, and sensual delight.)

The rich language of Baudelaire's poem conveys a sensation of languid intoxication and splendor. The key words "Luxe, calme et volupté"—repeated again after each of the last two stanzas of the poem—had compelling connotations for Matisse. He utilized the third stanza, with its dreamy evocation of calm sea and setting sun, as the point of departure for his canvas:

238

238. Maurice de Vlaminck (1876–1958). *Landscape near Chatou*, 1905. Oil on canvas, 23¾ x 28⅞ in. Stedelijk Museum, Amsterdam.

—Les soleils couchants	(—The sunsets
Revêtent les champs,	Bathe the fields,
Les canaux, la ville entière,	The canals, the entire town,
D'hyacinthe et d'or;	In hyacinth and in gold;
Le monde s'endort	The world falls asleep
Dans une chaude lumière.	In a warm light.)[13]

Matisse pushed beyond the immediacy of his experience at St. Tropez, beyond the distant examples of the classical nude and the Symbolist allegories of the previous decade. For the first time, he found a way to synthesize nature and imagination, tradition and innovation. Working with studies he had executed in the south, he created a new totality in his studio. Baudelaire's invitation to the realm of the imagination inspired the painter to embark on his own journey to the realm of art where he, like the poet, exchanged the vivid and chaotic present for the remote and the idyllic. Though inspired by Baudelaire's verses, Matisse achieved his own lyricism exclusively through sensuous deployment of color and design, not narrative. His aesthetic goal, like that of the painters from whom he had adopted Divisionism, was harmonious order.

239. André Derain (1880–1954). *The Old Tree*, 1904. Oil on canvas, 16 x 13 in. Musée National d'Art Moderne, Centre Georges Pompidou, Paris.

240. Maurice de Vlaminck (1876–1958). *Houses at Chatou*, 1905–6. Oil on canvas, 32 x 38⅝ in. The Art Institute of Chicago; Gift of Mr. and Mrs. Maurice W. Culberg.

239

240

The *1901* exhibition of van Gogh's work at the Bernheim-
Jeune gallery was a revelation for such young painters
as Derain and Vlaminck, and it marked the onset of the
liberation of color that was celebrated four years later in
the Salon d'Automne. Vlaminck was the first to visit the
exhibition, and his enthusiasm for the Dutch painter was
infectious. Back at work in Chatou, he and Derain tried
to apply the lessons of van Gogh's pure color to their
own canvases. Vlaminck later wrote in his autobiogra-
phy that he immediately heightened his tonal values and
" . . . translated what I saw instinctively, without any
method. . . . I squeezed and ruined tubes of aquamarine
and vermilion, which, incidentally, cost quite a lot of
money. . . ."

241

241. André Derain (1880–1954). *The Bank of the River, Chatou*, 1904. Oil on canvas, 31¾ x 51⅛ in. William S. Paley.

242. André Derain (1880–1954). *Self-Portrait with Soft Hat*, 1904. Oil on canvas, 14 x 10 in. Mr. and Mrs. Nathan Smooke, Los Angeles.

Matisse's enthusiasm for Neo-Impressionism proved to be short-lived, however, primarily because he was dissatisfied with its results:

> At one time, placing my dominant color, I couldn't keep myself from placing near it a reaction just as violent. . . . I couldn't succeed in realizing my luminous harmony according to the prescribed rules. . . . Above all, I no longer succeeded in containing my drawing. . . . Cross . . . said to me that I would not remain long in neo-impressionism. Indeed, several months later, working before an exalted landscape, I only dreamed of making my colors sing, without taking the rules and prohibitions into account. . . .[14]

Matisse's dream of making his colors sing would lead him to adopt a distinctly new approach to painting during the summer of 1905. In order to find his own style, he rejected the strictures of Neo-Impressionism and the fatherly counsels of Signac and Cross, removing himself to another Mediterranean coastal town, Collioure, where he once again resumed the more congenial role of mentor to his younger companion Derain. The outcome of this renewed search for a color-based style would be revealed at the celebrated Salon d'Automne later that year.

Chatou and Collioure

Situated on the Seine a short distance from Paris, the village of Chatou had inspired Renoir to paint some of the most delightful canvases in the repertory of Impressionist boating scenes. In 1900 Derain and Vlaminck, who both lived there, had developed the habit of working together before the same motif, as Renoir and Monet had done some thirty years earlier at La Grenouillère and Argenteuil. The temperaments of the two

friends could not have been more opposite. Vlaminck was a self-proclaimed bohemian—exuberant, boastful, and inclined to exaggerate the importance of his discoveries. Derain was the product of an upper-middle-class background, a hard-working student at the Ecole des Beaux-Arts—reflective and sensitive to the multitude of artistic ideas then current but lacking the confidence to move ahead. Together they attended an exhibition of van Gogh's work in 1901. Both were deeply impressed by the Dutch painter's oeuvre, and each recorded his feelings in language that provides an insight into his personality. Vlaminck's statement is characteristically emotional: "I was so moved I wanted to cry with joy and despair. On that day I loved van Gogh more than I loved my father." [15] The pensive and sober Derain, on the other hand, was struck by the prophetic nature of van Gogh's art: "We are about to embark on a new phase [of painting]. Without partaking of the abstraction apparent in van Gogh's canvases . . . I believe that lines and colors are intimately related and enjoy a parallel existence from the very start. . . ." [16]

Because he was called to military service at the end of 1901, Derain was prevented from exploring the freedom of color and drawing that he had appreciated in van Gogh's painting until his discharge nearly three years later. In the interim he had to content himself with the news he received from Vlaminck about developments in Paris. Nonetheless, on his return to the city Derain quickly forged a style that anticipated many of the elements central to Fauvism before they were collectively manifested. His powerful *Self-Portrait with Soft Hat* (plate 242), done in 1904, proclaimed simplified drawing and bold and arbitrary color a year before Matisse painted his celebrated portrait of his wife, *Woman with a Green Stripe*. Derain's landscapes of Chatou, done the same year (plate 241), offer an interesting play of flatly painted areas against more vigorously painted ones, which suggests a synthesis of the Nabis and van Gogh. Like Matisse, whose example may have inspired him, Derain profited from his investigations of Im-

243

244

243. André Derain (1880–1954). *Big Ben, London*, 1906. Oil on canvas, 31⅛ x 38½ in. Musée d'Art Moderne Pierre Levy, Troyes, France.

244. André Derain (1880–1954). *Landscape by the Sea: Côte d'Azur*, 1905. Oil on canvas, 20⅞ x 25 in. National Gallery of Canada, Ottawa.

pressionism and Neo-Impressionism; his visit to London shortly after the 1905 Salon des Indépendants produced some startling images of the Thames, and his dynamic *Big Ben, London* (plate 243) encourages speculation that he was measuring his sensibility and skill against those of Monet, whose paintings of the same subject had been exhibited in Paris two years earlier.

It was not until Derain began working with Matisse in the Mediterranean port of Collioure during the summer of 1905 that the younger artist freed himself completely from Impressionism and Neo-Impressionism. This relatively brief but inordinately fruitful period of close association pushed both artists beyond their recent exposure to theory and produced the canvases that created such a succès de scandale in the Salon d'Automne several months later. Exposure to the intense southern light and continuous

245

exchange with Matisse changed Derain's approach to color and execution. More clearly defined units of color emerged, as did a more open sense of composition. The effort it cost Derain was considerable. "It's no fun at all," he wrote to Vlaminck, "but I'm staying on because I'm compelled to buckle down seriously and put my back into it." [17]

Even the older, more confident Matisse was not immune to discouragement; Derain reported to Vlaminck that Matisse was experiencing a "crisis" in his painting. Dissatisfied with the decorative Divisionism he had formulated at St. Tropez a year earlier, he had pushed himself to virtual stylelessness in works such as *Young Woman near a Stream* (plate 245). Frustrated by the absence of drawing and modeling from Divisionism, Matisse also rebelled against its dilution of color. Three years later he reminisced: "All the paintings of this school had the same effect: a little pink, a little blue, a little green; a very limited palette with which I didn't feel very comfortable. . . . My dominant colors, meant to be supported and given force by their contrasts, were in fact devoured by these contrasts, which I made as important as the dominants. That led me to paint with flat tones: it was Fauvism." [18]

Unlike Matisse's Neo-Impressionist–inspired compositions, his canvases done at Collioure flaunt intense color, contrasted in broad areas. During his sojourn there the painter became acquainted with Daniel de Monfried, a friend of Gauguin's, who showed Matisse and Derain his superb collection of the artist's Tahitian paintings. It was probably the experience of these works that encouraged Matisse to see color in a new way and to experiment with a thinner paint that produced a markedly different effect from the mottled or mosaiclike surfaces of Neo-Impressionist pictures. Although Matisse never expressed an attraction to the work of Gauguin, he had acquired one of his paintings from Vollard at the same time that he had purchased his Cézanne, and it is more than likely that his recent experiences with Neo-Impressionism had made him more receptive to the simplified and sure message of Gauguin's highly personalized style.

A landscape Matisse painted that summer at Collioure in vivid orange and green served as the basis for a grand conception, *Joy of Life* (plate 246), which he executed in Paris during the winter of 1905–6. This large, daring canvas resumed the concern with idealized subject matter first expressed in *Luxe, calme et volupté*, but it broke new ground in that Matisse now approached form and color with greater freedom, distancing himself even more from Neo-Impressionism. *Joy of Life*, which appeared at the Salon des Indépendants in March 1906, created a sensation.

At the Salon d'Automne of 1905—the exhibition that had inspired the name Fauvism—Matisse had no doubt seen works by Gauguin and Ingres. The latter's *Golden Age* must have influenced the development of *Joy of Life*, for Matisse adopted the timeless and remote setting of that touchstone of Neoclassicism. Moreover, his inclusion of two subthemes—dance and music—found in many of Ingres's Odalisques would also provide him with rich material for extended thematic and formal investigation. Matisse himself provided an explanation of how *Joy of Life* had been transformed from a spontaneous landscape to a deliberately constructed artifice: "This picture was painted through the juxtaposition of things conceived independently, but arranged to-

245. Henri Matisse (1869–1954). *Young Woman near a Stream*, 1905. Oil on canvas, 13⅝ x 11 in. Sidney Janis Gallery, New York.

246. Henri Matisse (1869–1954). *Joy of Life*, 1905–6. Oil on canvas, 68⅜ x 95½ in. The Barnes Foundation, Merion, Pennsylvania.

246

247

gether.'' [19] Just as Moreau had preferred an imaginary world to the natural one, and Gauguin had sought inspiration in the exotic, Matisse now found in the world of art itself an inexhaustible stimulus that liberated him from dependence on observation. *Joy of Life* announced that liberation.

The novelty of Matisse's approach provoked some ridicule, but he was not without supporters. Denis regarded *Joy of Life* as a tour de force: '' . . . one finds, especially in the work of Matisse, the artificial; not the literary artificial, as would be a study of idealist expression; not the decorative artificial, as the Turkish and Persian weavers have imagined; no, it is something more abstract yet: *it is painting beyond every contingency, painting in itself, the act of pure painting. . . .*'' [20] Signac, on the other hand, rightly perceived the work to be a repudiation of Neo-Impressionism and bristled at the unrelieved flatness of the large composition: ''Matisse, whose attempts I have liked up to now, seems to have gone to the dogs. Upon a canvas of two-and-a-half meters, he has surrounded some strange characters with a line as thick as your thumb. Then he has covered the whole thing with flat, well-defined tints, which—however pure—seem disgusting.'' [21]

Derain's own progression from the Neo-Impressionist–oriented compositions of 1905 to a comparably expressive but more flatly painted style can be observed in a number of large works. The Divisionist style of *The Golden Age* (plate 247) superficially recalls both Matisse's *Luxe, calme et volupté* and *Joy of Life*, but the greater energy of the forms and the more insistent character of the drawing suggest that it may

247. André Derain (1880–1954). *Composition (The Golden Age)*, 1905. Oil on canvas, 68½ x 74½ in. The Museum of Modern Arts of the Islamic Republic of Iran.

248. André Derain (1880–1954). *The Dance*, 1905–6. Oil on canvas, 72⅝ x 89⅝ in. Private collection.

have been worked on over a long period of time. In attempting this large-scale composition, which integrates many nude figures and elements of landscape, Derain departed radically from his earlier work. Moreover, his inclusion of the subtheme of dancers and of figures similar to Matisse's raises the question of who influenced whom. Yet despite any resemblance, the raw vitality and more evident fragmentation of Derain's canvas contrasts with the thoughtful color and more cohesive surface design of Matisse's picture.

Like Matisse, Derain isolated the various elements of his composition in subsequent paintings. *The Dance* (plate 248) offers a friezelike arrangement and an exotic palette that recall Gauguin's Tahitian landscapes. It was Gauguin's work that introduced many of the Fauves to exotic, non-Western art forms, although their own investigation of African tribal works would profoundly alter their conception of the primitive in the next few years. Derain himself soon turned away from the flat forms and decorative colors embodied in *The Dance* and related works from 1906. By the following year, his admiration for African art and his new appreciation of Cézanne, stimulated no doubt by the exhibitions that followed Cézanne's death, were already changing Derain's approach to the human figure.

248

249. André Derain (1880–1954). *The Turning Road*, 1906. Oil on canvas, 50¼ x 76⅝ in. The Museum of Fine Arts, Houston; John A. and Audrey Jones Beck Collection.

250. André Derain (1880–1954). *Woman in Chemise*, 1906. Oil on canvas, 39⅜ x 31¾ in. Statens Museum for Kunst, Copenhagen; J. Rump Collection.

251. Raoul Dufy (1877–1953). *The Beach at Ste. Adresse*, 1904. Oil on canvas, 25½ x 31¾ in. Musée National d'Art Moderne, Centre Georges Pompidou, Paris.

252. Raoul Dufy (1877–1953). *Trouville*, 1907. Oil on canvas, 21⅛ x 28⅝ in. Private collection.

Fauves and "Fauvelets"

The 1907 Salon des Indépendants marked both the peak of Fauvism's popularity and the moment when it began to falter. Vauxcelles, surveying the exhibition, playfully invented a hierarchy of its protagonists, designating "M. Matisse, fauve-in-chief; M. Derain, fauve-deputy; MM. Othon Friesz and Dufy, fauves-in-attendance . . . M. Delaunay . . . infantile fauvelet. . . ."[22] The names of Friesz and Dufy were relatively unknown to the public, and Vauxcelles's mention of them gave a new prominence to their contributions. Dufy had been painting along his native Normandy coast with Marquet for some time; their beach scenes and harbor views of Ste. Adresse (plate 251), Honfleur, Trouville (plate 252), and Le Havre recall earlier examples by Eugène Boudin and Monet and constitute one of the many thematic links between Fauvism and Impressionism. Indeed, his admiration for Boudin and Pissarro had prompted Dufy to formulate a modified Impressionism before his conversion to the more synthetic approach of Matisse and Marquet. A simplified organization of firmly outlined shapes and bright, flat color enlivened by unbridled gaiety are the hallmarks of a group of flag paintings that Dufy and Marquet executed between 1906 and 1907 (plates 255, 256). Apart from their obvious acknowledgment of Monet's splendid paintings of the late 1870s (plate 257), these works recall the more general Impressionist tradition of lively holiday subjects. Still, the impulse to pursue a theme already enshrined by their predecessors only partially explains the popularity of such subjects with some of the Fauves. There was also a compelling formal attraction: holiday scenes demanded bright colors and encouraged a degree of decorative abstraction, and it was these elements that were emerging as central to the painterly vision of the early twentieth century.

Like his more celebrated townsman Monet, Othon Friesz had displayed artistic talent at an early age; he received a scholarship from the city of Le Havre to attend the Ecole

249

250

251

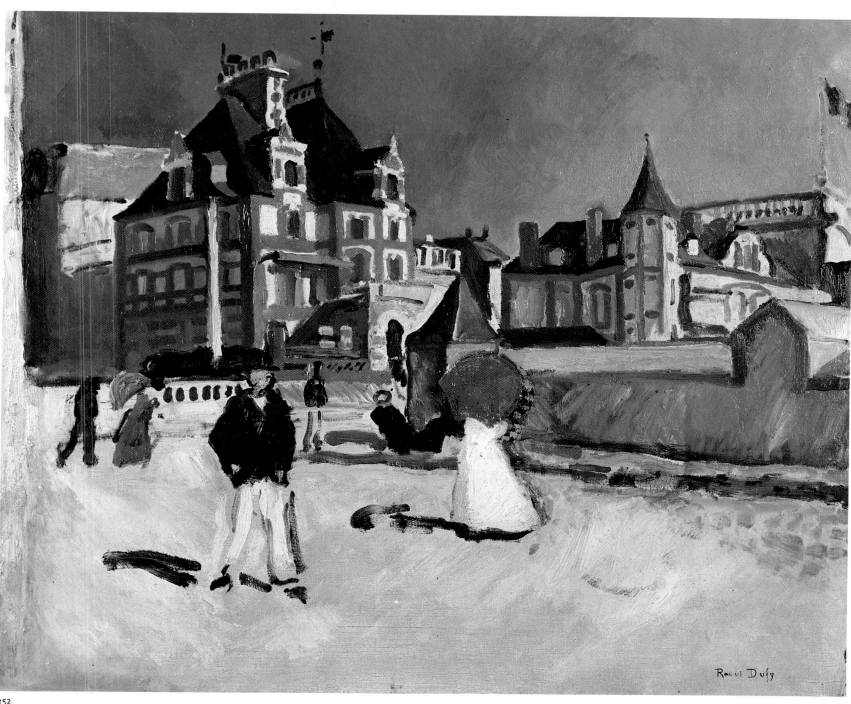

252

des Beaux-Arts. In Paris, Friesz developed a preference for the light-filled compositions of the Impressionists, and the landscapes and seascapes that he showed at the Salon des Indépendants in 1903 and at the Salon d'Automne in 1904 had already elicited some critical approval when he began to ally himself with Matisse, employing more agitated brushwork and fiery color. At the Ecole des Beaux-Arts, Friesz had befriended a younger student from Le Havre, Georges Braque. In the summer of 1906 Friesz introduced Braque to Fauvism while the two were working together in the Belgian river port of Antwerp. However, the full impact of Braque's exposure to Fauvist color would not be evident until his trip to L'Estaque that fall. Braque's deep admiration for the recently deceased Cézanne prompted him to work in the landscape so closely associated with that master. Combining a modified Divisionism with vibrant

254

253. Raoul Dufy (1877–1953). *The Three Umbrellas*, 1906. Oil on canvas, 23⅝ x 28⅝ in. The Museum of Fine Arts, Houston; The John A. and Audrey Jones Beck Collection.

254. Albert Marquet (1875–1947). *The Pont-Neuf*, 1906. Oil on canvas, 19⅞ x 24 in. National Gallery of Art, Washington, D.C.; Chester Dale Collection, 1962.

color and a new open composition, he produced paintings that made his earlier work seem tentative and incomplete (plate 259). The following summer Braque and Friesz joined up again at the port of La Ciotat, near the Spanish border. The landscapes that Braque painted there, while employing the same intense palette he had developed in L'Estaque, express a new sense of order and harmony (plate 260).

Braque's 1907 landscapes announced a concern with clarity and structure that had been informed by his intensified study of Cézanne. The cumulative impact of Cézanne's large watercolor show at the Bernheim-Jeune gallery in June of that year and the huge memorial exhibition at the Salon d'Automne would be manifested even more dramatically in the landscapes that Braque painted the following year. The painter was also beginning to move in distinctly non-Fauvist circles; in November 1907, Braque met the Spanish painter Pablo Picasso and was astonished by a work in progress, *Les Demoi-*

255

256

257

255. Raoul Dufy (1877–1953). *A Street Decked with Flags*, 1906. Oil on canvas, 31⅞ x 25⁹/₁₆ in. Musée National d'Art Moderne, Centre Georges Pompidou, Paris.

256. Albert Marquet (1875–1947). *The 14th of July in Havre*, 1906. Oil on canvas, 31¾ x 25½ in. Musée de Bagnols-sur-Cèze.

257. Claude Monet (1840–1926). *Rue St. Denis, Paris, Fête du 30 juin 1878*, 1878. Oil on canvas, 24⅜ x 13 in. Musée des Beaux-Arts, Rouen.

258

259

260

258. Georges Braque (1882–1963). *Road near L'Estaque*, 1908. Oil on canvas, 23¾ x 19⅜ in. The Museum of Modern Art, New York; Given anonymously.

259. Georges Braque (1882–1963). *L'Estaque*, 1906. Oil on canvas, 18⅛ x 21⅝ in. Musée National d'Art Moderne, Centre Georges Pompidou, Paris.

260. Georges Braque (1882–1963). *Small Bay at La Ciotat*, 1907. Oil on canvas, 65 x 81 in. Musée National d'Art Moderne, Centre Georges Pompidou, Paris.

selles d'Avignon (plate 292). The immediate consequence of that meeting was a confirmation of Braque's growing need to "create a new sort of beauty . . . in terms of volume, of line, of mass, of weight." [23] During the summer of 1908 he returned to La Ciotat and subsequently to L'Estaque, where he was joined by Dufy. There Braque's distinctly Cézannesque palette, emphatically geometricized forms, and faceted space asserted his rupture with Fauvism. When Braque attempted to exhibit four of these landscapes (plate 258), the jury of the Salon d'Automne, which included Matisse, rejected them. With that, Braque removed himself from the orbit of Matisse and gravitated to Picasso.

Of all the painters linked with Fauvism, the personality and works of Vlaminck most closely approximate the stereotypes of elemental energy and unbridled freedom that

were associated with Vauxcelles's term. Vlaminck's flamboyant character, his emotionalism, and his lack of formal art training may have predisposed him to disdain artistic conventions, and the artist provided his own existential definition of the movement, which confirms this view: "Fauvism was not an invention, an attitude, but a way of being, acting, thinking, and breathing." [24] As we have seen, even before the major van Gogh retrospective Vlaminck had been drawn to his emotionally loaded color and agitated brushwork. Like his predecessor, he was fascinated with popular and folk art, with the naive and the untutored. Unlike Derain, whose training and temperament prompted him to explore theory and widely ranging subject matter in the years following the establishment of their friendship, Vlaminck remained firm in his commitment to a direct confrontation with landscape. Only later, after prolonged discussion with Derain and exposure to Picasso's ever-widening circle, did he finally succumb to the growing enthusiasm for the art of Cézanne.

262

Kees van Dongen had come to Paris from his native Holland, where he had attended the Rotterdam Academy of Fine Arts. Settling permanently in Paris in 1901, he utilized his satirical skills to produce humorous vignettes of popular life for various newspapers. Like other Fauves, he engaged in a mild flirtation with Neo-Impressionism before establishing a more personal style. Van Dongen's interest in human subjects isolated him somewhat from the majority of the Fauves, as did his interest in interior subjects. Like Toulouse-Lautrec, van Dongen was attracted to the low life of Montmartre—the cafés, their entertainers and patrons—which he depicted in harsh colors and simplified designs (plates 262, 263). His concern with the carnal as opposed to the sensuous and with the violent as opposed to the exuberant distinguished his work from the mainstream of Fauvism and called critical attention to his paintings' strident physicality. After exhibiting at the Salon d'Automne in 1905 and at the Salon des Indépendants the following year, he began to attract a critical following. The contacts he had maintained in Holland brought van Dongen opportunities to exhibit in his native country, so that he served as a link between the Paris-based Fauves and painters in northern Europe.

261. Maurice de Vlaminck (1876–1958). *Landscape with Red Trees*, 1906–7. Oil on canvas, 25⅝ x 31¾ in. Musée National d'Art Moderne, Centre Georges Pompidou, Paris.

262. Kees van Dongen (1877–1968). *Moulin de la Galette*, 1904. Oil on canvas, 65 x 54 in. Musée d'Art Moderne Pierre Levy, Troyes, France.

263. Kees van Dongen (1877–1968). *Modjesko—Soprano Singer*, 1908. Oil on canvas, 39⅜ x 32 in. The Museum of Modern Art, New York; Gift of Mr. and Mrs. Peter A. Rubel.

263

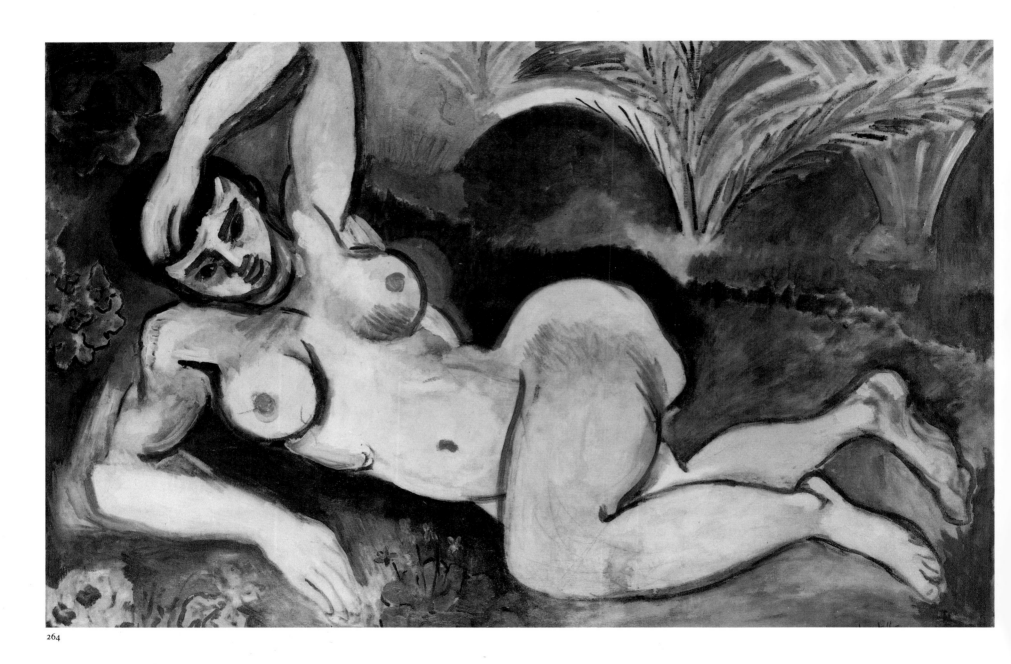

264

Cézannism

In his review of the 1905 Salon des Indépendants, Vauxcelles had identified Matisse and his circle as "disciples of Cézanne." Two years later, Matisse's submission to the Salon des Indépendants, *The Blue Nude* (plate 264), confirmed his profound understanding of Cézanne's approach to form. His powerful "masculine nymph"—as Vauxcelles called it [25]— represented a new direction, a search for the heroic rather than the graceful. The work was almost certainly a tribute to the master of Aix, who was honored later that year at the Salon d'Automne with a memorial exhibition of fifty-six paintings. This retrospective permitted the first extensive appraisal of Cézanne's art and generated a movement that would offer clear alternatives to Fauvism. In this new approach, which would shortly be termed Cubism, the instinctive was replaced by the analytic; high color gave way to low-keyed or monochromatic color; openness was replaced by structure; and exuberance was increasingly supplanted by sobriety.

Derain's response to Cézanne was perhaps even more emphatic than Matisse's between 1906 and 1908. His rejection of the Gauguinesque exoticism and flat color that had sustained him only a short time before manifested itself in *Three Figures Seated on the Grass* (plate 267), completed before the Cézanne exhibition. While Derain retained intense color in this painting, he fortified the outlines and achieved an effect analogous to that of a painted relief. There is also a new sense of weight in the forms and a more deliberate geometry, which may reflect a thoughtful synthesis of Cézanne's approach with that of the African sculptures that Derain had begun to collect. Indeed, *Three Figures Seated on the Grass* is a clear precursor of Cubism rather than a somewhat aberrant Fauvist work. What it signaled—not only for Derain but for Fauvism in general—was the arrival at a point of no return. In succeeding years Derain's work was to suffer from a lack of allegiance to a specific movement. Marginally involved with a

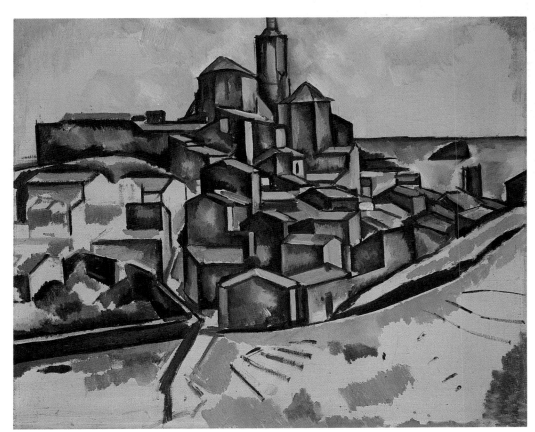

264. Henri Matisse (1869–1954). *The Blue Nude*, 1907. Oil on canvas, 36¼ x 55⅛ in. The Baltimore Museum of Art; The Cone Collection, formed by Dr. Claribel Cone and Miss Etta Cone of Baltimore, Maryland.

265. André Derain (1880–1954). *Cadaques*, 1910. Oil on canvas, 23⅝ x 28¾ in. National Gallery, Prague.

265

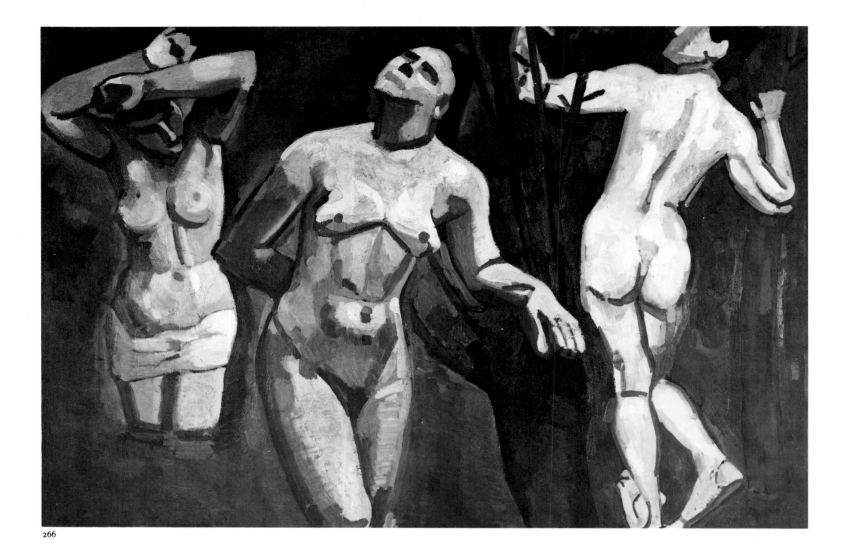

266

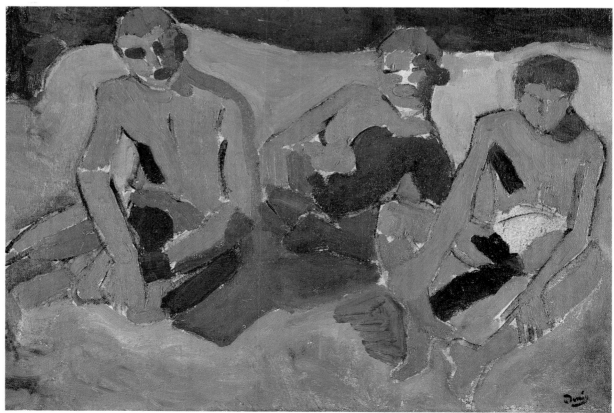

267

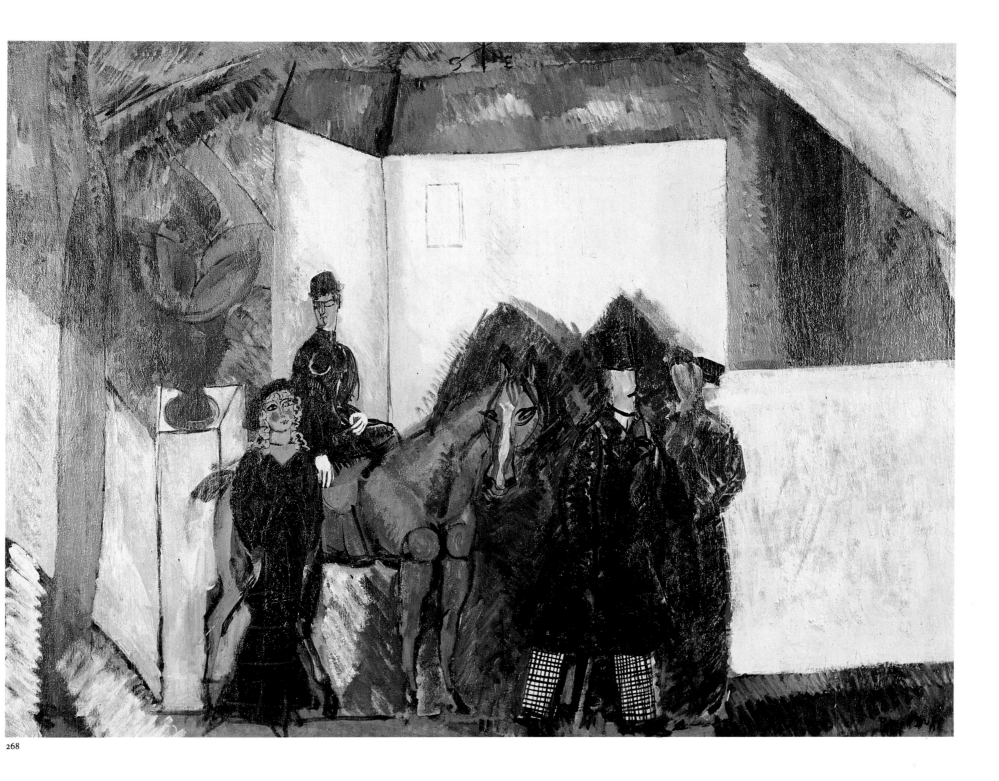

268

266. André Derain (1880–1954). *Bathers*, 1907. Oil on canvas, 52 x 76¾ in. The Museum of Modern Art, New York; William S. Paley and Abby Aldrich Rockefeller Funds.

267. André Derain (1880–1954). *Three Figures Seated on the Grass*, 1906–7. Oil on canvas, 14⅞ x 21⅝ in. Musée d'Art Moderne de la Ville de Paris.

268. Raoul Dufy (1877–1953). *Promenade in the Bois de Boulogne*, 1913. Oil on canvas, 34 x 45 in. Mr. and Mrs. Samuel J. LeFrak.

triumphant Cubism, he was to slip into what is best described as academic modernism. His experience was shared by other Fauves—Vlaminck, Marquet, and Dufy—whose work increasingly succumbed to self-caricature and eclecticism. Only Matisse possessed the vision, the intellect, and the discipline needed to transform the raw energy of Fauvism into an art of absolute and enduring order.

Matisse's ''Notes of a Painter''

By 1908 Cubism had taken its toll on Matisse's circle, and the erstwhile "fauve-in-chief" had begun to reconsider his own aesthetic priorities: "I made an effort to develop [my] personality by counting above all on my intuition and by returning again to

fundamentals."[26] This resolve to concentrate on fundamentals had certainly been reinforced by the artist's trip to Italy during the summer of 1907, where he studied the frescoes of Giotto and Piero della Francesca. The compositional lessons of these early Renaissance masters of the monumental and the decorative provided a clear alternative to the modern works available in Paris.

The first effects of Matisse's new dedication to the essentials of expression can be seen in the large canvases *Le Luxe I* (plate 269) and *Music*, which were shown in the 1907 Salon d'Automne and listed as sketches in the accompanying catalog. The latter

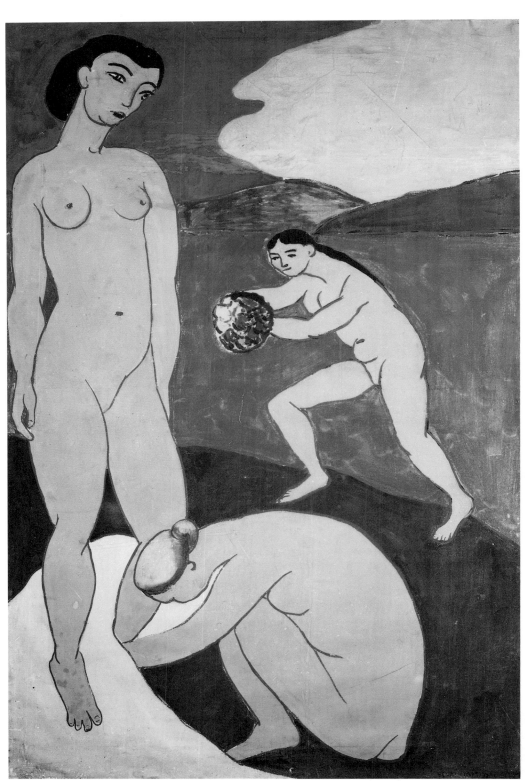

269. Henri Matisse (1869–1954). *Le Luxe I*, 1907. Oil on canvas, 82½ x 53¾ in. Musée National d'Art Moderne, Centre Georges Pompidou, Paris.

270. Pierre Puvis de Chavannes (1824–1898). *Young Girls by the Sea*, 1879. Oil on canvas, 24 x 18½ in. Musée du Louvre, Cabinet des Dessins, Paris.

271. Henri Matisse (1869–1954). *Le Luxe II*, 1907–8. Oil on canvas, 82⅜ x 54⅝ in. Statens Museum for Kunst, Copenhagen; J. Rump Collection.

269

was exhibited five years later in London, where it excited an enthusiastic response from the influential critic Roger Fry. It was also among the thirteen paintings by Matisse selected by the American painter Arthur B. Davies for inclusion in the controversial Armory Show of 1913, which introduced America to modern European art. Both subjects derive from *Joy of Life*, though the scale of *Le Luxe I* is even more monumental. Evident are a new clarity of design, a more subdued palette, and a new calm that make *Joy of Life* seem busy by comparison. Matisse carried these qualities even further in a second version of *Le Luxe* painted the following year (plate 271). Moving beyond the

270

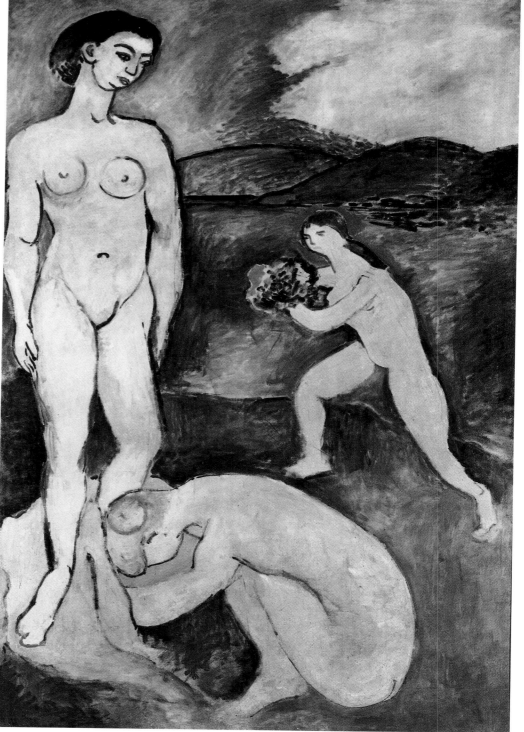

271

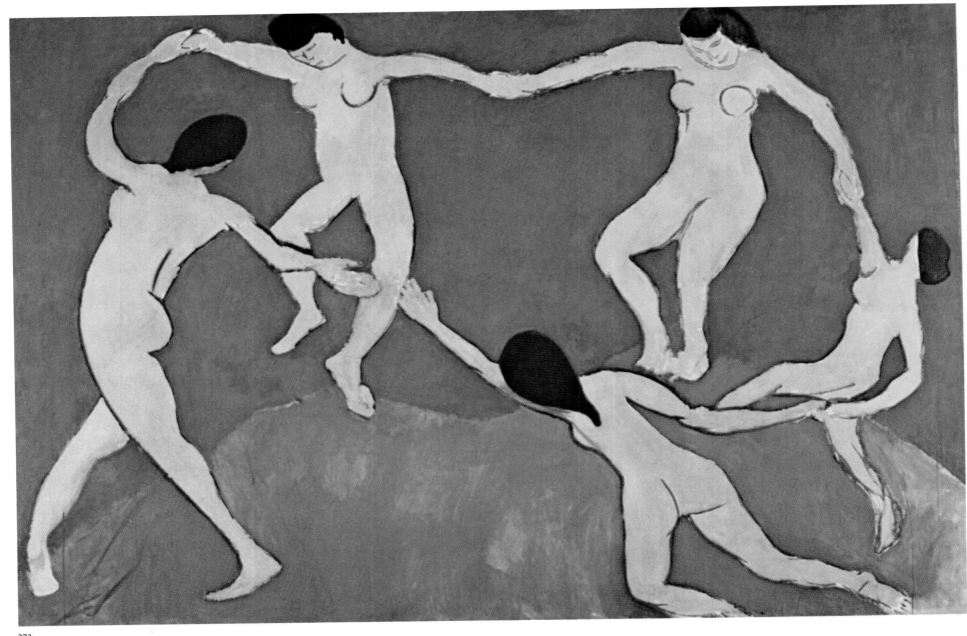

272

272. Henri Matisse (1869–1954). *Dance (First Version)*, early 1909. Oil on canvas, 8 ft. 6½ in. x 12 ft. 9½ in. The Museum of Modern Art, New York; Gift of Nelson A. Rockefeller in honor of Alfred H. Barr, Jr.

273. Henri Matisse (1869–1954). *The Red Studio*, 1911. Oil on canvas, 71¼ x 84¼ in. The Museum of Modern Art, New York; Mrs. Simon Guggenheim Fund.

spontaneity of Fauvism and bypassing the analytical approach espoused by Braque and Picasso, he succeeded in creating a work whose classical forms and decorative harmonies surpassed those of the Puvis de Chavannes canvas that had served as one of its inspirations (plate 270).

In the year that saw the crisis and dissolution of Fauvism, Matisse formulated the literary equivalent of what—in his art—was becoming an extended discourse on painting. "Notes of a Painter" was written at the invitation of the editors of *La Grande Revue* and published on Christmas Day, 1908. It remains Matisse's most significant statement about art. In a period distinguished by the quality and quantity of the art manifestos it produced, this relatively short text is singular in the informality of its language and the highly personal character of its content.

Speaking of his recent development, Matisse observed: "I cannot copy nature in a servile way; I am forced to interpret nature and to submit it to the spirit of the picture. From the relationship found in all the tones, there must result a living harmony of colors, a harmony analogous to that of a musical composition."[27] Matisse was neither the

first nor the last artist to link painting and music, but, in contrast to the Neo-Impressionists, for example, he related the achievement of harmony to trial and error during the process of painting rather than to a predetermined scientific system. Matisse's attachment to objects and his appreciation of the sensory did not stop him from creating an art that transcended its sources. Whether inspired by the elements of everyday life or by a vision of some golden age, his goal was constant. "What I dream of is an art of equilibrium, of purity and tranquility, without troubling or depressing subject matter, which would be for every mental worker, for the businessman as well as the man of letters . . . a soothing, calming influence on the mind, something analogous to a good armchair which relieves physical fatigue." [28] This remarkable passage with its conception of art as a source of quiet pleasure seems to repudiate the frenetic energy associated with the peak years of Fauvism. Other sections of "Notes of a Painter" reflect

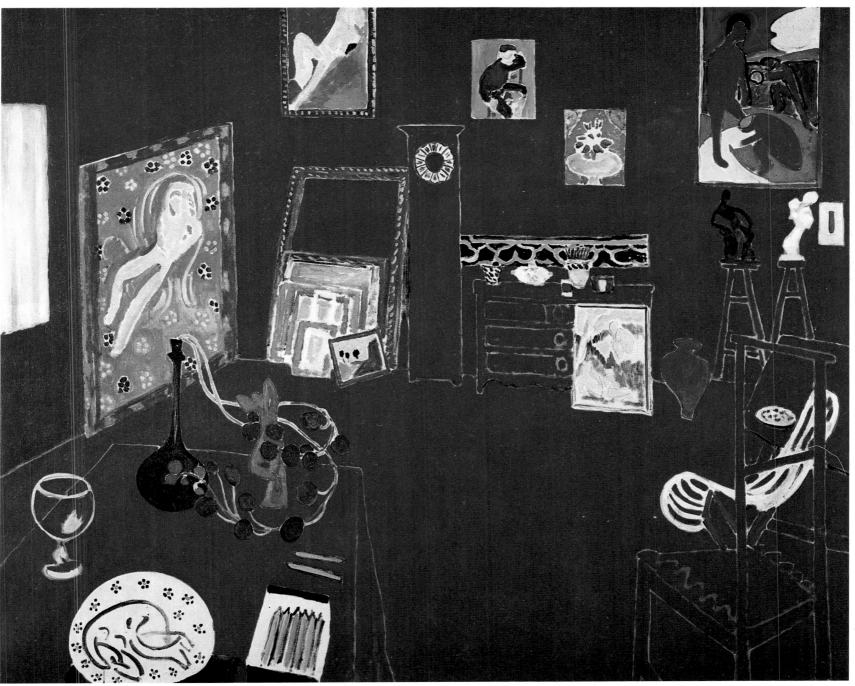

273

Matisse's dissatisfaction with the instantaneity favored by the Impressionists and his reverence for the timeless values of classic art. Above all, the text announces Matisse's view that painting is a process of synthesizing sensations into significant forms and that the goal of this synthesis is nothing less than the elevation of the human spirit.

At the time "Notes of a Painter" was published, Matisse had turned to teaching and was beginning to attract collectors such as Gertrude Stein and her brothers; their friends from Baltimore, the Cone sisters; Hans Purrmann, a German painter who studied with Matisse in his studio in the Sacré-Coeur; the Hahnlosers of Switzerland; and the wealthy Russian merchants Ivan Morosov and Sergei Shchukin. It was for Shchukin's Moscow palace that Matisse conceived an ensemble of three panels whose content and function he described to a critic in April 1909:

> I imagine the visitor coming from the outside. There is the first floor. One must summon up energy, give a feeling of lightness. My first panel represents the dance, that whirling round on top of the hill. On the second floor, one is now within the house; in its silence—I see a scene of music, with engrossed participants; finally the third floor is completely calm and I paint a scene of repose, some people reclining on the grass, chatting or daydreaming.[29]

It is clear from Matisse's statement that he originally envisioned three separate states—action, absorption, and relaxation—that were closely linked with his emerging view of the character and function of painting. The first two panels that Matisse described, *Dance and Music* (plate 274), look back to the "sketches" from his summer in Collioure that Matisse had exhibited in 1907. In their startling simplicity of design and their reduction of the palette to three saturated colors, they recall the effect of early fresco painting. The third-floor panel may have been unacceptable to Shchukin, for it was never installed in his house. Indeed, Matisse did not take up the canvas again until 1916, and when he did, he so altered its forms, colors, and content that the connection with the earlier works is not immediately apparent (plate 365).

At the time Matisse received this commission, Sergei Diaghilev's Ballets Russes were electrifying Paris with their dynamic new choreography and brilliantly colored sets. Matisse became addicted to their performances, and it is tempting to speculate about the effect they may have had on his conceptualization of movement and rhythm. Even today, the primal energy of *Dance* and the crude, unmodeled frontality of *Music* are disturbing. In the glittering opulence of Shchukin's Moscow palace they must have shocked the elegant and privileged society he entertained.

Matisse was extremely sensitive to decorative forms, whether in painting, textiles, or the furnishings of rooms. He was particularly taken by the vital shapes and uncompromising two-dimensionality of Islamic art, and the major Islamic exhibition that he saw in Munich in 1911 must have stimulated his imagination. Matisse had already executed a number of paintings that featured repetitive textile patterns, Persian rugs, and tapestries, and he fused these ornamental objects with their surrounding spaces to create a lively decorative tension. With the conscious paring down of accessories and the concentration on "essentials" that increasingly occupied him after the publication of "Notes of a Painter," Matisse tempered this decorative impulse, but did not abandon it. In *The Red Studio* (plate 273) he daringly restricted himself to the use of an all-permeating, saturated red that absorbs the ordinary objects of the room and obliterates its walls and floors. The only relief from this color is provided by works of art—Matisse's own Fauve paintings, sculptures, and even ceramics designed by the artist. The result is a work at once intellectual and decorative, a summation of Matisse's artistic life up to that point and a splendid reaffirmation of the objective reality of painting itself. Indeed, *The Red Studio* can be understood as a discourse on the self-reflexive nature of painting: how art stimulates other art and how it can create its own universe. In subsequent works Matisse continued to explore a decorative rather than a con-

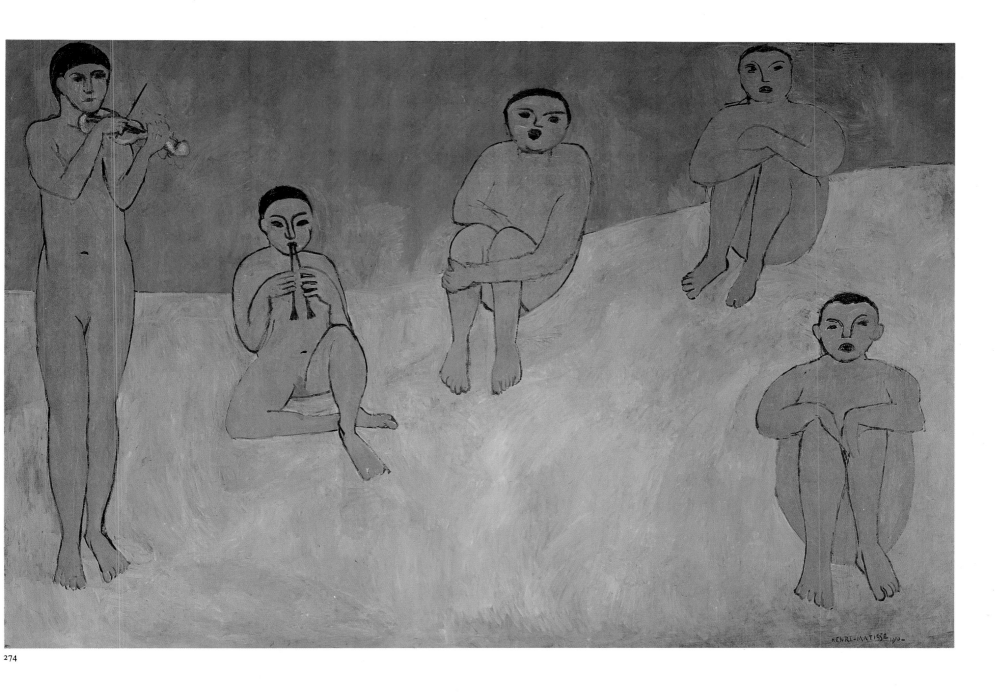

274

274. Henri Matisse (1869–1954). *Music*, 1910. Oil on
canvas, 8 ft. 6¼ in. x 12 ft. 8⅞ in. The Hermitage,
Leningrad.

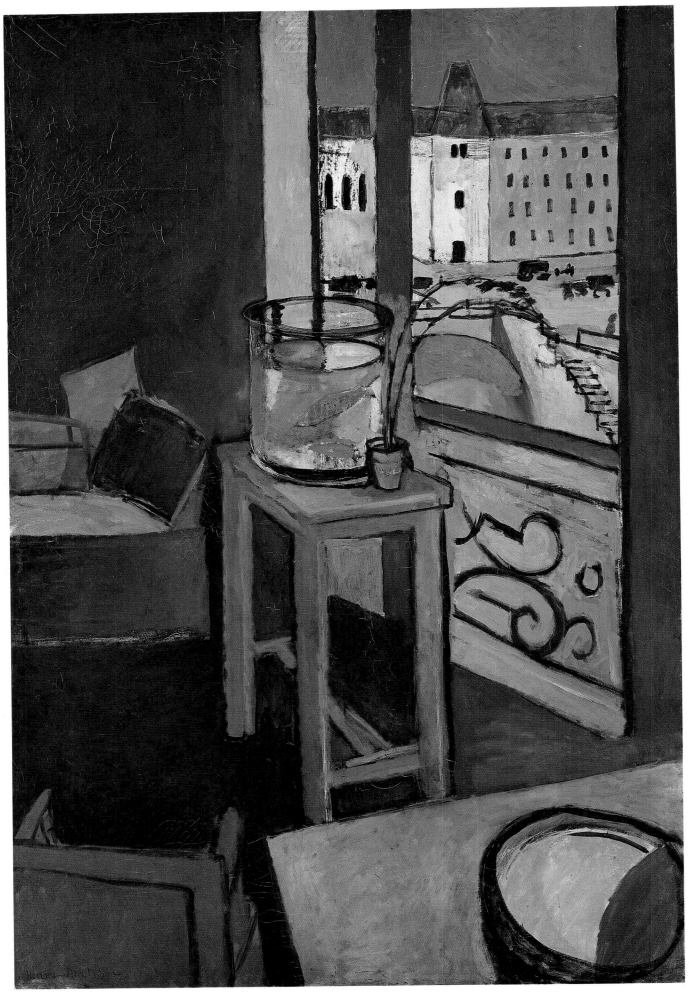

275

275. Henri Matisse (1869–1954). *Bowl of Goldfish*, 1914. Oil on canvas, 57¾ x 38⅛ in. Musée National d'Art Moderne, Centre Georges Pompidou, Paris.

276. Henri Matisse (1869–1954). *Palm Leaf, Tangiers*, 1912. Oil on canvas, 46¼ x 32¼ in. National Gallery of Art, Washington, D.C.; Chester Dale Fund, 1978.

structed space and also examined the different ways in which color and line could be utilized to express his expanding sense of the lyric aspects of nature. This is particularly evident in certain paintings he made after visiting Morocco in 1911–12 and 1913 (plates 276, 403), where the confrontation with luxurious vegetation and a light unlike any he had ever experienced produced landscapes whose lyrical color rivals that of Gauguin's.

The influence of Cézanne, already so evident in the Salon d'Automne of 1907, permeated the last phase of Fauvism and the Cubism that rapidly overtook it. The exclusion of Braque's work from the last collective exhibition of Fauvism in 1908 was a clear signal that something new was happening, something that could have no place within the context of that group. Ironically, while the Fauves were expressing doubts about an approach rooted in the sensory and proclaimed largely through color, the impact of their work was just beginning to be felt abroad. Matisse, whose reputation had been established by his work and enhanced by his writings, had the widest influence. His "Notes of a Painter" was translated into German and Russian, and his canvases appeared in fairly large solo shows in Berlin and at Alfred Stieglitz's pioneering gallery in New York. He was encouraged by friends such as the Steins to advise a few students, whose numbers increased from only a handful in the spring of 1908 to more than one hundred just three years later. While few of Matisse's students achieved international prominence, they played an important role in circulating the master's views and generating interest back home about new developments in art during that feverish period of creativity preceding the outbreak of World War I.

Cubism would dominate the international art scene from 1910 until the end of the war, but Matisse remained committed to the basic Fauvist belief in the vital role of color in generating form and design. While the Cubists' approach to art emphasized the independence of art from what it purported to represent—making their canvases objectlike in the process—Matisse continued to explore traditional subject matter and techniques while consistently asserting the sensuous side of art. In the 1920s a general reaction against the theoretical rigor of Cubism appeared to vindicate his enduring faith in the expressive power of painting.

276

Die Brücke

In Dresden a group of young artists who called themselves Die Brücke—Ernst Ludwig Kirchner, Erich Heckel, Karl Schmidt-Rottluff, and Max Pechstein—were already using high color, simplifying their drawing, and emphasizing decorative elements by the time they were exposed to the work of Matisse and the Fauves. Most of the young artists who formed the nucleus of Die Brücke (the name implied a symbolic bridge to the future) had met at Dresden's famed Technical College, where they were pursuing studies in architecture. United by a common interest in the popular roots of German art and a deep scorn for the prevailing bourgeois values of Imperial Germany, they envisioned a utopian brotherhood not unlike the one that van Gogh had longed for. Their initial manifesto, written by Kirchner in 1905, proclaimed a vague platform of "freedom of life and of movement against the long-established older forms." Rejecting both the social and the artistic status quo (they disdained Impressionism as a reflection of the materialistic society they sought to combat), the Brücke group informally exhibited their work in a factory showroom and later rented a vacant butcher shop in a working-class neighborhood. There they formulated their plan of attack, seeking nothing less than the destruction of a civilization rooted in self-satisfied materialism. This conscious politicization of their art distinguished them from their French contemporaries.

In 1906 the membership of the Brücke was expanded when Emil Nolde joined its ranks; four years later the Berlin-based painter Otto Mueller became part of the community when the local Secession group refused to exhibit his work. In the early years the Brücke painters, like their Fauvist counterparts, produced mainly nudes, landscapes, and portraits. The nude was frequently placed within a landscape, where it

symbolized the concept of liberation through nature that was championed by these opponents of false bourgeois morality. Compared with the work of the Fauves, even at their freest, the colors of Kirchner or Pechstein are shrill and abrasive, while the nudes of Mueller or Schmidt-Rottluff are angular and certainly the antithesis of sensuous. An interest in early German art—which paralleled a more general fascination with pre-Renaissance painting—led the Brücke artists to study the woodcuts of the fifteenth and sixteenth centuries, and their subsequent exploration of that medium reverberated in the progressively sharper definition of form in their paintings. At the same moment when Derain and Vlaminck were searching Paris shops for tribal masks and other non-Western artifacts, Kirchner, Nolde, and Schmidt-Rottluff were discovering the African and Polynesian works that had recently been installed in German ethnographic museums. As in the case of the Fauves, the impact of this confrontation with the primitive served to heighten the emotional and symbolic charge of the Brücke painters' work.

The cohesiveness of the Brücke experiment was shattered after six years—an artistic lifespan significantly longer than that of Fauvism. The relocation of most of the community from Dresden to Berlin in 1911 was prompted by the obvious economic advantages offered in the larger, more sophisticated capital, and this, in turn, altered the consciousness of the various painters who began to cultivate their individual styles. Moreover, as in France, the challenge of a rigorously formalistic art (Cubism) and the increasing pessimism of the prewar climate contributed to the disintegration of the group in 1913.

277

278

277. Ernst Ludwig Kirchner (1880–1955). *Dodo and Her Brother*, c. 1908. Oil on canvas, 67⅛ x 37³/₁₆ in. Smith College Museum of Art, Northampton, Massachusetts.

278. Ernst Ludwig Kirchner (1880–1955). *Milli Asleep*, 1909–10. Oil on canvas, 25⅛ x 36¼ in. Kunsthalle, Bremen.

279

280

279. Ernst Ludwig Kirchner (1880–1955). *Self-Portrait with Model*, 1909–10. Oil on canvas, 58¾ x 39⅜ in. Kunsthalle, Hamburg.

280. Ernst Ludwig Kirchner (1880–1955). *The Loam Pit*, c. 1906. Oil on cardboard, 20 x 27⅞ in. Thyssen-Bornemisza Collection, Lugano.

281. Max Pechstein (1881–1955). *Portrait of a Girl*, 1908. Oil on canvas, 65 x 50 in. Nationalgalerie Staatliche Museen Preussischer Kulturbesitz, Berlin.

281

282

282. Karl Schmidt-Rottluff (1884–1976). *Three Nudes*, 1913. Oil on canvas, 38½ x 41¾ in. Nationalgalerie Staatliche Museen Preussischer Kulturbesitz, Berlin.

283. Otto Mueller (1874–1930). *The Large Bathers*, 1910–11. Oil and tempera on canvas, 71⅞ x 50⅜ in. Kunsthalle der Stadt Bielefeld.

284. Emil Nolde (1867–1956). *Dancing Round the Golden Calf*, 1910. Oil on canvas, 88 x 105 in. Bayerische Staatsgemaldesammlungen, Munich.

283

284

300. Henri Rousseau (1844–1910). *Portrait of Pierre Loti*, 1910. Oil on canvas, 24 x 19⅝ in. Kunsthaus, Zurich.

301. Henri Rousseau (1844–1910). *The Representatives of the Foreign Press Coming to Salute the Republic*, 1907. Oil on canvas, 51⅛ x 55⅝ in. Musée du Louvre, Paris; Gift of Pablo Picasso.

302. Henri Rousseau (1844–1910). *The Dream*, 1910. Oil on canvas, 80½ x 117½ in. The Museum of Modern Art, New York; Gift of Nelson A. Rockefeller.

During 1908 Braque abandoned the figure, preferring to concentrate on landscape and still-life painting, which he found more congenial. That Cézanne was now his predominant model is evident in certain elements implicit in that master's style, namely, the compressed space, perspectival distortion, and distillation of natural and man-made forms into geometric essentials that appear in the pictures Braque painted at L'Estaque that summer. Braque did intentionally immerse himself in the landscape of Cézanne, but he maintained a purposeful obliviousness to the actualities of the site while he painted there, resisting the familiar, seductive orientations utilized by Cézanne. Comparison of Braque's landscapes with those by the older master reveals how consciously Braque disregarded the "facts" of vision: light, texture, and space. Such compositions as *Houses at l'Estaque* (plate 303) already adumbrate the mature language of Cubism. In later years, while acknowledging the inspiration that Cézanne's work had provided for these paintings, Braque insisted that he had begun with, and remained faithful to, an *idée fixe*, a conception that he had determined beforehand and subsequently realized in the studio.

302

*"I couldn't portray a woman in all her natural love-
liness. . . . I haven't the skill. No one has. I must, there-
fore, create a new sort of beauty, the beauty that ap-
pears to me in terms of volume, of line, of mass, of
weight, and through that beauty interpret my subjective
impression. Nature is a mere pretext for a decorative
composition, plus sentiment. It suggests emotion, and I
translate that emotion into art. I want to expose the Ab-
solute, and not merely the factitious woman."*

Georges Braque, 1910

303. Georges Braque (1882–1963). *Houses at l'Estaque*,
1908. Oil on canvas, 28¾ x 23½ in. Kunstmuseum,
Bern; Hermann and Margrit Rupf Collection.

304. Georges Braque (1882–1963). *Large Nude*, 1907.
Oil on canvas, 55¾ x 40 in. Alex Maguy, Paris.

305. Georges Braque (1882–1963). *Fishing Boats*, 1909.
Oil on canvas, 36 x 28¾ in. The Museum of Fine Arts,
Houston; The John A. and Audrey Jones Beck Collection.

306. Paul Cézanne (1839–1906). *Bibemus Quarry*, 1895.
Oil on canvas, 25⅝ x 31⅞ in. Museum Folkwang, Essen.

304

303

In 1907 much was made of the publication, in conjunction with Cézanne's memorial
exhibition, of a letter to Emile Bernard in which Cézanne stated: " . . . everything in
nature is modelled on the sphere, the cone, the cylinder. One must learn to paint from
these simple forms." [10] As this and other correspondence make clear, Cézanne's under-
standing of perception not only emerged through the process of painting but became
inseparable from it. It was this new, cogitative aspect of seeing, so brilliantly articu-
lated in Cézanne's late works, that penetrated the cool intellect of Braque.

As noted in the last chapter, Braque submitted a group of his landscapes inspired by
Cézanne to the Salon d'Automne in September 1908. When the jury, which included
Matisse, rejected some of his entries, Braque withdrew all of them. In November they
were shown at the gallery of an enterprising young German, Daniel Henry Kahnweiler,
which would become the principal showcase for Cubist works. In his review of the ex-

hibition Louis Vauxcelles offered his appraisal of the sources and strategies that informed the new works: "Monsieur Braque is a very daring young man. The bewildering example of Picasso and Derain has emboldened him. Perhaps, too, the style of Cézanne and reminiscences of the static art of the Egyptians have obsessed him disproportionately. He constructs deformed metallic men, terribly simplified. He despises form, reduces everything, places, figures and houses, to geometrical schemes, to *cubes*." [11] If Vauxcelles had inadvertently provided a name for the new style—and there is evidence that his characterization repeated Matisse's own description of it—the critic's emphasis on the solidity of Braque's forms is misleading. A far more fluid vision of the world was at the heart of Braque's conception, and subsequently of Picasso's. In this new vision the density of an object gave way to weightlessness: contours no longer defined opaque shapes but functioned as simple demarcations of increasingly luminous, transparent planes.

305

306

The Emergence of Analytic Cubism

Over the next two years Braque and Picasso developed a close working relationship that accelerated the evolution of Cubism's new pictorial language. By 1909 both painters had drastically restricted their palettes to a narrow range of brown, green, and gray. The imposition of these neutral colors facilitated the artists' examination of the spatial relationships of objects in landscapes and still lifes. Braque's and Picasso's emphasis on analysis, on constitution and reconstitution, resulted in the creation of a shallow and ambiguous pictorial space, one that both recedes from the surface of the canvas and extends outward from it. In these works the sensuous pleasure usually associated with landscape or still life has been replaced by austere intellectualization.

Because their formal concerns were so similar, the differences between Picasso's and Braque's styles are sometimes elusive. Yet there is a tension in Picasso's compositions that contrasts with the programmatic clarity of Braque's. In Braque's *Still Life with Violin and Pitcher* (plate 308), the contours of forms are systematically violated by a faceting that seems to reiterate the essentially vertical pictorial structure. No longer are light and shade used to enhance the description of objects; rather, their presence or absence seems dictated by exclusively structural concerns. The inclusion of an illusionistic nail, which casts a "shadow" at the top of the canvas, makes the forms below appear pinned to the wall, thus reminding the viewer of the essential two-dimensionality of the canvas. This awareness of the painting as object, expressed in the French term *tableau-objet*, was to remain fundamental to the so-called Analytic Cubism that evolved from about 1909 to 1912. Increasingly in such Cubist works, the ambiguity of the spatial and for-

Apollinaire and his mistress, the painter Marie Laurencin, along with the poet Max Jacob, Picasso and his mistress, Fernande Olivier, and a rotating company of painters, poets, and patrons like the Steins constituted the "bande à Picasso" (Picasso's gang), which gathered regularly for suppers and improvised entertainments in the artist's studio in the ramshackle Bateau Lavoir—so nicknamed because it resembled the old laundry boats along the Seine. Laurencin immortalized such a gathering in this group portrait, whose intentionally simplified and naive style reveals her affinity with Rousseau and with the Cubists.

307

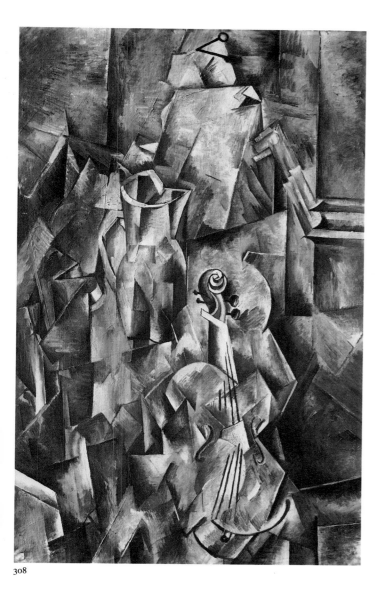

308

307. Marie Laurencin (1885–1956). *Group of Artists*, 1908. Oil on canvas, 24¾ x 31⅛ in. The Baltimore Museum of Art; The Cone Collection, formed by Dr. Claribel Cone and Miss Etta Cone of Baltimore, Maryland.

308. Georges Braque (1882–1963). *Still Life with Violin and Pitcher*, 1910. Oil on canvas, 46½ x 28¾ in. Kunstmuseum, Basel.

mal configuration would result in the displacement of visual reality by a conceptual reality. Yet despite its progressive distancing from nature, Cubist painting never completely relinquished its reference to external reality, for it had to acknowledge that reality in order to establish its difference from it. Indeed, Picasso claimed that he never painted an abstract picture, implying that he had never made a work from purely invented, as opposed to observed, elements.

While Braque's probing of the relationship between nature and art expressed itself mainly in landscape and still life, Picasso's fascination with portraiture, manifested before the onset of Cubism, compelled him to return to it. He probably began his portrait of the celebrated dealer Ambroise Vollard (plate 309)—who had been exhibiting and purchasing Picasso's work since 1901—at the end of 1909 and finished it the next spring. Although Picasso's interest in dissecting form led him to construct an irregular network of faceted shapes, he still respected the integrity of his model, maintaining a delicate balance between the external reality required by portraiture and the internal reality of the painting itself. Vollard's large head and prominent features jut out with ruddy plasticity from the monochromatic maze of intersecting planes. If one compares this portrait to the one done by Cézanne a decade earlier (plate 310), the source of Picasso's emphasis on construction becomes clear. The basic frontality of Cézanne's work, its subordination of the superficial aspects of the sitter's physical identity to the dictates of the total composition, and its sense of light emanating from both within and without the human form, make it seem likely that Picasso was consciously measuring his portrait against the earlier example.

Picasso's progression from the transcription of nature to a more fully articulated abstraction can be measured in his 1910 portrait of Daniel Henry Kahnweiler (plate 311). This clever and energetic art merchant, who had purchased works by the Fauves, Picasso, and Braque from 1907 on, was to become the *éminence grise* of Cubism, keeping a large stock of paintings by his artists and displaying a constantly changing selection of works on the walls of his gallery. By 1912 Kahnweiler had persuaded Picasso and Braque to sign contracts that gave him the exclusive right to purchase their entire output, so that he virtually controlled the distribution of their work and that of other Cubists before the outbreak of World War I. His perspicacious cooperation with avant-garde galleries and artists' groups in Germany, Austria-Hungary, and the United States was to contribute mightily to Cubism's international reputation, as would his articles and books, including his pioneering study, *Der Weg zum Kubismus* (The Rise of Cubism), published in 1920. It was in this book that Kahnweiler identified the summer of 1910 as the moment when Picasso consistently began to violate the contours of figures and objects, utilizing geometric planes to link his image with its background:

. . . these painters distinguish between primary and secondary qualities. They endeavor to represent the primary . . . qualities as exactly as possible. In painting, these are the object's form and its position in space. They merely suggest the secondary characteristics such as color and tactile quality, leaving their incorporation into the object to the mind of the spectator. This new language has given painting an unprecedented freedom. . . . It can, in order to give a thorough representation of the object's primary characteristics, depict them as stereometric drawing on the plane surface, or, through several representations of the same object, it can provide an analytical study of that object which the spectator then reassembles in his mind. . . .[12]

Kahnweiler's interpretation of Picasso's methodology and goals is supported by his portrait, in which the emphasis on formal devices fairly overwhelms the representational considerations, although the features of the sitter do emerge from the network of facets characterized by arbitrary light and shade and essentially nondescriptive handling of paint. It is this insistence on pictorial structure at the expense of the subject that distinguishes the peculiarly introverted approach of Analytic Cubism.

"Picasso did a very notable portrait of me. . . . Of course when they saw this picture, even people who considered themselves connoisseurs indulged in the facile pleasantry of asking what it was meant for. But the son of one of my friends, a boy of four, standing in front of the picture, put a finger on it and said without hesitation: 'That's Voyard.'"

Ambroise Vollard, 1936

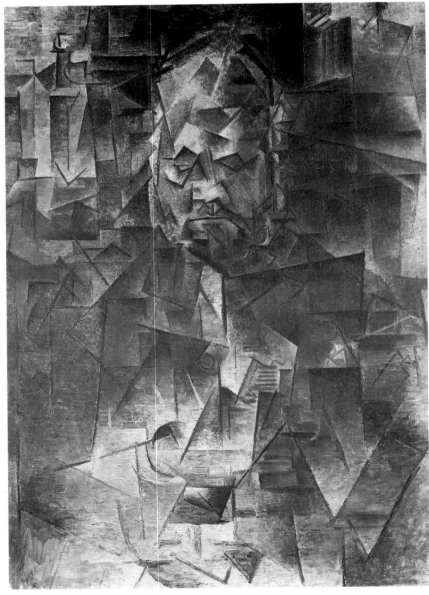

309

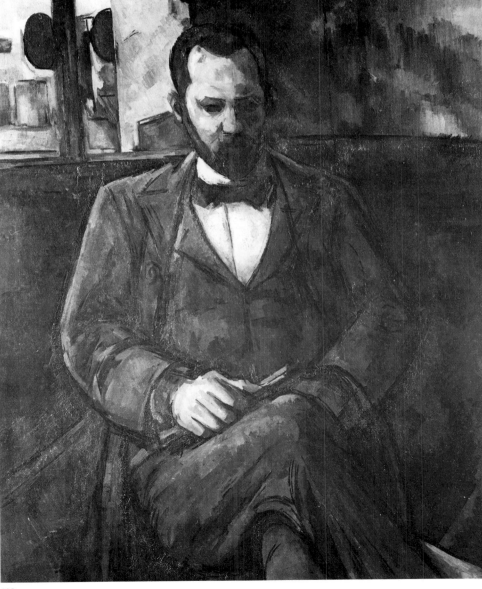

310

Collage and Synthetic Cubism

In their progress toward abstraction, Braque and Picasso were creating a pictorial syntax in their paintings of 1910–11 that was becoming increasingly difficult to comprehend and thus threatened to upset the precarious balance the artists had recently achieved between the demands of representation and those of abstraction. They sought a new solution by experimenting with collage during the following year, but even before this they had introduced stenciled letters, numbers, and words (or fragments thereof) into their work. The words or word-fragments generally referred to a specific object in the painting, such as a newspaper, or, as in Braque's circular canvas *Soda* (plate 312), provided an association with other elements in the composition: a glass, a pipe, and a sheet of musical notation, which suggest the atmosphere of a café. Braque

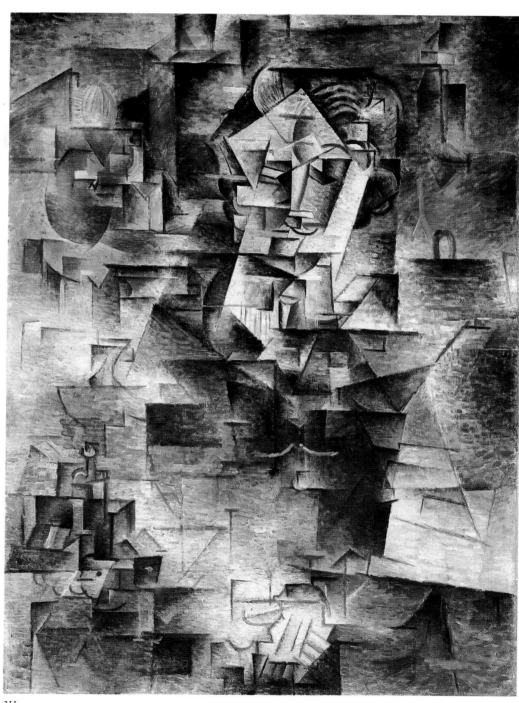

309. Pablo Picasso (1881–1973). *Portrait of Ambroise Vollard*, 1909–10. Oil on canvas, 36¼ x 25⁹⁄₁₆ in. Pushkin Museum of Fine Arts, Moscow.

310. Paul Cézanne (1839–1906). *Portrait of Ambroise Vollard*, 1899. Oil on canvas, 39½ x 32 in. Musée du Petit Palais, Paris.

311. Pablo Picasso (1881–1973). *Portrait of Daniel Henry Kahnweiler*, 1910. Oil on canvas, 39⅝ x 28⅝ in. The Art Institute of Chicago; Gift of Gilbert W. Chapman in memory of Charles B. Goodspeed.

311

312

himself shed some light on the function of these elements, stating that they were "forms which could not be distorted because being themselves flat, they could not be in space, and thus by contrast their presence in the picture made it possible to distinguish between objects situated in space and those which were not."[13] It also appears that the introduction at this time of circular and, later, of oval canvases allowed Braque and Picasso to create more compact and unified pictorial structures without the inevitable implications of the windowlike rectangle.

By the spring of 1912 both artists were including real and simulated "real" elements in their work. In *Still Life with Chair Caning* (plate 314), Picasso glued a piece of oilcloth with a printed imitation of caning to an oval canvas whose various painted elements—a glass, a pipe, a lemon—suggest yet another café. Just as the printed letters *JOU* allude to *journal*, the French word for newspaper, so does the fictitious caning signify a chair. Even more dramatically than in earlier Cubist works, this technical innovation emphasizes the complex relation of the real to the artificial, of truth to falsehood. This complexity was reinforced by the plausible double meaning of the fragment *JOU*, which could also allude to the word *jouer*, that is, "to play." Although the

312. Georges Braque (1882–1963). *Soda*, 1911. Oil on canvas, diameter: 14¼ in. The Museum of Modern Art, New York; Acquired through the Lillie P. Bliss Bequest.

313. Georges Braque (1882–1963). *Still Life with Violin*, 1913. Collage with gouache and charcoal on chipboard, 28¼ x 20⅜ in. The Cleveland Museum of Art; Purchase, Leonard C. Hannon, Jr., Bequest.

314. Pablo Picasso (1881–1973). *Still Life with Chair Caning*, spring 1912. Oil and oilcloth on canvas with rope, 10⅝ x 13⅝ in. Musée Picasso, Paris.

313

314

oilcloth is patently more "real" than the painted objects, it is also clearly "false" because it pretends to be chair caning. In addition, the painted objects have been given a fictive three-dimensionality that contrasts with the literal flatness of the glued-down oilcloth. To further complicate the composition, Picasso added a rope to its edge to serve as an unconventional frame that also resembles the decoratively carved edges of café table tops. By contesting the idea that an artist must recreate reality with paint alone, he rejected centuries of convention. In this collage Picasso not only redefined the mimetic tradition, established in the Renaissance, by incorporating machine-made materials, he mocked the hallowed importance of the artist's hand in fabricating illusion by demonstrating the superiority of the mechanically produced image.

The introduction of collage into their painting indicated that both Braque and Picasso recognized that they had exhausted the possibilities of the analytical approach to form and space. Braque subsequently began to limit his use of pasted-on ingredients to pieces of paper (*papier-collé*), whose flatness ultimately resulted in the total elimination of illusionistic space. *Still Life with Violin* (plate 313) demonstrates the effect of this technique, although spatial relationships are still implied by the overlapping of the pasted elements. The use of paper strips also introduced color and texture through a

315. Pablo Picasso (1881–1973). *Violin Hanging on the Wall*, 1913. Oil and sand on canvas, 25⁹⁄₁₆ x 18⅛ in. Kunstmuseum, Bern; Hermann and Margrit Rupf Collection.

316. Pablo Picasso (1881–1973). *Still Life*, 1914. Painted construction with upholstery fringe, 10 x 18 x 3⅝ in. The Tate Gallery, London.

316

means other than painting. This experimentation with collage and *papier-collé* helped transform Cubism from an analytic to a synthetic style. The exploration of formal relationships in the natural world that had dominated Analytic Cubism was replaced in Synthetic Cubism by the construction of an independent and avowedly two-dimensional world arbitrarily created through the manipulation of paper and paint.

While the elegant economy of Braque's *Still Life with Violin* exemplifies Synthetic Cubism's logical progression toward flatness and simplification, a similar subject by Picasso, *Violin Hanging on the Wall* (plate 315), reveals additional aspects of this new approach. A striking feature of this painting is the reappearance of color and texture. The mixing of sand and pigment, particularly evident on the left side of the canvas, gives the painting an uneven surface, while the introduction of simulated wood paneling contributes a familiar note of paradox to the work.

The new preference for sensuous colors and textures in Picasso's works of this period reached a climax with the splendid *Ma Jolie* (plate 406). Against a neutral background whose flatness is emphasized by the stenciled refrain from a popular song, "O Manon, ma jolie," Picasso has offered a group of typically Cubist objects: a sheet of music, a bottle, a guitar, a pipe, a goblet, a playing card, and a die. A prominent feature of this work is the assertion of individual textures, an outgrowth of the use of collage to emphasize the discrete nature of various pictorial elements. The widest possible range of surfaces has been introduced here, from the smoothly painted background to the stippled areas underneath the guitar and goblet. Moreover, the shapes possess an organic quality that seems a partial repudiation of Picasso's more severely geometric approach of two years earlier. In addition, the introduction of the words *ma jolie*, with their romantic connotation, indicates the artist's new willingness to incorporate private feelings and associations into his work.

From 1913 on, Braque had been making cardboard models of still-life objects (now for the most part lost) to facilitate the organization of his paintings, and Picasso followed his example. It was Picasso who then recognized the potential of these models as sculpture, transforming one of a guitar into a wall relief of sheet metal and wire. The consequences of this act for the history of sculpture have been even more profound than those of collage for painting. Rejecting the classical materials of sculpture—clay, stone, and bronze—Picasso also revolutionized the process of creating sculpture. In place of modeling, carving, or casting, he substituted a constructive method that paralleled the technique of collage. His *Still Life* (plate 316), for example, conveys the same joie de vivre found in *Ma Jolie*, albeit in a more overtly humorous way. Whereas previous Cubist still lifes had combined references to music and the pleasures of drinking, reading, and smoking, thus evoking the traditional functions of such pictures as representations of the senses, this painted wood relief offers only a workman's hearty snack. Its unmistakable elements are a wine goblet, some bread and salami, and a knife, but Picasso predictably confounded this ostensible simplicity by introducing a real strip of wood, whose illusionistically painted motif simulates a carved molding, and a gaudy piece of gold-threaded fringe, whose palpable reality casts a shadow on the wall behind it.

Braque's and Picasso's Cubism has been characterized as excessively preoccupied with posing and solving pictorial problems. Nonetheless, their emphasis on the formal aspects of painting did not mean that they were insensitive to subject matter. On the contrary, what emerges from their canvases are personal and particular references to their own milieu: the cafés they frequented, the studios where they worked, and even the friendships and love affairs that engaged them. In this respect, the Cubism of Braque and Picasso can be said to have resumed, on its own terms, the recording of daily life and intimate experience that was historically associated with Impressionism.

317

317. Juan Gris (1887–1927). *Portrait of Picasso*, 1912. Oil on canvas, 36⅞ x 29¼ in. The Art Institute of Chicago; Gift of Leigh Block.

318. Juan Gris (1887–1927). *The Smoker*, 1913. Oil on canvas, 28⅞ x 21½ in. Thyssen-Bornemisza Collection, Lugano.

Juan Gris

During the two years before World War I, Cubism gathered a prestigious critical reputation that attracted artists from all over Europe and the United States. While many of those who turned to Cubism simply absorbed the most superficial of its formal and technical concerns, there were others who were more profoundly nurtured by the innovations of Braque and Picasso. Among these, Juan Gris is perhaps most noteworthy.

Born José Victoriano González, the artist left his native Madrid at the age of nineteen to settle in Paris. Upon his arrival, he immediately gravitated to Picasso's studio, the fabled Bateau-Lavoir ("laundry boat"), where he met Apollinaire, André Salmon, Max Jacob, and other intimates of the painter. He subsequently was introduced to Braque and Kahnweiler, the latter becoming his closest friend and first biographer. From 1906 to 1911 Gris supported himself by making satirical drawings for Spanish and French magazines, which already displayed the stylization of form and sensitivity to decorative two-dimensional effects that would later find full expression in his paintings.

Gris's proximity to Picasso provided him with a mentor and the opportunity to mix with the most advanced creative artists of the period. When Gris began painting seriously in 1910, his initial still lifes were clearly influenced by the authority and austerity

of Cézanne. Yet within a year his work displayed an astonishing sophistication of conception and subtle techniques of abstraction that could be compared favorably with those of Braque and Picasso. Gris's celebrated *Portrait of Picasso* (plate 317), exhibited in the Salon des Indépendants in 1912, established his position within the evolving Cubist movement. While following the example of his sitter's own portraits of Vollard and Kahnweiler in its fragmented anatomy and physiognomy and its restricted palette of grays and blues, this tribute to Picasso projects a greater solidity and an unswerving structural clarity that seem to result from conscious stylization. The painting's unity is reinforced by the indication of a single light source (in contrast to works by Braque and Picasso), which provides a more orderly integration of its diverse geometric elements and fuses them more smoothly with the background.

Gris's early training in engineering at the School of Arts and Industries in Madrid may have helped him to organize his thinking and thus facilitated the rapid development of his personal style. In 1911 Gris began to frequent a circle of artists including Marcel Duchamp, Albert Gleizes, Fernand Léger, Jean Metzinger, Francis Picabia, and Jacques Villon, who held regular gatherings in which considerable time was spent discussing the aesthetic significance of mathematics and science. Taking to heart the words of Apollinaire that "geometry is to the plastic arts what grammar is to . . . the writer," [14] they proclaimed themselves La Section d'Or (The Golden Section) and sought to ally themselves with the tradition of ideal proportion implied in that name. It was with these artists that Gris appeared in the Salon des Indépendants in 1912, and he also participated in a show entitled *La Section d'Or* in a private gallery that fall. His association with the group sparked his determination to establish a proportional system for his own painting.

By 1913 Gris's experimentation with collage and *papier-collé* was affecting the construction of his paintings. In *The Smoker* (plate 318) he used a system of overlapping vertical, horizontal, and triangular planes, which are differentiated by color and texture but which—unlike Picasso's and Braque's—are no longer transparent. On these wedges of color Gris wittily juxtaposed one or more aspects of the object represented—a splintered top hat, an eye, an ear, a chin, a cigar—to create what might be described as abstract caricature.

The following year Gris plunged wholeheartedly into the technique of *papier-collé*, executing a number of works in which virtually the entire surface of the canvas was covered with different types of paper. He sketched his compositions in advance, so that each piece of paper, each painted element, would fit into its designated place. Unlike the sharp edges of the pasted paper in a Braque *papier-collé*, Gris's are artfully disguised so that it is difficult to determine what is real and what is painted. Although Gris had apparently accepted the concept of the *tableau-objet*—that is, the recognition of the painting as an independent physical object—he was still committed to having the paper fragments represent something. In *The Man in the Café* (plate 319) he endowed the underlying structure of planes with an architectonic clarity while giving the drastically simplified overlying elements a new sense of weight through careful shading. Like Braque and Picasso, Gris used printed matter to call attention to the essentially fictional nature of the painted elements, but he also made his own humorous contribution to the sense of playfulness that often enlivens Cubist collage. The caption of a newspaper article in *The Man in the Café* states that "one will no longer fake works of art," a playful reference to the painting's content. At the same time, the words allude to the polemical character of Cubism itself and to its insistence on defining the character and limitations of the real.

After concentrating exclusively on collage for a year, Gris stopped working in the medium altogether toward the end of 1914. Picasso gave up collage at almost the same

319. Juan Gris (1887–1927). *The Man in the Café*, 1914. Oil on *papier collé* mounted on canvas, 39 x 28⅜ in. Mr. and Mrs. William R. Acquavella, New York.

time, and it is likely that the tragedy of the war made both painters feel that their private intellectual games were inappropriate. But it is also possible that Gris may have found collage, with its emphasis on the temporal and the two-dimensional, uncongenial to his innate attraction to classical and monumental forms. Determined to move away from the cumulative effect he associated with collage, he began to strive for more integrated compositions, writing to Kahnweiler, who as a German national was then residing in Switzerland:

> I think I have really made progress recently and that my pictures begin to have a unity that they lacked until now. They are no longer those inventories of objects which used to depress me so much. But I still have to make an enormous effort to achieve what I have in mind. For I realize that although my ideas are well enough developed, my means of expressing them plastically are not. In short, I have not got an aesthetic, and this I can only acquire by experience.[15]

In *Still Life before an Open Window (La Place Ravignan)* of 1915 (plate 320), Gris's search for greater unity temporarily assumed a more representational guise. Here the artist was motivated by a desire to integrate distinctly different elements: an interior still life that includes the familiar "inventories" noted in his letter to Kahnweiler and an exterior street scene. The still life is painted in a style of modified abstraction, the street scene in one of modified representation, and the transition from one to the other is facilitated by the decorative grillwork of the balcony. A key element in building the unity that Gris sought in this kaleidoscopic vision was color. Putting aside the subdued palette of *The Man in the Café*, he introduced strong contrasts of intense hues. The mysteriously evocative blue of the exterior, for example, permeates the painted fabric of the interior as well, invading the fruit bow! and heightening the viewer's awareness of the carefully modulated pinks and greens. The intellectualization of the still life or interior that had marked Gris's earlier approach to these genres has given way here to a more emotional treatment.

It is possible that the artist's growing friendship with Matisse may have opened his eyes to the formal and iconographic potential of the open-window motif.[16] Yet Gris's vast knowledge of the history of art would certainly have made him aware of the theme, which had been familiar since the Renaissance and especially popular with painters of the early nineteenth century, who utilized it to express the conflict between nature and art. In fact, Gris was drawn to the imagery of the window at a moment of misgivings about his aesthetic direction. His exposure to Cubism, while offering an outlet for his penetrating intellect, did not provide a forum for his emotions. He found himself torn between the attraction of feelings, which he could not control, and of the mind, which enabled him to impose order on what he experienced.

Within months after completing *Still Life before an Open Window*, Gris began work on a group of somberly colored still lifes in which he again resorted to the collage-inspired construction of a shallow space through overlapping planes, mixing trompe-l'oeil—so evident in the painting of the wood-grained surfaces of table and molding—with purely abstract shapes. In his use of stylized though still illusionistic shadows in one of these still lifes, *Fantômas* (plate 321), Gris seems to have been intent on drawing attention to the ambiguity of the space. This quality is underscored by his use of chalky white lines, probably the elements painted last, which add a diagrammatic three-dimensionality to the colored shapes. The title *Fantômas*, prominently visible on the book on the table, refers to a fictional criminal celebrated for his manual dexterity. Its inclusion suggests that Gris—who, as a painter, was constantly involved with deception—identified with this underworld character; it also recalls a celebrated statement by Degas: "A painting is a thing which requires as much knavery, as much malice, as much vice as the perpetration of a crime."[17]

320

321

320. Juan Gris (1887–1927). *Still Life before an Open Window (La Place Ravignan)*, 1915. Oil on canvas, 45⅜ x 35⅛ in. Philadelphia Museum of Art; The Louise and Walter Arensberg Collection.

321. Juan Gris (1887–1927). *Fantômas*, 1915. Oil on canvas, 23½ x 28⅞ in. National Gallery of Art, Washington, D.C.; Chester Dale Fund, 1976.

As rigorous and logical in his theorizing as he was in his painting, Gris provided a succinct description of his deductive method:

I work with the elements of the intellect, with the imagination. I try to make concrete that which is abstract. I proceed from the general to the particular, by which I mean I start with an abstraction in order to arrive at a true fact. . . . Cézanne turns a bottle into a cylinder, but I begin with a cylinder and create an individual of a special type. . . .

Cézanne tends towards architecture, I tend away from it. That is why I compose with abstractions (colors) and make my adjustments when these colors have assumed the form of objects. . . .[18]

The School of Cubism

The inventors of Cubism had worked in semi-isolation, but between 1910 and 1914 a collective Cubist style emerged. During this period a number of exhibitions and a substantial body of theoretical and critical literature attested to the diffusion of the style. The first reference to a Cubist school occurred in 1910 in connection with works by Gleizes, Metzinger, Léger, and Robert Delaunay shown that year at the Salon des Indépendants and the Salon d'Automne. A popular critic designated these works "geometrical follies," but Apollinaire was struck by their collective "return to composition," which proclaimed "the rout of Impressionism." [19] Subsequently, in response to the careless use of the term Cubism by journalists, Apollinaire went on to characterize some of the paintings at the Salon d'Automne as " . . . a flat, lifeless imitation of works not on view and painted by an artist with a strong personality, who, what is more, has not let anyone share his secrets. This great artist is Pablo Picasso. The Cubism at the Salon d'Automne was only the jackdaw in borrowed plumage." [20] While Apollinaire was probably correct in identifying the derivative styles of Gleizes and Metzinger as attempts to assimilate the breakthroughs of Picasso and Braque, he later appreciated the more original character of Delaunay's and Léger's work.

Virtually all of these painters had been working in the prevailing colorist idioms of the early twentieth century—Gleizes in a late Impressionist style, Metzinger and Léger in a variant of the Neo-Impressionism that was still much in evidence in the Salons, and Delaunay in a hybrid of Neo-Impressionism and Fauvism. Most of them had known each other even before the 1910 exhibitions, but it was seeing their work together that made them conscious of their similar interests and prompted them to "form a group, see more of each other and exchange ideas," as Gleizes later recalled. [21] The following year, when they succeeded in having their canvases hung in a separate gallery in the Salon des Indépendants, Cubism was effectively launched as a recognized movement.

322. Albert Gleizes (1881–1953). *Woman with Phlox*, 1910. Oil on canvas, 37⅞ x 39½ in. Museum of Fine Arts, Houston; Gift of the Esther Florence Whinery Goodrich Foundation.

323. Albert Gleizes (1881–1953). *Landscape with Figures*, 1911. Oil on canvas, 57⅛ x 54⅜ in. Musée National d'Art Moderne, Centre Georges Pompidou, Paris.

324. Albert Gleizes (1881–1953). *Chartres Cathedral*, 1912. Oil on canvas, 28⅝ x 23⅝ in. Kunstmuseum Hannover; Sprengel Collection.

325. Jean Metzinger (1883–1956). *Tea Time*, 1911. Oil on wood, 29¾ x 27⅜ in. Philadelphia Museum of Art; Louise and Walter Arensberg Collection.

322

323

324

325

Gleizes's discovery of the Analytic Cubism of Braque and Picasso is visible in *Woman with Phlox* (plate 322), exhibited at the 1911 Salon des Indépendants. Like his mentors, Gleizes restricted his palette to neutral tones. That he had not grasped the real significance of their faceting of forms, however, can be seen both in the relatively conventional modeling of his superficially geometricized forms and in his more traditional construction of space. Moreover, Gleizes was inclined to choose popular subjects— domestic interiors, country scenes, labor, leisure, and sport—that are vastly different from the hermetic and more contemplative themes of Braque, Picasso, or Gris and that document his lingering attachment to Impressionism. In none of Gleizes's canvases is there the vital empiricism or compelling logic that characterizes the masterpieces of Cubism. Instead, he established workmanlike formulas that would soon seem arid and timid.

Metzinger, who was coauthor with Gleizes of *Du Cubisme* (1912), the first theoretical study of the movement, had met Picasso in 1909 and had even published an article about his and Braque's paintings. The more didactic and systematic cast of his mind is reflected in such compositions as *Tea Time* (plate 325), which he showed in the Cubist-dominated Salon d'Automne of 1911. It is evident from this painting that Metzinger had studied Picasso's figure compositions of the previous two years and that he had tried to adopt the more obvious aspects of the analytic approach. Yet Metzinger's vision was rooted in naturalism: he merely superimposed on his subject a system of right angles and diagonals that schematized the more erratic practices of Picasso while remaining fundamentally representational.

Gleizes and Metzinger's written contribution to the history of Cubism definitely overshadowed their pictorial achievements. Their book, which was translated into English only a year after its appearance in France, publicized the philosophic basis of Cubism although it probably exaggerated the movement's scientific character. Still, Gleizes and Metzinger did shed light on the modernist self-sufficiency of Cubism: "A painting carries within itself its *raison d'être*. You may take it with impunity from a church to a drawing-room, from a museum to a study. Essentially independent, necessarily complete, it need not immediately satisfy the mind: on the contrary, it should lead it, little by little, toward the imaginative depths where burns the light of organization." [22]

Cubist Variations

Léger and Delaunay, who had become friends in 1909, were already working in advanced styles when they became acquainted with the work of Braque and Picasso in Kahnweiler's gallery. Both painters had reacted strongly to Cézanne and Rousseau. Indeed, Delaunay later acknowledged Cubism's indebtedness to Cézanne when he observed that the master had "anticipated Cubism because his planes of color, or rather light, had broken up objects and left them existing as a collection of pieces." [23] Léger maintained that Cézanne was the only Impressionist to have "fully understood what was incomplete about Impressionism. He felt the necessity of renewing *form* and *design* to match the new *color* of Impressionists. His life and his work were devoted to the quest for this synthesis. . . ." [24]

326

327

Fernand Léger

In 1910 Léger completed an ambitious canvas, *Nudes in the Forest* (plate 326), which translates the forms of early Cubism into a mechanical geometry. If the subject recalls the tradition of the classical nude as it had recently been manifested in the work of Cézanne, Matisse, Derain, and Picasso, Léger's response to the challenge of the theme was certainly original, and his handling of the figures was distinctly sculptural. His female nudes resemble gigantic wood mannequins constructed mainly of cylinders and cones. Their brown coloration makes it virtually impossible to distinguish them from the rocks, bushes, and trees of the crowded landscape. Moreover, the juxtaposition of the various geometric fragments creates an intense effect of jumpy motion that can be likened to the grinding of a large machine. The painter himself described the work as "a battle of volumes." [25]

In *Stairway* (plate 328) Léger moved further beyond representation, painting two monumentally geometricized forms conceived in primary colors and heavy black outlines. While the result—in its reductivism and its rejection of anecdote—can be compared with Analytic Cubism, the basic physicality of Léger's forms is quite different. Fascinated by the rhythm of urban life, and particularly by industrialization, he was

326. Fernand Léger (1881–1955). *Nudes in the Forest*, 1909–10. Oil on canvas, 47¼ x 67 in. Rijksmuseum Kröller-Müller, Otterlo, The Netherlands.

327. Fernand Léger (1881–1955). *The Level Crossing*, 1912. Oil on canvas, 36½ x 32 in. Ernst Beyeler.

328

328. Fernand Léger (1881–1955). *Stairway*, 1914. Oil on canvas, 36⅜ x 56¾ in. Kunstmuseum, Basel.

329. Francis Picabia (1879–1953). *Dances at the Spring*, 1912. Oil on canvas, 47⅝ x 47⅝ in. Philadelphia Museum of Art; The Louise and Walter Arensberg Collection.

inspired to search for plastic equivalents to dynamic energy. Though he relinquished the subtlety of spatial discourse that was the hallmark of Braque's and Picasso's Cubism, Léger succeeded in imparting clarity and order to the muddle of the modern world. By 1913–14 he had eliminated description from his work, concentrating instead on the purely plastic qualities of objects in space. In a series of compositions he called Contrasts of Forms, Léger asserted a new concept of pictorial reality, which he articulated in writings published at the same time. It is significant that in stressing the uniqueness of modern painting, Léger also insisted on its link with Impressionism, which he saw as a "primitive" stage in the development from "visual realism" to "realism of conception": "From now on, everything can converge towards an intensity of realism obtained by purely dynamic means. Painterly contrasts in the purest sense (the use of comple-

mentaries in colors, lines and forms) are the basic structural elements of modern pictures."[26]

It was his affirmation of technology and popular culture that, more than any other single factor, differentiated Léger from most of his Cubist contemporaries and determined the course of his development. His emphasis on art's relationship to modern life was expressed in his virtual obsession with energy and movement:

> If pictorial expression has changed, it is because modern life has made this necessary. The daily life of modern creative artists is much more condensed and more complex than that of people in earlier centuries. . . . When one crosses a landscape in an automobile or an express train, the landscape loses in descriptive value, but gains in synthetic value. . . . A modern man registers a hundred times more sensory impressions than an eighteenth-century artist, so that, for instance, our language is full of diminutives and abbreviations. The condensation of the modern picture, its variety, its breaking up of forms, are the result of all this. . . . Many superficial people raise the cry "anarchy" on seeing these pictures. . . . They think that painting has abruptly broken the chain of continuity when, on the contrary, it has never been so truly realist, so close to its own period. . . .[27]

Robert Delaunay

Léger's impassioned investigation of dynamism was joined by other artists—notably Delaunay, Picabia (plate 329), and Duchamp—who had all been involved with the Section d'Or group. In his pioneering but highly subjective account of Cubism, *Les Peintres Cubistes* (1913), Apollinaire classified these artists variously as "purists" and "Orphic" Cubists. Although he provided no precise definition of his terms, Apollinaire made it clear that these painters were reacting against the static qualities of compositions by Braque, Picasso, and Gris. The Orphic Cubists would later be identified with the focus on color as the major organizational and expressive component of painting. The leading exponent of this vital challenge to the "scientific cubism" of Picasso and Braque was Robert Delaunay.

Younger than Picasso by four years, Delaunay developed precociously within the orbits of late Neo-Impressionism and Fauvism. His abiding admiration of Seurat, stimulated no doubt by the latter's large retrospective at the Salon des Indépendants in 1905, caused the younger artist to adopt Seurat's rigorous methodology and to pursue his study of Seurat's color back to its roots in the writings of Chevreul. While there is no incontrovertible evidence that these theories influenced Delaunay's style, they surely contributed to his appreciation of the scientific and intellectual character of painting. Delaunay was just twenty when bright, arbitrary color began to overwhelm the Pointillism of his canvases. Coincidentally, like other artists, he was awakening to the importance of Cézanne. Delaunay's development can be seen in a series of paintings done of the church of Saint-Séverin (plate 330), in which he explored the effects of variegated light on the building's interior. Just as Cézanne had analyzed the distorting effects of light on landscape or the human figure, Delaunay recorded its metamorphosing impact on solid piers and vaults. If the fragmented and spatially dynamic views of Saint-Séverin reveal his adoption of a Cézannesque approach to light and form, a much more radical intention motivated his series of drawings and paintings of the Eiffel Tower undertaken between 1909 and 1911 (plates 331, 332). This soaring structure was an icon of modernity for writers and artists, though only Seurat, Rousseau, and Delaunay had actually painted it at that point. Built in 1889, it was certainly one of the most visited, most photographed, and therefore most familiar images in the early modern world. The Eiffel Tower represented an extraordinary feat of engineering, a triumph of technical skill that transformed inert mass into an upwardly thrusting network of apparently weightless elements. It also seemed a symbol of human progress, of the capacity

329

330

of intelligence and will to transcend physical limitations. Delaunay underlined this broader significance when he inscribed the words "La tour s'addresse à l'univers" ("The Tower addresses the universe") on the back of his first canvas, painted in 1909.

To capture the essence of this modern miracle, Delaunay turned to Cubism. In his drawings and oil paintings of the tower he demonstrated his later claim that it had attracted him because of its geometrical design. The colossal scale and unmistakable modernity of the structure offered a challenge to the methods of Cubism, which had previously been restricted to the rendering of discrete objects. The monument's size made it impossible to encompass in a single glance, except from a considerable distance, thus reinforcing the impression of fragmentation. Close viewing was further complicated by the necessity of moving around the structure in order to fully comprehend its design. In addition, its painted surface was reflective and thus changed according to the light. Delaunay described his method of painting the tower in a lecture: "You see for example the group of cumulus clouds. Well, their luminous rays enabled me to

330. Robert Delaunay (1885–1941). *Saint-Séverin No. 3*, 1909–10. Oil on canvas, 45 x 34⅞ in. Solomon R. Guggenheim Museum, New York.

331. Robert Delaunay (1885–1941). *The Red Tower (Champ de Mars)*, 1911. Oil on canvas, 64 x 51½ in. The Art Institute of Chicago; Joseph Winterbotham Collection.

332. Robert Delaunay (1885–1941). *Eiffel Tower*, 1910. Pen and ink on brown cardboard, 24¼ x 19¼ in. The Museum of Modern Art, New York; Abby Aldrich Rockefeller Fund.

331

break the continuity of the line of the tower. I wanted to find points of view on different sides and juxtapose them, but although I hoped to find the complete form I could not do so because at that time I was caught between traditional painting and the new reality." [28] That "new reality" was the interaction of color and light, which would be the subject of prolonged investigation in his paintings of 1912–14.

The assertive energy of Delaunay's pictorial re-creation of modern Paris was replaced in 1912–13 by a more orderly and lucid examination of the properties of light, color, and space in his *disques simultanés*, or "simultaneous disks" (plate 333). In these ground-breaking works, Delaunay moved to the frontier of abstraction, well beyond the Cubist insistence that the artist was free to reconstruct nature. The oppositions between the concentric bands of pure color in these targetlike compositions function as their subject. It was this radical formulation of contrasting color as subject that had prompted Apollinaire to characterize Delaunay's style as "Purist" and "Orphic." However, such severing of painting from any connection with observed reality was certainly antithetical to the prevailing aesthetic of Cubism.

Delaunay found it difficult to sustain his commitment to pure art and turned again in 1914 to semirepresentational compositions. *The Cardiff Team* (plate 335), a painting that was surely inspired by Delaunay's appreciation of Rousseau—in particular the

"The Tower rose above Paris, as slender as a hat pin. When we walked away from it, it dominated Paris, stiff and perpendicular; when we approached it, it bowed and leaned over us. Seen from the first platform, it wound like a corkscrew, and seen from the top, it collapsed under its own weight, its neck sunk in. Delaunay . . . wanted to depict Paris around it, to situate it. We tried all points of view, we looked at it from all angles. . . . And those thousands of tons of iron, those 35 million bolts, those 300 meters high of interlaced girders and beams, those four arcs with a spread of 100 meters, all that jellylike mass flirted with us."

Blaise Cendrars, 1924

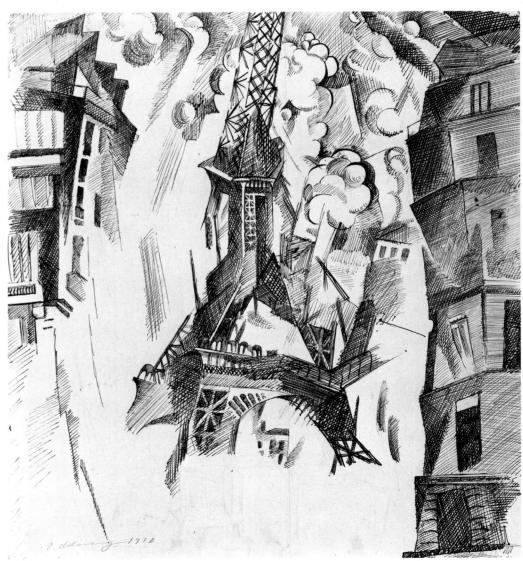

332

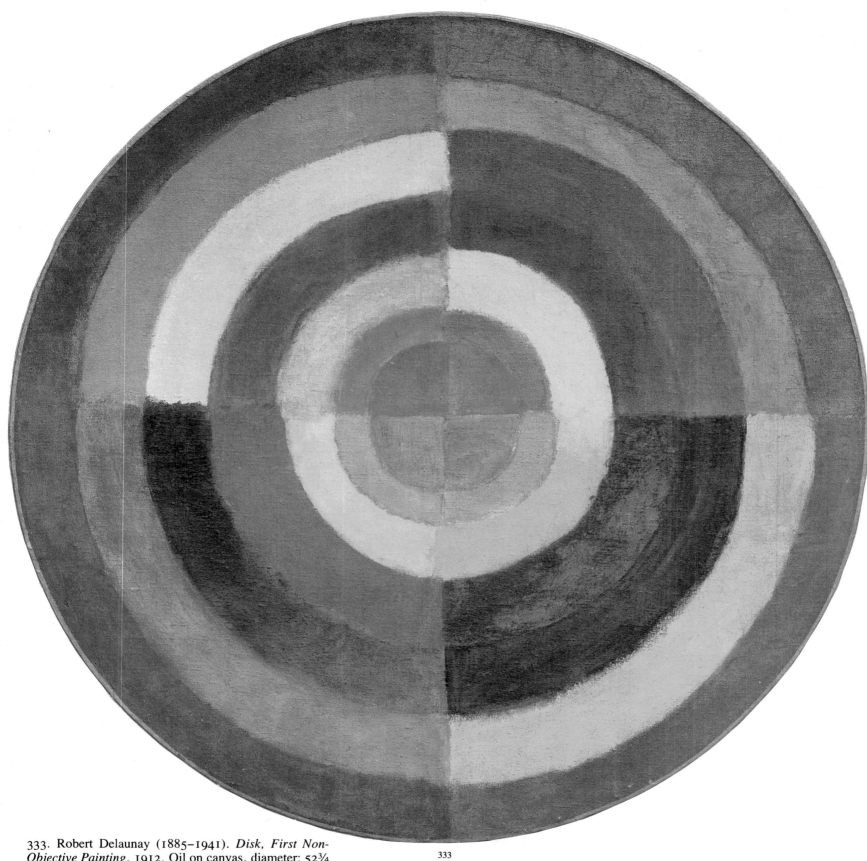

333

333. Robert Delaunay (1885–1941). *Disk, First Non-Objective Painting*, 1912. Oil on canvas, diameter: 52¾ in. Mr. and Mrs. Burton Tremaine, Meriden, Connecticut.

334. Henri Rousseau (1844–1910). *Football Players*, 1908. Oil on canvas, 39½ x 31⅝ in. Solomon R. Guggenheim Museum, New York.

335. Robert Delaunay (1885–1941). *The Cardiff Team*, 1912–13. Oil on canvas, 128½ x 87 in. Musée d'Art Moderne de la Ville de Paris.

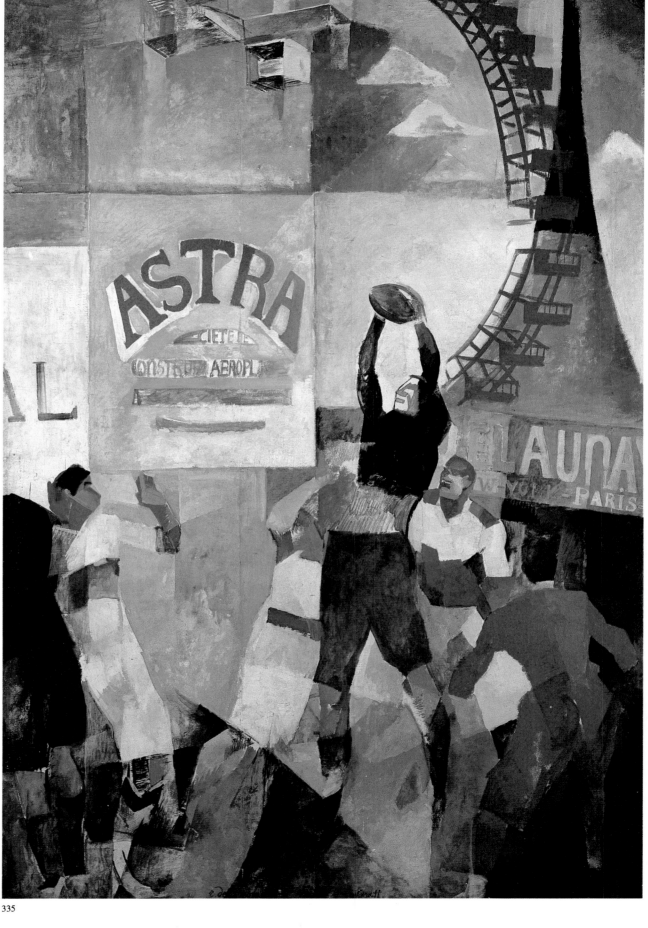

336. Robert Delaunay (1885–1941). *Homage to Blériot*, 1914. Oil on canvas, 76½ x 50½ in. Kunstmuseum, Basel; Emmanuel Hoffmann Foundation.

337. Marcel Duchamp (1887–1968). *The Sonata*, 1911. Oil on canvas, 57 x 44½ in. Philadelphia Museum of Art; Louise and Walter Arensberg Collection.

338. Marcel Duchamp (1887–1968). *Nude Descending a Staircase, No. 2*, 1912. Oil on canvas, 58 x 35 in. Philadelphia Museum of Art; Louise and Walter Arensberg Collection.

latter's *Football Players* (plate 334)—resumes a concern with distinctly modern and popular subject matter. In this work, Delaunay recycled the familiar image of the Eiffel Tower and also included other examples of modern engineering skill, such as a gigantic ferris wheel and an airplane whose name, "Astra," boldly declaims the sense of vibrant, cosmic energy that inspired its creation.

Delaunay's most ambitious modern allegory, *Homage to Blériot* (plate 336) of 1914, immortalized the daring triumph of the French pilot who, five years earlier, had been the first man to fly across the English Channel. Utilizing the simultaneous disk as an emblem of the all-penetrating energy of light, the artist multiplied and transformed the disk into splintered forms that suggest wheels, motors, a propeller, and plane insignia. The exuberant optimism of this work distinguishes it from the essentially neutral content of Analytic or Synthetic Cubist paintings and links it with Léger's positive response to the potential of technology.

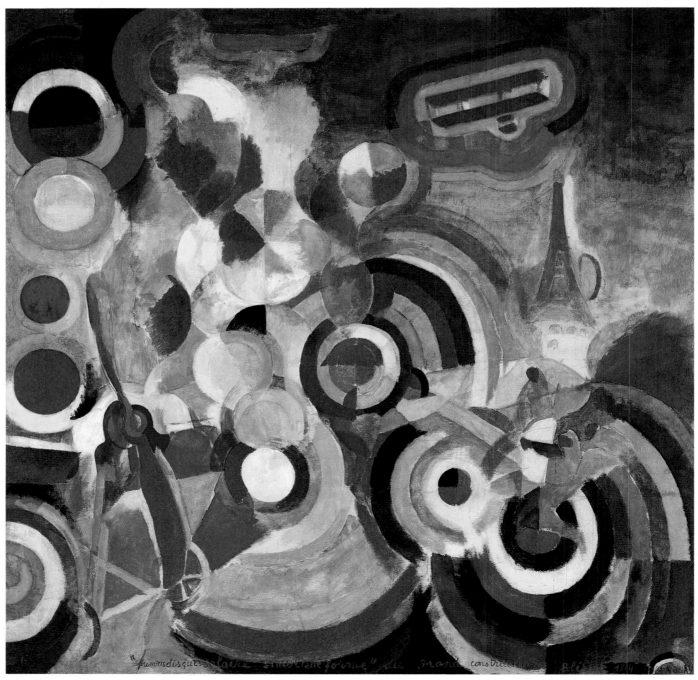

336

337

338

Marcel Duchamp

Duchamp's involvement with Cubism was late in developing—1911—and lasted only two years. Moreover, it was marked from the beginning by the skeptical unorthodoxy that became his artistic trademark. The formidable Duchamp and his artist-brothers, Jacques Villon and Raymond Duchamp-Villon, shared an intellectualizing approach to art, savoring its speculative aspects as much as the creative act. As we have seen, by 1910 they had gathered around them the core of artists whose interest in developing independent but related alternatives to Braque's and Picasso's Cubism would result in the organization of the Section d'Or.

Until 1912 Duchamp concentrated on subjects inspired by his family life: his brothers playing chess, his sisters making music. *The Sonata* (plate 337) suggests a partial adoption of Cubist strategies in the centralization of the image and the simplification and tentative fragmentation of forms, but its subject can be understood within the conventions of Intimist painting as well. By 1912, however, Duchamp's interest in formal fragmentation had converged with his fascination with machine imagery to inspire a group of paintings, of which *Nude Descending a Staircase, No. 2* (plate 338) is certainly the most notorious. Employing the browns and grays of Analytic Cubism, Duchamp stylized the process of figural dismemberment and presented it in sequential movement. While contemporary explorations in photography and the experiments of the Italian Futurists may have affected Duchamp's formulations, they cannot adequately explain the peculiarly mechanistic quality of this painting. Duchamp's "nude-machine" appears to self-destruct, dispersing its bladelike parts and consuming the staircase in the process. The artist's motivation appears to have been satirical and anti-Cubist, parodying the methodology of Braque and Picasso. The jury of the Salon des Indépendants must have interpreted the work in this way; in any event, they rejected it. The renown that the painting still enjoys resulted not from any contribution it made to the development of Cubism but from the outrage that greeted its appearance in America at the historic Armory Show of 1913. Duchamp's reservations about the future of painting would cause him to abandon the medium within less than a decade and lead to his concentrated investigation of "Readymades": ordinary objects whose identity and significance he altered by taking them out of context.

By the time Duchamp's parody of Cubist style and technique was shown in New York, the movement had gathered international momentum, thanks to the commercial and organizational genius of Kahnweiler and other dealers. This momentum was shattered by the outbreak of war in August 1914. Yet even before this tragic disruption of their professional lives, the manifestly different aesthetic concerns of Picasso, Léger, and Delaunay, for example, were beginning to express themselves through increasingly independent stylistic development. With the outbreak of hostilities and the departure from Paris of many of Cubism's major protagonists, its hegemony would be challenged by other existing artistic currents. Nonetheless, as the first genuinely new art movement of the twentieth century, Cubism had provoked changes in the form and content of painting that would prove as profound as those effected by the Renaissance. Artists and viewers alike perceived the style as absolutely modern in its ability to convey the increasing complexity of their own experience. In the first five years of its existence, Cubism had demonstrated a capacity to accommodate its initial concerns and methodology to diverse cultural conditions as it traveled beyond the confines of Paris, and this would provide it with an incredible resilience during the pluralistic years following World War I.

Futurism

The Italian Futurists shared the Cubists' fascination with all things modern, but, unlike their French counterparts, they linked their aesthetic to a bold social program. The Futurists proclaimed their goals in a series of flamboyant manifestos published between 1909 and 1913 that captured the imagination of writers and artists throughout the world. The author of the first manifesto, the poet F. T. Marinetti, urged his countrymen to reject the moribund glories of their cultural heritage and to seek meaning and inspiration in the energetic industrialized society of the present. His central image was a powerful and swift machine: "We affirm that the world's magnificence has been enriched by a new beauty: the beauty of speed. A racing car whose hood is adorned with great pipes, like serpents of explosive breath—a roaring car that seems to ride on grapeshot—is more beautiful than the *Victory of Samothrace*." [29]

Marinetti was joined in his aesthetic campaign by a group of painters including Giacomo Balla, Umberto Boccioni, Carlo Carrà, Luigi Russolo, and Gino Severini. This group—the Futurists—published a second, "technical" manifesto in which they outlined a credo that called for abandoning all forms of representational art. Yet the confidence that marked the Futurists' swaggering manifestos was not borne out by their tentative efforts to translate ideas into art. Initially, their canvases were marked by the Divisionism that had been a formative influence on most of them. The sweeping sense of movement that is so often the subject of Boccioni's painting (plate 339) is exchanged in the work of Balla for a more specific rendering of sequential motion, as in *Girl Running on a Balcony* (plate 340). The schematic overlapping of transparent planes sug-

gests a familiarity with Analytic Cubism, though the color and brushwork are still indebted to Divisionism.

The Futurists' love affair with technology and power was transformed by the outbreak of hostilities in 1914 into a veritable worship of the bellicose energy of tanks and armored trains. In Boccioni's *Charge of the Lancers* (plate 342), a tempera with newspaper collage, the schematized thrusts of diagonals and the repetitive circles convey the forward movement of the horsemen, while the Analytic Cubist grays and blacks evoke the sensation of guns, swords, and smoke. The use of the newspaper differs significantly from its Cubist inspirations: rather than being an integral part of the composition, the clipping explicates or parallels the subject by referring to specific military campaigns.

The first major exhibition of Futurist painting was held in Milan in 1911, and in the following year a selection of works was shown at the Bernheim-Jeune gallery in Paris. Futurist paintings were subsequently seen in England, Germany, and Holland, where they aroused excitement and influenced some local artists. But the impact of the movement was short-lived. Italy's entry into the war in 1915, an action that was ardently encouraged by the Futurists, brought an end to the movement's tenuous coherence. The death of Boccioni in the war deprived Futurism of one of its most inspired protagonists, and the subsequent realignment of artists around Marinetti produced no comparable outburst of creativity. Indeed, within a relatively short time the aggressive and anarchistic stance that had marked the movement's original rhetoric would be absorbed by the new Fascist regime.

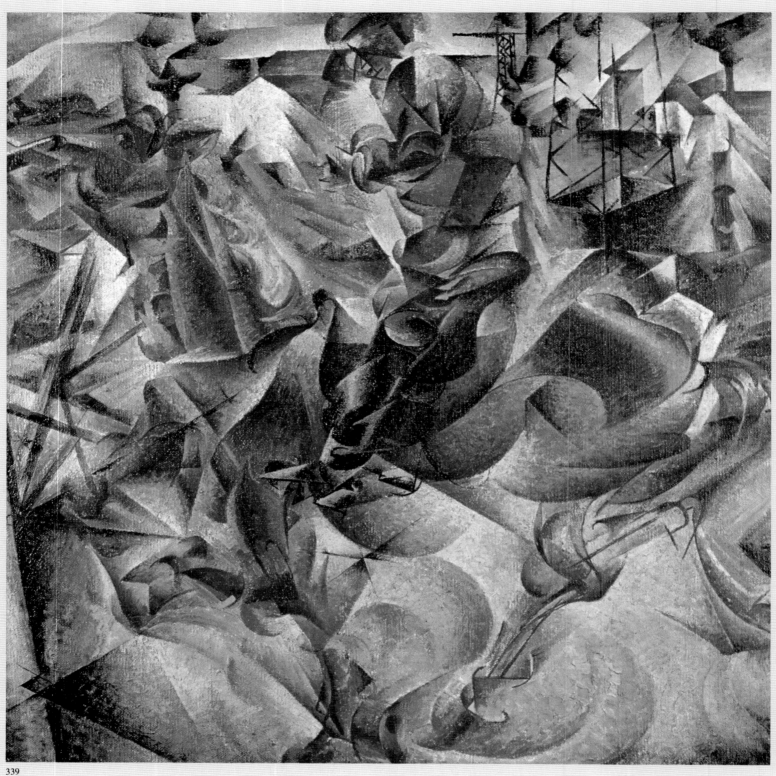

339

339. Umberto Boccioni (1882–1916). *Elasticity*, 1912.
Oil on canvas, 39¾ x 39¾ in. Pinacoteca di Brera,
Milan; Deposito Jucker.

340. Giacomo Balla (1871–1958). *Girl Running on a
Balcony*, 1912. Oil on canvas, 49¼ x 49¼ in. Civica
Galleria d'Arte Moderna, Milan; Raccolta Grassi.

340

342

341. Gino Severini (1883–1966). *Dynamic Hieroglyphic of the Bal Tabarin*, 1912. Oil on canvas with sequins, 63⅝ x 61½ in. The Museum of Modern Art, New York; Acquired through the Lillie P. Bliss Bequest.

342. Umberto Boccioni (1882–1916). *Charge of the Lancers*, 1915. Tempera and collage on cardboard, 12½ x 19⅝ in. Pinacoteca di Brera, Milan; Deposito Jucker.

8 THE SCHOOL OF PARIS
Innovation and Nostalgia

BY the early months of 1914, as Europe drifted toward the cataclysm of the Great War, Paris had become the center of an international movement that enthusiastically described itself as Cubist, though the meaning of this term was never completely clear. Since 1912 the radical new approach of Picasso and Braque and their early epigones had been familiar to avant-garde circles from New York to Moscow. Predictably enough, scores of ambitious young painters now flocked to Paris and took up styles that, in one way or another, had a Cubist connection.

Braque and Picasso continued to collaborate as Synthetic Cubism entered what Alfred Barr has described as its "rococo" phase.[1] Together they spent the early summer of 1914 at Avignon, where they were joined by André Derain. The paintings and *papiers-collés* they produced there flaunt a new interest in lively color and decorative texture. A device that served both of these ends, the application of closely spaced multicolored dots, was clearly borrowed from the Pointillism of Seurat and Signac. The Cubist use of this stippling, however, had nothing to do with "scientific" modulations of color and light; it was instead a playfully perverse homage to the Neo-Impressionist style, part of the new lyricism and flight from the austerities of Analytic Cubism that characterized the work of Picasso and Braque in 1913–14.

The friends' idyllic summer was abruptly ended by political events. On June 28 the Austrian archduke Franz Ferdinand and his wife, Sophie, were assassinated by a Serbian nationalist at Sarajevo. Austria-Hungary and her ally, Germany, issued a series of ultimatums, and the other European powers, locked in rival military alliances, were dragged inevitably into the conflict. On August 3, Germany declared war on France. Braque and Derain immediately left Avignon to enlist; Picasso saw them off at the station. For Cubism, their parting marked the end of an era: Picasso and Braque were never to work together again, though each would continue to produce paintings in a Cubist style.

As a citizen of neutral Spain, Picasso was not required to fight; in October he returned to Paris. Apollinaire, on the other hand, the son of a Polish mother and an Italian father, applied for French citizenship and enlisted. He pursued his military career with the same panache that had marked his life as a poet; but in 1916, after being wounded in the head, he was invalided out of the army and returned to Paris and his literary endeavors. Braque also received a head wound, which left him temporarily blind, and

343. Detail of plate 391.

317

344

he was demobilized in 1916, receiving the Legion of Honor and the Croix de Guerre. His convalescence was a long one, and not until the summer of 1917 did he begin to paint again. Finally, Derain served at Verdun and in the Vosges. In 1916, while he was still at the front, he was given his first one-man show at the Galerie Paul Guillaume in Paris. Apollinaire contributed an introduction to the catalog, which reflected his newly nationalistic perspective: "Derain's art is now imbued with that expressive grandeur that stamps the art of antiquity. It comes to him from the great masters of the old French schools, especially the school of Avignon. . . ."[2]

Intellectual and artistic Paris was divided between the patriots and those who regarded the war as both a calamity and an absurdity. Picasso is supposed to have exclaimed to Gertrude Stein, "Won't it be awful when Braque and Derain and all the rest of them put their wooden legs up on a chair and tell about the fighting!"[3] Picasso's private life and artistic development seem not to have been greatly affected by the war. The Cubist movement, however, saw its fortunes reversed. World War I surpassed all others in pettiness of chauvinistic display, and the international status that Cubism had attained therefore counted against it. Its "Spanish" origins and the fact that progressive German dealers such as the Berlin-based Herwarth Walden had eagerly embraced it led large sections of the French public to identify Cubism as unpatriotic.

Left to his own devices during the war, Picasso produced a large number of paintings in which a decorative intention was uppermost, paintings with flat, clearly defined shapes, bright colors, and occasional patches of Pointillist stippling. At the same time, he returned to motifs from the past, such as the figure of Harlequin (plate 344), which he subjected to considerable variation—from the geometrically severe to the more lyrically decorative—as he tested the different options of Synthetic Cubism. Picasso also produced at that time a number of drawings that evince a renewed interest in a painstakingly accurate and even classicizing description of reality. While it is tempting to attribute these multiple approaches to Picasso's restless character, it is clear that they were also an outgrowth of an important aspect of Cubism, namely, its belief that no single pictorial style was sufficiently complete to justify the exclusion of all others. This pluralism would lead to the startling variety of styles in Picasso's painting of the 1920s.

344. Pablo Picasso (1881–1973). *Harlequin and Woman with a Necklace*, 1917. Oil on canvas, 78¾ x 78¾ in. Musée National d'Art Moderne, Centre Georges Pompidou, Paris.

345. Pablo Picasso (1881–1973). *Drop Curtain for the Ballet "Parade,"* 1917. Gesso on canvas, 34½ x 54 in. Musée National d'Art Moderne, Centre Georges Pompidou, Paris.

Parade

A brilliant young poet, Jean Cocteau, had begun to figure importantly in the cultural milieu of Paris by the outbreak of the war. The narcissistic son of a rich banker, assiduously unconventional in his views yet a shameless snob, Cocteau was to become for the art world of the war years what Apollinaire had been for the avant-garde before the war. It was apparently Cocteau who had the idea, in 1916, for the ballet *Parade*, which was to be produced by Sergei Diaghilev's wildly fashionable Ballets Russes. Diaghilev had first brought his company from St. Petersburg to Paris in 1909, and despite the furor provoked by the premiere of Igor Stravinsky's *Rite of Spring* in 1913 his lavishly staged spectacles had attracted an enthusiastic following. Cocteau was to provide the scenario for *Parade*, his new friend Picasso the sets and costumes, and Erik Satie—a forty-year-

345

old avant-garde composer—the music. Diaghilev's protégé Léonide Massine would eventually devise the choreography, almost as an afterthought. Such a venture was not altogether unprecedented; Wagner, after all, had postulated the Gesamtkunstwerk: a fusion of music, drama, poetry, and dance. But the active collaboration of several of the leading proponents of their respective arts on a piece for the theater was indeed a novelty, and one that was to prove extremely fertile.

Cocteau later wrote, "It was in the middle of the street, between the Rotonde and the Dôme, that I asked Picasso to do *Parade*." He added: "The artists around him couldn't believe that he would go along with me. A dictatorship hung heavy over Montmartre and Montparnasse. Cubism was going through its austere phase. Objects that could be placed on a café table, and Spanish guitars, were the only pleasures allowed. To paint a stage set for a Russian ballet (the dedicated painters knew nothing of Stravinsky) was a crime."[4]

The concept of *Parade* is extremely simple. The sideshow of a small traveling circus is presided over by two barkers (or "Managers," as Cocteau called them), who present the performers—a Chinese juggler, an American dancing girl, and two acrobats—in a vain effort to entice passers-by into the tent. Yet conflicts soon arose among the collaborators, largely over the amplified sound effects that Cocteau insisted on including but that Satie resented as conflicting with his score. Picasso, not surprisingly, favored a visual emphasis. Cocteau wrote to a friend, Valentine Gross: "Make Satie understand, if you can cut through the apéritif fog, that I really do count for something in *Parade*, and that he and Picasso are not the only ones involved. I consider *Parade* a kind of renovation of the theater, and not a simple 'pretext' for music. It hurts me when he dances around Picasso screaming 'It's you I'm following! *You* are my master!'"[5] Satie also wrote to Gross: "If you knew how sad I am! *Parade* is changing for the better, behind Cocteau's back! Picasso has ideas that I like better than Jean's! . . . What am I to do? Picasso tells me to go ahead, following Jean's text, and he, Picasso, will work on another text, his own, which is dazzling! prodigious! . . . Now that I know Picasso's wonderful ideas, I am heartbroken to have to set to music the less wonderful ideas of our good Jean."[6]

Eventually the score was completed, and in February 1917 Cocteau and Picasso left for Rome to join Diaghilev and his company for rehearsals. (Cocteau considered this a coup on his part. "The Cubist code," he wrote, "prohibited any trip other than that between Montmartre and Montparnasse on the Nord-Sud metro."[7]) Picasso installed himself in a studio on the via Margutta, where he constructed a model for the *Parade* set. It was during this stay in Rome that he fell in love with one of Diaghilev's dancers, Olga Koklova, whom he married the following year.

Parade opened at the Théâtre du Chatelet, Paris, on May 18, 1917, on a bill with *Les Sylphides* and *Petrouchka*. Ernest Ansermet conducted. Apollinaire contributed the program note, which has gone down in history because in it the word *surréaliste* was used for the first time, to indicate the heightening of reality produced (it was hoped) by the interaction of art forms in the ballet. Artists and musicians were on hand to applaud Picasso and Satie, and many of Cocteau's society friends were present. But the audience was predominantly bourgeois and hostile. Picasso's drop curtain (plate 345)—hardly a revolutionary work, with its somewhat romanticized view of circus folk—was admired. But the very presentation of such a frivolous performance during a time of national emergency offended conservatives, for whom Cubism was already tainted by its cosmopolitanism. Cries of "Dirty Germans!" filled the theater, and Cocteau later claimed that he was attacked by women with hat pins.[8] Press notices were negative, but overnight *Parade* turned Picasso into the celebrity he would remain for the rest of his life.

346

346. Fernand Léger (1881–1955). *The Card Players*, 1917. Oil on canvas, 50½ x 76 in. Rijksmuseum Kröller-Müller, Otterlo, The Netherlands.

The Impact of the War:
Fernand Léger and Juan Gris

If Picasso's artistic activity was essentially untroubled by the outbreak of World War I, there were other painters whose development would be significantly altered by the experience. Of the artists mobilized in 1914, Fernand Léger—who became a sapper in the infantry and later served as a stretcher-bearer on the battlefield—was one of the most powerfully affected. His mind had always had a theoretical bent, and his paintings of 1913–14 had verged on pure abstraction. Now, however, concrete reality burst upon his consciousness:

> In the space of two months I learned more than in all my life. Ah, those big lads! . . .
> When it was proposed to me to go into the camouflage unit far from the front, I didn't want
> to leave them. . . . When the boys played cards, I remained at their side, I watched them, I
> made drawings, sketches. I wanted to grasp them. I was so impressed by the lads and the
> desire to draw them came to me spontaneously.[9]

In 1916 Léger was gassed near Verdun, and it was while he was convalescing in Paris that he painted his monumental vision of army life, *The Card Players* (plate 346), based on the numerous sketches he had made at the front. The theme of the card game,

347

popular in genre painting since the seventeenth century, had been effectively used in several paintings by Cézanne; as Léger transformed it, it became both an evocation of a precarious moment of contemporary existence and a rendering of the artist's highly individual version of Cubism. The figures, enclosed in an oppressively confined space, are fragmented, but light from a constant source unifies the scene and reinforces its anecdotal quality—a quality that had been taboo in orthodox Analytic Cubism. Anatomical parts have been replaced, as they generally were in Léger's work, by metallic-looking tubular forms, which may have been intended here as a metaphor for the soldier's transformation into parts of a great "machine." The men resemble the shell castings and cartridge clips around them, just as the figures in Léger's earlier *Nudes in a Forest* merge with the rocks and vegetation. Yet the soldiers are not, as has been claimed, dehumanized; on the contrary, we are keenly aware of their lively response to the fast-moving card game, which brings them release from the tensions of war. Although the colors—Léger's beloved primary hues, here thinned and grayed—suggest an uneasy mood, *The Card Players* nevertheless displays a wry humor that reflects Léger's rather flippant attitude toward art (once asked if he was a Cubist, he replied, "No, I'm a Tubist" [10]), as well as his essentially enthusiastic participation in the soldier's world.

347. Juan Gris (1887–1927). *Woman with a Mandolin, after Corot*, 1916. Oil on plywood, 36¼ x 23⅝ in. Kunstmuseum, Basel.

348. Juan Gris (1887–1927). *Breakfast*, 1914. Pasted paper, crayon, and oil on canvas, 31⅞ x 23½ in. The Museum of Modern Art, New York; Acquired through the Lillie P. Bliss Bequest.

349. Paul Cézanne (1839–1906). *Harlequin*, 1888–90. Oil on canvas, 39⅜ x 25⅝ in. Mr. and Mrs. Paul Mellon, Upperville, Virginia.

350. Juan Gris (1887–1927). *Harlequin at Table*, 1919. Oil on canvas, 39¾ x 25⅝ in. Mrs. Morton G. Neumann, Chicago.

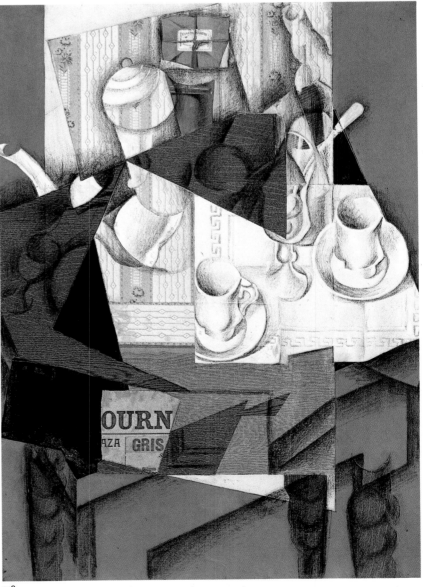

348

Gris's initial interest in the Harlequin theme, in 1917, was certainly stimulated both by his study of Cézanne—who had painted a notable Harlequin nearly thirty years earlier—and by Picasso's revived enthusiasm for it. His close friendship with the Cubist sculptors Henri Laurens and Jacques Lipchitz prompted him to undertake his first and only sculpture: a painted plaster Harlequin (1918). This activity may account in part for his increased interest in imparting volume to his forms through the faceting and emphatic contrasts of light and dark that mark this composition. At the same time, Gris still pursued the aims of Synthetic Cubism by providing the canvas with a characteristically decorative coherence, deftly established through the continuity of pattern from the Harlequin's costume to the floor.

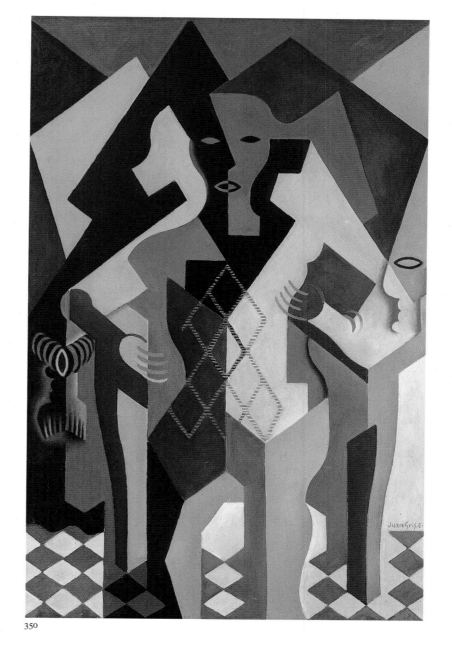

350

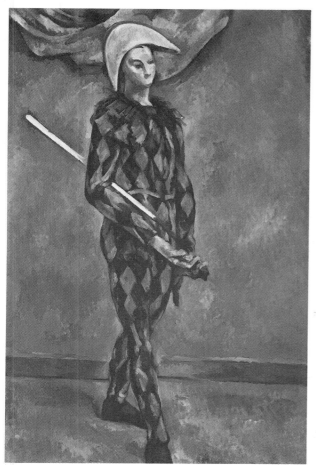

349

Juan Gris

The outbreak of the war and the absence of many of his comrades from Paris seem to have afflicted Gris with a sense of isolation and even fear. In letters to Kahnweiler he described the animosity that he, as a foreigner and a Cubist, had encountered in Paris: "They say appalling things in the canteens of Montmartre and make terrible accusations against myself and against everyone who has had dealings with you." [11] Yet his troubles did not prevent Gris from working prodigiously as he attempted to clarify and refine his Synthetic Cubist style. At times, as in *Breakfast* (plate 348), he would reduce the number of objects represented and limit himself to presenting a few simultaneous aspects of forms, using a bolder and more simplified planar structure to create his spatial effect. But he also began to make naturalistic drawings, as Picasso had done, and in 1916 he turned again to the human figure. One of his first efforts at figural composition was *Woman with a Mandolin, after Corot* (plate 347). The subject of this work—a female musician—may have made him more receptive to the male musicians and acrobats that his friend Picasso had painted a dozen years earlier, and indeed Picasso himself had since returned to the Harlequin theme. But it is also likely that Gris was drawn

to the subject by the example of Cézanne's painting of 1888–90 (plate 349), which he had sketched a number of times. With its lucid construction and subtle play of color and design, Gris's *Harlequin at Table* (plate 350) of 1919 achieves a vigorous synthesis of form and space. By the time it was painted, Gris had already assumed a position of leadership in a group of artists that included Metzinger, Severini, and the Cubist sculptor Jacques Lipchitz, and it is easy to understand why Gris's methodical approach attracted such didactic painters as Metzinger.

While Picasso would bend Cubism in the 1920s to accommodate emotion or fantasy, Gris adhered more rigorously to its austere language. Only in the mid-1920s, a few years before his death at the age of forty, did he begin to introduce more fluid shapes into his compositions. Yet even in his last years his work reflected that passion for logic and genius for creating an equilibrium between the two- and three-dimensional aspects of form that had distinguished it from its inception. In his avoidance of anecdote and his emphasis on the essential, Gris aspired to a universality of expression that was inspired by his love of the art of the past. In 1921 he provided a succinct rumination on his art: "Though in my system I may depart greatly from any form of idealistic or naturalistic art, in practice I cannot break away from the Louvre. Mine is the method of all times, the method used by the old masters: there are technical means and they remain constant." [12]

Peintres maudits: Amedeo Modigliani and Maurice Utrillo

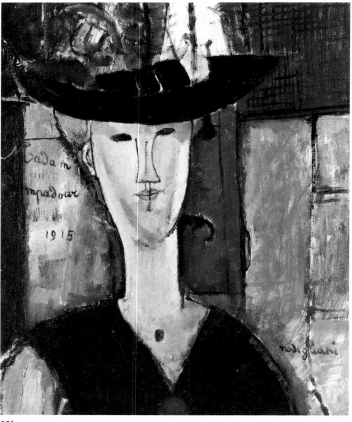

351

An Italian painter whose genius asserted itself in Paris during the years when so many French artists were at the front was Amedeo Modigliani. Born in Livorno in 1884 to a cultivated middle-class family of Sephardic origin, he studied art in Florence and Venice, moving to Paris in 1906. Initially his main interest was sculpture, but—partly because of the expense and difficulty of obtaining traditional materials and partly because of his precarious health—he turned definitively to painting around 1915, specializing in portraits. He also espoused the bohemian life of an artist with an abandon that made him stand out among his companions. Modigliani's fame as a *peintre maudit* (a term used to describe a type of artist whose rootlessness and self-destruction seem to be predestined), especially after his death at a tragically young age in 1920, has provoked abundant commentary, and he even inspired the protagonist of a popular novel, Michel Georges-Michel's *Les Montparnos*. Modigliani's friend Cocteau provided a thumbnail sketch of the Italian's personality:

> Refined by illness (he was tubercular), he had the air of a true aristocrat. Alcohol, drugs, overwork and poverty gave him an outlook on life in which tenderness and cynicism were mingled.
>
> He lived for six years in Montmartre, wandering from café to café, from one hovel to another, sour-tempered, generous, and loyal. In 1915, he . . . settled [sic!] in Montparnasse, floating uncertainly about, with no fixed abode, and searching on his nightly peregrinations for a world already dead, or not yet born. [13]

Maurice de Vlaminck offered another insight: "I knew [Modigliani] when he was hungry. I have seen him drunk. But in no instance did I ever find him lacking in nobility or generosity. I never knew him to be guilty of the least baseness, although I have seen him irascible at having to admit the power of money, which he scorned but which could so hamper him and hurt his pride." [14] Though Modigliani's personal history was one of deterioration and ultimate collapse, this process is in no way reflected in his work. The unrest that characterizes his early canvases soon disappears and is replaced, ironically, by serenity and control.

352

351. Amedeo Modigliani (1884–1920). *Madame Pompadour*, 1915. Oil on canvas, 23⅞ x 19½ in. The Art Institute of Chicago; Joseph Winterbotham Collection.

352. Amedeo Modigliani (1884–1920). *Portrait of Frank Burty Haviland*, c. 1914. Oil on cardboard, 24½ x 19½ in. Los Angeles County Museum of Art; William Preston Harrison Collection.

Modigliani worshiped Cézanne. For years he carried in his pocket a reproduction of the master's *Boy in a Red Vest*. The few surviving paintings from Modigliani's early Paris years also register the influence of Picasso's melancholy Blue Period, as well as that of the Fauves and of African sculpture. This youthful eclecticism is still discernible to some extent in a masterly work of about 1914, the portrait of Modigliani's painter-friend Frank Burty Haviland (plate 352). The room in which Haviland sits has been reduced to a grid of verticals and horizontals, no doubt in response to the Cubist aesthetic, and the brushwork, with its disconnected dabs of bright color, may reflect the Neo-Impressionist stippling reintroduced by Picasso the previous year. But the extreme delicacy of the line that defines Haviland's profile and conveys his intensely contemplative mood is uniquely Modigliani's. In the slightly later *Madame Pompadour* (plate 351)—probably a portrait of Beatrice Hastings, the English poet and journalist with whom Modigliani had a stormy affair during the early years of the war—the artist's unmistakable personal style is fully realized in the frontal, abstractly conceived head with its oval outline, small almond-shaped eyes, flattened nose, and compressed lips arranged in a masklike countenance.

354

353. Amedeo Modigliani (1884–1920). *Jean Cocteau*, 1916. Oil on canvas, 39½ x 32 in. The Art Museum, Princeton University; Henry and Rose Pearlman Foundation.

354. Amedeo Modigliani (1884–1920). *Paulette Jourdain*, 1919. Oil on canvas, 38⅜ x 25⁹⁄₁₆ in. Alfred A. Taubman, Bloomfield Hills, Michigan.

355

Commenting on the similar appearance of Modigliani's sitters, Cocteau wrote: "If, in the end, all his models look alike, it is in the same way as Renoir's girls. He reduced us all to his type, to the vision within him, and he usually preferred to paint faces conforming to the physiognomy he required." [15] This remark contains a grain of truth in that the mature work has a remarkable stylistic consistency. But a portrait of Cocteau himself, painted in 1916 (plate 353), amply demonstrates Modigliani's ability to communicate a subject's individuality. The spiky line creates a perfectly adequate likeness of the poet's narrow and angular features, but it also underscores his restless intellect, sardonic wit, and foppish self-absorption. Cocteau is said to have found the portrait "diabolical" and to have considered it proof that Modigliani detested him. [16]

A few outdoor scenes, painted toward the end of his life, suggest that Modigliani might have been a superb landscapist had he chosen to follow that road (plate 356). But it was the human form, the human persona, that held his interest. A series of nudes executed in the last year of his life reveals a new monumentality and geometric simplification combined with an elegiac refinement of line (plate 355); the stark outlines and restrained voluptuousness of these figures have been compared to the Odalisques of Ingres.

While Modigliani made no major formal or theoretical contribution to the art of the twentieth century, his penetrating vision captured the existential loneliness of his con-

temporaries. His lyric conciseness earned him posthumous fame in the early 1920s, when many other painters were attempting to humanize their work.

Maurice Utrillo

Suzanne Valadon, the illegitimate daughter of a laundress from a village near Limoges, was brought to Paris by her mother as a baby and grew up in Montmartre. A lively and attractive adolescent, she began to model for artists, first for Puvis de Chavannes and later for Renoir. Valadon became a painter of some accomplishment, working in a pleasing, rather facile Post-Impressionist mode. Degas befriended her, and Toulouse-Lautrec was one of her many lovers, as was Erik Satie.

In 1883 Valadon gave birth to a son, Maurice, whose father was probably a minor painter named Boissy. Eight years later, in a magnanimous gesture, the Catalan art critic Miguel Utrillo y Molins officially adopted Maurice and gave the boy his surname, but played no further role in his upbringing. Maurice's early life was centered in Montmartre, though for several years he lived in suburban Montmagny with his mother (whom he adored) and with Paul Mousis, a gentleman who married her in 1896. As a

356

357

355. Amedeo Modigliani (1884–1920). *Reclining Nude*, c. 1919. Oil on canvas, 28½ x 45⅞ in. The Museum of Modern Art, New York; Mrs. Simon Guggenheim Fund.

356. Amedeo Modigliani (1884–1920). *Cypresses and House*, 1919. Oil on canvas, 24 x 18⅛ in. The Barnes Foundation, Merion, Pennsylvania.

357. Suzanne Valadon (1867–1938). *Utrillo in Front of His Easel*, 1919. Oil on canvas, 18⅞ x 17¾ in. Musée d'Art Moderne de la Ville de Paris.

359

358

child and youth Maurice showed few signs of talent, artistic or otherwise. While still a schoolboy, he began to drink heavily; "he gave the impression that he was born drunk," a companion later observed.[17] He left school early, and failed at several jobs. By the time he was nineteen, his alcoholism had become so worrisome that Valadon, on the advice of a doctor, taught him to paint as a kind of occupational therapy. As therapy it was a disaster; though Maurice quickly mastered the métier and eventually acquired a taste for it, before long he was exchanging his pictures for the price of a liter of wine. This practice earned him the nickname "Litrillo," bestowed by the Montmartre urchins who taunted him mercilessly. By 1905 he was a regular customer at the Lapin Agile, a favorite meeting place for the painters and poets from the Bateau-Lavoir, but Utrillo was a solitary drinker and seems to have had little contact with the others.

Despite his drinking, Utrillo was an extremely prolific painter. Though he had little knowledge of art other than his mother's (he is said never to have entered a museum), he was attracted to the solid Impressionism of Sisley and Pissarro, whose pictures he saw in dealers' shops, and his earliest work was painted in an imitative Impressionist style. Around 1908 he entered his so-called white period, during which he began to produce the pictures that were eventually to make him one of the most popular artists of the century: outdoor scenes that were often—though by no means exclusively—views of Montmartre streets, dominated by buildings with whitish walls. (The characteristic shades and textures of those walls are partially the result of Utrillo's practice of mixing plaster with his paint.)

Gradually Utrillo's work attracted attention. After the owners and customers of Montmartre cafés had begun to buy his paintings, local dealers—especially Louis Libaude—followed suit. In 1909 Utrillo exhibited for the first time at the Salon d'Automne. Louis Vauxcelles praised his work in the May 1912 number of *Gil Blas*; in the same year two of the artist's Montmartre scenes were included in an exhibition in Munich. Utrillo was given his first one-man show at the Galerie Eugène Blot in 1913 and at about the same time was taken up by Octave Mirbeau, who was chiefly interested in his reputation as a *peintre maudit*. Beginning with an auction at the Hôtel Drouot in 1914, Utrillo's art began to fetch high prices.

From 1912 on, Utrillo was in and out of public mental hospitals and private sani-

toria, attempting unsuccessfully to cure his alcoholism. In May 1915 he was, predictably, declared unfit for military service. Rather astonishingly, though, his ability to produce remained unimpaired: it is estimated that during the war years he completed twelve hundred paintings. Part of his secret was the use of ordinary picture postcards as sources for his compositions. They enabled him not only to recreate familiar Parisian views but also to depict provincial villages that he had never visited.

During the war years Utrillo struck up a friendship with Modigliani. Despite the vast differences in their cultural background, intellectual makeup, and artistic orientation, the two men seem to have felt a genuine affection for each other; accounts, many no doubt apocryphal, of their exploits while under the influence of alcohol have entered the legend of bohemian Paris. When Utrillo was derided for his complete obliviousness to twentieth-century developments, Modigliani is said to have defended him by saying: "You have to paint what you see."[18] What Utrillo saw, closed in his studio, was a plein-air world from which the variegated life of nature that had so inspired the Impressionists had utterly vanished. In his canvases, human pleasure is virtually absent; when men and women do appear in Utrillo's street scenes, they are reduced to conventionalized signs. But the man-made—in the form of streets and houses aligned according to a rudimentary linear perspective unusual in late nineteenth- and twentieth-century art— is represented with a humble, melancholy charm that occasionally overcomes the essential banality of Utrillo's vision. While Utrillo's accomplishments are modest compared with those of Braque, Picasso, or Matisse, his popular success can be attributed to the directness of his subject matter and the simplicity of his means. The Parisian public, weary of the hermetic aesthetics that had dominated the art world for half a century, wholeheartedly welcomed his uncomplicated visions of a world that was fast disappearing. In Utrillo's paintings they found a nostalgic haven from an increasingly alien reality.

360

358. Maurice Utrillo (1883–1955). *Street in a Paris Suburb*, c. 1920. Oil on canvas, 18⅛ x 24 in. Museum Ludwig, Cologne.

359. Maurice Utrillo (1883–1955). *Factories*, c. 1908. Oil on canvas, 19½ x 28¾ in. Mr. and Mrs. Alex Lewyt, New York.

360. Maurice Utrillo (1883–1955). *The Main Street of Banleue*, 1913–15. Oil on canvas, 29 x 36¼ in. Nelson-Atkins Museum of Art, Kansas City, Missouri; Gift of the Friends of Art.

361

Post-Cubist Pluralism

The dogged rise to popularity of Modigliani and Utrillo through highly individual achievement was one aspect of a complex phenomenon that began to manifest itself in Paris during the war years. The cultural hegemony that the Cubist movement had exercised between 1910 and 1914 was a thing of the past. With the careers of so many Cubist painters disrupted by the war and with Cubism discredited in the eyes of a jingoistic public, other artistic tendencies could compete for recognition. Picasso himself, as has been mentioned, had begun to cultivate a more exuberant art that was largely devoid of theoretical overtones, without altogether renouncing Synthetic Cubism. Artists of a slightly earlier generation, who had been temporarily eclipsed by the triumph of Cubism, were now rediscovered. The distinct movements of the turn of the century were largely replaced by a heterogeneous grouping of artists that soon became known as the School of Paris. These artists did not create a new style; instead, each one cultivated an individual manner of his own, ostensibly unconcerned with the connections— or lack of connections—between his work and that of his fellow artists. With a few notable exceptions, the emphasis was on decorative effect rather than on formal investigation or emotional expression. The personal approach of the School of Paris was to dominate the international art world for many years to come.

Pierre Bonnard

Pierre Bonnard was forty-seven years old when the war broke out. After the disintegration of the Nabi group, his art had become considerably less innovative, lapsing into a kind of generic Post-Impressionism. Beginning, however, in 1906 (the year of his first trip to the south of France), it acquired new vigor through his exposure to the intense colors of the Midi. Bonnard's supreme gift was as a colorist; remaining faithful to it, he would continue for decades to transcend the factions and polemics of the Parisian art world, revealing, in a multitude of joyous canvases, his irrepressible responses both to cyclical nature and to his comfortable domestic world. Bonnard's *Signac and His Friends Sailing* (plate 362), begun in 1914 but not finished until 1924, is certainly a celebration of Mediterranean sun and leisure. At the same time, it places the artist squarely within the Impressionist tradition of the 1870s: its snapshotlike composition is derived from that of Manet's *Boating*, while its theme of carefree camaraderie inevitably recalls Renoir's paintings of Bougival, Chatou, and other pleasure spots along the Seine.

The influence of Degas, on the other hand, had always been crucial in the bath and boudoir scenes at which Bonnard excelled (plate 364). But in pictures like *Dressing Table and Mirror* (plate 363)—in which we see Marthe Bonnard, nude and visible only from the neck down, seated on the edge of her bed with her dog Dingo curled up nearby—domestic anecdote is strictly subordinate to the exploration of spatial relationships, color, and light. The dressing table, on which toilet articles and a bouquet of flowers are casually arranged, constitutes the principal plane of the composition but is

361. Pierre Bonnard (1867–1947). *Portrait of Ambroise Vollard*, c. 1914? Etching, printed in black, 13^{15}/$_{16}$ x 9^3/$_8$ in. The Museum of Modern Art, New York; Purchase.

362. Pierre Bonnard (1867–1947). *Signac and His Friends Sailing*, 1924. Oil on canvas, 48^5/$_8$ x 54^5/$_8$ in. Kunsthaus, Zurich.

362

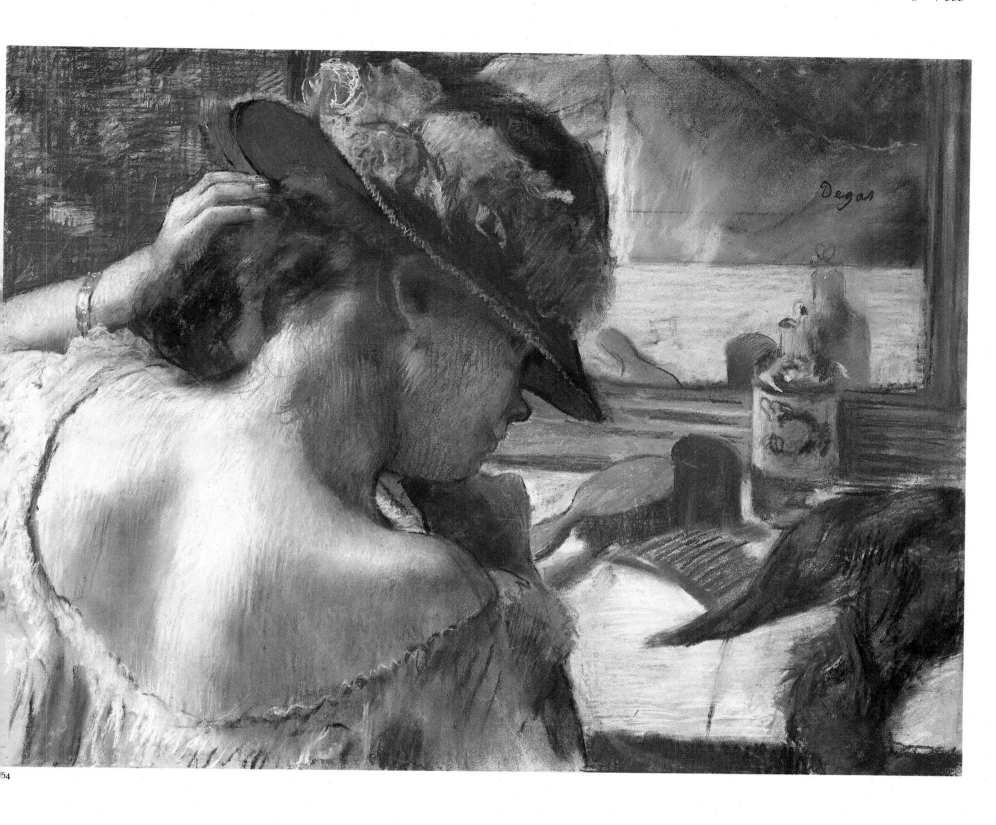

363. Pierre Bonnard (1867–1947). *Dressing Table and Mirror*, c. 1920. Oil on canvas, 49 x 43½ in. The Museum of Fine Arts, Houston; The John A. and Audrey Jones Beck Collection.

364. Edgar Degas (1834–1917). *Before the Mirror*, 1889. Pastel on paper, 7⅜ x 9¾ in. Kunsthalle, Hamburg.

seen in a gauzy half-light, whereas strong sunlight illuminates the part of the room inhabited by Marthe and reflected in the mirror. The two spaces seem almost completely disjointed—we know that they are continuous only because the vase of flowers appears in both. Bonnard's use of the mirror device, here as in many of his other paintings, has clear parallels in Matisse's outdoor-indoor scenes with windows. But we are reminded even more forcibly of Degas's inspired use of reflective surfaces to encapsulate fragments of the space before them and thus call attention to the ambiguity of the natural and the artificial in painting.

365

365. Henri Matisse (1869–1954). *Bathers by a River*, 1916–17. Oil on canvas, 8 ft. 7 in. x 12 ft. 10 in. The Art Institute of Chicago; Worcester Collection.

366. Georges Rouault (1871–1958). *Little Olympia*, 1906. Watercolor and pastel on paper, 21⅝ x 24¾ in. Statens Museum for Kunst, Copenhagen; J. Rump Collection.

Henri Matisse

Matisse was deeply affected by the war. He had volunteered for military service when hostilities erupted but was rejected because of his age. Dividing his time between his Paris studio, his suburban home at Issy-les-Moulineaux, and Nice (where he was to move in 1919), he led an outwardly tranquil life and continued to paint prolifically. But a letter he wrote in 1916 reveals something of his state of mind: "This war will have its reward—what a gravity it will have given to the lives of even those who did not participate in it. . . . Waste no sympathy on the idle conversation of a man who is not at the front. Painters, in particular, are not clever at translating their feelings into words—and besides a man not at the front feels rather good for nothing."[19] The key word here is "gravity." Matisse never painted themes connected with the war; but his somber mood—reinforced, it seems, by a sense of guilt—is certainly reflected in his work from 1914 to 1917. The lyrical and sensual spontaneity that had animated his earlier pictures was repressed (albeit temporarily) in favor of a concentration upon formal structure. Ironically, Matisse was moving toward austerity, stressing geometric shapes and limiting his palette to a few relatively subdued colors, during exactly the same

While the powerful simplification of form and the so-briety of color in Bathers by a River *have been linked to Matisse's subdued state of mind and to his temporary re-ceptivity to Cubism during World War I, his letters indi-cate that he probably worked intermittently on the pic-ture from 1913. Thus, it also reflects elements of his recent Moroccan experience—the treatment of the fo-liage and the alternating of dark and light bands of color—which combine with the original forms and those of 1916–17 to produce an interesting record of the evo-lution of his style.*

years when Picasso was moving away from geometric rigor toward a new coloristic lyricism. The belated influence of Cubism on Matisse has often been cited in this con-nection, and a series of intense discussions with Juan Gris, with whom he struck up a warm friendship at Collioure in 1914, apparently did encourage the latter to reorder his decorative and expressive priorities in the interests of compositional lucidity.

Matisse had begun *Bathers by a River* (plate 365) in 1909–10 as a companion piece to *Dance* and *Music*, the decorative murals executed for the palace of the Russian col-lector Shchukin. A surviving sketch indicates that the painter had originally conceived the composition as an expansive celebration of joie de vivre in an essentially natu-ralistic setting. It is not clear when or why he stopped working on the third canvas, but when he resumed painting it in 1916 his approach had changed radically. The composi-tion was simplified, several figures were eliminated, and those that were retained were subordinated to an abstract system of architectonic divisions based on vertical bands of color. The painting reflects a new formal and coloristic gravity, and the anatomical sim-plifications and compressions are, in fact, comparable to those of Cubism. Yet contem-poraneous Cubism offered no thematic model for Matisse's canvas, which projects a monumental grandeur and a solemnity unprecedented in his oeuvre.

To fully appreciate the place of *Bathers by a River* in his development, one must turn to Matisse's sculpture, specifically the series of Backs that he began at the same time as the Shchukin panels. In these bronze reliefs the artist tackled the problem of how to integrate heroically scaled figural elements into a two-dimensional background without compromising their formal identity. It seems likely that his sculptural solution provided the stimulus for the resumption of the long-abandoned Shchukin panel. In any event, Matisse's adaptation of a compositional strategy previously employed in another me-dium seems entirely consistent with his empirical approach to art, as was his use of different modes—representational, decorative, or analytical—to achieve different ex-pressive ends. Indeed, this periodic shifting of aesthetic gears, already evident in his earlier development, would increase in the years that followed.

Georges Rouault

An artist of Matisse's generation who had exhibited with the Fauves in 1905, Georges Rouault painted pictures that have little to do either with naturalistic representation or with the aesthetic debates that inflamed his contemporaries. His compositions are icons in which oppressive black outlines and dark, brooding colors convey human and reli-gious messages as simply and expressively as possible. His subject matter was the trag-edy and dignity of life at the margins of society. While in this regard Rouault shared certain interests with Toulouse-Lautrec, his social consciousness was informed by a passionate (if somewhat unconventional) Catholicism, which led him to portray the lives of thieves, clowns, and prostitutes as mystically permeated by the sufferings of Christ. This predilection for subjects with social or moral significance and his funda-mental religiosity set Rouault apart from the mainstream of decorative expressionism. Looking at these images, at once powerful and pathetic, one is reminded that, aside from Cézanne, his real masters were Goya and Daumier.

Beginning in 1913 Rouault was championed by Ambroise Vollard; the dealer's great ambition was to become a producer of books, and he grasped the painter's extraordi-nary power as an illustrator. Rouault virtually abandoned painting for a decade to de-vote himself to the graphic media, creating several series of etchings, woodcuts, and lithographs for Vollard. The most important of these series was the monumental *Miserere et Guerre*, executed between 1916 and 1927, which inspired him to turn once more to the painting of related themes (plate 368).

Late in life, Rouault summed up his credo as an artist: "I am a believer and a con-

366

367

368

formist. Anyone can revolt; it is more difficult silently to obey our own interior promptings, and to spend our lives finding sincere and fitting means of expression for our temperaments and our gifts. . . ."[20] Although the essentially decorative concerns that came to dominate the School of Paris never impinged upon his sensibility, Rouault's work was widely appreciated—proof, if any were needed, of the aesthetic diversity that characterized the art world from the war years onward.

Emigrés in the School of Paris

Paris was the center not only of French but of European painting as well. The city acted as a catalyst for native-born and foreign artists, and, in return, its range of artistic expression was broadened through exposure to the traditions of other nations. A small group of uprooted Eastern European artists was stimulated by their encounters with the various manifestations of the avant-garde, which gave them the means to communicate images of their homelands in a more universal visual language. The most productive, and certainly the most important, of these artists was Marc Chagall.

367. Georges Rouault (1871–1958). *The Three Judges*, 1913. Gouache and oil on cardboard, 29⅞ x 41⅝ in. The Museum of Modern Art, New York; Sam A. Lewisohn Bequest.

368. Georges Rouault (1871–1958). *"Who Does Not Paint Himself a Face?"* 1922. Plate 8 from *Miserere*, 1922–27. Etching, aquatint, and roulette over heliogravure, printed in black, composition: 22⁵⁄₁₆ x 16¹⁵⁄₁₆ in. The Museum of Modern Art, New York; Gift of the artist.

369. Marc Chagall (1887–1985). *Homage to Apollinaire*, 1911. Oil with gold and silver powder on canvas, 78⅝ x 74½ in. Van Abbemuseum, Eindhoven, The Netherlands.

Marc Chagall

Chagall's place in the School of Paris was unusual. While most of his French colleagues were exploring or reassessing the formal consequences of abstraction, he happily clung to the representational, utilizing such techniques of abstraction as fragmentation and multiple views to fortify his essentially poetic themes. Born in Vitebsk, Russia, in 1887, he received his training at the St. Petersburg Academy, where one of his teachers was the brilliant stage designer Léon Bakst. Arriving in Paris at the age of twenty-three, Chagall took a studio in Montparnasse, where many other emigré artists lived. He quickly aligned himself with Delaunay and the Orphic Cubists, whose distinctive works he doubtless saw in various salons of 1910 and 1911. Chagall himself exhibited at the Salon des Indépendants in 1914 and was praised by Apollinaire (to whom he had dedicated a canvas, plate 369, three years earlier) as the best colorist in the exhibition. Later in 1914 Chagall showed work at Herwarth Walden's Der Sturm gallery in Berlin. He was, in short, the antithesis of a provincial artist, achieving international success at an early age. Yet the salient theme of his vast oeuvre is *shtetl* life, with its Jewish pathos, humor, and fantasy.

369

370. Marc Chagall (1887–1985). *Dedicated to My Fiancée*, 1911. Oil on canvas, 83⅝ x 52 in. Kunstmuseum, Bern; Hermann and Margrit Rupf Collection.

371. Marc Chagall (1887–1985). *Self-Portrait with Seven Fingers*, 1912–13. Oil on canvas, 50⅜ x 42 in. Stedelijk Museum, Amsterdam.

372. Marc Chagall (1887–1985). *I and the Village*, 1911. Oil on canvas, 75⅝ x 59⅝ in. The Museum of Modern Art, New York; Mrs. Simon Guggenheim Fund.

371

370

Perhaps ironically, and certainly in contradiction to the prevailing critical assessment of his work, Chagall himself has minimized the importance of this material:

> There is nothing anecdotal in my pictures—no fairy tales—no literature in the sense of folk-legend associations. . . . For me a picture is a plane surface covered with representations of objects—beasts, birds, or humans—in a certain order in which anecdotal illustrational logic has no importance. The visual effectiveness of the painted composition comes first. . . . I make use of cows, milkmaids, roosters, and provincial Russian architecture as my source forms . . . because they are part of the environment from which I spring and which undoubtedly left the deepest impression on my visual memory of any experiences I have known. . . . But . . . the important thing here is not "subject" in the sense pictorial "subjects" were painted by the old academicians. The vital mark these early influences leave is, as it were, in the handwriting of the artist.[21]

Through his association with the painters and poets of Orphism, Chagall developed the pictorial means to express the images and legends that haunted his visual memory. The Orphic Cubist concept of simultaneity, with its combination of intense colors and overlapping transparent planes, proved eminently suitable to his juxtapositions of past and present, of Russia and Paris, of fantasy and reality. Perhaps inspired by Delaunay,

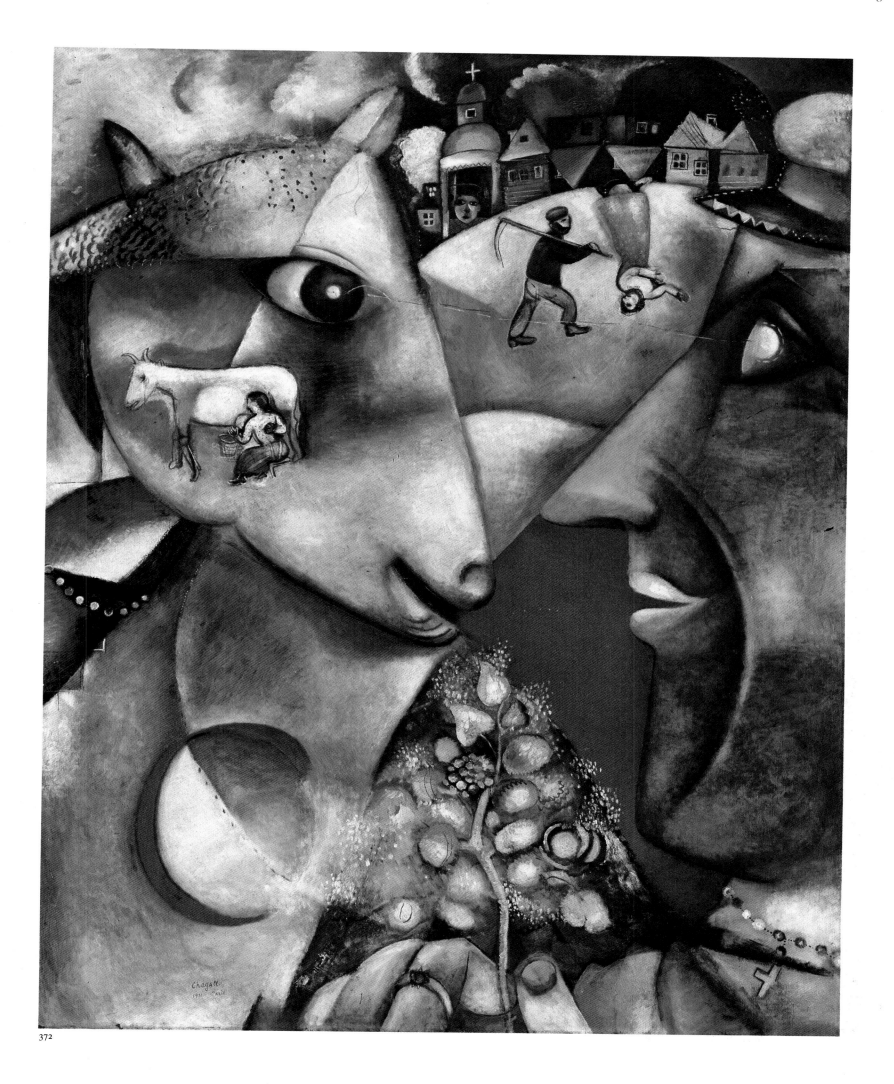

373. Marc Chagall (1887–1985). *Paris through the Window*, 1913. Oil on canvas, 52⅜ x 54¾ in. The Solomon R. Guggenheim Museum, New York.

374. Detail of plate 373.

Chagall painted three views of the Eiffel Tower in 1911, and he turned to it again in *Paris through the Window* (plate 373), one of the last canvases he painted before his temporary return to Russia in 1914. The square "window" of the canvas frames a totally invented view of the city dominated by its still-controversial symbol of the modern. While the definition of elements such as the bouquet of flowers, the half-closed window, and the body of the cat is relatively straightforward, the naturalism of the work is subverted by such patently unreal images as the two-faced man, the upside-down train, the horizontally strolling couple, and the cat's human countenance. Moreover, Chagall's uninhibited use of color, so different from the more calculated palettes of his French contemporaries, supports the visionary and emotional charge of his work.

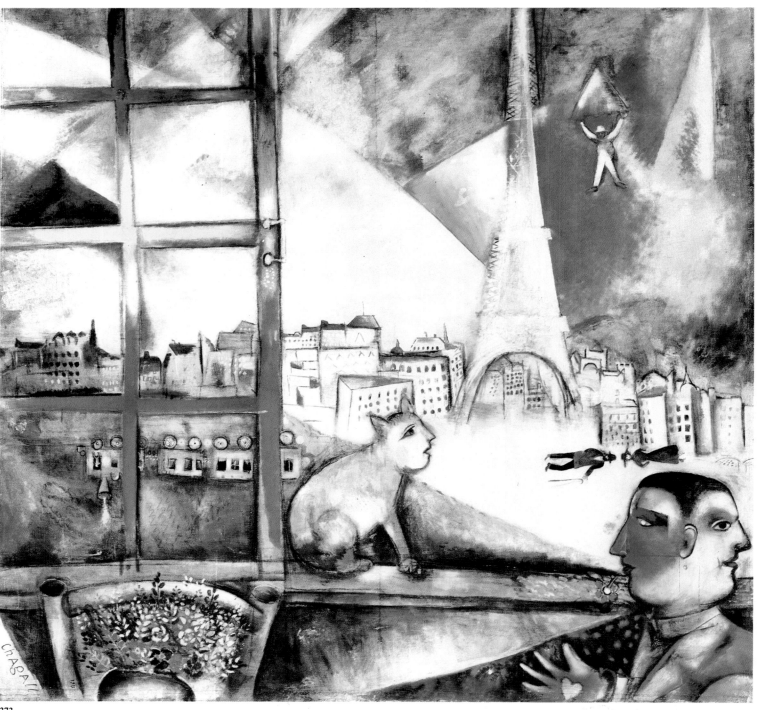

373

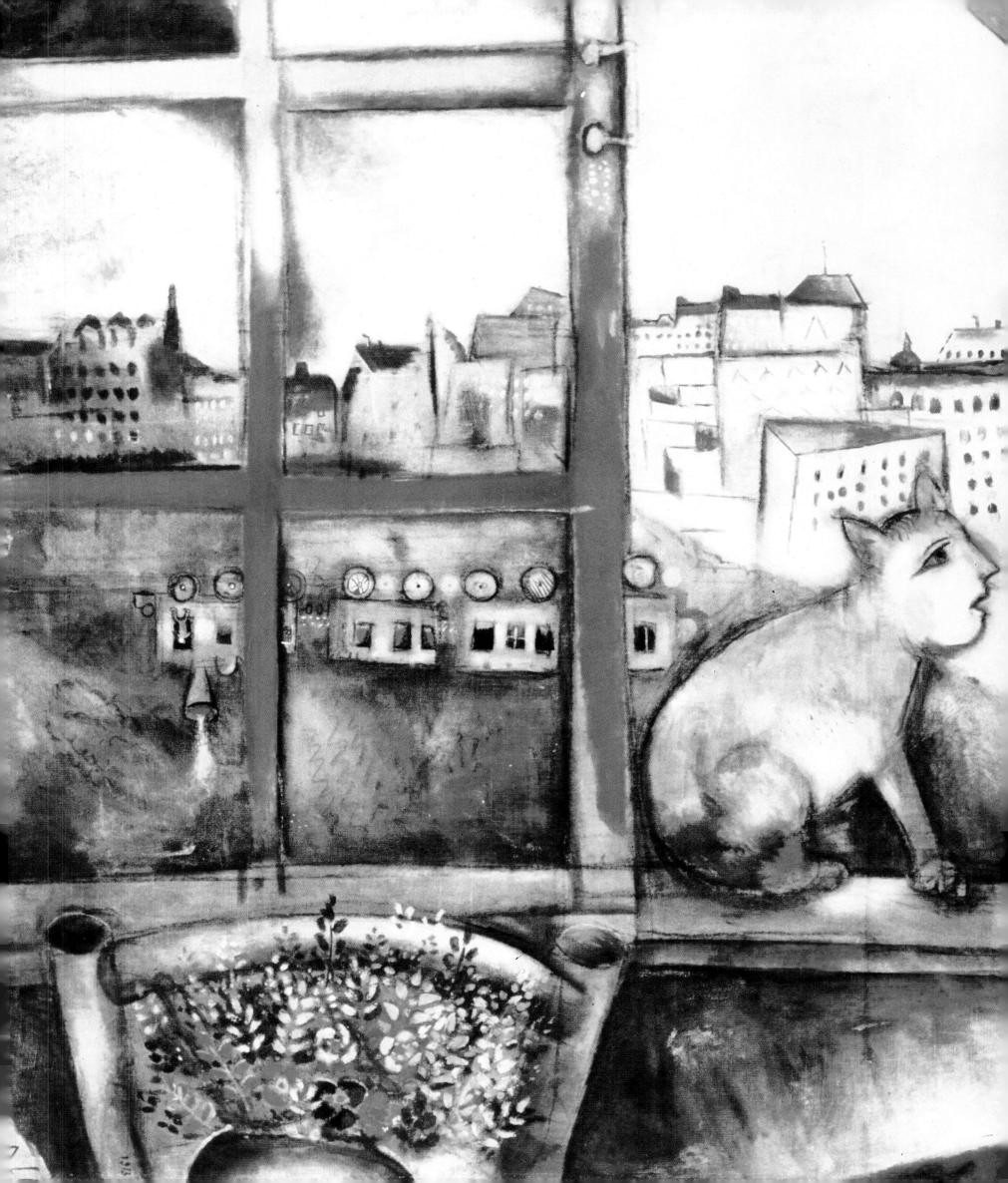

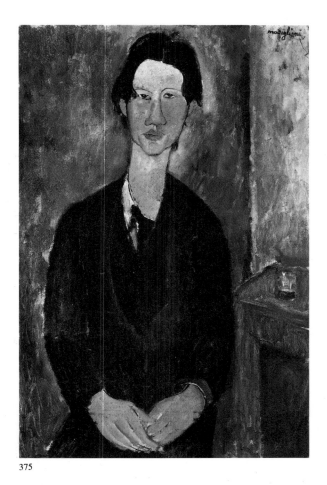

375

Chaim Soutine

Chaim Soutine's origins resembled, at least superficially, those of Chagall. He was born in 1893 in Smilovitchi, a small *shtetl* in western Russia. Unlike Chagall, Soutine did not reiterate the sights and sounds of his youth in his work, but he did infuse it with a pervasive emotionalism and pessimism that, rightly or wrongly, have been linked to his experiences as a Jew from Eastern Europe. Soutine had some formal training in Minsk and Vilna. After his arrival in Paris in 1913 he worked in the celebrated studio of Félix Cormon, which had figured prominently in the development of such artists as van Gogh and Toulouse-Lautrec. While Fauvism and German Expressionism surely contributed to Soutine's adoption of an intense palette and a free manner of drawing, he was largely self-taught, and his study of the old masters—especially Tintoretto, El Greco, and Rembrandt—in the Louvre played an important role in his artistic formation. Soutine's oeuvre includes livid still lifes depicting slaughtered birds or oxen in sanguine tones, landscapes that writhe with apocalyptic energy, and numerous portraits of young boys—for the most part servants or laborers—whose distorted countenances reflect the tragedy and hopelessness that permeated the artist's own life.

After a trip to the south of France with Modigliani, one of the few artists who befriended him and championed his work, Soutine spent about three years at Ceret, portraying the countryside in a febrile and primitive style whose shrill color and deformations of pictorial structure extend the expressionism of van Gogh and the Germans. Yet Soutine established his personal idiom not so much through his exposure to those painters as through an essentially instinctive intensification of color and light, which was part of the Impressionist legacy to twentieth-century modernism.

375. Amedeo Modigliani (1884–1920). *Portrait of Chaim Soutine*, 1917. Oil on canvas, 36⅛ x 23½ in. National Gallery of Art, Washington, D.C.; Chester Dale Collection, 1962.

376. Chaim Soutine (1894–1943). *Still Life with Skate*, 1924. Oil on canvas, 36 x 24 in. Dr. and Mrs. Paul Todd Makler.

377. Chaim Soutine (1894–1943). *Landscape at Ceret*, 1921. Oil on canvas, 31⅜ x 34⅛ in. Perls Galleries, New York.

376

377

378

379

378. Jules Pascin (1885–1930). *Two Gentlemen*, 1917. Oil on canvas, 65 x 54 in. Josefowitz Collection.

379. Jules Pascin (1885–1930). *Claudine Resting*, c. 1923. Oil on canvas, 34¼ x 23¾ in. The Art Institute of Chicago; Collection Mr. and Mrs. Carter H. Harrison.

380. Fernand Léger (1881–1955). *Still Life*, 1924. Oil on canvas, 36¼ x 23¾ in. Galerie Beyeler, Basel.

Jules Pascin

A third member of the group of Eastern European painters identified with the School of Paris was a Bulgarian, Jules Pascin. Born Julius Pincas in 1885 in a small town near the Rumanian border, he studied briefly at the Academy in Vienna before moving to Munich. His precocious skill as a draftsman was recognized by the editors of the satirical review *Simplicissimus*, to which the artist made regular contributions between 1903 and 1905. Barely twenty when he arrived in Paris, Pascin quickly established a reputation for his depictions of modern life, in particular his brothel scenes, which recalled Degas's and Toulouse-Lautrec's fascination with such subjects. While his restless and self-destructive temperament linked Pascin in a general way with Modigliani and Soutine, his caustic use of line distinguished his work from the more lyrical emotionalism of those artists.

At the outbreak of the war Pascin traveled to England and then to the United States. On his return to Paris in the fall of 1920, his life became increasingly hedonistic and unsettled. The popularity of his erotic subjects made him more and more dependent on them for continued success, which limited his expressive range and ultimately contributed to the profound disillusionment that would result in his dramatic suicide at the age of forty-five.

OVERLEAF:

381. Fernand Léger (1881–1955). *In the Factory*, 1918. Oil on canvas, 22¹/₁₆ x 14¹⁵/₁₆ in. Sidney Janis Gallery, New York.

382. Fernand Léger (1881–1955). *Disks in the City*, 1920. Oil on canvas, 51³/₁₆ x 64 in. Galerie Louise Leiris, Paris.

383. Fernand Léger (1881–1955). *Reclining Nude*, 1921. Oil on canvas, 19¾ x 25⅝ in. Perls Galleries, New York.

380

The Retrospective Years

The deaths of three eminent figures—Degas, Apollinaire, and Renoir—coincided with and contributed to the transition from the artistic climate of the early twentieth century to that of the 1920s. Degas died in 1917. He had not exhibited since 1893 and had spent the last decade of his life blind and in embittered retirement, his mind absorbed by anti-Semitism and reactionary politics. At the sales of the contents of his studio that took place in March and May of the following year, his works fetched phenomenal prices, bringing the achievements of the Impressionists to public attention once again and prompting Apollinaire to write that "[their] proceeds have already exceeded anything ever recorded in the history of art from an auction held after the death of a painter. . . ." [22] Apollinaire, who had never fully recovered from his war injury, succumbed to the influenza epidemic of 1918 and was buried on November 11, the day that armistice was declared. For over a decade he had been the most enthusiastic and effective champion of modernity. He not only defended the often baffling developments in the visual arts, he also befriended their creators, profiting as much from his contact with them as they from him. Apollinaire wrote perceptively about virtually all the principal painters, from Picasso, Braque, and Matisse to Delaunay and Chagall. With his death the spirit of intellectual adventure that had spurred innovation in the heady prewar years largely disappeared. Renoir, unlike Degas, had continued to paint almost to the end of his life—but at Cagnes-sur-Mer, far from the Parisian hub of the artistic universe. His death in 1919 also added considerable impetus to the reevaluation of Impressionism that was taking place.

Articles and books by influential critics began to appear, and for the first time the modern movement was seen as the continuation of a revolution begun by the Impressionists and expanded by the Cubists. This new perspective was summed up by Léger in a talk he gave at New York's Museum of Modern Art in 1935: "During the last fifty years the entire effort of artists has consisted of a struggle to free themselves from certain old bonds. . . . This effort towards freedom began with the impressionists and has continued to express itself until our own day. The impressionists freed color—we have carried their attempt forward and have freed form and design." [23]

Although Léger was the first Cubist painter to stress the connection with the pioneer modern style, his own work never took a retrospective turn but moved resolutely forward. Putting his military experience behind him, he revived his earlier concern with interpreting the distinctive forms and rhythms of the modern world. Typically, his paintings of the 1920s are nearly abstract compositions in which certain industrial objects can be perceived. In canvases such as *Disks in the City* (plate 382), Léger recreated the rapidly shifting and fragmented visual experience of the modern urban environment. The machine aesthetic that emerged so forcefully in his earlier paintings is now monumentalized, and the human inhabitants of what may be called an automated landscape are reduced to small, impersonal components of the overall design. Yet Léger remained optimistic, consistently emphasizing the modern world's potential for order and beauty rather than chaos and brutality. The architectonic character of these canvases reflects his determination to impose a structural unity of verticals and horizontals upon the more arbitrarily disjointed planes of his earlier style.

Like Picasso and others, Léger was drawn in the 1920s to a more classic sense of stability, an attraction that climaxed with his powerful nudes. His *Reclining Nude* (plate 383), a machine-age odalisque, inevitably conjures up the tradition of Ingres and Manet, but the atmosphere of cool sensuality or probing realism associated with those masters is replaced here by a dispassionate constructivism that geometricizes the human anatomy as objectively as it had the elements of landscape. In 1923 Léger's determination to capture the essential spatial and temporal experiences of the machine age

381

382

383

384

384. André Derain (1880–1954). *Landscape*, c. 1924. Oil on canvas, 13¹⁄₁₆ x 16¹⁄₁₆ in. The Brooklyn Museum; Anonymous gift.

385. Pierre Bonnard (1867–1947). *The Riviera*, c. 1923. Oil on canvas, 31 x 30 in. The Phillips Collection, Washington, D.C.

386. Pierre Bonnard (1867–1947). *The White Tablecloth*, 1924. Oil on canvas, 46 x 35 in. Berry-Hill Galleries, New York.

387. Pierre Bonnard (1867–1947). *The Open Window*, 1921. Oil on canvas, 46½ x 37¾ in. The Phillips Collection, Washington, D.C.

prompted him to turn away from the static medium of painting and embrace the popular idiom of film. Through the technique of montage he was able to juxtapose human, animal, and geometric forms, advertisements, and machinery with unprecedented freedom. His *Ballet mécanique* expanded the formal and dynamic qualities of Léger's painting and served as a precedent for other artists' subsequent experimentation with film.

It was André Derain, with his luminous and harmonious landscapes, who emerged in the 1920s as the artist whose work most clearly continued the Impressionist legacy. Derain, for many, was the embodiment of the School of Paris. Clive Bell, the English critic whose writings played a decisive role in shaping the attitudes toward art that prevailed in the postwar period, declared: "The leader has already been chosen. Derain is the chief of the new French school—a school destined manifestly to be less cosmopolitan than its predecessor." For Bell, Derain had become "the greatest power

385

386

387

among young French painters, [who were] seeking shelter and grace under [his] vast though unconscious naturalism. . . . Chardin, Watteau, and Poussin [were] his direct ancestors." [24]

Bonnard, too, now came to occupy a position of greater prestige. In 1918 he was chosen, together with Renoir, as honorary president of a group called La Jeune Peinture Française, and in 1920 he served on the committee that arranged to purchase for the Louvre one of the key works of nineteenth-century Realism, Courbet's *The Painter's Studio*. The acquisition of this monumental canvas by a painter who had been one of the primary instigators of the changes that had led to Impressionism was another demonstration of the status the movement now enjoyed. A large retrospective of Bonnard's work from 1891 to 1922 was held in Paris at the Galerie Bruet in 1924. In the same year, a monograph on the artist by Claude Roger-Marx helped to cement his reputation as a kind of French national treasure. But by now Bonnard's cultivated and highly personalized Impressionist style seemed distinctly old-fashioned to many of the artists who had been profoundly affected by Cubism. Picasso, for one, found Bonnard's work weak, characterizing it as a "potpourri of indecision" [25]—a reference to the obvious lack of emphatic formal contrast, which the father of Cubism had himself pursued so determinedly.

Henri Matisse

With the end of the war in 1918 Matisse's spirits revived and his interest in Cubism all but vanished. His art of the ensuing decade may be considered conservative in that it returns to the essentially decorative aesthetic that had guided him in the years just before the war. Yet the period was to prove one of the most creative of his entire career. The artist's new vitality is already evident in *Tea* (plate 388), painted in his garden at Issy shortly before he and his family moved to Nice in 1919. This composition epitomizes that sense of well-being in civilized surroundings that was to infuse so many of Matisse's paintings. Summer light softly penetrates the cool vegetation, and the picture's style—despite the few lingering recollections of Cubism in the abrupt definition

388. Henri Matisse (1869–1954). *Tea*, 1919. Oil on canvas, 55³⁄₁₆ x 83³⁄₁₆ in. Los Angeles County Museum of Art; Bequest of David L. Loew in memory of his father, Marcus Loew.

389. Henri Matisse (1869–1954). *Woman at a Fountain*, 1919. Oil on canvas, 31¾ x 25⅝ in. Basil Goulandris, Lausanne.

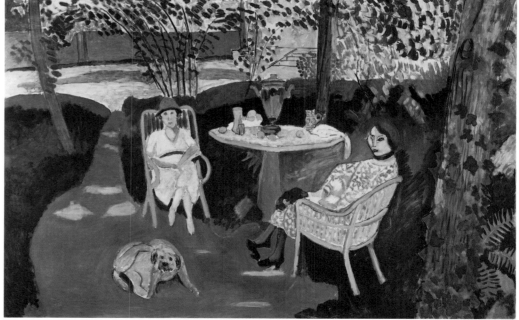

388

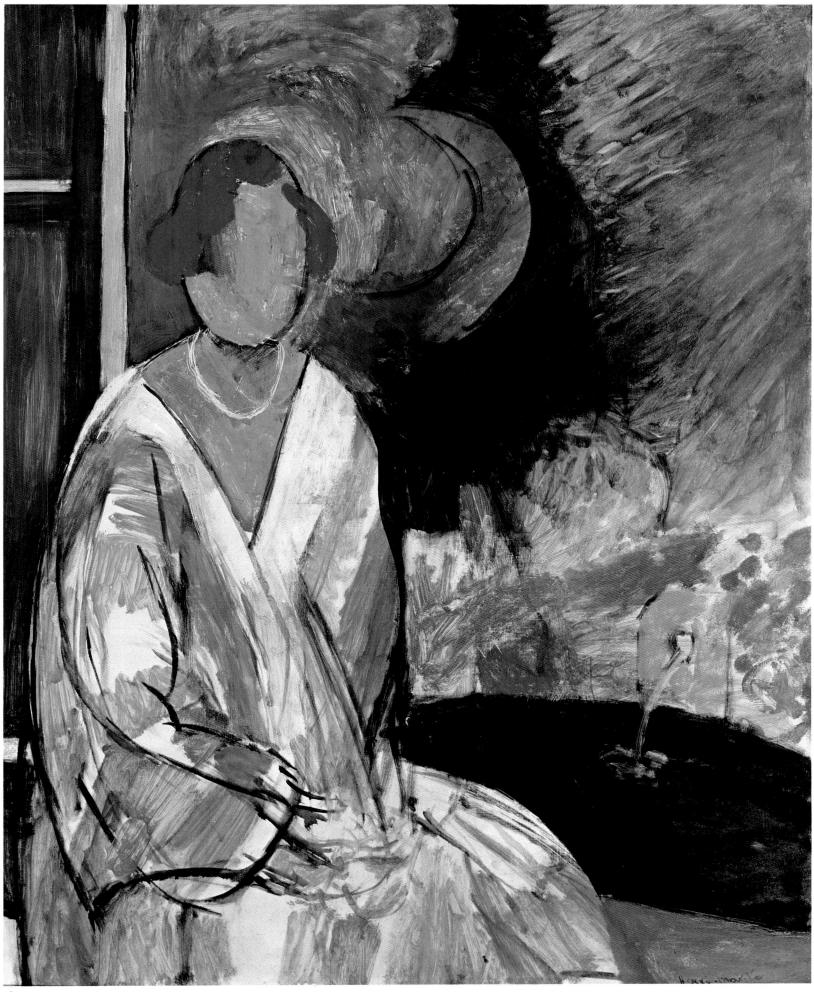

389

390. Henri Matisse (1869–1954). *The Painting Lesson*, 1919. Oil on canvas, 29⅛ x 36⅝ in. Scottish National Gallery of Modern Art, Edinburgh.

391. Henri Matisse (1869–1954). *Regatta, Nice*, 1921. Oil on canvas, 32 x 25½ in. Perls Galleries, New York.

of the table and in the head of Marguerite, seated in the foreground—is unabashedly Impressionist in feeling.

The Painting Lesson (plate 390), of the same year, is more ambitious in its manipulation of forms in space. It combines the theme of the painter's studio (a favorite of Matisse) with a domestic setting that was dear to both the Impressionists and the Nabis. Significantly, Matisse employs the oval mirror to reflect both the vase of flowers on the table and a fragment of the sunlit exterior, creating, in effect, a painting within a painting. The pictorial strategy of the reflective mirror recalls Bonnard's *Dressing Table and Mirror*, painted about the same time, although the function of the mirror in Bonnard's picture—extending and encapsulating space—is more conventional. Matisse adds yet another layer of aesthetic or philosophic reality to his composition by interjecting himself at his easel in the act of depicting the girl and the flowers. In contrast to the vivid

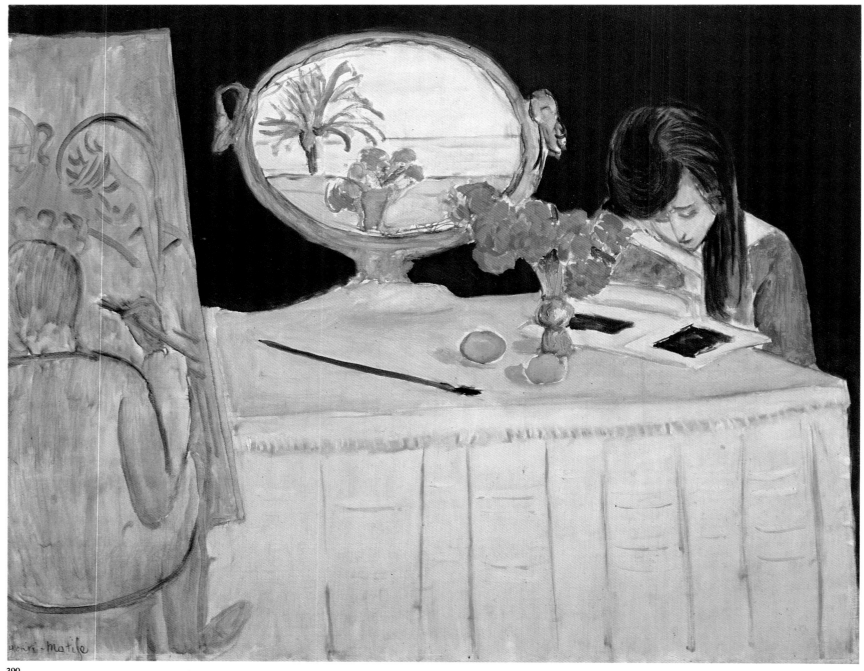

390

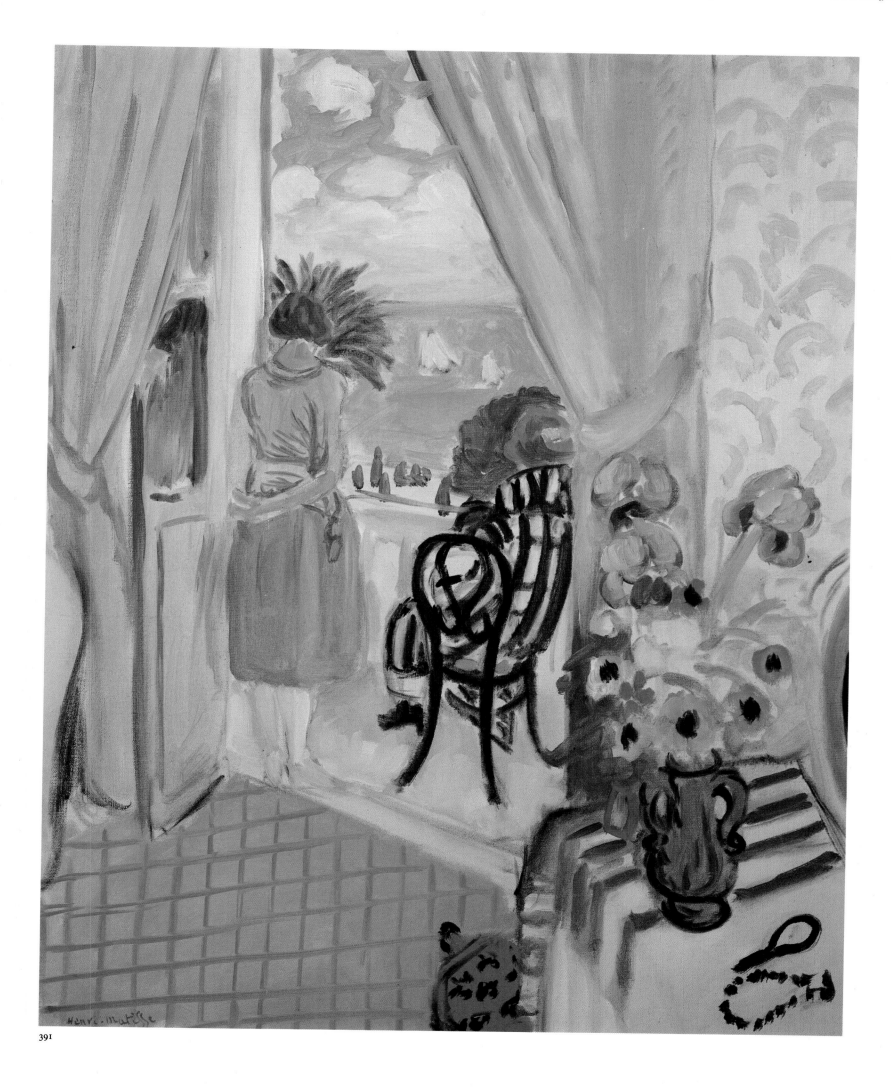

391

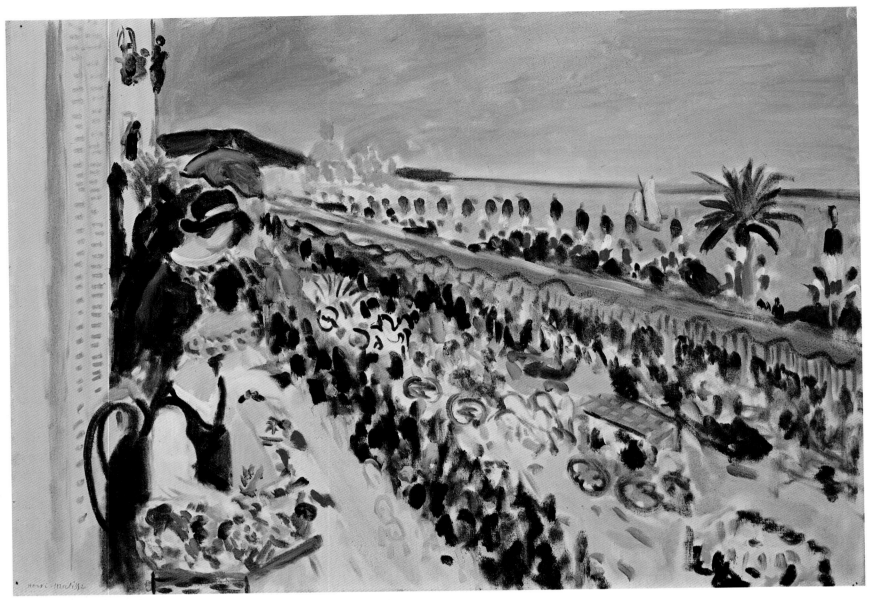

392

colors that dominate the rest of the painting, the artist and his canvas are depicted in an ocher monochrome, as if to underscore the unity of the artist with his work of art and their separateness from the natural world.

Color and sunlight flood all the canvases that Matisse painted in the south. In *Regatta, Nice* (plate 391) he again addressed the interpenetration of indoor and outdoor. From a balcony, two figures watch the boats scudding by under puffs of white clouds, while a magnificent bouquet of poppies and irises competes with the artificial gaiety of the elaborate wallpaper and carpets. In *Carnival at Nice* (plate 392), on the other hand, the radiant outdoors commanded the artist's full attention. Matisse's debt to his great Impressionist predecessors is immediately apparent: with its skewed view of a flag-lined thoroughfare animated by a holiday throng, *Carnival at Nice* reminds us of Monet's Paris boulevards and flag-decked street scenes of the 1870s. Though the locale has been transferred from the capital to the subtropical Promenade des Anglais, an identical excitement is conveyed through the seemingly spontaneous application of brilliant splashes of color.

All of Matisse's Nice paintings share a luxuriousness that is reflected in the elegant furnishings of the spacious interiors, the well-dressed and handsome women, and the

benevolent light of untroubled skies. The atmosphere of this privileged world can be summed up in a word: repose. Yet the freedom from anxiety that Matisse sought as both the ideal working condition and the goal of his work was often misunderstood by contemporaries as mindless sensuousness or technical facility, since it differed from the overt intellectualization of Cubism. The painter Amédée Ozenfant, one of the theoreticians of the aggressively reformatory Purist movement of the 1920s, indicted the artist's new achievements: "Matisse's work, like Renoir's, is a prolongation of the superficial painting of the eighteenth century. It is indeed difficult to find any effects of the theoretical preoccupations that furrowed the artist's brow . . . years ago."[26] Ozenfant's criticism fails to recognize the novelty of Matisse's Nice paintings. Nor does it acknowledge the artist's own admission that he was exhausted from long and difficult years of experimentation and that he required a change of climate, with its immediate physicality, to liberate himself from the intellectual restraints that had always governed his art.

Matisse's lifelong striving to reconcile the old and the new was regenerated in this environment, as he reaffirmed shortly after his move to Nice: ". . . When one has obtained what one wants from a particular domain, when one has explored all the possibilities inherent in one direction, it is important to change one's course at the right time and look for something new. . . . Actually, I'm looking for a new kind of synthesis . . . [and there is] a painting done this summer, where I've brought together all that I have attained recently with what I knew and could do before."[27] The Nice paintings resume, in an intimate and decidedly bourgeois setting, Matisse's abiding search for the idyllic state he had first envisioned in *Luxe, calme et volupté* and *Joy of Life*.

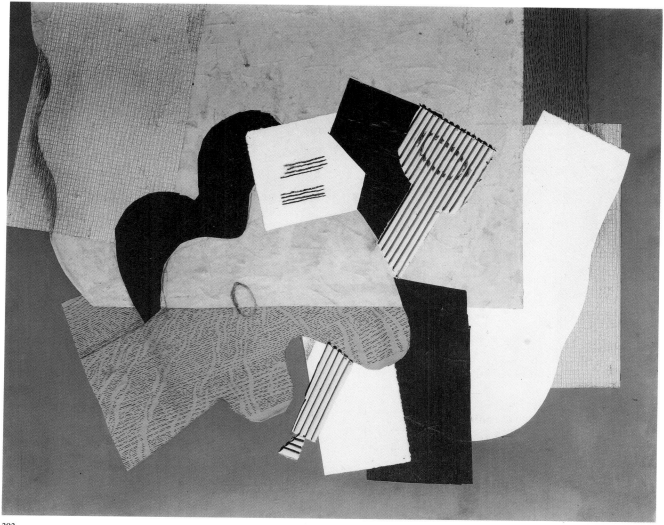

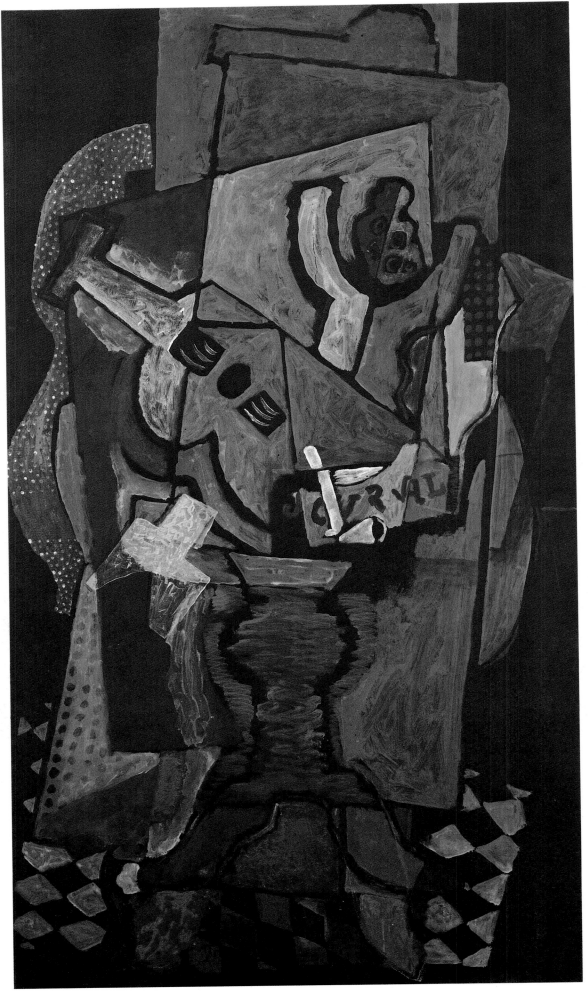

394

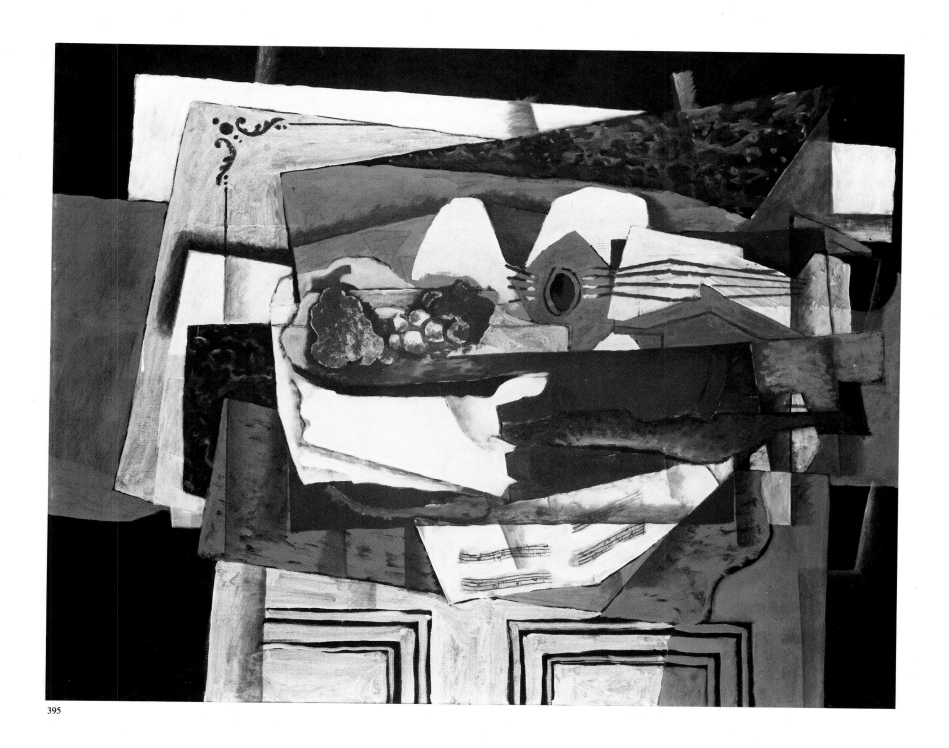

395

394. Georges Braque (1882–1963). *Still Life*, 1918. Oil
on canvas, 51⅛ x 29⅜ in. Van Abbemuseum, Eindhoven,
The Netherlands.

395. Georges Braque (1882–1963). *Le Buffet*, 1920. Oil
on canvas, 32 x 39½ in. Galerie Beyeler, Basel.

396

397

398

396. Georges Braque (1882–1963). *The Fireplace*, 1923. Oil on canvas, 51⅛ x 29⅛ in. Kunsthaus, Zurich.

397. Georges Braque (1882–1963). *Still Life with Guitar, Glass, and "Socrate,"* 1921. Oil on canvas, 16½ x 28¾ in. Musée National d'Art Moderne, Centre Georges Pompidou, Paris.

398. Georges Braque (1882–1963). *Still Life with Pears*, 1925. Oil on canvas, 11¾ x 29⅜ in. Musée National d'Art Moderne, Centre Georges Pompidou, Paris.

Georges Braque

The legacy of Impressionism cannot, of course, be seen in all of the art produced in France during the decade after World War I, although a generally retrospective mood did predominate. When Braque began to paint again in the summer of 1917, he took up his Synthetic Cubist style almost where he had left it three years earlier. His *papier-collé Musical Forms* of 1918 (plate 393), in fact, is one of the supreme masterpieces of that style, a work of monumental simplicity in which areas of black were used, in Braque's distinctive manner, to create the effect of a sculptural relief. In the following years Braque limited himself largely to the still-life subjects that had always been his forte; a recurrent theme of the 1920s was the combination of a musical instrument with a bowl of fruit atop a massive mantelpiece or table (plate 395). These "cabinet paintings"—lyrical in tone and decorative in function—have a distinctly classical flavor. In them Braque deliberately affirmed the continuity of his art with that of Chardin and the whole French tradition of *nature morte*. In painting these still lifes, Braque abandoned the ambiguities of Synthetic Cubism and reasserted his quest for an ideal clarity of structure. By distributing solid forms and somber though resonant colors evenly across the canvas, he forced the viewer to move slowly from passage to passage in a manner analogous to the intense deliberation with which the painting had been made. Rarely has a modern painter made so concrete, so tangible his aspiration to measure, order, and calm.

399

399. Pablo Picasso (1881–1973). *The Three Musicians*, 1921. Oil on canvas, 79 x 87¾ in. The Museum of Modern Art, New York; Mrs. Simon Guggenheim Fund.

In his canvases of the 1920s Braque never compromised the systematic rigor of his Cubist approach. Rather, the representational elements were subjected to the control of his intellect; their decorative potential was weighed against the dictates of abstract order and structure before they were finally admitted. His Cubist experience enabled Braque to approach nature from a unique vantage point that helped him to create an art that both united and transcended naturalism and abstraction. Though their approaches to painting seem radically different, Braque ultimately shared with Matisse an ideal vision of painting as both intellectual and sensory.

Pablo Picasso

Picasso's postwar development was far more complex than that of any of his contemporaries. The contradictory artistic currents that animated those years were mirrored in the variety of his themes and of their execution. One of Picasso's strengths as an artist was his ability to absorb the experiences of an era—its certainties and its anxieties—and give them visual meaning. His prodigious technical gifts matched the versatility of his thinking and allowed him to explore fully the sensory, emotional, and philosophical concerns that had dominated his artistic generation. It had been clear by 1907 that a purely descriptive art was no longer sufficient to express the experience of modern life, but it was by no means certain in 1920 that abstraction offered a completely satisfactory alternative. The issue was still open, and Picasso, characteristically, welcomed its challenge. Indeed, he developed two antithetical styles that he alternated during the early 1920s: an extension of his earlier Synthetic Cubism and a monumental and classicized realism.

With his wife, Olga, and his newborn son, Paulo, Picasso spent the summer of 1921 in a villa at Fontainebleau. There he painted two versions of a monumental composition, *The Three Musicians*, which recapitulated a number of themes that had occupied him over the years. In the version now in New York (plate 399), a Pierrot with a recorder, a Harlequin with a guitar, and a singing monk (who appears to be Russian) with a skull-like head are grouped around a table. Behind them, but at the same time under the table, is a monstrous dog with erect ears. The figures, composed of overlapping and intersecting quasi-geometric planes, are contained in a shallow, boxy space that seems, at first glance, to be volumetrically constructed. On closer inspection, however, the space—like the figures themselves—defies a completely rational reading. On the table is an arrangement of shapes that, although not literally decipherable, looks like a self-contained *papier-collé* still life. An immediate sense of gaiety is communicated by the painting's bright colors and many humorous details. But it is a gaiety tempered by malaise, thanks to the macabre masks of the musicians and the shadowy presence of the Cerberus-like dog. The tune the musicians are playing could well be a dance of death.

By 1920 a full-fledged Neoclassical revival was in the air—evidenced, for example, in Stravinsky's score for *Pulcinella*, a Diaghilev-Massine ballet with a *commedia dell'arte* theme for which Picasso designed the costumes and decor. Even as he was approaching the culmination of Synthetic Cubism in his masterful *Three Musicians*, Picasso had begun to work on a series of friezelike compositions of a distinctly different character, in which massive, rigidly articulated figures are represented in an overblown realist style that would not have shocked an academician. These new forms, solid and impenetrable, are painted in gray and terra cotta tones that enhance their sculptural pretension and suggest a vague parallel with provincial Greek art. Four years earlier, when working on *Parade*, Picasso had visited the great archaeological museums and sites in Rome and Naples. The direct exposure to this calm and balanced art, so different from the tension of Cubism, surely contributed to the classicism that pervades his work of the early 1920s. It also provided the perfect style to express the tranquility

401

400. Pablo Picasso (1881–1973). *Mother and Child*, 1921. Oil on canvas, 56¼ x 64 in. The Art Institute of Chicago; Mary and Leigh B. Block Charitable Foundation, Mayman Corp., Mrs. Maurice Rothschild, Mr. and Mrs. Edwin E. Hikin, Hertle Fund.

401. Pablo Picasso (1881–1973). *Paulo Dressed as a Harlequin*, 1924. Oil on canvas, 51⅛ x 38⅜ in. Musée Picasso, Paris.

that characterized the early years of his marriage to Olga. In *Mother and Child* (plate 400), Picasso uses the language of classical sculpture to monumentalize his new domesticity; a number of paintings and sketches of his wife and young son from the same time are more sentimental in tone and commonplace in style. Indeed, Picasso reached a nadir of sentimentality in the summer of 1924 with his portrait of Paulo dressed as a Harlequin and perched all too endearingly on the edge of an elaborately upholstered chair (plate 401).

In March and April of the following year Picasso, with his wife and son, visited Monte Carlo while the Ballets Russes were performing there. He produced a series of drawings of dancers in a linear, classical style, and, in a startling change of mood, he began work on a canvas that was surely inspired by the performances he attended. The wild, demonic *Three Dancers* (plate 402) is a celebration not of Apollonian measure

but of maenadic frenzy. The violently contorted figures are deftly set off by the geometrically ordered background, in which ornamental panels alternate with a Mediterranean sky. A grotesque tension pervades the entire composition, and the clash of jagged and pointed forms produces an unbearable shrillness.

Not since the *Demoiselles d'Avignon* had Picasso created such a powerful image. The two paintings, in fact, are related—both in the visual motifs they employ and in their emotional tone. The earlier work may well have been on Picasso's mind in 1925, for in July, less than a month before the completion of *Three Dancers*, the *Demoiselles* was reproduced for the first time, in the review *La Révolution surréaliste*. In fact, just a year before Picasso started work on the *Three Dancers*, the poet André Breton had published a manifesto of Surrealism in which he defined what would become the major aesthetic current in the art and literature of the later 1920s and 1930s as "purely psychic automatism through which we undertake to express, in words, writing, or any other activity, the actual functioning of thought, thoughts dictated apart from any control by reason and any aesthetic or moral consideration. . . . Surrealism rests upon belief in the higher reality of specific forms of associations, previously neglected, in the omnipotence of dreams, and in the disinterested play of thinking. . . ."[28] In arguing the relevance of Surrealism to the modern condition, Breton claimed that the distinguishing features of the modern mind were its "restlessness" and its "convulsiveness"[29]—precisely the extreme qualities of style that were newly proclaimed in Picasso's radical painting: he was, in fact, the only painter of his generation to respond seriously to its provocative rhetoric.

From the 1920s until the outbreak of World War II, Paris continued to function as the laboratory of modern painting, the crucible where a constantly changing international avant-garde tested its ideas. If other art centers at the time (Berlin, Weimar, and Moscow, for example) responded more immediately to the radical political, social, and economic developments that would affect the destiny of Europe and the world, only Paris demonstrated the capacity to accommodate the new while cultivating a continuity with the past.

The puzzling popularity of the so-called School of Paris—in truth, a rather vague description of a collective impulse toward intensified personal expression as opposed to a coherent style like Impressionism or Neo-Impressionism—provided the first indication of this Parisian tendency toward historical accommodation. At the same time, the pluralistic nature of art in Paris during and immediately after World War I was itself a cultural backlash, a retreat on the part of many artists from the didactic emphasis, the theoretical rigors, or the philosophic speculation that had accompanied the reaction to Impressionism. The stress on the rational procedure of Neo-Impressionism or Cubism gave way to a more pragmatic approach as artists sought to consolidate the insights gained from their recent experimentation with a greater awareness of Impressionism and Post-Impressionism. The characterization of the School of Paris as an essentially hedonistic celebration of painting and pleasure indirectly acknowledges the role that Impressionism played in the ongoing assessment of the nature and function of painting that took place in the 1920s. However, it also implies that artists lost sight of the intellectual and moral demands of painting—a point that, in the case of Braque, Picasso, and Matisse, is certainly open to debate. What is clear is that these great modern masters did recognize, in various ways and only after developing a more austere abstract language, the Impressionists' justifiable delight in the material aspects of painting: the decorative vitality of design, the compelling impact of color, and the eloquence of surface.

402. Pablo Picasso (1881–1973). *Three Dancers*, 1921. Oil on canvas, 84¾ x 56 in. The Tate Gallery, London.

OVERLEAF:

403. Henri Matisse (1869–1954). *Moroccan Landscape*, 1911. Oil on canvas, 45¼ x 31⅜ in. Moderna Museet, Stockholm.

Henri-Matisse

403

Notes

Introduction (pages 13–15)

1. Roger Fry, *Vision and Design* (London: Chatto and Windus, 1920), p. 239.
2. Ibid., p. 241.

1. Beyond Impressionism: The Last Years

(pages 17–59)

1. Unpublished notes of Louis Le Bail, in John Rewald, *The History of Impressionism*, 4th rev. ed. (New York: Museum of Modern Art, 1973), p. 458.
2. Degas, quoted in Elizabeth Gilmore Holt, ed., *From the Classicists to the Impressionists: Art and Architecture in the 19th Century* (New York: New York University Press, 1966), p. 401.
3. John Rewald, ed., with the assistance of Lucien Pissarro, *Camille Pissarro: Letters to His Son Lucien* (New York: Pantheon Books, 1943), p. 30.
4. Ambroise Vollard, *Renoir: An Intimate Record* (New York, 1925), pp. 118–19.
5. Ibid., p. 121.
6. Monet to Durand-Ruel, December 1, 1883, in Lionello Venturi, *Les Archives de l'Impressionisme* (Paris: Durand-Ruel, 1939), vol. 1, p. 264.
7. Eugène Manet to Morisot [March 1882], in Denis Rouart, *Correspondance de Berthe Morisot* (Paris, 1950), p. 106.
8. Hans Huth, "Impressionism Comes to America," *Gazette des Beaux-Arts* 29 (April 1946): 226.
9. Ibid., p. 250.
10. Gustave Geffroy, *Claude Monet, sa vie, son oeuvre* (Paris: G. Grès, 1922), vol. 1, p. 110.
11. Willem G. C. Byvanck, *Un Hollandais à Paris en 1891: Sensations de littérature et d'art* (Paris, 1892); quoted in Steven Z. Levine, *Monet and His Critics* (New York: Garland Publishing, 1976), p. 134.
12. Ibid., p. 122.
13. Maria and Godfrey Blunden, *Impressionists and Impressionism* (New York: Rizzoli International Publications, 1976), pp. 160–61.
14. This statement is attributed to Cézanne by Joachim Gasquet, a poet and the son of one of the painter's boyhood friends, who later published letters from Cézanne and recounted conversations with him in *Paul Cézanne* (Paris: Editions Bernheim-Jeune, 1926); see p. 130 for this statement. That Gasquet often embellished Cézanne's words has been forcefully argued by John Rewald.
15. Judith Wechsler, ed., *Cézanne in Perspective* (Englewood Cliffs, N.J.: Prentice-Hall, 1975), p. 27.
16. Maurice Denis, "Cézanne," *L'Occident*, September 1907; quoted in Rewald, *Impressionism*, p. 560.
17. Ibid.

18. Gustave Geffroy, "Paul Cézanne," *La Vie artistique* 3 (1894): 249–60; quoted in Linda Nochlin, ed., *Impressionism and Post-Impressionism, 1874–1904: Sources and Documents* (Englewood Cliffs, N.J.: Prentice-Hall, 1966), pp. 105–6.
19. Cézanne to Bernard, October 23, 1905; quoted in John Rewald, ed. and trans., *Paul Cézanne: Letters* (New York: Hacker Art Books, 1976), p. 316.

2. Neo-Impressionism: Deliberate and Constant Technique (pages 61–113)

1. Signac to Monet, undated; quoted in Rewald, *Impressionism*, p. 503.
2. Paul Signac, *D'Eugène Delacroix au Néo-Impressionisme*; quoted in Norma Broude, *Seurat in Perspective* (Englewood Cliffs, N.J.: Prentice-Hall, 1978), p. 59.
3. "Notes inédites de Seurat sur Delacroix," *Le Bulletin de la vie artistique*, April 1, 1922, pp. 154–58; quoted ibid., p. 13.
4. Félix Fénéon, "Les Impressionistes en 1886," *La Vogue*, June 13–20, 1886; quoted in Nochlin, *Impressionism and Post-Impressionism*, p. 110.
5. Pissarro to Durand-Ruel, November 6, 1886; quoted in Venturi, *Archives*, vol. 2, p. 24.
6. Félix Fénéon, "L'Impressionisme aux Tuileries," *L'Art moderne*, September 19, 1886; quoted in Broude, *Seurat*, p. 38.
7. Robert Herbert, *Neo-Impressionism*, exhibition catalog (New York: Solomon R. Guggenheim Museum, 1968), p. 14.
8. Gustave Kahn, "Chronique de la littérature et de l'art: Exposition Puvis de Chavannes," *La Revue indépendante*, January 6, 1888; quoted in Broude, *Seurat*, p. 20.
9. Emile Verhaeren, "Le Salon des Vingt à Bruxelles," *La Vie moderne*, February 26, 1887; quoted ibid., p. 24.
10. Seurat to Signac, August 26, 1888; quoted in John Rewald, *Post-Impressionism* (New York: Museum of Modern Art, 1978), p. 104.
11. Broude, *Seurat*, p. 39.
12. Pissarro to Signac, June 16, 1887; quoted in Rewald, *Post-Impressionism*, p. 102.
13. Richard Shone, *The Post-Impressionists* (London: Octopus Books, 1979), p. 43.
14. Aaron Scharf, *Pioneers of Photography* (London: British Broadcasting Corporation, 1975), p. 129.
15. Seurat to Maurice de Beaubourg, August 28, 1890; quoted in Broude, *Seurat*, p. 18.
16. Signac to van Gogh, April 1889; quoted in J. van Gogh-Bonger and V. W. van Gogh, eds., *The Complete Letters of Vincent van Gogh* (Greenwich, Ct.: New York Graphic Society, 1958), vol. 3, p. 404.
17. Paul Signac, "Impressionistes et révolutionaires," *La Révolte*, June 13–19, 1891; quoted in Nochlin, *Impressionism and Post-Impressionism*, p. 124.

18. Ibid., p. 125.
19. Shone, *Post-Impressionists*, p. 52.
20. Entry in Signac's diary, December 29, 1897; quoted in Rewald, *Post-Impressionism*, p. 98.
21. Unpublished notes of Signac; quoted in Nochlin, *Impressionism and Post-Impressionism*, p. 126.
22. Draft of letter from Pissarro to Henry van de Velde, c. March 1896; quoted in Rewald, *Post-Impressionism*, pp. 388–89.
23. Téodor de Wyzewa, "Georges Seurat," *L'Art dans les deux mondes*, n. 22, April 1891; quoted in Broude, *Seurat*, p. 31.
24. Paul Signac, *D'Eugène Delacroix au Néo-Impressionisme*; quoted in Nochlin, *Impressionism and Post-Impressionism*, p. 123.
25. John Rewald, ed., "Excerpts from the Unpublished Diary of Paul Signac: I (1894–1895)," *Gazette des Beaux-Arts* 36 (July–September 1949): 174.

3. Symbolism: The Escape from Nature

(pages 115–49)

1. Jean Moréas, "Manifeste littéraire: Le Symbolisme"; quoted in Robert Delevoy, *Le Symbolisme* (Geneva: Skira, 1982), p. 71.
2. Robert Goldwater and Allen Lane, *Symbolism* (London: Penguin Books, 1979), p. 75.
3. Gustave Kahn, "Réponse des Symbolistes," *L'Evénement*, September 28, 1886; quoted in Rewald, *Post-Impressionism*, p. 134.
4. Charles Baudelaire, *The Painter of Modern Life and Other Essays*, trans. and ed. Jonathan Mayne (London: Phaidon Press, 1964), p. 116.
5. Ibid.
6. Edouard Dujardin, "Le Cloisonnisme," *La Revue indépendante*, May 19, 1888; quoted in Rewald, *Post-Impressionism*, p. 143.
7. J. K. Huysmans, *Against Nature*, trans. Robert Baldick (London: Penguin Books, 1959), pp. 69–70.
8. Charles Chassé, *The Nabis and Their Period*, trans. Michael Bullock (New York: Praeger, 1969), p. 28.
9. Georges Rouault, "Gustave Moreau," *L'Art et les artistes* 13 (1926): 39.
10. Chassé, *The Nabis*, p. 28.
11. John Rewald et al., *Odilon Redon, Gustave Moreau, Rodolphe Bresdin*, exhibition catalog (New York: Museum of Modern Art; Chicago: Art Institute of Chicago, 1961), p. 18.
12. Pierre Louis Mathieu, *Gustave Moreau* (Boston: New York Graphic Society, 1976), p. 241.
13. Rewald, *Redon, Moreau, Bresdin*, p. 22.
14. Odilon Redon, *A Soi-même: Journal (1867–1915)* (Paris: Corti, 1961), p. 27.

370 | Notes

15. Rewald, *Redon, Moreau, Bresdin*, p. 30.
16. Ibid., p. 36.
17. Ibid., p. 43.
18. Redon, *A Soi-même*, p. 29.
19. Chassé, *The Nabis*, p. 23.
20. Ibid., p. 25.
21. Robert Pincus-Witten, *Occult Symbolism in France. Josephin Peladan and the Salons de la Rose+Croix* (New York: Garland Publishing, 1976), p. 40.
22. Ibid., p. 46.
23. Ibid., p. 89.
24. Ibid., p. 92.
25. Ragna Stang, *Edvard Munch* (New York: Abbeville Press, 1979), p. 31.
26. Ibid., p. 74.
27. Reinhold Heller, *Edvard Munch: "The Scream"* (New York: Viking Press, 1973), p. 46.
28. Stang, *Munch*, p. 15.

4. Bernard, Gauguin, and van Gogh:
The Isolated Ones (pages 151–83)

1. Rewald, *Post-Impressionism*, p. 215, n. 12.
2. Gauguin to Schuffenecker, August 1888; quoted in M. Malingue, ed., *Lettres de Gauguin à sa femme et à ses amis* (Paris: B. Grasset, 1946), pp. 134–35.
3. G.-A. Aurier, "Concurrence," *Le Moderniste*, no. 10, June 27, 1889; quoted in Rewald, *Post-Impressionism*, p. 261.
4. Gauguin to Schuffenecker, summer 1890; quoted in A. Alexandre, *Paul Gauguin, sa vie et le sens de son oeuvre* (Paris: Bernheim-Jeune, 1930), pp. 110–11.
5. Rewald, *Post-Impressionism*, p. 452.
6. G.-A. Aurier, "Symbolisme en peinture: Paul Gauguin," *Mercure de France*, March 1891; quoted in Rewald, *Post-Impressionism*, p. 449.
7. Van Gogh to Bernard, March 18, 1888; quoted in Ronald Pickvance, *Van Gogh in Arles*, exhibition catalog (New York: Metropolitan Museum of Art, 1984), p. 12.
8. Van Gogh to Bernard, June 18, 1888; quoted ibid., p. 102.
9. G.-A. Aurier, "Les Isolés: Vincent van Gogh," *Mercure de France*, January 1890; quoted in Nochlin, *Impressionism and Post-Impressionism*, p. 137.

5. The Nabis: Prophets and Painters
(pages 185–217)

1. Maurice Denis, *Théories, 1890–1910*, 4th ed. (Paris: Rouart et Watelin, 1920), p. 167.
2. See George L. Mauner, *The Nabis: Their History and Their Art, 1888–1896* (New York: Garland Publishing, 1978), pp. 32–33.
3. Paul Sérusier, *ABC de la peinture: Correspondance* (Paris: Floury, 1950), p. 42.
4. Ibid., pp. 39–40.
5. Denis, *Théories*, p. 1.
6. Ibid., p. 12.
7. Claude Roger-Marx, *L'Estampe et l'affiche* I (1897): 223.
8. Georges Bernier, *La Revue blanche*, exhibition catalog (New York: Wildenstein, 1983), p. 48.
9. Gabriel Weisberg et al., *Japonisme: Japanese Influence on French Art, 1854–1910*, exhibition catalog (Cleveland: Cleveland Museum of Art; New Brunswick, N.J.: Rutgers University Art Gallery; Baltimore: Walters Art Gallery, 1975), p. 64.
10. Bret Waller and Grace Seiberling, *Artists of "La Revue blanche*," exhibition catalog (Rochester: Memorial Art Gallery of the University of Rochester, 1984), p. 18.
11. Denis to Vuillard, 1898; quoted in Mauner, *The Nabis*, pp. 193–96.

6. Fauvism: An Orgy of Pure Colors
(pages 219–67)

1. Louis Vauxcelles, *Gil Blas*, October 17, 1905; quoted in John Elderfield, *The Wild Beasts: Fauvism and Its Affinities*, exhibition catalog (New York: Museum of Modern Art, 1976), p. 43.
2. Ibid.
3. Georges Duthuit, *The Fauvist Painters*, trans. Ralph Mannheim (New York: Wittenborn, Schultz, 1950), p. 35.
4. Quoted in Jean-Paul Crespelle, *The Fauves* (Greenwich, Ct.: New York Graphic Society, 1962), p. 7.
5. Duthuit, *Fauvist Painters*, p. 26.
6. Louis Vauxcelles, *Gil Blas*, March 20, 1908; quoted in Gaston Diehl, *The Fauves* (New York: Harry N. Abrams, 1975), p. 12.
7. Pierre Schneider, *Matisse* (New York: Rizzoli, 1984), p. 53.
8. "Interview with Jacques Guenne," 1925; quoted in Jack D. Flam, ed., *Matisse on Art* (London: Phaidon Press, 1973), p. 55.
9. Jean Puy; quoted in Duthuit, *Fauvist Painters*, p. 24.
10. Catherine C. Bock, *Matisse and Neo-Impressionism* (Ann Arbor, Mich.: University Microfilms International, 1978), p. 41.
11. Ibid.
12. Ibid., pp. 54–55.
13. Charles Baudelaire, *Oeuvres complètes* (Paris: Bibliothèque de la Pléiade, 1966), pp. 51–52; my translations.
14. Bock, *Matisse and Neo-Impressionism*, pp. 75–76.
15. Maurice de Vlaminck, *Dangerous Corner* (London: Elek Books, 1947), p. 147.
16. André Derain, *Lettres à Vlaminck* (Paris: Flammarion, 1955), p. 48.
17. Ibid., p. 51.
18. "Matisse Speaks," statement to E. Tériade, 1951; quoted in Flam, *Matisse on Art*, p. 130.
19. Schneider, *Matisse*, p. 242.
20. Maurice Denis, *L'Ermitage*, November 15, 1905; quoted in Bock, *Matisse and Neo-Impressionism*, p. 94.
21. Alfred H. Barr, Jr., *Matisse: His Art and His Public* (New York: Museum of Modern Art, 1951), p. 82.
22. Louis Vauxcelles, *Gil Blas*, March 20, 1907; quoted in Elderfield, *Wild Beasts*, p. 110.
23. Braque, quoted in Gelett Burgess, "The Wild Men of Paris," *Architectural Record* (New York) 19 (May 1910): 407.
24. Diehl, *Fauves*, p. 100.
25. Louis Vauxcelles, *Gil Blas*, March 20, 1907; quoted in Elderfield, *Wild Beasts*, p. 63.
26. Barr, *Matisse*, p. 101.
27. Henri Matisse, "Notes of a Painter"; quoted in Flam, *Matisse on Art*, p. 37.
28. Ibid., p. 38.
29. Charles Estienne, "Interview with Matisse"; quoted in Flam, *Matisse on Art*, p. 49.

7. Cubism: Toward an Absolute Reality
(pages 269–315)

1. Gertrude Stein, *Picasso* (Boston: Beacon Press, 1959), p. 14.
2. Guillaume Apollinaire, *The Cubist Painters, Aesthetic Meditations*, 1913, trans. Lionel Abel (New York: Wittenborn, Schultz, 1949), pp. 11–12.
3. Jean Leymarie, *Picasso, the Artist of the Century* (New York: Viking Press, 1972), p. 2.
4. See William Rubin, *"Primitivism" in 20th Century Art*, exhibition catalog (New York: Museum of Modern Art, 1984), vol. 1, pp. 241–43.
5. Ibid., p. 242.
6. André Malraux, *Picasso's Mask*, trans. June and Jacques Guicharnaud (New York: Holt, Rinehart and Winston, 1976), p. 11.
7. Ibid., p. 18.
8. Roger Shattuck, *The Banquet Years* (New York: Harcourt, Brace and Co., 1969), p. 85.
9. Dora Vallier, "Braque, la peinture et nous," *Cahiers d'art*, no. 1 (October 1954): 14.
10. John Rewald, ed. and trans., *Paul Cézanne: Letters*, 4th ed. (New York: Hacker Art Books, 1976), p. 30.
11. Louis Vauxcelles, *Gil Blas*, November 14, 1908; quoted in Edward F. Fry, *Cubism* (New York: McGraw-Hill, 1966), p. 50.
12. Daniel-Henry Kahnweiler, *The Rise of Cubism*, trans. Henry Aronson (New York: Wittenborn, Schultz, 1949), pp. 11–12.
13. Vallier, "Braque," p. 16.
14. Apollinaire, *Cubist Painters*, p. 13.
15. Gris to Kahnweiler, March 26, 1915; quoted in Mark Rosenthal, *Juan Gris*, exhibition catalog (Berkeley: University Art Museum, University of California; New York: Abbeville Press, 1983), p. 155.
16. Ibid., p. 66.
17. Degas, quoted in Holt, ed., *From the Classicists to the Impressionists*, p. 402.
18. Daniel-Henry Kahnweiler, *Juan Gris: His Life and Work*, trans. Douglas Cooper (New York: Harry N. Abrams, 1969), p. 138.
19. Guillaume Apollinaire, *Chroniques d'art (1902–1918)*, ed. L. C. Breunig (Paris, 1960), p. 72; my translation.
20. Ibid., pp. 125–26.
21. Gleizes's unpublished memoirs; quoted in John Golding, *Cubism: A History and an Analysis, 1907–1914* (New York: George Wittenborn, 1959), p. 24.
22. Albert Gleizes and Jean Metzinger, "Cubism," in Robert L. Herbert, ed., *Modern Artists on Art* (Englewood Cliffs, N.J.: Prentice-Hall, 1964), p. 5.
23. Douglas Cooper, *The Cubist Epoch* (London: Phaidon Press, 1971), p. 79.
24. Fernand Léger, "Les Origines de la peinture et sa valeur représentative," *Montjoie*, no. 9–10 (June 14–29, 1913): 9–10; quoted in Fry, *Cubism*, p. 123.
25. Golding, *Cubism*, p. 148.
26. Léger, "Les Origines de la peinture"; quoted in Fry, *Cubism*, p. 124.
27. Fernand Léger, "Les Réalisations picturales actuelles," *Soirées de Paris*, June 15, 1914, pp. 349–50; quoted in Fry, *Cubism*, pp. 135–36.
28. Cooper, *Cubist Epoch*, p. 79.
29. F. T. Marinetti, "The Founding and Manifesto of Futurism 1909," in Umbro Apollonio, ed., *Futurist Manifestos* (New York: Viking Press, 1970), p. 21.

8. The School of Paris: Innovation and
Nostalgia (pages 317–67)

1. Alfred H. Barr, Jr., *Picasso: Fifty Years of His Art* (New York: Museum of Modern Art, 1946), p. 90.
2. L. C. Breunig, ed., *Apollinaire on Art: Essays and Reviews, 1902–1918*, trans. S. Suleiman (New York: Viking Press, 1972), p. 445.
3. Roland Penrose, *Picasso: His Life and Work*, 3d ed. (Berkeley and Los Angeles: University of California Press, 1981), p. 207.
4. Francis Steegmuller, *Cocteau: A Biography* (Boston: Little, Brown, 1970), p. 165.
5. Ibid., p. 167.
6. Ibid.
7. Ibid., p. 174.
8. Ibid., p. 175.
9. Douglas Cooper, *Fernand Léger: Dessins de guerre, 1915–1916* (Paris: Berggruen & Cie., 1956), p. 12.
10. Douglas Cooper and Gary Tinterow, *The Essential Cubism, 1907–1920: Braque, Picasso and Their Friends* (London: Tate Gallery, 1983), p. 204.
11. Gris to Kahnweiler, April 19, 1915; quoted in Rosenthal, *Gris*, p. 155.
12. Ibid., p. 159.
13. Jean Cocteau, *Modigliani*, trans. F. A. McFarland (London: A. Zwemmer, 1950), n.p.
14. Vlaminck, *Dangerous Corner*, p. 215.
15. Cocteau, *Modigliani*, n.p.
16. Steegmuller, *Cocteau*, p. 150.
17. Peter de Polnay, *Enfant Terrible: The Life and World of Maurice Utrillo* (London: Heinemann, 1967), p. 60.
18. Ibid., p. 240.
19. Matisse to Hans Purrmann, June 1, 1916; quoted in Barr, *Matisse*, p. 182.
20. Robert Goldwater and Marco Treves, eds., *Artists on Art from the XIV to the XX Century* (New York: Pantheon, 1945), p. 415.
21. Ibid., pp. 432–34.
22. Apollinaire, *Apollinaire on Art*, pp. 468–69.
23. Goldwater and Treves, *Artists*, p. 424.
24. Clive Bell, *Since Cézanne* (New York: Harcourt Brace, 1922), pp. 205–6.
25. Robert Hughes, *The Shock of the New* (New York: Alfred A. Knopf, 1981), p. 141.
26. Amédée Ozenfant, *Memoires (1886–1962)* (Paris: Segher, 1968), pp. 215–16.
27. Schneider, *Matisse*, p. 496.
28. André Breton, *Manifeste du Surréalisme*, 1924; quoted in Werner Haftmann, *Painting in the 20th Century* (New York: Praeger, 1965), p. 189.
29. Ibid., p. 282.

404

404. Edouard Vuillard (1868–1940). *The Game of Checkers*, 1906. Oil on cardboard, 29⅞ x 42¾ in. Private collection, Switzerland.

Selected Bibliography

GENERAL

Chipp, Herschel B., ed. *Theories of Modern Art.* Berkeley: University of California Press, 1968.

Goldwater, Robert, and Treves, Marco, eds. *Artists on Art from the XIV to the XX Century.* New York: Pantheon, 1945.

Herbert, Robert L., ed. *Modern Artists on Art.* Englewood Cliffs, N.J.: Prentice-Hall, 1964.

Holt, Elizabeth Gilmore, ed. *From the Classicists to the Impressionists: Art and Architecture in the 19th Century.* New York: New York University Press, 1966.

Nochlin, Linda, ed. *Impressionism and Post-Impressionism, 1874–1904: Sources and Documents.* Englewood Cliffs, N.J.: Prentice-Hall, 1966.

Venturi, Lionello, ed. *Les Archives de l'Impressionisme.* Paris: Durand-Ruel, 1939.

Vollard, Ambroise. *Recollections of a Picture Dealer.* Boston: Little, Brown and Co., 1936.

White, Barbara E., ed. *Impressionism in Perspective.* Englewood Cliffs, N.J.: Prentice-Hall, 1978.

1. Beyond Impressionism: The Last Years

Blunden, Maria, and Blunden, Godfrey. *Impressionists and Impressionism.* New York: Rizzoli International Publications, 1976.

Isaacson, Joel. *The Crisis of Impressionism*, exhibition catalog. Ann Arbor: University of Michigan Museum of Art, 1979.

Kelder, Diane. *The Great Book of French Impressionism.* New York: Abbeville Press, 1980.

Leymarie, Jean. *Impressionism.* 2 vols. Geneva: Skira, 1955.

Pool, Phoebe. *Impressionism.* New York: Praeger, 1967.

Rewald, John. *The History of Impressionism.* 4th rev. ed. New York: Museum of Modern Art, 1973.

2. Neo-Impressionism: Deliberate and Constant Technique

Fénéon, Félix. *Les Impressionistes en 1886.* Paris: Publications de la Vogue, 1886.

———. *Oeuvres.* Paris: Gallimard, 1948.

Henry, Charles. "Introduction à une esthétique scientifique," *La Revue contemporaine*, August 25, 1885, pp. 1–34.

Herbert, Eugenia W. *The Artist and Social Reform, France and Belgium, 1885–1898.* Freeport, N.Y.: Books for Libraries Press, 1971.

Herbert, Robert. *Neo-Impressionism*, exhibition catalog. New York: Solomon R. Guggenheim Museum, 1968.

House, John, et al. *Post-Impressionism*, exhibition catalog. London: Royal Academy, 1979.

Lee, Ellen Wardwell. *The Aura of Neo-Impressionism: The W.*

J. Holliday Collection. Indianapolis: Indianapolis Museum of Art, 1983.

Rewald, John. *Post-Impressionism from van Gogh to Gauguin.* 3d ed. New York: Museum of Modern Art, 1978.

Shone, Richard. *The Post-Impressionists.* London: Octopus Books, 1979.

Signac, Paul. *D'Eugène Delacroix au Néo-Impressionisme.* Edited by Françoise Cachin. Paris: Hermann, 1964.

Sutter, Jean, ed. *The Neo-Impressionists.* Greenwich, Ct.: New York Graphic Society, 1970.

3. Symbolism: The Escape from Nature

Aurier, G.-A. *Oeuvres posthumes.* Paris: Mercure de France, 1893.

Balakian, Anna. *The Symbolist Movement.* New York: Random House, 1967.

Baudelaire, Charles. *The Painter of Modern Life and Other Essays.* Translated and edited by Jonathan Mayne. London: Phaidon Press, 1964.

Chassé, Charles. *Le Mouvement Symboliste dans l'art du XIXe siècle.* Paris: Librairie Floury, 1947.

Delevoy, Robert. *Le Symbolisme.* Geneva: Skira, 1982.

Goldwater, Robert, and Lane, Allen. *Symbolism.* London: Penguin Books, 1979.

Huysmans, J. K. *Against Nature.* Translated by Robert Baldick. London: Penguin Books, 1959.

Jullian, Philippe. *The Symbolists.* London: Phaidon Press, 1974.

Lacambre, G. *French Symbolist Painters*, exhibition catalog. London: Hayward Gallery; Liverpool: Walker Art Gallery, 1972.

Lehmann, A. G. *The Symbolist Aesthetic in France, 1885–1895.* Oxford: Blackwell, 1950.

Lucie-Smith, Edward. *Symbolist Art.* London: Thames and Hudson, 1972.

Mallarmé, Stéphane. *Oeuvres complètes.* Paris: Bibliothèque de la Pléiade, 1965.

Pincus-Witten, Robert. *Occult Symbolism in France. Josephin Peladan and the Salons de la Rose+Croix.* New York: Garland Publishing, 1976.

Rewald, John, et al. *Odilon Redon, Gustave Moreau, Rodolphe Bresdin*, exhibition catalog. New York: Museum of Modern Art; Chicago: Art Institute of Chicago, 1961.

4. Bernard, Gauguin, and van Gogh: The Isolated Ones

Chassé, Charles. *Gauguin et le groupe de Pont-Aven.* Paris, 1921.

Lövgren, Sven. *The Genesis of Modernism: Seurat, Gauguin, Van Gogh and French Symbolism in the 1880s.* Stockholm: Almqvist and Wiksell, 1959.

Rookmaaker, H. R. *Synthetist Art Theories: Genesis and Nature of the Ideas on Art of Gauguin and His Circle.* Amsterdam: Swets and Zeitlinger, 1959.

Roskill, Mark. *Van Gogh, Gauguin and the Impressionist Circle.* London, 1970.

5. The Nabis: Prophets and Painters

Bernier, Georges. *La Revue blanche*, exhibition catalog. New York: Wildenstein, 1983.

Chassé, Charles. *The Nabis and Their Period.* Translated by Michael Bullock. New York: Praeger, 1969.

Jaworska, Wladyslawa. *Gauguin and the Pont-Aven School.* Translated by Patrick Evans. Greenwich, Ct.: New York Graphic Society, 1972.

Mauner, George L. *The Nabis: Their History and Their Art, 1888–1896.* New York: Garland Publishing, 1978.

University of Kansas Museum of Art. *Les Mardis: Stéphane Mallarmé and the Artists of His Circle.* Lawrence, Ks.: University of Kansas Museum of Art, 1965.

Waller, Bret, and Seiberling, Grace. *Artists of "La Revue blanche,"* exhibition catalog. Rochester: Memorial Art Gallery of the University of Rochester, 1984.

Weisberg, Gabriel, et al. *Japonisme: Japanese Influence on French Art, 1854–1910*, exhibition catalog. Cleveland: Cleveland Museum of Art; New Brunswick, N.J.: Rutgers University Art Gallery; Baltimore: Walters Art Gallery, 1975.

6. Fauvism: An Orgy of Pure Colors

Crespelle, Jean-Paul. *The Fauves.* Greenwich, Ct.: New York Graphic Society, 1962.

Diehl, Gaston. *The Fauves.* New York: Harry N. Abrams, 1975.

Duthuit, Georges. *The Fauvist Painters.* Translated by Ralph Mannheim. New York: Wittenborn, Schultz, 1950.

Elderfield, John. *The Wild Beasts: Fauvism and Its Affinities*, exhibition catalog. New York: Museum of Modern Art, 1976.

Giry, Marcel. *Fauvism: Origins and Development.* New York: Alpine Fine Arts Collection, 1982.

Muller, Joseph-Emile. *Fauvism.* New York: Praeger, 1967.

Oppler, Ellen. *Fauvism Reexamined.* New York: Garland Publishing, 1975.

Rewald, John. *Les Fauves*, exhibition catalog. New York: Museum of Modern Art, 1952.

7. Cubism: Toward an Absolute Reality

Apollinaire, Guillaume. *The Cubist Painters, Aesthetic Meditations, 1913*. Translated by Lionel Abel. New York: Wittenborn, Schultz, 1949.
Breunig, L. C., ed. *Apollinaire on Art: Essays and Reviews, 1902–1918*. Translated by S. Suleiman. New York: Viking Press, 1972.
Cooper, Douglas. *The Cubist Epoch*. London: Phaidon Press, 1971.
Cooper, Douglas, and Tinterow, Gary. *The Essential Cubism, 1907–1920: Braque, Picasso and Their Friends*. London: Tate Gallery, 1983.
Fry, Edward F. *Cubism*. New York: McGraw-Hill, 1966.
Gleizes, Albert, and Metzinger, Jean. *Du Cubisme*. Paris: E. Figuière, 1912.
Golding, John. *Cubism: A History and an Analysis, 1907–1914*. New York: George Wittenborn, 1959.
Gray, Christopher. *Cubist Aesthetic Theories*. Baltimore: Johns Hopkins University Press, 1953.
Judkins, Winthrop. *Fluctuant Representation in Synthetic Cubism, Picasso, Braque, Gris, 1910–1920*. New York: Garland Publishing, 1976.
Kahnweiler, Daniel-Henry. *The Rise of Cubism*. Translated by Henry Aronson. New York: Wittenborn, Schultz, 1949.
Rosenblum, Robert. *Cubism and Twentieth-Century Art*. New York: Harry N. Abrams, 1961.
Shattuck, Roger. *The Banquet Years*. New York: Harcourt, Brace and Co., 1969.

8. The School of Paris: Innovation and Nostalgia

Dorival, Bernard. *The School of Paris in the Musée d'Art Moderne*. Translated by Cornelia Brookfield and Ellen Hart. London: Thames and Hudson, 1962.

Nacenta, Raymond. *School of Paris: The Painters and the Artistic Climate of Paris since 1910*. Greenwich, Ct., and New York: New York Graphic Society, 1981.
Raynal, Maurice. *From Picasso to Surrealism*. Vol. 3 of *The History of Modern Painting*. Geneva: Skira, 1950.
Silver, Kenneth E. *'Esprit du corps': The Great War and French Art, 1914–1925*. Ann Arbor, Mich.: UMI Research Press, 1983.

ARTISTS

Pierre Bonnard

Bouvet, Francis. *Bonnard: The Complete Graphic Work*. Translated by Jane Brenton. New York: Rizzoli, 1981.
Dauberville, Jean and Henry. *Bonnard: Catalogue raisonné de l'oeuvre peint*. 4 vols. Paris: Editions J. et H. Bernheim-Jeune, 1965.
Newman, Sasha M. *Bonnard: The Late Paintings*, exhibition catalog. London: Thames and Hudson, 1984.
Soby, James Thrall, and Wheeler, Monroe. *Bonnard and His Environment*. New York: Museum of Modern Art, 1964.
Terasse, Antoine. *Pierre Bonnard*, exhibition catalog. Paris: Gallimard, 1967.

Georges Braque

Carra, Massimo. *L'Opera completa di Braque*. Milan: Rizzoli, 1971.
Cogniat, Raymond. *Georges Braque*. New York: Harry N. Abrams, 1980.
Gieure, Maurice. *Georges Braque*. New York, 1956.
Hope, H. R. *Braque*, exhibition catalog. New York: Museum of Modern Art, 1949.
Mangin, Nicole, ed. *Georges Braque: Catalogue de l'oeuvre: Peintures 1916–1957*. 6 vols. Paris: Maeght, 1959–73.

Pouillon, Nadine, and Monod-Fontaine, Isabelle. *Braque*, exhibition catalog. Paris: Centre Georges Pompidou, Musée National d'Art Moderne, 1982.
Vallier, Dora. *Braque, l'oeuvre gravé: Catalogue raisonné*. Paris: Flammarion, c. 1982.

Mary Cassatt

Breeskin, Adelyn Dohme. *Mary Cassatt: A Catalogue Raisonné of the Oils, Pastels, Watercolors and Drawings*. Washington, D.C.: Smithsonian Institution Press, 1970.
Hale, Nancy. *Mary Cassatt: A Biography of a Great American Painter*. Garden City, N.Y.: Doubleday, 1975.
Mathews, Nancy Mowll, ed. *Cassatt and Her Circle: Selected Letters*. New York: Abbeville Press, 1984.
Pollock, Griselda. *Mary Cassatt*. New York: Harper and Row, 1979.

Paul Cézanne

Badt, Kurt. *The Art of Cézanne*. New York: Hacker Art Books, 1985.
Loran, Erle. *Cézanne's Compositions*. Berkeley: University of California Press, 1963.
Rewald, John, ed. and trans. *Paul Cézanne: Letters*. 4th ed. New York: Hacker Art Books, 1976.
Rubin, William, et al. *Cézanne: The Late Work*, exhibition catalog. New York: Museum of Modern Art, 1977.
Schiff, Richard. *Cézanne and the End of Impressionism: A Study of the Theory, Technique, and Critical Evaluation of Modern Art*. Chicago: University of Chicago Press, 1984.
Venturi, Lionello. *Cézanne: Son art, son oeuvre*. 2 vols. Paris: P. Rosenberg, 1936.
Vollard, Ambroise. *Paul Cézanne: His Life and Art*. Translated by Harold van Doren. New York: N. L. Brown, 1923.
Wechsler, Judith, ed. *Cézanne in Perspective*. Englewood Cliffs, N.J.: Prentice-Hall, 1975.

Marc Chagall

Chagall, Marc. *My Life*. Translated by Elizabeth Abbot. New York: Orion Press, 1960.
Compton, Susan. *Chagall*, exhibition catalog. Philadelphia: Philadelphia Museum of Art, 1985.
Haftmann, Werner. *Marc Chagall*. Translated by Heinrich Baumann and Alexis Brown. New York: Harry N. Abrams, 1973.
Leymarie, Jean. Preface to *Marc Chagall*, exhibition catalog. Paris: Grand Palais, Réunion des Musées Nationaux, 1969.
Meyer, F. *Marc Chagall*. Translated by Robert Allen. New York: Thames and Hudson, 1964.

Henri Edmond Cross

Compin, Isabelle. *H. E. Cross*. Paris: Quatre Chemins, 1964.
Denis, Maurice. *H. E. Cross*, exhibition catalog. Paris: Galerie Bernheim-Jeune, 1910.
Rewald, John. *H. E. Cross*, exhibition catalog. New York: Fine Arts Associates, 1951.

Edgar Degas

Guérin, M., ed. *Degas Letters*. Translated by Marguerite Kay. Oxford: B. Cassirer, 1948.
Guillaud, Maurice, et al. *Degas: Form and Space*. Paris: Marais-Guillaud Editions, 1984.
Lemoisne, P. A. *Degas et son oeuvre*. 4 vols. Paris: P. Brame and C. H. Hauke, 1946.
McMullen, Roy. *Degas: His Life, Times, and Work*. Boston: Houghton Mifflin, 1984.
Reff, Theodore. *Degas: The Artist's Mind*. New York: Metropolitan Museum of Art, 1976.
Valéry, Paul. *Degas, danse, dessin*. Paris: Gallimard, 1938.
Vollard, Ambroise. *Degas: An Intimate Portrait*. Translated by Randolph T. Weaver. New York: Greenberg, 1927.

Robert Delaunay

Buckberrough, Sherry A. *Robert Delaunay: The Discovery of Simultaneity*. Ann Arbor, Mich.: UMI Research Press, 1982.
Dorival, Bernard. *Robert Delaunay, 1885–1941*. Brussels: J. Damase, 1975.
Hoog, Michel. *Robert Delaunay*. New York: Crown, 1976.

405. Paul Cézanne (1839–1906). *Portrait of Gustave Geffroy*, 1895. Oil on canvas, 45¾ x 35 in. Musée d'Orsay, Paris.

405

Maurice Denis

Aichele, K. P. "Maurice Denis and Georges Desvallières: From Symbolism to Sacred Art." Ph.D. dissertation, Bryn Mawr, 1976.
Denis, Maurice. *Théories, 1890–1910*. 4th ed. Paris: Rouart et Watelin, 1920.
———. *Journal I*. 3 vols. Paris: Editions La Colombe, 1957–59.
Jamot, Paul. *Maurice Denis*. Paris: Librairie Plon, 1945.

André Derain

Derain, André. *Lettres à Vlaminck*. Paris: Flammarion, 1955.
Diehl, Gaston. *Derain*. New York: Crown, 1964.
Hilaire, Georges. *Derain*. Geneva: Pierre Cailler, 1959.
Sutton, Denys. *André Derain*. London: Phaidon Press, 1959.

Marcel Duchamp

Cabanne, Pierre. *Dialogues with Marcel Duchamp*. Translated by Ron Padgett. New York: Viking Press, 1971.
Schwartz, Arturo. *The Complete Works of Marcel Duchamp*. New York: Harry N. Abrams, 1970.

Raoul Dufy

Laffaille, Maurice. *Dufy: Catalogue raisonné de l'oeuvre peint*. Geneva: Editions Motte, 1972.
Robertson, Bryan, et al. *Raoul Dufy*, exhibition catalog. London: Hayward Gallery, 1983.
Werner, Alfred. *Raoul Dufy*. New York: Harry N. Abrams, 1953.

Paul Gauguin

Andersen, Wayne. *Gauguin's Paradise Lost*. New York: Viking Press, 1971.
Bowness, Alan. *Paul Gauguin*. London: Phaidon Press, 1971.
Dorra, H. "Emile Bernard and Paul Gauguin." *Gazette des Beaux-Arts* 65 (1955): 227–46.
Guérin, Daniel, ed. *The Writings of a Savage, Paul Gauguin*. New York: Viking Press, 1978.
Jirat-Wasiutynski, Vojtech. *Paul Gauguin in the Context of Symbolism*. New York: Garland Publishing, 1978.
Malingue, M., ed. *Lettres de Gauguin à sa femme et à ses amis*. Paris: B. Grasset, 1946.
Wildenstein, Georges, and Cogniat, Raymond. *Gauguin*, exhibition catalog. Paris: Les Beaux-Arts, 1964.

Juan Gris

Cooper, Douglas, ed. *Letters of Juan Gris (1913–1927)*. Translated by Douglas Cooper. London: Privately printed, 1956.
Cooper, Douglas. *Juan Gris: Catalogue raisonné de l'oeuvre peint établi avec la collaboration de Margaret Potter*. 2 vols. Paris: Berggruen, 1977.
Kahnweiler, Daniel-Henry. *Juan Gris: His Life and Work*. Translated by Douglas Cooper. New York: Harry N. Abrams, 1969.
Rosenthal, Mark. *Juan Gris*, exhibition catalog. Berkeley: University Art Museum, University of California; New York: Abbeville Press, 1983.

Fernand Léger

Buck, Robert T., et al. *Fernand Léger*, exhibition catalog. Buffalo: Albright-Knox Art Gallery; New York: Abbeville Press, 1982.
Cooper, Douglas. *Fernand Léger: Dessins de guerre, 1915–1916*. Paris: Berggruen & Cie., 1956.
Delevoy, R. L. *Léger, Biographical and Critical Study*. Translated by Stuart Gilbert. Geneva: Skira, 1962.
Descargues, Pierre. *Fernand Léger*. Paris: Editions Cercle d'Art, 1955.

Henri Matisse

Barr, Alfred H., Jr. *Matisse: His Art and His Public*. New York: Museum of Modern Art, 1951.
Bock, Catherine C. *Matisse and Neo-Impressionism*. Ann Arbor, Mich.: University Microfilms International, 1978.
Flam, Jack D., ed. *Matisse on Art*. London: Phaidon Press, 1973.
Gowing, Lawrence. *Matisse*. New York and Toronto: Oxford University Press, 1979.
Schneider, Pierre. *Matisse*. New York: Rizzoli, 1984.

Amedeo Modigliani

Cocteau, Jean. *Modigliani*. Translated by F. A. McFarland. London: A. Zwemmer, 1950.
Crespelle, Jean Paul. *Modigliani: Les Femmes, les amis, l'oeuvre*. Paris: Presses de la Cité, 1969.
Sichel, Pierre. *Modigliani*. New York: E. P. Dutton, 1967.
Werner, Alfred. *Amedeo Modigliani*. New York: Harry N. Abrams, 1966.

Claude Monet

Isaacson, Joel. *Claude Monet, Observation and Reflection*. Oxford: Phaidon Press, 1978.
Levine, Stephen S. *Monet and His Critics*. New York: Garland Publishing, 1976.
Seitz, William Chapin. *Claude Monet*. New York: Harry N. Abrams, 1960.
Wildenstein, Daniel. *Monet: Biographie et catalogue raisonné*. 3 vols. Lausanne and Paris: Bibliothèque des Arts, 1974–79.
Wildenstein, Daniel, et al. *Monet's Years at Giverny: Beyond Impressionism*. New York: Metropolitan Museum of Art, 1978.

Gustave Moreau

Kaplan, Julius. *Gustave Moreau*, exhibition catalog. Los Angeles: Los Angeles County Museum of Art, 1974.
Mathieu, Pierre Louis. *Gustave Moreau*. Boston: New York Graphic Society, 1976.

Pablo Picasso

Barr, Alfred H., Jr. *Picasso: Fifty Years of His Art*. New York: Museum of Modern Art, 1946.
Leymarie, Jean. *Picasso, the Artist of the Century*. New York: Viking Press, 1972.
Lipton, Eunice. *Picasso Criticism, 1901–1939*. New York: Garland Publishing, 1975.
Malraux, André. *Picasso's Mask*. Translated by June and Jacques Guicharnaud. New York: Holt, Rinehart and Winston, 1976.
Penrose, Roland. *Picasso: His Life and Work*. 3d ed. Berkeley and Los Angeles: University of California Press, 1981.
Rubin, William, ed. *Pablo Picasso: A Retrospective*, exhibition catalog. New York: Museum of Modern Art, 1980.
Schiff, Gert. *Picasso in Perspective*. Englewood Cliffs, N.J.: Prentice-Hall, 1976.
Stein, Gertrude. *Picasso*. Boston: Beacon Press, 1959.
Zervos, Christian. *Pablo Picasso: Oeuvres*. Paris: Cahiers d'Art, 1932.

406

406. Pablo Picasso (1881–1973). *Ma Jolie*, 1914. Oil on canvas, 17¾ x 15¾ in. Private collection.

407

407. Georges Seurat (1859–1891). *The Artist in His Studio*, 1884. Conté crayon on paper, 12⅛ x 9 in. Philadelphia Museum of Art; The A. E. Gallatin Collection.

de Hauke, C. M. *Seurat et son oeuvre*. 2 vols. Paris: Paul Brame et C. M. de Hauke, 1961.
Homer, William Innes. *Seurat and the Science of Painting*. Cambridge, Mass.: MIT Press, 1964.
Rewald, John. *Georges Seurat*. New York: Wittenborn Press, 1943.
Russell, John. *Seurat*. New York: Praeger, 1965.

Paul Signac

Cachin, Françoise. *Paul Signac*. Paris: Bibliothèque des Arts, 1971.
Kornfeld, E. W., and Wick, P. A. *Catalogue raisonné de l'oeuvre gravé et lithographié de Paul Signac*. Bern: Editions Kornfeld et Klipstein, 1974.
Rewald, John, ed. "Excerpts from the Unpublished Diary of Paul Signac: I (1894–1895)." *Gazette des Beaux-Arts* 36 (July–September 1949): 97–128, 166–74.

Chaim Soutine

Castaing, Marcellin, and Leymarie, Jean. *Soutine*. Translated by John Ross. New York: Harry N. Abrams, 1964.
Tuchman, Maurice. *Chaim Soutine, 1893–1943*, exhibition catalog. Los Angeles: Los Angeles County Museum of Art, 1968.
Wheeler, Monroe. *Soutine*, exhibition catalog. New York: Museum of Modern Art, 1950.

Henri de Toulouse-Lautrec

Cooper, Douglas. *Henri de Toulouse-Lautrec*. New York: Harry N. Abrams, 1966.
Dortu, M. G. *Toulouse-Lautrec et son oeuvre*. 6 vols. New York: Collectors Editions Ltd., 1971.
Roger-Marx, Claude. *Toulouse-Lautrec*. Paris: Editions Universitaires, 1957.
Sugana, G. M. *The Complete Paintings of Toulouse-Lautrec*. New York: Harry N. Abrams, 1973.

Maurice Utrillo

Petrides, P. *Maurice Utrillo: L'Oeuvre complète*. 2 vols. Paris: P. Petrides, 1962.
Polnay, Peter de. *Enfant Terrible: The Life and World of Maurice Utrillo*. London: Heinemann, 1967.
Werner, Alfred. *Maurice Utrillo*. New York: Harry N. Abrams, 1981.

Vincent van Gogh

de la Faille, J.-B. *The Works of Vincent van Gogh: His Paintings and Drawings*. New York: Reynal and Co., 1970.
Hulsker, Jan. *The Complete van Gogh: Paintings, Drawings, Sketches*. New York: Harry N. Abrams, 1980.
Pickvance, Ronald. *Van Gogh in Arles*, exhibition catalog. New York: Metropolitan Museum of Art, 1984.
Shapiro, Meyer. *Vincent van Gogh*. New York: Harry N. Abrams, 1950.
van Gogh-Bonger, J., and van Gogh, V. W., eds. *The Complete Letters of Vincent van Gogh*. Translated by J. van Gogh-Bonger. 3 vols. Greenwich, Ct.: New York Graphic Society, 1958.
Welsh-Ovcharov, Bogomila, ed. *Van Gogh in Perspective*. Englewood Cliffs, N.J.: Prentice-Hall, 1974.

Maurice de Vlaminck

Genevoix, Maurice. *Vlaminck*. 2 vols. Paris: Flammarion, 1954.
Perls, Klaus G. *Vlaminck*. New York: Hyperion Press, 1941.
Selz, J. *Vlaminck*. New York: Crown, 1963.
Vlaminck, Maurice de. *Dangerous Corner*. London: Elek Books, 1947.

Edouard Vuillard

Chastel, André. *Vuillard, 1864–1940*. Paris: Floury, 1946.
Preston, Stuart. *Vuillard*. New York: Harry N. Abrams, 1985.
Roger-Marx, Claude. *Vuillard: His Life and Work*. Translated by E. B. D'Auvergne. London: P. Elek, 1946.
Russell, John. *Edouard Vuillard: 1868–1940*, exhibition catalog. Toronto: Art Gallery of Ontario, 1971.

Camille Pissarro

Falla, P. S. *Pissarro*, exhibition catalog. Boston: Museum of Fine Arts, 1980.
Pissarro, Ludovico-Rodo, and Venturi, Lionello. *Camille Pissarro: Son art, son oeuvre*. Paris: P. Rosenberg, 1939.
Rewald, John, ed., with the assistance of Lucien Pissarro. *Camille Pissarro: Letters to His Son Lucien*. Translated by Lionel Abel. New York: Pantheon Books, 1943.
Rewald, John. *Camille Pissarro*. New York: Harry N. Abrams, 1963.
Shikes, Ralph H., and Harper, Paula. *Pissarro, His Life and Work*. New York: Horizon Press, 1980.

Pierre Puvis de Chavannes

d'Argencourt, Louise, et al. *Puvis de Chavannes, 1824–1898*, exhibition catalog. Ottawa: National Gallery of Canada, 1977.
Wattenmaker, Richard J. *Puvis de Chavannes and the Modern Tradition*, exhibition catalog. Toronto: Art Gallery of Ontario, 1976.

Odilon Redon

Bacou, R. *Odilon Redon*. 2 vols. Geneva: P. Cailler, 1956.
Mellerio, A. *Odilon Redon: Peintre, dessinateur et graveur*. Paris: Floury, 1923.
Redon, Odilon. *A Soi-même: Journal (1867–1915)*. Paris: Corti, 1961.

Pierre Auguste Renoir

Callen, Anthea. *Renoir*. London: Orbis, 1978.
Daulte, François. *Auguste Renoir: Catalogue raisonné de l'oeuvre peint*. Lausanne: Editions Durand-Ruel, 1971.
House, John, et al. *Renoir*, exhibition catalog. Boston: Museum of Fine Arts; New York: Harry N. Abrams, 1985.
Rewald, John, ed. *Renoir Drawings*. New York: H. Bittner, 1946.
Vollard, Ambroise. *Renoir: An Intimate Record*. New York, 1925.
White, Barbara Ehrlich. *Renoir: His Life, Art, and Letters*. New York: Harry N. Abrams, 1984.

Georges Rouault

Courthion, Pierre. *Rouault*. New York: Harry N. Abrams, 1962.

Henri Rousseau

Certigny, Henry. *Le Douanier Rousseau en son temps: Biographie et catalogue raisonné*. 2 vols. New York: Hacker Art Books, 1984.
Shattuck, Roger, et al. *Henri Rousseau*, exhibition catalog. New York: Museum of Modern Art, 1985.

Paul Sérusier

Boyle-Turner, Caroline. *Paul Sérusier*. Ann Arbor, Mich.: UMI Research Press, 1983.
Denis, Maurice. *Sérusier, sa vie, son oeuvre*. Paris, 1943.
Sérusier, Paul. *ABC de la peinture: Correspondance*. Paris: Floury, 1950.

Georges Seurat

Broude, Norma. *Seurat in Perspective*. Englewood Cliffs, N.J.: Prentice-Hall, 1978.

Acknowledgments

It will be obvious to the reader that my greatest debt is to the museums, collectors, and galleries who provided the splendid visual material for this book. Particular thanks are due to Arthur Altschul, Samuel Josefowitz, Jean-Claude and Yann Bellier, and Barry Friedman for information and assistance that simplified the task of pictorial research.

At the onset of my work, François Daulte shared his intimidating knowledge of Impressionist and Post-Impressionist painting with me. His advice and his congeniality encouraged me to continue. Although the shape and content of the book have undergone changes in the ensuing three years, I hope the results justify his initial enthusiasm.

At times, the organizational and writing demands of the subject sorely taxed my skill and energy. In an effort to meet their challenge I sought the counsel of friends: Susie Bloch lent her insight and knowledge of the literature of Cubism, and John Daley's editorial expertise guided my faltering efforts to come to terms with the School of Paris. Ronny Cohen and Beth Harris provided research and bibliographical help that was greatly appreciated.

I have indicated that this was not an easy project; in fact, it is doubtful that it would have taken shape at all without the extraordinary effort of my editors. The first, Andrea Belloli, dealt with the initial, rough version of the text, and I am grateful for her struggle to make order out of chaos. When other commitments made it impossible for her to continue, Nancy Grubb assumed the burden of seeing the manuscript through revisions to its final form. She deserves not only my profound thanks but also the publishing world's equivalent of the *croix-de-guerre* for her professionalism, her determination, and her grace during long and enervating periods of combat. Others at Abbeville—Sarah Kirshner, who worked doggedly at securing permissions for the numerous illustrations, and Howard Morris, designer par excellence—cannot go unmentioned.

Six years ago, on a similar occasion, I invoked the name of Harry N. Abrams, Abbeville's founder, whose vision and spirit inspired the publication of my volume on French Impressionism. Now my thanks are directed to Robert Abrams and Mark Magowan for their unfailing support and for their patience. These were the essential ingredients in the realization of this book.

D.K.

Index

379

Photographic Credits

Editors: Nancy Grubb and Andrea Belloli
Designer: Howard Morris
Production manager: Dana Cole
Picture researcher: Sarah Kirshner

Front cover: Paul Signac. *Against the Enamel of a Background
 Rhythmic with Beats and Angles, Tones and Colors, Portrait of
 M. Félix Fénéon in 1890*, 1890. Detail of plate 84.
Back cover: Pierre Bonnard. *In a Southern Garden*, 1913. Detail of
 plate 225.

Library of Congress Cataloging in Publication Data

Kelder, Diane.
 The great book of post-impressionism.

 Bibliography: p.
 Includes index.
 1. Post-impressionism (Art) 2. Painting, Modern—19th
century. 3. Painting, Modern—20th century. I. Title.
ND192.P6K45 1986 759.05'6 86-3320
ISBN 0-89659-574-9

First edition